4 WEEKS

Ashton, Dore.

Noguchi east and
west.

$34.50

DATE			

Noguchi
East and
West

Dore
Ashton

With special photographs

by Denise Browne Hare

Alfred A. Knopf

New York

1992

Harry N. Abrams, Inc.: Excerpts from *The Isamu Noguchi Garden Museum* by
Isamu Noguchi. Published 1987 by Harry N. Abrams, Inc., New York. All rights
reserved. Reprinted by permission.
The Crossroad Publishing Company: Excerpts from *Symbolism, the Sacred, & the
Arts* by Mircea Eliade. Copyright © 1985 by The Crossroads Publishing Company.
Reprinted by permission.
Centre Georges Pompidou: English translation of excerpts from "Japon des Avant
Gardes." Copyright © 1986 Centre Georges Pompidou. Reprinted by permission.
Alfred A. Knopf, Inc. and Faber and Faber Ltd.: Excerpt from "The Irish Cliffs of
Moher" from *The Collected Poems of Wallace Stevens*. Copyright 1952 by Wallace
Stevens. Rights in the U.K. administered by Faber and Faber Ltd., London.
Reprinted by permission of the publishers.
Princeton University Press: Excerpts from *Zen and Japanese Culture* by Daisetz T.
Suzuki. Copyright © 1959 by Princeton University Press. Copyright renewed 1987.
Reprinted by permission.
Thames and Hudson Ltd.: Excerpts from *A Sculptor's World* by Isamu Noguchi.
Reprinted by permission.
Walker Art Center: Excerpts from *Noguchi's Imaginary Landscapes* by Martin
Friedman. Reprinted by permission of Walker Art Center, Minneapolis.

Library of Congress Cataloging-in-Publication Data
Ashton, Dore.
Noguchi east and west / Dore Ashton ; with special photographs by
Denise Browne Hare.
p. cm.
Includes bibliographical references and index.
ISBN 0-394-58804-5
1. Noguchi, Isamu, 1904– . 2. Japanese American sculptors—
Biography. I. Title.
NB237.N6A8 1992
709′.2—dc20
[B] 91-18974 CIP

Manufactured in the United States of America

FIRST EDITION

Contents

A color insert, with special photographs by Denise Brown Hare, follows page 276.

Preface

NOGUCHI HAD a very long life and numberless encounters. He circled the world many times over. I have not tried to document his every move, or even his entire oeuvre. In writing a critical biography, I held in mind an image—that of the bamboo tree, a tree which Noguchi loved and used in his work. The bamboo is segmented, as was Noguchi's life, yet it grows tall and, despite its compartmented structure, is a single organism. I think of Noguchi's life's work as an organism and have set out to highlight the various experiences, circumstances, and sources that nourished it. I have concentrated on works that seem to me significant in the trajectory of his life, but have unavoidably omitted detailed discussion of other equally important works, which have been discussed in other books. They are listed in the bibliography. All quotations not attributed in notes are from conversations with the author.

Acknowledgments

MY RESEARCH in Japan was supported by a grant from the Asian Cultural Council whose New York director, Richard S. Lanier, was exceptionally kind and tendered much wise advice. In Tokyo, the Asian Cultural Council, through the good offices of Hitomi Wada, guided and assisted me with unflagging patience. Both Denise Browne Hare, who traveled with me in Japan taking photographs for this book, and I are grateful for the unlimited goodwill and practical help we received from the Asian Cultural Council.

The Isamu Noguchi Foundation and the Isamu Noguchi Garden Museum staff deserve the kind of thanks that are very difficult to express adequately. Almost no aspect of this book could have been fulfilled without their consistent help. I warmly thank Shoji Sadao, Noguchi's colleague and friend, for his unfailing interest and support; Amy Hau for her extensive help in finding material in the Noguchi archives; Bonnie Rychlak and Erick Johnson, who shared insights with me; Marge Goldwater, former director of the museum, for her warm interest; and Horacio Castaño for his essential services. A special thanks goes to Priscilla Morgan of the foundation for her generous sharing of documents and information.

In the United States, many scholars kindly shared their resources with me. Nancy Grove, whose own work on Noguchi is invaluable, offered excellent advice, as did Diane Apostolos-Cappadona. The poet Grace Schulman, art historian Fred Licht, Jamake Highwater, Lillian Kiesler, Yuumi Domoto, Arne Ekstrom, Barry and Gloria Garfinkel, Li-Lan, Dorothy Norman, Alison de Lima Greene, Naoto Nakagawa, and Francis Tanabe all shared their insights unstintingly. The director of the Boston Museum, Alan Shestack, went far beyond the call of duty in assisting me, as did Jean Erdman, John Cage, Erick Hawkins, Lucia Dlugoszewski,

Evan Turner, and Gordon Onslow-Ford. As always Clive Phillpot, director of the library at the Museum of Modern Art, provided invaluable help. I wish to thank Dr. Jerome Schulman for his exceptional kindness in finding scientific answers for me. I also thank my colleagues Herb Bott and Ulla Volk at the Cooper Union Library for their exceptional efforts.

In Europe, I thank the brilliant scholar Věra Linhartová, whose writings and letters were indispensable to this book, and Luigi Sansone, who helped me find Noguchi's Italian haunts.

Many of Noguchi's friends in Hawaii helped me, and I want to thank them all, above all, Roger Dell, former director of education at the Honolulu Museum; Ronn Ronck; and Deborah Waite.

Needless to say, without the guidance of dozens of people in Japan, I would have been lost. First, there is Professor Hide Ishiguro, philosopher and essayist, whom I deeply admire, and who was always willing to discuss difficult issues with me. I also thank Professor Shuji Takashina, Mikio Kato, and the musician Christopher Blasdel for their general and most helpful discussions. Both Professor Kijima and Mr. Shinichiro Foujita, director of the Ohara Museum, gave me invaluable opinions about current Japan, as did Tadayasu Sakai, vice director of the Kamakura museum, and Tsutomu Mizusawa. I owe a special debt to the photographer Michio Noguchi, who spoke with me at length about his brother Isamu and who was always willing to supply information I could find nowhere else. Many of Noguchi's friends received me and discussed his work and life with me. The most important interviews were with Tōru Takemitsu, Kenzō Tange, Hiroshi Teshigahara, Shigeo Anzai, Yusaku Kamekura, Yoshio Taniguchi, Arata and Aiko Isozaki, Mami and Hisao Domoto, and Genichiro Inokuma. I thank them all warmly.

Both Denise Browne Hare and I would have been defeated by language problems had we not had Marc Keane in Kyoto and Kathleen Hirano in Shikoku as expert translators. Mrs. Hirano's knowledge of the local idioms was invaluable.

In Noguchi's Japanese retreat, Mure, we were received with such cordiality by Mr. and Mrs. Masatoshi Izumi, their daughter Mihoko, and others that I cannot thank them profoundly enough. Mr. Izumi spent many hours with me and proved to be a wonderful mentor. I am also grateful to the architect Tadashi Yamamoto of Takamatsu, and the master gardener Tuemon Sanō of Kyoto, for specialized information. Finally, I want to thank Kimiko Fuji Kitayama, my college friend, who first taught me the beauty of Japanese culture, and Takako Ueki, my student, who helped with translation.

Noguchi
East and
West

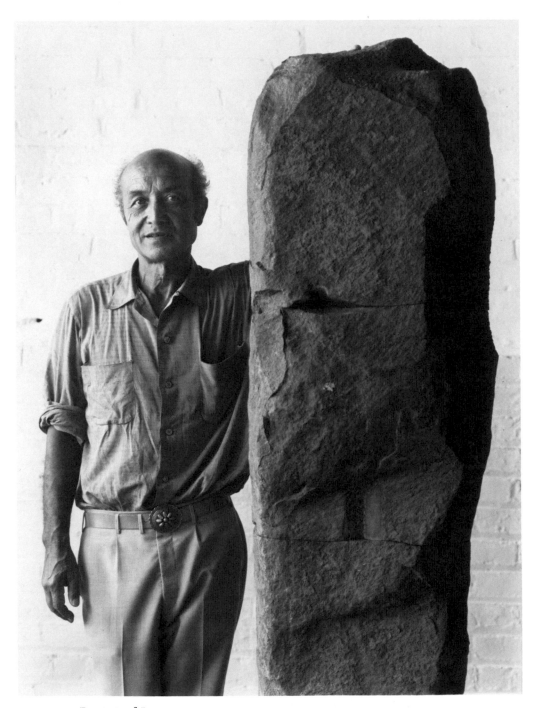

Portrait of Isamu
Noguchi, ca. 1970.
Photo: Evelyn Hofer

Introduction

WHENEVER NOGUCHI REMINISCED, even about his childhood, he used the technique of the teller of tales. His memory was selective, artful, almost Proustian in its fetching up of vital detail. Noguchi shaped the story of his childhood over a long life. Almost always it commenced with an idyllic place, the seaside home that his mother had created in Chigasaki, Japan, with its pine grove near the sea. In recounting his own original story, Noguchi often added significant embellishments. Once, for instance, in an interview, he was speaking of the half-Japanese, half-Western house his mother built, telling of how she enlisted him, at the age of eight, in the rituals of building. This was a story he had told often, but this time, it had a slightly different tone:

> In 1950, when I had gone to Japan after the war, these friends of mine and I, we all took a trip to Chigasaki and went looking for this house which had a round window which looked out on Mt. Fuji. And it had peach trees out in front. And we looked around and we found it. We found the house and we walked in. It hadn't changed much. It grew old, of course, it was all gray and it had been all fresh. And we were sitting there talking when around the corner comes this little old lady and she says, "Isamu-san, Isamu-san." Just like that. I don't know what it was, but she recognized me and she said: "Look, I have some sweet potatoes, you'll like them very much." And she gave them to me.
>
> By some strange fluke, one doesn't think of time, you know, and I thought she was the old lady who used to live there across the street. It was only later that I realized that she couldn't have been the old lady because of how many years had passed, you see. But she probably had known me as a child. She recognized me. How wonderful it is to be recognized by people. I don't know why she happened to come around with sweet potatoes in her apron . . .

It is the voice of the storyteller, the mythmaker, that adds the image: the little old lady with the sweet potatoes in her apron. Sweet potatoes offered is one thing. Sweet potatoes gathered in an apron conjures a great deal more, as the artist with his selective memory instinctively knows. This story, like all myths, is first lived, then given another dimension ("one doesn't think of time," "how wonderful it is to be recognized") without prosaic philosophizing.

In certain temperaments there is an inbred resistance to the abstract-ing process that is felt to deaden experience. When, for instance, Gershom Scholem described the young Walter Benjamin, he stressed that "Benja-min accepted myth alone as 'the world': it was already present in myth. Myth was everything; all else, including mathematics and philosophy, was only obscuration, a glimmer that had arisen within it."[1]

The temperament that seeks the "other" explanation of the world (Scholem specified that Benjamin was "still not sure what the purpose of philosophy was, as there was no need to discover 'the meaning of the world': it was already present in myth") seeks meaning as imagined rather than thought. The mythic way of apprehending meaning was native to Noguchi. There are countless testimonies in his life's work to his quick-ened sense of meaning as deposited in the stories commonly called myths. The myth of Orpheus, for example, served him as a touchstone in many and diverse situations. He stretched it, shaped it, mined its ambiguities to suit his needs and circumstances. But there was always an inner consist-ency that bespoke the nature of his questing. In one instance in 1985, in a conversation with the Israeli writer Matti Megged, he spoke of his great attraction to Jerusalem and the hill of stones offered to him for his sculp-ture garden:

> I came in some respects as one who returns home. I thought of
> these people as people like me who wanted to shape a certain part
> of earth that would be theirs. I wanted to discover anew the myth
> of Orpheus—up and down, inside and outside—not bound by any
> space but attached through the stones from which it is born.

This aspect of the Orpheus myth suited his need in Jerusalem. In other situations, he recast the tale and aligned it with its mythical cognate in Japan. When he wrote of his collaboration with Igor Stravinsky on the ballet *Orpheus* in 1948, he said:

> Never was I more personally involved in creation than with this
> piece which is the story of the artist. I interpreted "Orpheus" as
> the story of the artist blinded by his vision (the mask). Even
> inanimate objects move to his touch—as do the rocks, at the pluck
> of his lyre. To find his bride or to seek his dream or to fulfill his
> mission, he is drawn by the spirit of darkness to the netherworld.
> . . . Here, too, entranced by his art, all obey him; and even Pluto's
> rock turns to reveal Eurydice in his embrace (she has been mar-
> ried to Death, as in the Japanese myth of Izanagi-No-Mikoto and
> Izanami-No-Mikoto).[2]

While Noguchi was working on *Orpheus*, he had already been for some years a witness of, and sometime participant in, the formation of what later came to be called the New York School, or the abstract expressionist movement. His association with such important artists in that movement as Arshile Gorky and Willem de Kooning had been very close on occasion. He took part in the intense discussions that occurred in the late 1930s and early 1940s that so often focused on the question of mythical as opposed to historical time. American artists had been exceptionally receptive to the strong currents from Europe at the time—currents that brought them the views of the surrealists, who were energetically reordering a worldview and creating an expansive psychological viewpoint that included not only the promptings of subconscious repositories of imagery but also an emphasis on the significant origin myths of all cultures. Since Noguchi had spent important months in Paris, encountering the works of certain artists prominent in the surrealist movement even as he set himself to work as Constantin Brancusi's apprentice, he was able to find common ground with a small number of New York artists eagerly assimilating surrealist principles during that time. Most of all, he was able to communicate with his friend Arshile Gorky, who, like him, was an outsider both by birth and by temperament.

Gorky was well known for his self-dramatization as an exotic. Friends admired him—this physical giant with the melancholy dark eyes, bohemian apparel, and accented English—but they also smiled indulgently when they recalled his sentimentality about his background. Gorky had come to the United States from Armenia as a youth. His early artistic formation was entirely within the modern canon established by Cézanne and extended by the cubists. But, in the mid-1930s, hearing of Parisian preoccupations, Gorky had looked to himself and discovered, near at hand, the means of his own imaginative liberation in his very own background. It was then that he began to cultivate the poetic overtones of the mythic voice—the rhythm of the chant. It provided him with the sense of spaciousness, the psychological space that his painting required. Like Noguchi, who, after his initial trip as a young artist to the East, had profited from the innate expansiveness of myth—its elasticity, its capacity to suggest, its allegorical motor—Gorky slipped easily into mythmaking, creating for himself a childhood universe safe from the ravages of materialism, which was regarded by all the artists in his circle as the arch foe of creation. In 1939, when he and Noguchi spent considerable time together, Gorky was speaking of the artist's imperative, saying that he must "resurrect his ancient role as the uncoverer and the interpreter, but never the recorder of life's secrets."[3] By 1942, Gorky was in full mythic voice and answered a questionnaire from the Museum of Modern Art in New York:

About 194 feet away from our house in the road to the spring my
father had a little garden with a few apple trees which had retired
from giving fruit. There was a ground constantly in shade where
grew incalculable amounts of wild carrots, and porcupines made
their nests. There was a blue rock buried in the black earth with
a few patches of moss placed here and there like fallen clouds. But
from where came all the shadows in constant battle like the lanc-
ers of Paolo Uccello's paintings? This garden was identified as the
Garden of Wish Fulfillment. . . . Above all this stood an enormous
tree all bleached under the sun, the rain, the cold, and deprived
of leaves. This was the Holy Tree. I myself don't know why this
tree was holy but I had witnessed many people, whoever did pass
by, that would tear voluntarily a strip of their clothes and attach
this to the tree . . .[4]

Like Gorky, Noguchi periodically reinvented his own past, especially
when he could share his natural proclivities with others exploring in simi-
lar directions. Wherever the voice of the far distant reaches of time
echoed, particularly during the years between and immediately after the
two world wars, there were artists who attended. No doubt circumstances
modified what was probably an instinctive and perhaps defensive drift to
the horizons beyond modern time. The great search of mythical horizons
that absorbed so many artists during those years often led them to their
own backyards. After the French surrealists had excited local interest in
the American Indians, for instance, Barnett Newman, one of the most
enterprising seekers, used his own American locus to find the myths of the
Pacific Northwest Indians. Noguchi, whose mother had begun his educa-
tion with a thorough course in Greek mythology, had first engaged the
orphic voice in its Greek guise; but later, he modified the myth to accom-
modate his renewed passion for Japanese things. The myth he referred to
in his comment on the ballet *Orpheus* belongs to the most distant Japanese
horizon. It is an origin myth, told with many variations in various ancient
texts. Since it figures in Noguchi's works, it is worth examining—at least
in a much reduced account:

In the beginning the gods in high heaven created the siblings
Izanagi and Izanami, who were charged with creating the island
of Japan and, also, other deities. Izanami, in giving birth to fire,
was horribly burned and ascended to the netherworld. Her
brother-husband, like Orpheus, went to retrieve her but, when he
saw her decaying body, fled in disgust. Once back he cleansed
himself in a stream and gave birth to other deities, among them
Amaterasu, the sun goddess, and her unruly brother Susanoo, the
wind god.

The next sequence of the myth has been much remarked, especially by artists, who respond to both its humor and its symbolic significance. The wind god was beloved by his sister but was a very trying person. He not only broke down the field dividers in her rice fields and defecated in her palace, but he also destroyed her weaving looms. In exasperation, the sun goddess retreated to a cave, plunging into the world of darkness. The gods debated loudly what to do, and after several fruitless attempts to lure Amaterasu from the cave, they devised an entertainment (or ritual, depending on the interpretation) that was something like a sacred striptease. As the gods roared with laughter, the sun goddess peered from her cave to see what was happening, and as she did so, the gods thrust a mirror before her. As she reached for her reflected image, one strong god pulled her from the cave and light was restored to the universe. In one of the many tellings of this tale, the mid-thirteenth-century writer of *The Tale of the Heike* ended his account with the comment: "In a degenerate age such as this, no one would be able to address the sacred mirror. . . . Those bygone days were incomparably superior to the present."[5] This opinion, from time to time, was shared by Noguchi.

The mirror in this origin myth—attribute of the sun goddess—was and is still an essential image in Japan. In its liberally adjusted symbolism, the mirror has the universality that always attracted Noguchi, as it had his modernist forebears, beginning with Baudelaire. Many of Noguchi's sculptures play upon the intrinsic quality of reflection found in nature—in the waters of the world, in the depths of the earth (where even stones secrete light), and in the music of nature, such as sounds responding to or reflecting patterns of wind and water. The far horizons peopled with protean deities were full of suggestion. They provided Noguchi with the spirit of free space his fertile imagination required. He shared this taste for the archaic with many artists of his century; his answer to an interviewer in 1961, who asked what kind of art he admired, could speak for many artists of his milieu:

Actually, the older it is, the more archaic and primitive, the better I like it. I don't know why, but perhaps it's simply because the repeated distillation of art brings you back to the primordial: the monoliths, the cave paintings, the scratchings, the shorthand by which the earliest people tried to indicate their sense of significance, and even further back, until you get to the fundamental material itself.[6]

To "get back to the fundamental material itself"—a pressing need for Noguchi, expressed again and again, not only in his verbal comments over the years, but in the work of his hand. Noguchi had a way of finding temporary fulfillment of basic needs. Often, the way was opened by

sympathetic mentors. He always spoke of his mentors with respect, most particularly of Brancusi, whose images, he used to say, "nestled" in his materials. It was Noguchi's discovery of Brancusi's work that led him, in his early twenties, to his double-pronged, lifetime project: to tap the sources of time and history through retrieval of the archaic innocence, and at the same time to be *of* his time, a modern in the great modern tradition of abstraction. When he made his way to Paris and, with his usual luck, to Brancusi's studio within a few days, he already had an intimation of what he required. He had applied for a Guggenheim grant in 1926 at the age of twenty-two, writing that it was his desire

> to view nature through nature's eyes, and to ignore man as an object for special veneration. . . .
>
> Indeed, a fine balance of spirit with matter can only concur when the artist has so thoroughly submerged himself in the study of the unity of nature as to truly become once more a part of nature—a part of the very earth, thus to view the inner surfaces and the life elements. The material he works with would mean to him more than mere plastic matter, but would act as a coordinant and asset to his theme.

A year later, Noguchi was assisting Brancusi, and he described how Brancusi taught him the use of tools, remarking, "There was this unity throughout."[7] It was the unity, traditionally found only in archaic myth at the beginning, that Noguchi craved and sought to elucidate with his own means, which was sculpture. Such unity, as he imagined it, could be found in the oldest of human memories and works. It was a principle he pursued all his life, as had Brancusi. Mircea Eliade, whom Noguchi read appreciatively, wrote searchingly about Brancusi's own sources, many of which sprang from his native Romania, and some of which were specifically mythical.[8] Much of what he said of Brancusi can be said of Brancusi's spiritual disciple Noguchi (a disciple Noguchi was, but only in spirit, for he consciously sought to avoid the stylistic imprint of the master). Eliade argued with critics who insisted that Brancusi, who lived in Paris for half a century, derived from the school of Paris rather than his native sources in the Carpathian Mountains. There is "the indubitable fact," Eliade said, that Brancusi seemed to have rediscovered a "Rumanian source" of inspiration after his encounter with certain "primitive" archaic artistic creations. This Eliade called a paradox that was one of the favorite themes of folk wisdom. (The secret, he quoted Heinrich Zimmer as saying, "the real treasure, the treasure that brings our wretchedness and our ordeals to an end, is never far away. We must never go looking for it in distant lands, for it lies buried in the most secret recesses of our own house.")

The influences of the school of Paris, Eliade said, "must have produced a kind of anamnesis that led ineluctably to a process of self-discovery." He continued:

> Brancusi's encounters with the creations of the Parisian avant-garde and those of the archaic world (Africa) triggered a process of "interiorization," a journey back toward a world that was both secret and unforgettable because it was simultaneously that of childhood and that of the imagination.[9]

Eliade's insight into Brancusi's process, his rediscovery "of the 'presence-in-the-world' specific to archaic man" through his intense relationship to his materials, were especially fruitful when he imagined Brancusi's working methods:

> We shall never know in what imaginative universe Brancusi was moving during his long polishing process. But that prolonged intimacy with the stone undoubtedly favored the material reveries so brilliantly analyzed by Gaston Bachelard. It was a sort of immersion in a deeply buried world where stone, the most "material" form of matter we have, revealed itself as a thing of mystery, since it embodies and conceals sacrality, energy, and chance.[10]

It is risky perhaps to speak of Noguchi as a seeker of universal truths. It is all too easy to attach bleak abstractions to the artistic process. Yet in Noguchi we have all the attributes of the journey—he wandered the world to the end, seeking comparisons, analogies, parallels that would confirm his intuitive perceptions and console him for the wrenching disjunctions of life itself, or at least of his life, lived from the beginning among strangers.

In his own telling, Noguchi's life was rich in encounters and satisfactions, but always there was an undertone of unease. He called himself a "waif," a "loner," and a "stranger." He alluded often to his ambivalent feelings toward the parent who abandoned him, sometimes calling his relationship with the father he scarcely knew one of "love-hate." In some of his tellings he seemed to see himself as a Telemachus who dreams long of some reconciliation that will overwhelm sad memories; banish, as in a dream, the harsh facts of his origin. The life that he lived in the world was shadowed, Noguchi felt, by the duality of his origins. How much this entered into his life's work can never be measured, but even a skeletal outline of his childhood and adolescence reveals countless sources of chagrin.

One possible profile of his life—a bare line drawing that can offer only a limited perspective—is that he was born in America where, half-

Japanese, he was part alien. His mother, Leonie Gilmour, whose part-Irish background he always stressed (particularly her appreciation of modern Irish literature), had fallen in love with Yonejiro Noguchi, later to become the well-known poet Yone Noguchi. Born barely a decade after the Meiji Restoration, Noguchi père was one of the many middle-class boys of his time sent to America to acquire a Western education. He settled in San Francisco in 1893; soon met the local bohemian poet, Joaquin Miller (whom he later described as a "hermit who lived on dews"), and his circle; was taken up, pampered, and published as a rare find: a beautiful Japanese boy who wrote quaint English. Judging from his letters and those of his American admirers, both men and women, Yone Noguchi played upon heartstrings in order to advance his fortunes as the sole representative of exotic Japan writing in English. In 1901 he was in New York, where, seeking editorial help with his English, he met Leonie Gilmour, a Bryn Mawr graduate who aspired to be a writer. Their romance, which for Noguchi at least was particularly expedient, lasted long enough for Gilmour to become pregnant. By the time Isamu was born on November 17, 1904, his father had gone to London to impress the literary establishment, with eminent success, and had returned to Japan. There, what would become another source of inner conflict for Isamu Noguchi emerged in Yone's reversion to militant patriotism during the 1904–1905 Russo-Japanese War: "I saw many a Rising Sun flag among the green trees beyond the yellow rice fields," he wrote after his twelve years in the West. "My patriotism jumped high with the sight of the flag. I felt in my heart to shout *Banzai*."[11] In later years, Yone Noguchi would become one of the most bitter and shrill exponents of Japanese conquest—always a source of pain for his half-American son.

When Isamu was two years old, Leonie Gilmour was finally persuaded to bring him to Japan (where his father had apparently already taken a Japanese wife). At first they lived in a house provided by the father—long enough for Yone to write an article titled "Isamu's Arrival in Japan," in which the seeds of Isamu's future are quite obvious. Yone described how the baby begged to go home; said he was "perfectly brown as any other Japanese child and that was satisfactory"; and spoke openly of the contest between the American and the Japanese parents. When Yone asked Isamu: "You Japanese baby?" the child answered yes, and turned to him. "And when I asked him how he would like to remain in America, he would turn to my wife and say 'yes.' " The ménage soon disintegrated, and Isamu would thenceforth be the exclusive charge of his hardworking and courageous mother.

Despite his being "perfectly brown," as Yone wrote, the child had the telltale pale eyes that by primary-school age would certainly have informed his fellow students of his alien origin. When he was thirteen, his

mother decided to spare him the pain of being an outsider, as he must surely have felt by then in his school situations, and, first establishing his American citizenship, sent him across the sea—an extremely slight, lone boy less than five feet tall, filled with trepidation—to an experimental school in Indiana, the heart of provincial America. By the time Noguchi arrived at the Interlaken School during the First World War, a summer camp was still functioning, but that fall the school gave way to an army camp. Noguchi was treated kindly by an eccentric educator and with an Americanized name—Sam Gilmour—attended high school in a small town in the Hoosier state. During his crucial adolescent years, then, Noguchi had to adapt to life in small-town America, unimaginably different from his early childhood in Japan. Immediately after, he was sent to New York, where his benefactor, Dr. Edward Rumley, thought he could be educated to a respectable profession. Instead, Noguchi found a temporary haven in the Italian community of plasterers and stonecutters (as he said, it was a life of "spaghetti and revolution") and, in his brief tenure as a student in Onorio Ruotolo's Leonardo da Vinci Art School, learned what he used to refer to as the tricks of the trade of academic stonecutting. By this time,

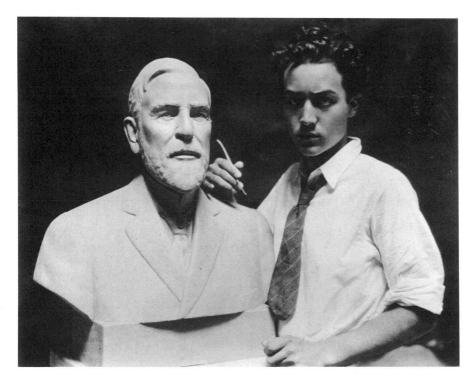

Noguchi in New York
studio, 1924

his mother had returned to America, but as he remarked sadly in his autobiography, his "extreme attachment" to her never returned.

By the time he was twenty, Noguchi had experienced enough disruption in his emotional life to toughen him, to make him wary of close ties, but not to blunt his burgeoning artistic sensibilities. He took his own studio in 1924 and, as he wrote, wryly, became the hope of the academy. The hope was never to be fulfilled because Noguchi soon discovered the world of international modern art. This discovery was closely identified in his memory with two exceptional figures, both of European orientation and both indefatigable proselytizers for the new creed of modernism. Noguchi dates his awakening as a modern artist to his discovery of these two older men, both of whom presented in their galleries vanguard modern art.

The first of these enthusiasts was the renowned photographer Alfred Stieglitz, whose gallery Noguchi began to frequent in 1926 and who almost certainly lectured the young sculptor, as he did everyone, on the importance of being modern. The other key figure, J. B. Neumann, was by nature avuncular, eager to shelter and shape young spirits, and always welcoming. In his gallery, the New Art Circle, Neumann showed not only the major artists from Germany, where he had begun his career, but also artists from all over the world and many cultures. The young Noguchi could converse with Neumann, a man of many enthusiasms, about almost anything. He could even explore the territory his father now inhabited as a writer on traditional Japanese artists. Neumann kept a print cabinet usually stocked with both Eastern and Western art. He published an endearing occasional magazine called *Artlover,* in which he often quoted not only Katsushika Hokusai ("At a hundred I shall be a marvel, and at a hundred and ten every blot, every line from my brush shall be alive!") and Ando Hiroshige, but also William Blake. He was a great admirer of Paul Klee and often quoted Klee's observations in conversation. Noguchi may have first heard about Klee's worldview—his conviction that an artist is in touch with, and an instrument of, the universe—in Neumann's gallery. Neumann, perhaps a father figure, seemed most eager to help Noguchi place himself within the American context and was aware of the young man's conflicts and his need to belong. In an undated note on Noguchi, probably written before Noguchi modeled Neumann's portrait in 1932, Neumann wrote:

> For Noguchi, so it seems to me, a background deeply rooted in American psychology is immensely important. Anyone familiar with his portrait sculpture will readily recognize a typically American approach in his direct, decisive grasp of each subject. Yet, in the unfinished work there is together with the characteristic American freshness and simplicity, a rare quality of sensibility and

sophistication. Call it European, Oriental, or what you will, its significance remains the same, and I think it casts some light on the importance of Noguchi for the particular stage of development we are now witnessing in American Art.[12]

Neumann was especially fond of quoting Goethe's introduction to the *Propylaen*, an acknowledged source of Klee's philosophy. In several issues of *Artlover*, he cited Goethe's belief that

the genuine artist, the tradition builder, strives for artistic truth; the other, who obeys merely a blind itch to create, strives for natural resemblance. Through the one, art is brought to its highest peaks, and through the other to its lowest depths.[13]

Noguchi was quick to respond to Neumann's enthusiasms. Already he had lived a life in several different registers, and he sought the kind of psychological wholeness promised by Neumann's simple philosophy that, as he printed on the window of his gallery, "to love art truly means to improve life." The views of Paul Klee that stressed nature as the source of creative order and envisioned a primal unity of matter that could be expressed through intuition by the artist were congenial to Noguchi's temperament. The rest of his life would be in one sense—one sense only, since Noguchi was ever available to explore fortuitous byways—a quest, driven by a perception of the world as a unified but expanding universe.

Noguchi's biography is rich in hints of the sources of his formative years, and while no single source can be isolated, some are more suggestive than others. Dr. Rumley, the progressive educator who founded the Interlaken School in Indiana where Noguchi began his American education, had placed Noguchi in the home of Dr. Samuel Mack, a Swedenborgian minister. The boy was thrust into a situation in which the thoughts that had helped to shape the modern movement—through such figures as Blake, Emerson, Poe, and Baudelaire—were sacred. The Swedenborgian notion of a universal rhyming scheme had attracted nineteenth-century artists who wished to see some kind of elemental unity in the universe; who relished the endless possibilities of analogy. The strong current of romantic art had flowed into the modern era, and artists of Noguchi's generation persisted in thinking of the artist as engaged in a spiritual quest. Many used the journeying metaphor and prolonged the romantic rebellion against the determinist vision of the world. Ivan Turgenev's Bazarov, in *Fathers and Sons*, sacrificed art to science. The modern artist wished to restore art to the realm of the imagination and free it of the rigid laws of science. Many pursued an ideal universalism, even into the realm of politics, where nationalism was abjured.

It was, then, as much from the great modern tradition in art, as from the peculiar circumstances of his origins, that Noguchi assumed the mantle of the spiritual voyager whose natural state of mind was one of exile. This was not always a comfortable situation; quite often Noguchi smarted at the crude perceptions of others who insisted on making much of his biracial condition. One of his deepest wounds was inflicted by a highly respected newspaper critic who thoughtlessly wrote a review in 1932 containing a searing remark: "Once an Oriental, always an Oriental."[14] Noguchi was not yet thirty. Much later, the Japanese also thoughtlessly reinforced his psychological condition of perpetual exile by regarding him, as he bitterly wrote in 1986, as a *gaijin*, an "outside person," as it is often translated. Still, in the largest view, Noguchi, like his friends among the artists in New York, many of whom had been born elsewhere, was proud to assume the identity of artist as alien, outside conventional society. It was a useful, fruitful state of mind and also a reality in modern culture.

Gradually Noguchi identified a need in himself to compensate for his personal deprivation of a place to which he could belong, but by the time it was realized in works of art, the personal element had been superseded. He often spoke of ancient monuments as being alive because they were still used, and his ambition was increasingly to shape a space, a usable place in which chaos, as he knew it in himself and his society, would be overmastered. His life's work, as he often said in later years, was about creating an "oasis." In choosing that word, with its connotation of a journeying toward, Noguchi was being extremely precise. Something in the ellipse of his life always remains of the visionary who lives else-where, who occupies an imaginary oasis. His great friend Martha Graham said in 1968: "Isamu—what I think he is—he's an ecstatic man. He's possessed."[15]

No doubt it was this ecstatic tendency that pressed Noguchi to take on larger and larger projects—testing the limits, as he later said—among them the creation of his own final places, his studios that were to be expanded into museums. In his early youth Noguchi had worked in thea-ter, which he had considered the ideal situation where the artist can control space. Theater was a place, he observed in many statements, in which things came together momentarily. Even his creation of individual sculptures seemed to him to derive from his need to create an atmosphere around him. As time passed, this need to create an environment, a place in which things came together, grew in his imagination beyond the literal theater into a theater of the world, a *theatrum mundi*. His own place, the studio cum museum, was always described as a retreat, but, paradoxically, a retreat that embraced the whole world:

> I always wanted to go beyond art objects. I wanted to reach what
> may be defined as a way of life, a space of life, or even a ghetto

closed and defended from the world. Or some monadic theater, a
world that exists, grows and changes from its own force.[16]

But he also talked about

the permanent contradiction between belonging and non-belong-
ing; between the wandering artist that doesn't belong any place,
and his desire to organize and find the balance between organic
form and geometrical organization.[17]

Remembering his urgent need to travel when he was twenty-one,
Noguchi saw his removal to France as a solution to his problem of national-
ity, "because when you become an artist, you really come into your own,
that is you find your own place, with no further worry as to whether you
are you or another . . . I think that artists are always making a place of
security for themselves, you know. Their studio becomes their home, their
museum."[18]

Noguchi's sense of estrangement, born circumstantially, became, with
his intelligent appraisals at each step in his life, a companionable aid. It
permitted him to share an aesthetic with Gorky, de Kooning, Mark
Rothko, and others in New York, and it prodded him to find resolution of
emotional conflict in art itself. Moreover, it became a source of his ideal-
ism, which again and again expressed itself in the nature of his works. The
artist is the exile who must reconcile. He can do this in the oldest way: by
evoking the *theatrum mundi*. What interested him, what motivated him,
was his hypothesis that there is a great spiral of the human spirit in which
all things can be found to relate.

In his library in Japan there is a book that I feel sure he read with
healthy skepticism but, at the same time, relished. It is *The God-Kings and
the Titans,* an imaginative attempt by James Bailey to establish a new
history in which seafaring peoples of the Mediterranean reached the
Americas thousands of years before conventional dating has established
their arrival. Bailey looked at pictographs, artifacts, and ancient sculptures
and found resemblances which he assumed demonstrated that the New
World was known to the Old during the Bronze Age. Noguchi, who always
studied ancient objects and pictographs with special attention, was no
doubt arrested by the many visual analogues Bailey pointed out. Yet, the
simple spiral, found in ancient Japanese and pre-Columbian artifacts,
could have derived just as easily from some universal human instinct, from
what Carl Jung called the collective unconscious. The evidence in Bailey's
book might not bear out Bailey's theory, but it would in a way bear out
Noguchi's basic belief that the "non-thinking" part of human nature cre-
ates art; that common experiences beget common forms. All discoveries of
similarity or analogy served Noguchi as confirmation of his earliest percep-

tions of art and the world and helped him to invent himself. Noguchi was always clear about the way an artist assimilates materials from all cultures. "It does not take long for a public familiar with modern art to become fascinated by the primitive," he wrote in 1957, commenting on the newly opened Museum of Primitive Art in New York City.

> The process of discovery by the artist, however, though possibly based on similar needs and satisfactions, is rooted in his own development, and is incidental to it. The Impressionists discovered the Japanese color print—more precisely, Manet searching for himself found the Japanese art as a relation which helped him in his own development.[19]

Like Manet, Noguchi journeyed to exotic places, but for Noguchi it was still a matter of a self that had to be found.

In his perpetual search for objective data that would support his romantic suppositions about the world, Noguchi looked not only to art, but also to science. The art and science paragon was ushered into his life, and remained there until his death, in the person of R. Buckminster Fuller, whom he met in 1929 after his return from Paris. Nine years older than Noguchi, Fuller was already a public figure, at least in Greenwich Village, where, at the bohemian restaurant run by Romany Marie, he would harangue his artistic audience on the virtues of global thinking and the infinite promises of technology. Fuller's eccentricities and his exuberance endeared him to New York's unconventional intelligentsia, but they did not take him too seriously. The twenty-five-year-old sculptor, however, was overwhelmed. Noguchi formed one of his deepest bonds with Fuller, whom he saw as a prophet, a figure of light much like the thundering prophets he had encountered in Blake. Here was a scientist, but a scientist with an unbridled fantasy, who, to this day, is regarded with some suspicion by the scientific establishment. Fuller was a kind of Johannes Kepler, for whom the dream was as significant as reality. (Like Kepler, whose dream was realized when twentieth-century voyagers went to the moon, Fuller's discoveries about the universe and its fundamental structures have been increasingly confirmed, as when scientists discovered that the tobacco virus is identical in structure to Fuller's model of the skewed spiral.)

Fuller himself regarded his personality as unique. "I seem to be a verb," he often stated as he delivered his remarkable marathon lectures. His appeal to Noguchi originated in his ceaseless insistence that there was unity in the cosmos, and in the totally unorthodox models he proposed to prove his thesis. Much more than any artistic futurist, Fuller presented visions to the young sculptor that never failed to excite him.

When Fuller wrote the introduction to Noguchi's autobiography, he launched the artist into his own visionary universe—somewhat to Noguchi's amusement. Fuller pointed out that Noguchi and the airplane were both born in the United States in the first decade of the twentieth century: "The airplane era laid a new cosmic egg in the nest of everyday reality, integrating all the previously separate civilizations' experiences in one history and geography."[20] The one-world theme that Fuller elaborated from the late 1920s until his death was important for Noguchi. Fuller's views were attractive alternatives to more classical visions of world harmony. They were always expounded with absolute assurance, and often with wild analogies intended to incite his listeners to search for the signs of a new worldview, not compartmentalized, in which the whole would always be greater than its parts. Although this was an old chestnut in the history of philosophy, it was energized by Fuller and given luster by his immensely imaginative demonstrations of what he called synergy. What fed into Noguchi's developing viewpoint during the early years of his friendship with Fuller was most of all Fuller's imaginative search for the fundamental structures of the universe. Noguchi saw parallels with his own activity as an artist and pondered the implications of Fuller's "omnidirectional geometry" throughout his life. As practical as Fuller meant to be, as much as he intended to modify through invention and correct technological maneuvering, he was, as was his young admirer Noguchi, an inveterate romantic, a "student of large systems," as he called himself, who was always susceptible to poetry. Although the myths that fired Fuller's imagination were of a different order than those that resided in Noguchi's, they were, all the same, proffered to the world in the unmistakable voice of the teller of things—a voice to which Noguchi was ever receptive.

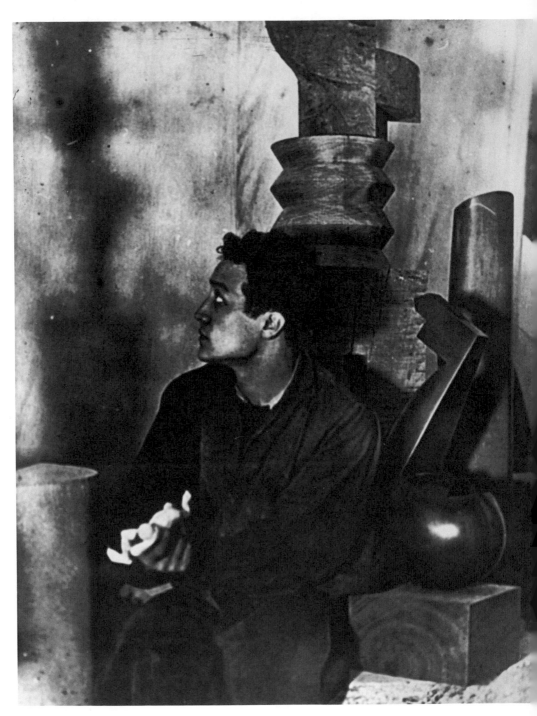

Noguchi in Paris studio,
1928

Early
Wander-
Years

WHEN NOGUCHI WON his Guggenheim grant and left for his first destination, Paris, in April 1927, he established what would become a lifelong travel route: to Europe, the Orient, back to New York, and, in later years, to Latin America. For the rest of his life Noguchi would forage in all four geographic regions for the motives of his art. In his initial proposal, Noguchi had suggested that before he visited the Orient, he would spend a year in Paris in order to perfect his skills as a stonecutter and woodcutter and "to gain a certain cultural background from residence in this European metropolis."[1] Shortly before he left New York, he had been shepherded by Marcel Duchamp through the important and controversial exhibition of Brancusi's work at the Brummer Gallery. This show, he always said, crystallized his uncertainties and set him on his course. The two aspects of his travel project—to acquire training as a sculptor in the modern way and to build a cultural background—were to be well realized. In Paris, Brancusi was evidently very much taken with the attractive twenty-two-year-old and immediately set him to work.

Noguchi later described his Paris days as divided between the white retreat of Brancusi's laboratory and the abundant social life of the famous Montparnasse cafés of the era, with bouts of drawing in the open academies. In the studio, Noguchi wrote, "Brancusi got me started with carving a flat plane in limestone preparatory to making a base. First he taught me how to correctly cut and true the edges and then by cutting grooves, to level the space between, then on to squaring the cube. He was insistent on the right way to handle each tool for the job and material, and on the respect to be accorded to each."[2] These were lessons that remained vital to Noguchi for the rest of his life, as were his memories of Brancusi's sculptures that were to be seen in the studio at the time of his apprenticeship: several versions in wood of *The Endless Column*, a capital and a section of the *Column of the Kiss* that would appear later in Tirgu-Jiu park in Romania, a bronze version of *The Bird in Space*, as well as other Brancusi necessities, such as a wooden winepress screw, some old house beams, architectural elements in plaster, and bases and seats of his own devising.

As Noguchi worked mostly in the mornings with Brancusi, his days were relatively unencumbered, and he seems to have encountered the entire Montparnasse pantheon, including many figures of importance in the history of modernism. His lack of French at the beginning somewhat limited conversation, especially with Europeans such as Chaim Soutine

and Alberto Giacometti, but it didn't seem to impede his progress with the artists' model Kiki, whom everyone knew and liked, or numerous other young women who found the tousled-haired youth magnetic. Most of his time was passed with English-speaking compatriots, above all with Alexander Calder, on the verge of becoming a vanguard experimenter, but, at the time, best known for his wire-figured circus. Noguchi was his "chief assistant," meaning that he cranked the phonograph that played "Ramona." The two Americans visited the Cirque d'Hiver and frequently went dancing together. Among other Americans Noguchi mentioned in his autobiography were Stuart Davis, Morris Kantor, and the young painter Andrée Ruellan. Recreational sorties aside, Noguchi studiously visited museums and seems to have informed himself of the activities of artists and poets in one of the most talked-about movements, surrealism.

Besides the Europeans and Americans drifting in and out of the Paris cafés in that glorious movable feast of the late 1920s, he found a few non-European artists, above all the already well-known painter Foujita, who befriended him, found him a studio, and was one of several Japanese through whom Noguchi kept alive his dream of retrieving the other half of his lost heritage. Although in later years Noguchi tended to tone down his account of Foujita, probably because of Foujita's later distasteful activities in Japan during the war (Noguchi sometimes compared Foujita to his father, who "was one of those people indirectly responsible for the war— patriotic, you know"), it seems that they were often together during that first sojourn in Paris. Foujita (1886–1968) was a colorful fixture on the Left Bank, always giving riotous parties and amusing his friends with such eccentricities as a watch tattooed on his wrist and outlandish costumes for the Quatres Arts balls. He had arrived in Paris in 1913, knew everybody, including Picasso, and, not unlike Noguchi, found his fortune in doing fashionable portraits. At his height, Foufou, as he was called affectionately by his French friends, earned enough to keep a large car and a chauffeur. In Noguchi's story, Foujita was yet another indirect link to his father. He had met Foujita through the dancer Michio Itō, an acquaintance of Yone Noguchi's whom Noguchi had encountered in New York in 1925.

In the Guggenheim application Noguchi had candidly expressed his need to reclaim his father, explaining that he had selected the Orient as a location for his "productive activities" because he had spent half his life there and because "My father, Yone Noguchi, is Japanese and has long been known as an interpreter of the East to the West, through poetry. I wish to do the same through sculpture." While he was acquiring the rudiments of European modernist culture in Paris, Noguchi was also contemplating his journey to the East, a plan that had been considerably enhanced by his earlier meeting with Itō, when the threads of connection, tenuous as they were, began to come together. Not only had Itō provided

him with letters of introduction to Jules Pascin and Foujita, but he had
apparently spoken to him of William Butler Yeats and Ezra Pound, and
Yone Noguchi's relationship with them. This trail of relationships inter-
ested Noguchi immensely, and throughout his life, he alluded to them in
interviews and writings.

When Noguchi met Itō in 1925, the young artist was newly established
in his own New York studio and had already begun his career as a portrait
sculptor. Most probably Noguchi sought out the dancer, for he was keenly
interested in dance and theater and used to watch rehearsals at the John
Murray Anderson School building where Itō was working. At the time, Itō
was highly appreciated in the New York artistic community as the man
who, in January 1923, had offered "Japanese Noh Drama, a performance
given for the first time outside Japan." The drama he had staged was
Hagoromo, one of the plays Ezra Pound had "finished" after Ernest
Fenollosa's translation.

Everything in Itō's background was calculated to engage the interest
of the young Noguchi. First, of course, was the fact that Itō had known his
father. Then there was Itō's personal history, filled with the kind of
adventures the young sculptor had begun to crave. Itō had been sent to
Europe at the age of seventeen to study music and voice. In 1911, at the
age of eighteen, he saw Nijinsky dance in Paris. Shortly after, in Berlin, he
saw Isadora Duncan and met the musician Emile Jacques-Dalcroze. In
1914 he turned up in London, where there was a small group of artistic
Japanese, among them Foujita, and a slightly larger group of local admir-
ers, eager to expand their newly acquired fund of information about the
Far East. This was the milieu in which Yone Noguchi had found favor
during his first visit to London at the age of twenty-seven in 1903 to 1904
and again in 1913 to 1914 (when he may have met Itō). Noguchi had
knocked on many doors, among them William Butler Yeats's. In January
1914 he had visited Yeats in Sussex, where he met Ezra Pound, who was
at work on Ernest Fenollosa's translation of the Noh drama. (Noguchi had
approached Pound before, sending him his books as he did to almost every
notable in literary London. Pound had written a friendly but guarded
letter of thanks in September 1911, saying it was very hard to write to him
without knowing more about him.) It was Pound's work on the Fenollosa
manuscript that inspired Yeats to attempt his own variation on a Noh
drama, for which the services of Michio Itō were required. Itō, who hung
about the Café Royale, where he managed to engage the interest of such
English luminaries as Jacob Epstein and Augustus John, had advertised
himself as a Japanese dancer in the hope of attracting patrons. When
Pound came across him (at a time when the poet was eagerly establishing
a kind of cenacle, what he called a "party of intelligence") Itō was imme-
diately put to work giving small performances to enthusiasts who had

recently been introduced to the Noh texts by Pound. Itō often described how he had run to libraries himself, never having studied Noh theater, in order to become the expert they thought he was; and the dancer Jean Erdman recalled that even later, in New York, he studied with a Japanese scholar.

Yeats, hearing from Pound about the young Japanese dancer, attended some of the private performances. He was convinced that Itō could help him to realize his drama *At the Hawk's Well*, which he had undertaken under the spell of the Noh plays Pound had read to him and which would bring to fruition insights he had earlier expressed concerning symbolic drama. As he would write in April 1916 (in the introduction to "Certain Noble Plays of Japan" by Pound and Fenollosa), in his play, intended for a drawing room, "the music, the beauty of form and voice all come to a climax in pantomimic dance."[3] Yeats announced that he had "invented a form of drama, distinguished, indirect and symbolic" and that he would use the mask, "the fine invention of a sculptor," to bring the audience close. "A mask never seems but a dirty face, and no matter how close you go is still a work of art; nor shall we lose by staying the movement of the features, for deep feeling is expressed by a movement of the whole body."[4] Like many of the poets in his circle, Yeats had long been interested in Japanese painting, and when he spoke of "the rhythm of metaphor" in *Hagoromo*, he remarked that "One half remembers a thousand Japanese paintings. . . . That screen painted by Korin, let us say, shown latterly by the British Museum, where the same form is echoing in wave and in cloud and in rock."[5] Itō had quickly caught the mood of Yeats's play, inventing his own version of Japanese dance in his characterization of the hawk, which would later become the source of his unique contribution to modern dance in America.

Itō's presence in Noguchi's life in 1925 to 1926 certainly stimulated the sculptor's interest in Noh drama, for in the portrait he made of Itō, he uncharacteristically shaped a face that in its sensual yet stern features resembled a traditional Noh mask, as critic Nancy Grove remarked.[6] During the sittings Itō, who was loquacious, regaled Noguchi with accounts of the great world of London and Paris. He also invited Noguchi to create masks for the 1926 production in New York of the Yeats play, providing the first of many opportunities for Noguchi to participate in the theater of the dance and to probe his own feeling for the poetics of dance. Around the same time, Noguchi became aware of Martha Graham, who in 1923 had danced *The Garden of Kama*, arranged by Michio Itō, and who could often be seen in rehearsal at the Anderson studios. The vogue for non-Western dance was well underway, and Itō stimulated Graham's interest in Oriental mythology. Moreover, artistic New York was experiencing the same revulsion to Western materialism as was the poetry circle

from which Itō had come in London. Writing in 1922 in the *Dial*, the young
poet Marianne Moore fiercely condemned "the fifty-fathom deep materi-
alism of the hour." Later, in *Poetry* in 1933, she would praise Yone
Noguchi for his spirituality.[7] Itō shared in the general turn toward arts of
other cultures, presumed less materialistic, and in a curious way antici-
pated another wave of preoccupation with the primitive as advanced by
Claude Lévi-Strauss after the Second World War. In his colorful diction,
Itō wrote:

> Everything in the world can be divided into two generalities: Art
> and Nature. The literal dictionary meaning of Art is that what
> ever results from human creation is called Art. The raw potato is
> Nature and when it is boiled it becomes Art. It is very simple.[8]

The Noh mask portrait of Itō was Noguchi's only work of its kind
during that period, suggesting that despite his collaboration with Itō and
his acquaintance with a few Japanese artists in Paris, especially Foujita,
Noguchi did not venture very far into Japanese lore. His interest in the
exotic was only slightly more intense than that of other young artists in the
circles he frequented. From Itō he undoubtedly learned more about early
modern poetry than about Japan. Despite his childhood in Japan, Noguchi
had been formed largely by his experiences in the United States. When he
got to Paris, he felt at home in its cosmopolitan freedom, and Foujita, for
instance, was probably only as interesting as his exaggerated foreignness
seemed to any number of other young artists crowding the capital. Nogu-
chi was not yet ready to assimilate the Oriental aesthetic, as his procrasti-
nation in Paris indicates. He had found life in Paris so congenial that he
had not managed to continue his proposed itinerary and his application for
a renewal of his Guggenheim grant was denied. At the end of 1928, he
returned to New York.

For the next year or so Noguchi enjoyed the agreeable and highly
social atmosphere of bohemian New York, frequenting downtown gather-
ing places such as Romany Marie's with Buckminster Fuller and broaden-
ing his already wide circle of acquaintances. Within months he had his first
one-man show, in which a number of his tentative explorations of abstract
art drew little response, being, as he himself said, obviously influenced by
Picasso and Russian constructivists. Consequently, "there was nothing to
do but to make heads."[9] These he did in abundance during the year of his
return in 1928 to New York. Ten months after his first exhibition at the
Eugene Schoen Gallery, he exhibited fifteen heads at the Marie Sterner
Gallery. In later years Noguchi sometimes made light of this period—"I
was something of a playboy"—but the portraits were important to him.
They not only provided his bread, they were also the means to public

success. These portrait heads demonstrated his technical prowess and versatility, which newspaper critics even then found disconcerting, and they earned him financial independence. From his own accounts of the period, it is obvious that he drew great satisfaction from the attention his exhibitions brought him and enjoyed a feeling of authority in an adult world. He had been only twenty-five when he had his first exhibition. In this unaccustomed situation of economic solvency in the spring of 1930, Noguchi began to plan once again the hegira to the East.

Noguchi always maintained that he did the portrait sculpture specifically to earn money for the crucial trip. When he had gathered enough, he set out. That is probably true, but it is also true that throughout his life, Noguchi, in desultory rhythms, felt strong impulses to retreat. Again and again he entered the complicated artistic life of a great metropolis and then felt compelled to withdraw to some remote fastness. The early success he had achieved in New York would certainly have detained most artists. But Noguchi was driven on. In the spring of 1930, he departed for Paris. There he made arrangements to go eastward on the Trans-Siberian Railroad (another adventurous idea, possibly inspired by his concourse with the Parisian avant-garde who, ever since Blaise Cendrars's famous poem on the subject, had romanticized this arduous means of travel). He meant to stop in Moscow to see Tatlin's monument to the Third International, which he didn't know had never been built, and from there go on to Japan. In his later reminiscences, he thought of this plan as impelled by his search for his lost heritage. "Well, I was going back to the place where I was a child, you might say," he told me. "There was a sort of feeling on my part that my future had some connection with the Orient, probably because I spent my childhood there. Or that I was not completely at home in America, or that my fate as an artist at least could not be entirely determined in America."

The feeling of incompleteness expressed so often was deeply connected with his craving to know the father who was at once "loathed" for having abandoned his American family and revered for his international position as a poet. Noguchi was always circumspect about the exact details and spoke little about his emotional state at the time, but there is scant doubt that the trip to Japan was meant to lead to a reconciliation with his almost unknown father. His first step in that direction had been to assume his father's name at around the age of nineteen. His next step was to inform his father that he was coming. But sometime before he left Paris, he received "a shock" in the form of a letter from Yone telling him he should not come to Japan using his name. Behind this letter lay a dramatic family story that has never been fully revealed, although there are many hints that Yone Noguchi, father to a large Japanese family, and moving steadily toward a militant nationalistic viewpoint, as were so many men of

letters during the late twenties, did not wish to flaunt the fact that he had a half-Caucasian child. This injunction was a profoundly wounding blow to the young sculptor. No matter how casually he would later refer to the letter, he always did mention it—indication enough of the permanent pain this Japanese father inflicted on a yearning son. All the same, Noguchi's ambition to master the lessons of the East was not diminished by the setback. He did embark on the Trans-Siberian Railroad but instead of heading for Japan, he set out for China.

In his memoirs and various interviews, Noguchi was relatively laconic about the events of his life in China. He does not explain how he happened to go to Peking, what kind of introductions he had, or why he was so cordially welcomed and looked after. He was undoubtedly aware of the tremendous internal political strife in China when he arrived in 1930, for among the few people he names in his autobiography is Nadine Hwang, "beautiful lieutenant in the army of the young marshal Chan Hseuh-liang (who wanted me to become a general)." This tantalizing reference suggests that Noguchi had rather rich adventures in China. Edgar Snow, in *Red Star Over China*, describes Noguchi's young marshal:

> Chang Hsueh-liang, as everyone knows, was until 1931 the popular, gambling, generous, modern minded, golf-playing, dope using, paradoxical warlord-dictator of the 30,000,000 people of Manchuria, confirmed in the office he had inherited from his ex-bandit father Chang-Tso-lin by the Kuomintang Government in Nanking, which had also given him the title Vice-Commander-in-Chief of the armed forces of China. . . . When I first met Chang in Mukden in 1929, he was the world's youngest dictator . . . his mind was quick and energetic, he seemed full of exuberance, he was openly, bitterly anti-Japanese, and he was eager to perform miracles in driving Japan from China and modernizing Manchuria. . . . Later, Chang would make common cause with the "Red bandits" who, unlike his master Chiang Kai Chek, were profoundly anti-Japanese.[10]

How the half-Japanese Noguchi managed to get along with the anti-Japanese general he never discussed, but in all probability he was deliberately not politically engaged; he resolutely followed his program to turn back to the past. His exhilarating experiences of the year before in New York with the progressivist Buckminster Fuller receded quickly as Noguchi adapted to life in Peking, employing a cook who spoke and cooked French, a houseboy, and even a rickshaw boy. "Peking was in a perfect state of anarchy," he recalled in 1956. "All the embassies had moved to Nanking—not a bad thing for an artist." Noguchi set about exploring

the city, awed by its thousand-year history. With its noises and smells, its pervasive dust, he always thought of Peking in its ancientness with affection.

When Noguchi recalled his eight months in China, he usually cited two of his most significant experiences. The first was his discovery of the magnificent monumental Altar of Heaven, a perfect cosmogony in white marble. Noguchi's first stirrings of interest in what he called "topographical sculpture" seemed to have occurred as he contemplated that august imperial structure built as a manifestation of the ancient Chinese world-view, which considered the earth to be an immense square in a universe moving in a circular orbit. The great marble square contains a circular enclosure that in turn is followed by a series of diminishing circular terraces leading to a final open terrace, which forms the Altar of Heaven proper. These would be the first of many stone terraces in Noguchi's wandering life whose symbolism engraved itself in his visual memory and emerged, eventually, in his own terrace inventions. The square and the circle—figures that had taken on aesthetic values specific to the modern movement in the Paris Noguchi had just left—were now perceived in their most ancient splendor.

Noguchi's second important experience was his introduction to Chi Pai Shih (Great White Mountain), a seventy-year-old master in the Wen Jen school of painting, the origins of which go back to the T'ang dynasty. Noguchi may have heard of him from his Japanese friends in Paris, for Chi Pai Shih had been generously patronized by Japanese connoisseurs in the early 1920s. He had begun life as a humble carpenter and had subsequently become famous as a maker of seals. When he was sixty, he changed his style, adopting the free approach of the literati painters for whom poetry was so important. As a Sung master wrote about the celebrated T'ang painter Wan Wei, "There is a painting in his poem and a poem in his painting." Noguchi's first direct exposure to the Chinese vision of a total work of art—the poem, the painting, and the calligraphy all given equal status in a single work—came when he submitted himself to the old master as an attentive pupil. Chi Pai Shih, who lived in a compound surrounded by his children and grandchildren, received the young Western artist with great kindness. He took him as a pupil because, as Noguchi explained, in China it was a great honor to be copied during your lifetime. "How ashamed I was of my limitations,"[11] Noguchi wrote later, as the master taught him to use large brushes and to control the flow of his ink. The drawings Noguchi made, some very large, show his concentration on learning the principles of brush painting, but rarely rise above the level of the neophyte. Still, the master encouraged him and, before he left, painted some grapes and a pale narcissus for him with the inscription, "Who says that flowers have no passion." Chi Pai Shih had impressed upon Noguchi

that a painting is incomplete without a poem and without a seal, a lesson that Noguchi later associated with the incorporation of time as a real element in a work of art. Groping toward his own aesthetic, Noguchi saw the integration of several elements in classical Chinese painting as an entry into the broader perspective he already sensed he needed. The capital experience in Chi Pai Shih's compound entered his rapidly growing fund of knowledge; he would draw upon it in countless ways in later years.

After eight months in Peking, Noguchi finally decided to make the excursion to Japan before his funds ran out. This first voyage was to be in many ways only a prelude. There were things he was not prepared to see, or that he willed himself not to see, or that he would only see later with the eyes of a mature man of manifold experience. With his keen intelligence Noguchi later thought about such early experiences as deposits, as in geology. On many occasions he remarked that one must be readied in order to undergo certain experiences, as for instance when he wrote in 1961: "It's true that we come to experience with our own limitations and see only that for which we are prepared."[12] At the end of his life, discussing one of his late stone sculptures, he reiterated his thought: "A gift comes from the past, the residue of what we have already done. The unwanted part. Then one day there is revealed to us another potential which we are now ready for."[13] In late 1930, when he made his decision to go to Japan, still in his twenties, the young sculptor was clearly unprepared for many aspects of modern Japan, and probably ill informed. In addition, the anxiety and emotional turmoil implicit in his equivocal situation as the unacknowledged son of a man who was now a major figure in Japanese cultural life played its part in his initial reaction to Japan, which was one of active dislike. "Japan is a violent country, the weather and nature pressed in upon you," he remembered of his first trip back. "As a foreigner one says why can't they play good music, or why is this Shinto temple more military than aesthetic?" Digressing, as Noguchi often did in conversation, he mused: "You know, being half-Japanese you are intrinsically disloyal." This theme recurs throughout his life, indicating the persistence of his malaise vis-à-vis his father. Even when he later made Japan a more significant part of his life by actually striking roots—occupying his own house there—he half remembered those early disagreeable impressions. In 1930, his discomfort undoubtedly lured him further into a quest for another Japan, one that stood in remote history, or at least centuries before his own advent, and that responded to his poetic needs.

He had been prepared in a curious way for this excursion to old Japan by Dr. Samuel Mack, the Swedenborgian minister with whom he had boarded during his high-school days in La Porte, Indiana. Dr. Mack seemed to Noguchi "a remarkable man." Under his tutelage he learned of Emanuel Swedenborg's visions, and through him he rediscovered William

Blake. Noguchi's lifelong interest in myth was inspired by his exposure to Swedenborgianism. "They believe the Bible is a myth which has to be interpreted," he explained. "They reveal the artistic merit of the Bible." His own preoccupation with "myth and the power of symbolic language," he thought, derived directly from this early exposure to Swedenborgianism. Noguchi's candor in revealing his sustained source certainly flew in the face of much twentieth-century thought and put him in a vulnerable position, for who could still admire Swedenborg, whom Kant had already demolished so forcefully? Yet Noguchi remained faithful and approached Japan in 1930 with the symbol consciousness of a Swedenborgian. He was alert to every nuance, every metaphor that suggested the universal rhyme scheme he already had in mind; the same forms echoing in waves and clouds and rocks, as Yeats wrote. The great capacity in Oriental philosophy for poetic analogy increasingly attracted him (and perhaps bore out lessons he had already learned in Paris, for an important source of analogical thinking in modern art and poetry from Baudelaire on is often traced back to Swedenborg). While Noguchi was not yet ready to immerse himself in Japanese aesthetics, as he would during his second pilgrimage in 1950, he made certain important discoveries—above all about his own proclivities—that would set him on his life's course with more assurance. The entire voyage, after all, had come about partly from his feeling in New York that he was undergoing "a crisis in beliefs."

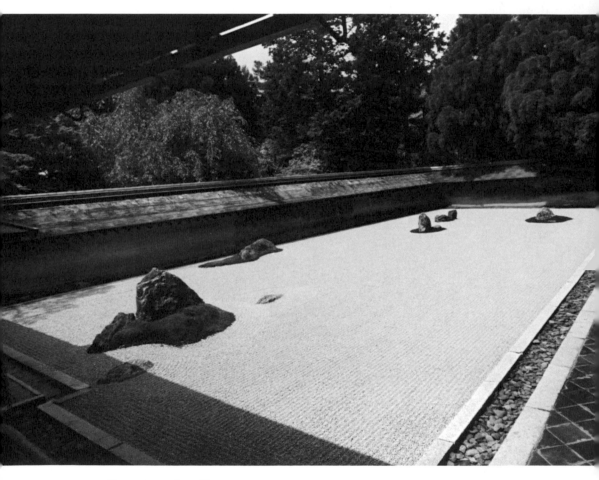

Ryoanji garden, Kyoto,
1989. Photo: Denise
Browne Hare

The

Search

for

Old

Japan

JAPAN WAS to be an unsettling but significant experience for Noguchi. In his autobiography he covers the entire visit in a single terse and circumspect paragraph in which he reports "a trying meeting" with his father in Tokyo. However, his father's brother Totaro Takagi received him warmly and even turned over a new house he had built in the Nihombashi district (which had been devastated in the great earthquake several years before) for Noguchi's use. Nothing certain is known of Noguchi's encounter with this representative of traditional Japan, but it was of some importance to his inner development, judging by the portrait sculpture of his uncle—one of only three works known to have been done by Noguchi during his two months in Tokyo—that he modeled in clay and later had cast in plaster. In his monograph on Noguchi, Sam Hunter has described this portrait as "Western style,"[1] but I think it is quite the contrary. True to his fundamental belief in what he always called the tactility of sculpture, Noguchi fashioned this portrait with notable tact, finding nuance and shadow in a mode almost diametrically opposed to the portraits he had done before he left New York. They had shown a sure and skillful hand smoothing out forms and calling upon the academic tricks and turns that had so endeared him to the conservative members of the National Sculpture Society when he first started out on his public career. This portrait of Uncle Takagi, on the other hand, was modeled with infinite delicacy, moment by moment, to suggest the introspective nature of the sitter. The shadows steal slowly over the features of an inward-turning personality, certainly not characteristic of Noguchi's New York sitters. There is nonetheless a palpable will to capture not only the spirit of the sitter, but accurate physiognomic details. This, I suspect, derived from Noguchi's obvious affection and respect for a man who had shown him special understanding and also from the artist's exposure in Tokyo to sculpture in the Zen Buddhist tradition. An insatiable student of his own art form, wherever Noguchi went he always pondered others' approaches to it, no matter in what time or place. His sojourn in Tokyo brought him to various museums and temples housing the sculptural treasures of Japan's past. One of the great traditions in ancient Japanese art resides in portraits of Zen priests that characteristically combine realistic detail with an attitude of meditation or, at least, worldly detachment. This tradition, of course, descends from China, where Noguchi had certainly encountered it. He often mentioned his interest in T'ang art, which had a great development in portraiture. Likeness was important in T'ang portraiture but was not the sole criterion. An

34

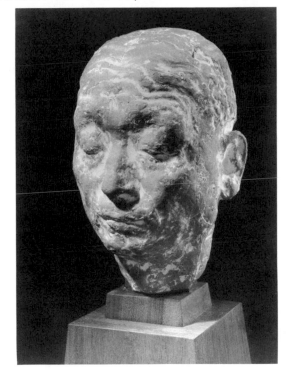

Uncle Takagi (Portrait of My Uncle), 1931. Terra-cotta, 11¾ × 7½ inches. Photo: F. S. Lincoln

anecdote written in the ninth century told of a woman of the court who was asked to look at two portraits of her husband and decide which was the better likeness. She answered that both were like her husband, but one was better because "The first painting has merely mastered my husband's features. The other has also conveyed his expression; it has caught his personality and the way he looks when he is speaking with a smile."[2]

In Noguchi's portrait of his uncle, the nearly closed eyes are the most obvious attribute of a meditative nature, but far more revealing is Noguchi's insistence on the tension of the muscles above the eyes and the carefully incised rivulets in the wrinkled brow of the intensely concentrating subject. It is realistic in the way of many classical Japanese portraits of priests, particularly those of the Kamakura period. Artists were at great pains to render facial musculature, the specific lines of tension, and even small details such as moles and tics. Unlike the sculptors of the Roman emperors, the Japanese realists were modest and direct and often suggested—as does Noguchi in *Uncle Takagi*—that both artist and sitter are mildly bemused.

The conflicting emotions Noguchi reported in his autobiography stemmed as much from his aesthetic predicament as from his obvious family woes. His homage to Uncle Takagi became, then, an homage to a

whole tradition that he was intent on possessing during this period. Fresh from Paris and the great international thrust of the modernists, the transition he had willed for himself could not have been easy. The preoccupations of Uncle Takagi we do not know specifically. (Was he a Buddhist? His younger brother Tsurujiro became a temple monk, and his older brother Yone frequently retreated to Buddhist temples.) From the evidence of the portrait, it seems he was a spiritual man. Noguchi, son of a westernizer who had returned to the fold and of a woman whose interest in Japanese traditions was exceptional (there is a photograph of Leonie Gilmour taking instruction in archery from a Zen monk), and pupil of a Swedenborgian idealist, was clearly drawn to the spiritual tradition from which Uncle Takagi had come.

The attraction had manifested itself even before Noguchi left New York, during his concourse with Michio Itō. He occasionally mentioned Tenshin Okakura (1862–1913), whose book, *The Ideals of the East*, first published in 1903, he had read in a 1921 English edition. The book was well known among the literati Noguchi met during his early New York years. In fact, the fashion for things Japanese had not abated in the United States since the American scholar Ernest Fenollosa, a Harvard graduate turned Buddhist, had first alerted his native New England to the artistic riches of the Orient. Okakura, first Fenollosa's pupil and later his rival proselytizer, had had great success with his open-minded American listeners, especially in Boston, where he became a dynamic curator at the Museum of Fine Arts. His book, beginning with the famous sentence "Asia is one," tendentious as it was, and irritatingly omniscient in tone, nevertheless became the starting point for many serious Orientalists in the United States (and, curiously, also for Japanese intellectuals who in their late-nineteenth-century zeal to westernize had strayed far afield from their own traditions).

As Noguchi once said, Okakura's book had shaped the course of his inquiry into the meaning of the East for his own development and was possibly the source for his first statement to the Guggenheim Foundation, in which he declared that he wanted to "see nature through nature's eyes"—a simplification of the Zen ideal—and that he would travel to India, China, and Japan, the precise itinerary suggested by Okakura, who always promulgated the idea of Asia as an entity, and a far more spiritual one than the West. "The old art of Asia," he wrote in *The Ideals of the East*, "is more valid than those of any modern school, inasmuch as the process of idealism, and not of imitation, is the raison d'être of the art impulse." Okakura's positions sometimes tilted dangerously toward bigoted nationalism, even racism, but for readers in the West, his incisive descriptions of Eastern art and religion served as a gateway into the much-romanticized world of the East. Noguchi, young, troubled, search-

ing, was not immune, and picked up his first general knowledge in reading Okakura.

After his sojourn in China and his work with Chi Pai Shih, Noguchi was in a mood to reject the contemporary world and escape its problems. In China he had been deeply impressed with terra-cotta T'ang sculptures and had formed the idea of finding the eminently skillful forgers of these ancient works, who were, as he was told in China, mostly in Japan, to study their techniques. His father, on the other hand, thought he ought to become acquainted with contemporary artists, and took him to see certain important artists in Tokyo. But, Noguchi exclaimed in his autobiography, "I wanted, on the contrary, the Orient." His resistance to his father can be sensed in Noguchi's account of his visit. There are strange lacunae, some the result of his not being "ready" for certain encounters, others stemming from his desire to avoid his own Western past, and some, perhaps, reflecting his consternation when he found that his father and his father's friends among poets and artists were well on the way to a bellicose defense of Japan's claim to a Greater East Asia.

The Japan Noguchi found in early 1931 was in a perilous state both culturally and politically. He sensed the political malaise and in later accounts made a point of recalling a menacing atmosphere: "My trip to Japan in 1931 had not been altogether pleasant. The preparations for war had already begun, the police were everywhere."[3] Also:

> The police were after you all the time, wanting to know where are you, who are you, what are you doing over here. All right, I was an American. I was visiting there. I was taking it all in. And all the ancient Japanese virtues and ancient Japanese art, songs and so forth, were pre-empted by the military.[4]

For the members of Yone Noguchi's circle, Isamu was a strange bird, arriving just at the moment when they were turning in on themselves once again and considering their youthful enthusiasm for Western things somewhat shameful. The cultural issues rending the art community were extremely complicated, and Noguchi, who knew relatively little about twentieth-century Japanese art history, was probably baffled. Various issues that he himself would later confront were becoming urgent in 1931, including the issue of Japaneseness—whether, in fact, a Japanese artist could be at once a modernist, which meant to be schooled in Western viewpoints, and an advocate of ancient Japanese virtues. Although Yone took Noguchi to visit various artists, Noguchi mentions only two: Kōtarō Takamura (1883–1956), well known as a sculptor and a poet, and his father, Koun, an old man with a flowing white beard who was "carving a large Buddha in wood," and who was one of the foremost traditional

sculptors in Japan. Of the younger man, Noguchi said only that he was under the influence of Auguste Rodin and took Noguchi to a bronze factory. Yet, he spoke English, and we cannot ignore the possibility that conversations with him added to the "conflicting emotions" Noguchi reported in his autobiography.

Slightly younger than Noguchi's father, Takamura had been an enthusiastic westernizer during the first decade of the century. He was among the bright students chosen by the state to travel to America and later England and France. He left Japan for America in 1906 and remained there for fifteen months, part of the time as an assistant to Gutzon Borglum, for whom Noguchi himself had once toiled. (It was Borglum, carver of great stone faces, who had told Noguchi he would never be a sculptor.) Takamura seems to have had a better relationship with Borglum, but it was during his sojourn at Borglum's studio that he first encountered ugly prejudice from passersby who called him a "Jap"—experiences that would later be recounted with great bitterness. After a stay in London, and many months in Paris, Takamura returned to Japan in 1909 fired by the desire to educate the country to see Western art through his own converted eyes. He began writing articles describing, among other things, the pictorial ideas of Henri Matisse and the sculptural innovations of Rodin. In 1910, he was the author of the first modern manifesto ever launched in Japan. The scholar Věra Linhartová wrote that the young Japanese artists of every stripe who were defending the cause of modern art recognized themselves in his outburst: "In one stroke he rejected the millennial conception of the authority of the Master which for thousands of years had not been contested."[5] Takamura's manifesto caused a furor behind which lay the turbulent history of the Japanese avant-garde that had again and again grouped and regrouped, often in order to resist the conservative demands of the state. (By the time Noguchi appeared, these old demands were being formulated as sinister policies that would endanger not only art, but artists themselves.) The ceaseless battle had its greatest impact before the First World War. As Linhartová pointed out, Takamura's manifesto occurred in a historic moment, just two months before the repression following the arrest of leaders of the anarcho-syndicalists in 1910.[6] Takamura's early appeal for individual liberty would epitomize the anguish of intellectuals in the face of recurring moments of government repression until after World War II.

The Takamura that Noguchi met, however, was no longer the firebrand who had blasted his society in a manifesto that had opened with the bold statement:

> I demand absolute freedom in the world of arts. And am thus ready to recognize in the personality of the artist an unlimited authority.[7]

This aggressively "Western" view of the artist's situation had been considerably modified by the time Noguchi talked with Takamura. After his return from the West, Takamura had begun to publish poetry and, during the later 1920s, was increasingly given to expressing his disaffection from Western thought. Like Yone Noguchi, he began to view Western influences as corrosive, and his own earlier enthusiasm with embarrassment. His poetry, so enlightened and enriched by Western inflections, turned more and more to the memories of slights, racial slurs, his Japaneseness even in erotic adventures, and his many chagrins. Later, when Takamura became, like Yone Noguchi, a full-fledged patriot, his poems were similarly venomous. In December 1941, Takamura would write "The Clear Winter," in which he said: "The world has completely changed. The final account has been done. We have been pushed around and looked down, squeezed and we joined in a *bal masque*. We kept trying to learn from them, and we fully tasted their meanness—now we can return to the past. We can find the *raison d'être* of our own folk. . . ."[8] Noguchi's father would go still further as a patriotic poet, writing the shocking poem "Slaughter Them! The American and the English Are Our Enemies," a terrible, prolonged shriek with lines such as:

> These were the countries which nurtured me for twelve years when I was young . . . Those friends who are still alive will probably say to me, 'this is a war between country and country. Our own friendship is too sacred to be destroyed.' What foolishness! The united Japanese millions will not accept such pious palaver. This is all-out, all-out; We'll show you how decisively we slaughter you, friendship and all![9]

It is hard to imagine any ground on which the young American and the older Japanese sculptor could meet. Takamura had, only a few years before, published poems about his American experiences in which he had spoken of the cozy refinement of his American surroundings and said, "A suffocating gratuitous Christian materialism is about to kill a dreamer, a Jap."[10] With his quick instincts, Noguchi would certainly have sensed an incipient conflict, which at that point he was most anxious to avoid. He was not in a mood to enter contemporary conflicts. He wished to put himself in a traditional situation, away from everything.

This would be achieved two months after his arrival. When he mentioned his interest in the T'ang forgers to his father, Yone Noguchi obligingly introduced him to the director of the National Museum in Tokyo, Jiro Harada, who recommended him to Jinmatsu Unō, a master potter in Kyoto. Turning his back on Tokyo, Noguchi wanted to go back to beginnings—not his own beginnings with Onorio Ruotolo, where he had learned to make terra-cotta effigies, but the archaic beginnings in which

art was shaped in the most basic forms from fired earth. His master Brancusi had had infinite contempt for clay, calling it "biftec" and deploring its easy effects. But Noguchi had had second thoughts in China when he saw the prodigious achievements of the T'ang sculptors, and now in Japan he would discover the astonishing range of expressive effects in the manipulation and firing of the earth itself. His enthusiasm was still further sparked by his study of the ancient *haniwa* artifacts and sculptures in the Kyoto museum. Kyoto with its plethora of temples and museums and its remarkable history was an excellent source of knowledge about the myriad developments of Japanese ceramics. It had been the home of countless potteries from its ancient beginnings and the base of the dynasty of raku potters, whose techniques are still influential today. From Noguchi's point of view as a working artist, he would find no better place than Kyoto. What is striking, though, is that this young artist, who already had a claim to fame, could put himself into the position of lowly apprentice. In doing so he fulfilled more than a practical need: Kyoto was necessary to him to reinforce his deep feeling that the ancient world of Japan had, somehow, an important role in his artistic destiny. In this he was not alone, for many Japanese found Kyoto the touchstone, the symbolic center pole of the fragile structure of their culture. Among visual artists, however, Noguchi was one of the first. It was rather poets and writers who first turned back to Kyoto after the earthquake of 1923, when much of the Tokyo area had been destroyed and modern life seemed to so many to be precarious beyond endurance. Kyoto became the site of several important literary landmarks in modern Japan, figuring in the novels and stories first of Junichiro Tanizaki, and later in those of Yasunari Kawabata. Their dialogue with the ceremonious and aesthetically moving past had become essential by the late 1920s. Visual artists were less certain of their direction, and the retrieval of certain ancient principles occurred emphatically only after the Second World War, when Noguchi himself had a part in the revival of traditional ceramic techniques.

Aesthetic shifts, occurring all too frequently in post-Meiji Japan, were marked by an extreme ambivalence on the part of artists. Noguchi, unlike his troubled Japanese peers, could avoid the thousand subtle torments by throwing himself wholly into an adventure with an exotic situation. His submission to a master was, in a way, a charade; a useful and fruitful charade, but all the same, something exciting in its novelty. In later years, when Kawabata, Tanizaki, and others were translated into English (Noguchi's Japanese was not up to reading literature), he would be able to fathom the interior struggles of contemporary Japanese artists during his first sojourn there. To some degree, his own later questions echoed those of the earlier generation.

The situation for artists in Japan before the Second World War is

presented by the contemporary art historian Shuji Takashina in a singular document, what he calls an "unforgettable essay" by Yasunari Kawabata, written in 1933 to commemorate his friend Harue Koga, an important leader of the avant-garde who died at the age of thirty-eight. Koga was the son of a Rinzai Buddhist priest—an important detail—and had been educated to take his father's place in a Buddhist university. However, as a young painter, Koga had had a series of experiences with modern art— first Parisian painting and cubism, then Paul Klee, who would be his deepest influence, and finally surrealism. Kawabata, who was always interested in painting, understood that there was something unique that set this artist off from other members of the westernizing avant-garde. The passage Professor Takashina cites is a penetrating commentary not only on Kawabata's own situation, but on the general problem of artists in Japan between the wars:

> I am always considered as an innovator who ceaselessly seeks and pursues a new tendency, an unprecedented form of literature; who is only satisfied with the unexpected, the unforeseen; who is only interested in novel experiences. I have even had the honor of being called a "prestidigitator." If really my life is thus, one would say that it has a common point with that of Koga. In effect, many people could qualify Koga as a "prestidigitator" because he seemed to be always attracted by an avant-garde research, driven by the idea of making something new, and that his style kept changing its visage. . . . Nevertheless, despite his firm will to appropriate for himself the entire heritage of modern Western civilization, he never forgot that childhood song, nourished by Buddhist instruction that he kept in the depths of his soul. . . . This ancient childhood song resounds also in my soul. . . . Perhaps we were really friends because we sang the same old song behind the mask of a new appearance.[11]

The ancient childhood song, at least in later years, haunted Noguchi also. His first encounter with Kyoto bestirred his earliest memories. This Kyoto, so often described by travelers, so overlaid with conventional responses, so laden with legend, became alive for Noguchi because he lived (as he proudly reported) in the home of a ditchdigger and worked there. Even then, aesthetes were complaining about the modern changes that electric trains had brought to the horizontal city, lying in the embrace of a magnificent semicirclet of mountains. Today there are still narrow streets lined with traditional houses, each with its minuscule garden, and, within walking distance, age-old rice fields still tended by hand. In 1931, as Noguchi recalled:

I . . . worked on ceramics with Uno Jinmatsu in Higashiyama
[district in Kyoto]. I was here for about four months during which
time I had a period of great introspection and silence. It was a
dusty city of unpaved streets of indescribable charm. I felt a
refuge from the vicissitudes of my emotional life at the time and
thus I feel very grateful to it. Indeed, I consider Kyoto to be my
great teacher. I think that old Kyoto—I don't know about new
Kyoto—was of inestimable significance to me as the ideal for the
future.[12]

On another occasion Noguchi hinted at his role as a pioneer, one of the first
modern artists to assimilate the ideals of old Kyoto to modern practice:

I was all alone. I had a pottery I went to, I did things in ceramics.
But I was also exposed to all these gardens and a way of life which
was then very somnolent. Nobody ever went there. Everything
was full of dust. But there I perceived an art which was beyond
art objects. It's the way of life, you might say . . .[13]

Although Kyoto's older districts are now paved and overrun with
eager tourists, the district where Unō had his pottery in Higashiyama still
has the flavor of a village. There are side streets lined with low-lying
traditional houses, bamboo fences of intricate design, and small natural
stone shrines to Buddhist deities with their curious bibs. The "somnolent"
life of the old city was emphasized by the immense silence of the forested
mountain always visible above the Higashiyama district (Higashiyama
means "Eastern Mountain" and is one of the legendary thirty-six mounts
of the eastern horizon). These mountains were often hung with mists, fine
atmospheric washes in the sky recalling early brush paintings.

While he stayed in the cottage of a ditchdigger, Noguchi experienced
a way of life that had not changed over centuries. A ditchdigger was
necessarily poor; the house probably didn't even have tatami mats to
soften the austere, paper-walled rooms. There may have been a cooking
fire sunk into the floor, or perhaps only a pottery stove, constantly smok-
ing, in the earth-floored side of the house. There was no running water
indoors, and often the women would take cooking vessels to the many
streams nearby to use the clean sand as abrasive. The house may even
have had a thatched roof and ancient weathered timbers, requiring con-
stant smoking to prevent rot. Meals then, as today, were taken on a table
only a foot above the floor and consisted of rice, with whatever else the
ditchdigger could afford as a minor accompaniment. For Noguchi, whose
adolescence was spent in the Midwest, home of wheat and bread, and for
whom beef, both in the United States and later in Paris, was staple fare,

the totally different mode of nourishment (his mother surely had served Japanese cuisine at home, but tempered by Western delicacies) was a strange and memorable experience.

Just as important for his future use as the days in the pottery were Noguchi's visits to the famed temple gardens of Kyoto, where many treasures of painting, sculpture, and calligraphy, now safe in museums, were still kept. Noguchi remarked that nobody ever went there, which was certainly true in 1931. The legendary gardens were generally neglected, as were important architectural structures, many of which were rotting away. He saw the most celebrated garden of Ryoanji, for instance, at a time when it had just been rediscovered by a few aesthetes, mostly European, and its stone and gravel arrangements were in disarrray. (The sixteenth-generation gardener Touemon Sanō from Kyoto who assisted Noguchi years later at UNESCO's headquarters in Paris, creating a garden, remembered playing freely in the enclosure as a child.) The wild and disheveled appearance of many of the temple gardens made a deep impression on Noguchi, who, at the end of his life, complained that they had been "cosmeticized." The romance of the ruined garden, a Western idea inspired by the East, was not foreign to him.

In Unō's pottery Noguchi made dozens of terra-cotta figures and urns, only a few of which have survived. Unō had a climbing kiln, one of the distinctive features of the Japanese ceramic industry, which, of course, with its hivelike sequence of structures ascending a hill, delighted the eye of the sculptor. Noguchi had set himself to learn the ancient techniques with a master who knew the secrets of old Chinese and Korean glazes, particularly celadon. The innumerable effects possible with types of glazes, degrees of heat, accidental changes, were revealed to him during those industrious few months. The rich alchemy of baked earth and the mysterious accidents that occurred in the firing stimulated his desire to possess the secrets of the past. His initial excitement when he saw the T'ang figurines in China was surpassed when he began to study closely ancient *haniwa*, the clay figures that surrounded grave mounds as far back as the third century A.D. These robust sculptures, usually a rich reddish color, were based on the simple, hollow cylinder shape from which artists derived a remarkable variety of forms. The cylinder was much beloved of Japanese craftsmen and showed up not only in these ceremonial sculptures but on the ridges of the roofs in ancient shrines, such as those of Ise, and in the fundamental design of the Buddhist stupa.

As Noguchi was using his hands, immersing them in local clay, shaping and firing both vessels and figures in the ancient-style kiln, he was mindful of the simple boldness of the *haniwa* he saw just a few blocks away in the Kyoto museum. Certain *haniwa* are composed like a bamboo stalk, in jointed segments, and surmounted with remarkable figures, not only of

animals but also of dancers, warriors, and flowers, all of which would turn up greatly modified in Noguchi's works in clay. Undoubtedly it was the splendid amplitude of the best of the *haniwa* that excited Noguchi and remained with him all of his creative life. Cylindrical structuring would, decades later, provide his unique contribution to public sculpture in works such as the Cleveland monument and the fountain in Detroit.

Just as the *haniwa* memory played throughout Noguchi's work, so did the memory of *haniwa* origins—those enormous grave mounds that he first saw as he traveled from Kyoto to Nara. During his stay in Kyoto, he met the great scholar of Oriental art, Langdon Warner, who took him to visit Horyuji Temple in Nara. En route lay the ancient tumuli to which Noguchi often referred later, relating the experience to his discovery of the tumuli of the American Indian Mound Builders in Ohio. The mound, the sacred hill, the mountain, crested with the work of human hands, remained central to his imagination. Often it was the sight of a moundlike hill that, as he used to say, "got me going."

Noguchi's days in Kyoto provided him with a lasting store of impressions, techniques, and images. He had immersed himself in the patterns of existence that had shaped the city for centuries; had deliberately masked out memories and associations with his own recent past; and had emerged with a deep sense of what he later called "primal matter beyond personalities and possessions."[14] But the prolonged reverie in Kyoto came to an abrupt close with the so-called Manchurian Incident in September 1931—the first overt action by a completely militarized government. Noguchi was on his way home almost immediately. He arrived in New York in October 1931.

Toward a
Theater
of
Two
Worlds

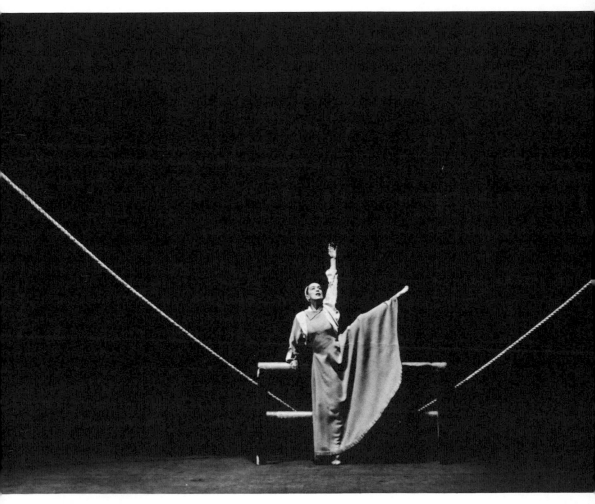

Set for Martha Graham's
Frontier, 1935. Rope,
cotton, wood. Photo:
Barbara Morgan

ABRUPT TRANSITIONS were already characteristic of Noguchi's life. He returned to New York's "excitements"; in his autobiography, cryptic as always, he spoke of his "enthusiasm" for America. He immediately sought out his friend Buckminster Fuller, whose influence was quickly manifested in the title of the first sculpture Noguchi made on his return: a streamlined figure in aluminum, based on his admiration for the dancer Ruth Page, which Fuller was prompted to call *Miss Expanding Universe*. Page was so much inspired by the sculpture that she later composed a dance for which Noguchi designed a daring costume: a large sack that completely enclosed her body except for a single opening for her head. The dance was titled *Expanding Universe*, confirming Fuller's oblique but real presence in the shaping of the avant-garde aesthetic of the 1930s.

For Noguchi, still so unsure of his direction, Fuller, who was almost ten years older and, despite his bohemian habits, well rooted and superbly confident, provided essential ballast. Noguchi always said that Fuller represented America to him, and at that point in his life, America had once again claimed him. One of the most important aspects of Noguchi's attachment to Fuller derived precisely from Fuller's distinctive pedigree. He came from a family whose august ancestor had fought with George Washington. Fuller had a great sense of family tradition and, above all, pride in being the great-nephew of Margaret Fuller, that extravagant friend of Ralph Waldo Emerson whose nonconformism led her to many adventures, one of which was the founding of the important literary magazine the *Dial*. The magazine lived into the twentieth century; Noguchi and everyone else in his Greenwich Village milieu still read it. Margaret Fuller's opinions reflected a fierce individualistic bias that earned her an enduring place in American radical history. Her descendant Bucky was no less ebulliently individualistic and very conscious of his distinct American formation. The New England literati surrounding Emerson were nonconformists, yet they thought of themselves as profoundly American and were eventually acknowledged, even if grudgingly, as important historical figures.

Noguchi's own interest in Emerson was initiated while he was still in high school. Later, he thought of the philosopher as the figure who had forced Americans to look to the East with respect. The Swedenborgian echoes in some of Emerson's writings, especially in the essay "Nature," spoke directly to the young artist—for example, such observations as "Every fact in outward nature answers to some state of the mind and that

state of the mind can only be described by presenting the natural fact as a picture." Although in later years Noguchi's views would expand and deepen, his Emersonian beginnings were always evident, and his lifelong friendship with Fuller—his one solid connection to America—was in many ways an expression of his own fragmented but authentic origins as an American thinker. He clung to the relationship with uncharacteristic tenacity. Fuller, on his part, showed genuine interest in the activities of the young artist who had strayed so far in the world, and he was always ready to listen to Noguchi's accounts of his exotic experiences in China and Japan. Since Fuller himself had already become a proselytizer for what he later called a "whole earth" point of view, Noguchi's burgeoning worldview found favor with him.

Memories of his sojourn in Japan receded rapidly as he reestablished himself in New York. Always seeking fresh experience, he quickly gathered new acquaintances and sources. The erratic course of his development for the next few years attests to a certain confusion that even his peaceful months in Kyoto had not resolved. To some degree his eclecticism can be put down both to circumstance—the New York he returned to was beginning to feel the dire consequences of the 1929 crash—and to his relative youth. Despite the fact that he was immediately able to arrange two exhibitions, one of his Chinese brush drawings and one of assorted sculptures including terra-cottas from Japan, portrait heads, and even a few abstractions from the year before he had left New York, Noguchi was still highly uncertain of his course. He was still in his twenties when he returned from Japan and still searching for the right road. He later said that at such moments he always found people who enlarged his vision. During the first months there were several significant figures in his life, and he made portrait sculptures of them, many of which were included in the exhibition five months after his return. One of the first was José Clemente Orozco, the Mexican muralist whom he studied closely and with visible respect, bringing out the older artist's intensity and strength of character in rugged modeling. Orozco had come to the United States in 1927, already a celebrated muralist, and was a major figure for young New York artists who were beginning to assess the political dimension of the Depression, as was Noguchi himself. Orozco's participation in the Mexican Revolution was much honored. Quite different was the presence of J. B. Neumann in Noguchi's life. Neumann's almost Oriental view of art and his fatherly interest lent moral support to Noguchi's ongoing task of sorting out his impressions and allegiances. A third portrait bust of that period, also suggestive of Noguchi's important encounters during the turbulent time, is of Marussia Burliuk, wife of another worldly adventurer and important historical figure, the painter David Burliuk.

Although in later years Noguchi did not stress his relationships with

early Russian avant-garde figures, they did play a part in his creative life. Even before he left New York for China, he had met Nicholas Roerich, the pioneering theater designer and painter who was reborn in New York as something of a guru. Noguchi's encounter with Roerich ended badly, but his interest in the Russian exile community of former revolutionary artists was obviously strong. Displaced, but carrying with them the mantle of heroic adventurers in twentieth-century vanguard art history, these colorful expatriates played a significant role in Noguchi's development as well as in that of numerous other artists whom he knew in New York.

David Burliuk and his wife, Marussia, kept a kind of bohemian version of a salon to which young artists gravitated. A samovar and *zakuski* were always available. Noguchi's friend Gorky was a regular, as was Noguchi himself. There was a special reason, however, for Noguchi's attraction to the Burliuk circle: Burliuk was perhaps the only person in New York who could truly understand the sculptor's recent Japanese experience, having spent two years there stirring up the art scene. That episode in Burliuk's life produced a sense of kinship in Noguchi. It is quite possible that he had heard of Burliuk's passage through Japan while he was in Tokyo, but more likely, he discovered it once he had returned to New York. In 1920 a capital exhibition was installed in Tokyo presenting radical Russian art, with some 472 works of which 150 were by Burliuk. Not only was the exhibition a revelation to hungry Japanese artists, but so was Burliuk himself, who, judging by a photograph of the period, had brought with him his hand-painted vest and always wore the extravagant costume of the Russian futurists. Burliuk was in Japan from October 1920 to August 1922 and is generally conceded by Japanese art historians to have been a significant figure in the formation of modern Japanese art. Although his own work became increasingly tame, even in Japan, his views on life and art remained robustly quirky and rebellious and were much appreciated by the young aspirants to modernity both in Tokyo and New York. It was in Burliuk's informal salon that Noguchi could meet and exchange views with artists such as Stuart Davis, whom he had known in Paris, Arshile Gorky, and the eccentric Russian who so much influenced his New York colleagues, John Graham.

During the decade following his return from the Orient, Noguchi's life, like that of his compatriots, was shadowed by the Depression. There were to be many turnings in his artistic experimentation. The Japanese experience, temporarily buried, was still waiting to emerge. The demands of the period were pressing: in the great crisis there was a need for a response among the artists, and they were energetically debating what the nature of that response should be. The climate of contention stoked Noguchi's own dawning interest in the possible social implications of his art. On the one hand, there was Fuller with his preachy nature, insisting in his

heightened language, which so appealed to Noguchi, that everyone had to work to improve the world and that he, Fuller, would lead the way. On the other hand, there were Noguchi's own embryonic thoughts about the larger implications of art and its important function in social communication—what he always called its "mutuality," perhaps in recognition of the diction he had heard so frequently in his days with the anarchistic Italian community around Ruotolo.

Noguchi's new speculations on the social functions of art were partly drawn from his recent visits to the temples and gardens of Japan. There he had begun to think about the nature of the manifold work of art in which sculptures, paintings, buildings, and gardens were conceived as a single entity, governed by an articulated intention to shape an environment that would be perceived as a whole by those who entered its precincts. These thoughts were milling about in Noguchi's mind during his concourse with Burliuk, who had always, from his earliest beginnings as a vanguard entrepreneur, advocated the rapprochement of art with life. At the same time, artists all around Noguchi were shifting their allegiances from the modernism that advocated the sacred autonomy of the art object to a social philosophy that emphasized the importance of art experienced communally. The climate was right for Noguchi's formulation of his first significant conceptions of public spaces, called by critic Sam Hunter his "landscape of vision" and by the director of the Walker Art Center, Martin Friedman, "imaginary landscapes."

In 1933, Noguchi had the first vision of what would become one of the prime motifs in his life's work. With his great interest in ancient cultures and his archaeological imagination, he had persistently sought out the kind of prodigious collaborative works in which men had moved mountains— sometimes in actuality, sometimes figuratively. This impulse, with its herculean implications, had immense appeal to Noguchi, whose mythic way of thinking was born early in his career. As he wrote in his final summation of his life's work in 1987:

> In 1933 a revelation seized me out of which came *Monument to the Plough*. This was to be a triangular pyramid about a mile wide at each base. One side would be ploughed, another planted, and the third left fallow. At the apex would be the plough devised by Jefferson and Franklin.[1]

His protector, Dr. Rumley, had first taught Noguchi that the steel plow had been devised through correspondence between Thomas Jefferson and Benjamin Franklin, and during this time, when Noguchi was eager to assert his own American provenance, Dr. Rumley was much on his mind. His idea, he later wrote in his autobiography, "indicated my wish to

Monument to the Plough,
1933. Drawing, original lost.
Photo: Isamu Noguchi

belong to America, its vast horizons of earth." Among the many public
projects put forward by artists during that Depression era, Noguchi's
unrealized project stands out for its singular imaginative largess, its truly
visionary character. It found very little approval with the critics of the
period. (Noguchi's craving to move the earth never abated. Four decades
later he described to me an enormous project of earth-moving that in-
volved four miles of industrial waste in Illinois—another of his vastly
ambitious dreams that would be unrealized.)

Soon after he sketched the lineaments of his *Monument to the Plough*,
Noguchi was seized by another revelation. This one would permanently
temper his thoughts and was still with him at the end of his life when he
attempted to realize a lifelong ambition in the city of Miami. The moun-
tain he had devised for his *Monument to the Plough* would now be
transferred from the vast reaches of Idaho to New York City itself in
Noguchi's imagination. He made the important model for *Play Mountain*,
which he later called "the kernel out of which have grown all my ideas
relating sculpture to the earth."[2] The pyramidal form that had dominated
the earlier model was again invoked; this time it was meant to dominate
an entire city block in New York. Although Martin Friedman described

the model as a kind of Art Deco relief, recalling, he said, the streamlined classicism of a Norman Bel Geddes 1930s stage set, it can more easily be described in relation to what Noguchi had seen in the Orient. There he had noted the ancient tumuli, set in their rectangular enclosures; the Altar of Heaven, with its progressively diminishing terraces; and the geometric pyramids and cones shaped in sand in the Zen gardens. The fact that Noguchi referred to it as a "seasonal pyramid" also suggests its Japanese origins, since so much Japanese art is keyed to the imagery of the seasons and stresses the temporal increment. In any case, *Play Mountain* was one of Noguchi's most cherished experimental images for a variety of reasons. For one, it was addressed to children who, as he said, "had nothing more than a cement area with a fence around it high enough so that they couldn't climb over it, in which they were left like birds in a cage or animals in a zoo."[3] Here his earliest memories of an unhappy interlude in a Tokyo park that filled him with foreboding came into play.

Although Noguchi's tenderness for children seemed rather impersonal to many who met him in later years, Dr. Rumley, in a warm memoir written in 1925, mentioned that his protégé loved the younger children at the school and showed "unusual kindness" to them. In later years it seemed to certain more critical commentators that Noguchi's relationship with children was based on his own sentimental view of himself as an abandoned waif, with all its attendant resentment. There was, however, another reason, which might be called a philosophical reason, for his strong and abiding interest in the playground motif: the element of play, as he instinctively knew, was more than just the province of children. It had entered into his own experience when he began to experiment with clay, and it was endemic to Japanese theories of art, particularly in Zen, which regarded play as a vital aspect of existence and, with it as a concomitant, humor. At some later point, Noguchi would discover the work of Johan Huizinga, which thoroughly explored the theory of *homo ludens*. At this stage in 1933, however, it was Noguchi's intuition alone that guided him to the grand concept of play and an ambition to enter the American scene by inventing playgrounds.

At the time there were many prospects opening, and Noguchi, in fact, was employed on one of the first experimental projects of the New Deal, the Public Works of Art Project, which was the forerunner of the Works Progress Administration's Fine Arts Project initiated in 1933–1934. This turned out badly, as did so many of Noguchi's ventures in this period. Within four months he was thrown off the project. He had submitted his monument and *Play Mountain* drawings, which the administrators had found totally wanting. He was informed that he could apply for reinstatement "provided he was willing to undertake work of a more purely sculptural character."[4] Around the same time, Noguchi met defeat at the hands

of his perpetual enemy, Robert Moses, the New York City parks commissioner who subsequently thwarted several of Noguchi's efforts to work in the city in which he lived.

Noguchi might have tolerated these setbacks better had he not suffered an experience that would never be forgotten and that exacerbated his inner conflict. In January 1935, he had an exhibition at the Marie Harriman Gallery in which he showed the full panoply of his divergent interests. This included the drawings for *Monument to the Plough* and *Play Mountain;* portrait heads; and a shocking sculpture in monel metal of a lynched black man, called *Death.* This exceedingly specific work, still shocking today, was based on a photograph Noguchi had seen in a left-wing journal. It startled and horrified viewers who predictably found it too realistic to be artistic. The worst reaction, unfortunately, came from the distinguished critic of the *New York Sun,* Henry McBride. In 1932, McBride had indicated his suspicion of Noguchi, emphasizing his Oriental origins, and with unusual archness (unusual, that is, for McBride, who was much respected among the vanguard artists for his early recognition of Matisse) writing: "Once an Oriental, always an Oriental, it appears."[5] In that first review McBride had acknowledged Noguchi's talents as a portraitist, but he had roundly scored the young artist for his facile brush drawings, pointing out with considerable accuracy that they lacked deep emotion and the "stern sense" of plan that is expected in great Eastern art. McBride's animus in this early piece was twice as offensive in the 1935 review. He indulged in unforgivable racism, as when, at the very outset, he referred to Noguchi as a semi-Oriental and called him "wily" for having proposed such American monuments. He continued in a deprecating tone and in the last sentence twisted the knife by calling the sculpture of the lynched man "just a little Japanese mistake." Noguchi was, of course, stunned and deeply disheartened by the widely read review. He kept it all his life and when he wrote his autobiography reproduced it almost in toto. If he had felt he was on his way to becoming a bona fide American artist, McBride, in terms that would be permanently engraved in Noguchi's soul, quickly disabused him. The issue of Noguchi's Japaneseness never quite left him and would nettle him desultorily throughout his public life in the United States.

Fortunately, he was rescued by Martha Graham from the devastation this review produced. By this time, he had known Graham for several years and had done her portrait even before he left for Japan. He often visited her studio to watch the evolution of her innovative approach to dance and to see his half-sister, Ailes, who from 1930 to 1933 had danced in Graham's troupe. In 1935, Graham, who had never before used sets, had the idea of inviting him to design the set for a new dance called *Frontier.* This was a great opportunity, one of the most important events

in Noguchi's creative life. It was, as he wrote in his autobiography, the genesis of an idea—to wed the total void of the theater space to form and action:

> A rope, running from the two top corners of the proscenium to the floor rear center of the stage, bisected the three-dimensional void of stage space. This seemed to throw the entire volume of air straight over the heads of the audience.
>
> At the rear convergence was a small section of log fence, to start from and to return to. The white ropes created a curious ennobling—of an outburst into space and, at the same time, of the public's inrush toward infinity.[6]

The concept was not in itself novel. The early Russian avant-garde had already conceived of the quadrature of the box stage as a unitary space in which events would have both a vertical and a horizontal life. But Noguchi's desire, as he said in 1956, was to "split the air of the stage" in a fundamentally sculptural way. That is, he felt, rather than saw, the continuum of the stage space; of the very air that he would symbolically cleave and shape. Graham's approach was always rooted in symbolism, with which Noguchi felt quite at home. She was intuitively aware, always, of the invisible dimensions suggested by the most minute gestures of her dancers. And she tended to envision her choreography as a whole before she saw the parts. Her leitmotivs were established in a minimal sentence or two. This meshed with Noguchi's own approach. He wished, by the most sweepingly simple means, to transport his feeling of the spatial continuum into her vision. He was touched by Graham's grand allusions to timelessness and infinity but knew that such abstract concepts could only be transmitted through the most powerful and reductive means. The orphic tone, which had so much meaning for him, would have to be invoked with great care.

The shock and great efficacy of Noguchi's invention for *Frontier* is apparent even in photographs. He approached his task with a zeal inspired perhaps by the American locus of Graham's scenario. The assignment was a sort of redress for his recent humiliation and provided Noguchi with a longed-for opportunity to express his "enthusiasm" for and relationship to America. Graham was overjoyed with his design. She spoke of

> the distance of the plains that I feel this girl is looking at, almost for the first time. She's arrived in a new area, a new landscape, and Isamu brought me this very simple, elegant thing—just ropes individuating the distance, the trail and the tracks of the railroad train, and the inevitable fence that gets built as soon as the pioneers take over.[7]

Rope used to bind
protective bamboo sheath
in Ise woods, 1989. Photo:
Denise Browne Hare

Not only did the theme inspire Noguchi, but it provided him with the
opportunity to prove to himself that he could bring together his lessons
from Japan with his deepest feelings for America. Whenever he discussed
this first realized total space, in which both human beings and objects
participated in a whole configuration in movement, he mentioned his use
of the memory of Noh plays he had seen a few years before in Japan. For
him, *Frontier* represented an ideal fusion of East and West in what he
called the "hypothetical space" that was the theater.

Two aspects of Noh theater infuse Noguchi's work with Martha
Graham. The first is the absolute poetic character of the events. Even if
his Japanese was unequal to the performances he had seen in Japan in
1931, Noguchi, like other foreign visitors, would have been supplied
with a summary text, albeit rather rudely translated. The repertory of
mythical stories was well known to Japanese viewers. Connoisseurs of
Noh knew all the basic events depicted. If, for instance, the narrator
made a few slow steps, then turned ever so slightly, they understood
that he had indicated a change in time, sometimes covering a span of
many years. For Noguchi, who from early childhood had been markedly
responsive to myth, it was not difficult to transport himself into the at-
mosphere of temporal dislocation characteristic of Noh. The leaps re-
quired of the imagination were natural to him. Moreover, as a man of
the generation born after the turn of the century, Noguchi shared with

other artists a vision of time and history tempered by the psychological distinctions made by Henri Bergson, Sigmund Freud, and Carl Jung. No habitué of Romany Marie's in the late 1920s was unaware of their recourse to myth, to archetype, in order to illustrate the new perception of time. The Noh play, as Noguchi immediately understood, is the optimal expression of the time-before-time of the mythologizers. It is also the world's oldest surviving form of theater that is wholly ceremonial and ritualistic in every detail.

The second and most important aspect of Noh theater for Noguchi was its visual structure, strikingly different from the theater of the West, yet, as he discovered, rich in suggestion for the new art of Western dance. He found in Noh its universal qualities and quickly adapted them to his modern tasks. When he spoke of the influence of Noh on his conception of *Frontier,* he said that what was good about ancient Japanese art was "its international qualities—it is of no time and place." It was to be precisely the feeling of no time and no place that gave *Frontier* its tone, while the specific story of an American experience was never denied.

Probably the most direct reference to Noguchi's encounter with Noh theater lies in his choice of rope as the prime plastic medium for the definition of time and space. Rope is not only a fundamental material to this day in Japan, but it is often, in Shinto shrines, still invested with sacred connotations. Even when it is not exactly sacred, rope is still used in ritualistic ways. The smallest piece of string used to tie a gift must be tied in a specific way in order to be acceptable, and the ritual of tying is strictly governed. While the meaning of its origin may be lost, the formal significance of the right kind of knot is always an implicit reminder of its ritualistic source.

Ropes, strings, and knots held interest for Noguchi in yet another way: his friend Bucky Fuller was quite obsessed with them. For years Fuller had searched for a visual demonstration of his eccentric theory of metaphysics. Only recently had he discovered the perfect means. (Fuller's metaphysics at the time, roughly, was that there are "patterned integrities" that exist independent of local phenomena or events and that the entire universe is controlled by a set of principles that govern both physical and metaphysical phenomena.) Fuller's triumphant reduction of his theory arrived in the form of the slipknotted rope. At the time, he used it assiduously in his many extemporary lectures and even maintained that the phenomenon he described with his rope demonstration was the basis for Einstein's theories. Noguchi was always filled with wonder by Fuller's theories, and the visual character of the rope demonstration perfectly matched his own way of perceiving.

Unquestionably Noguchi's first exposure to Noh theater left an indelible impression and would inform his own work not only in the theater but

also later in his great public projects. For his ongoing collaboration with Martha Graham, the character of Noh—a fourteenth-century development that historians generally believe emerged from earlier religious rituals, including dances performed by priests at ancient Shinto shrines—was perfectly suitable. Noguchi drew upon the knowledge he had acquired in Japan, where he had visited Shinto shrines in Nara in the company of Langdon Warner, who could explain small details such as the fluttering pieces of knotted white paper and the ropes encircling certain stones designated as sacred. These small details always caught Noguchi's eye. But so did the shrines themselves. As a friend of later years remarked, Noguchi always looked at everything partly with the eyes of the architect. In the far reaches of time, Shinto shrines had already assumed the character of little theaters:

> When worshippers wished to summon *kami* to earth they prepared a holy place, *himorogi*, by setting out four poles in the earth to mark the corners of the square or rectangle. At the center of the space stood a column where *kami* dwelt, *yorishiro*, and a rope (*shimenawa*) tied around the four posts enclosed this space. . . . To sanctify the rope (*shimenawa*) that marked the *himorogi*'s boundaries, white paper strips cut in a pattern representing the brilliance of the sun (*gohei*) were suspended from it. . .[8]

Later the symbolic structure of the shrine was absorbed into architectural patterns, and according to contemporary architect Arata Isozaki, the structure of the Noh stage directly reflects these ancient spirit-haunted visions of the universe. He described the structure of the Noh stage:

> At the back of the stage, a wooden wall called *kagami-ita* (mirror wall) harbors the divinity, *kami*; an aged pine tree painted on this wall symbolized the residence of the kami. The stage represents the world of the present, and backstage the world of the dead. The *kagami-no-ma* (*ma* of mirror) is placed just at the stage entrance. The bridge connecting the stage to the backstage symbolizes the space between the world of the present (stage) and the world of the dead (backstage). In Noh drama, the slow negation of the bridge-like passage represents the descent of the spirit to the earth.

Even today, to approach a Noh theater is to enter the spirit of an ancient tradition. The curious bridge, providing an asymmetry to the entire visual experience, immediately suggests a different existential tempo. The conventional back wall with its invariable pine tree brings the outside space

into the inside, sheltered space, and the tree by its very presence evokes
the animated, mountainous landscape of Japan.

With its simple stage spaces, Noh theater gives ample latitude to the
imagination of the viewer, which is stimulated by the stately entrance of
masked and costumed figures who move exceedingly slowly over the
bridge to center stage. Almost no scenery and very few props are used, but
the props are significant in their reminder that in Noh, realism is to be
avoided at all costs. Donald Keene, who, like almost every commentator
on Noh, said it is almost impossible to convey the experience to anyone
who has never seen it, mentioned that during the fourteenth century, Noh
became a theater for connoisseurs, embellished with quotations from
poetry and full of complicated wordplay:

> Overt action was rejected in favor of symbolic gesture. The props
> were reduced to miniatures or bare outlines of the things they
> represented. . . . A boat is represented by two thin strips of wood
> joined at the ends, and the area of the boat itself is often so
> restricted that some of the passengers must ride outside.[9]

Extreme reduction to a few highly significant props was characteristic of
Noguchi's own conception of theater, especially the theater of the dance.
Graham was always highly appreciative of the way he could make the
necessary allusions, augmenting the movement of the dancers. She spoke
of details, such as a headdress, a chair, a necklace, as intensifying her
image of herself in specific roles. Later, Noguchi would design even more
astonishing costumes and props, as for instance in his remarkable designs
in 1946 for Graham's parable of the Medea story, *Cave of the Heart*. He
called it a "dance of transformation as in the Noh drama" and invented
a brilliant device that was at once a prop and a costume. Graham de-
scribed it in a memoir in the *New York Times* after his death:

> When I brooded on what I felt was the unsolved problem of
> representing Medea flying to return to her father the Sun, Isamu
> devised a dress worked from brilliant pieces of bronze wire that
> became my garment as Medea moved with me across the stage as
> my chariot of flames.[10]

Although the wire sculpture Noguchi devised may be seen in the Isamu
Noguchi Garden Museum today, it only faintly recalls the effect the flexi-
ble sculptural members made as Graham moved within them, light glanc-
ing off them, and the whole—dancer and costume—trembling like a tree
in a storm: an authentic transformation.

Noguchi would later draw on other essential ingredients of Noh that

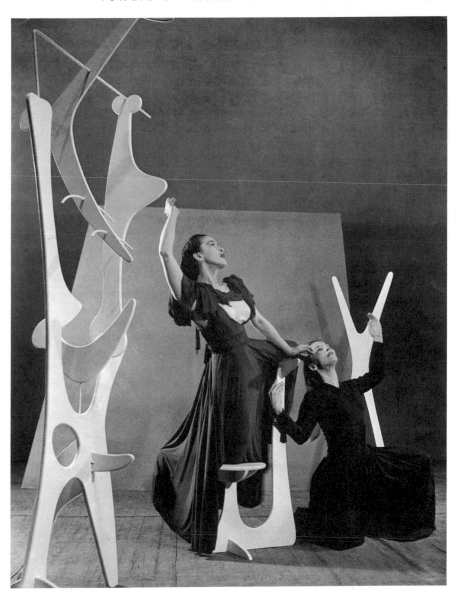

Herodiade, 1944, Martha
Graham, choreographer.
4 elements

functioned much the way the props did—the carved Noh masks, for exam-
ple. They were standardized, always carved in the same way, and slightly
altered to indicate age, sex, or emotional condition of the character. Deli-
cate modulations of the basically symbolic face occur in almost invisible
ways, an effect that Noguchi would later exploit not only in theater but in
individual sculptures. In contrast to the mask, the Noh costume often
functions to animate the entire stage space. The very nature of the cere-
monial robes is architectonic. Whoever has seen the hypnotically slow
movement of a Noh dancer knows how important the lines of the costume
become as, with each slight movement, they shift their axes. Rectilinear
shapes become slightly curvilinear, and right angles transform themselves
into diagonals as the Noh dancer moves. It is immensely thrilling to ob-
serve the drama of the most subtle of movements, slowly revealing, for
instance, the tip of the foot or a glimpse of a wrist. Such indications of
tempo and slow revelation as a means of creating artistic effect were
completely understood by Noguchi. Like Junichiro Tanizaki he cherished
the impression. Tanizaki in his celebrated essay "In Praise of Shadows,"
published in 1933, had observed: "In the Noh only the merest fraction of
the actor's flesh is visible—the face, the neck, the hands—and when a
mask is worn . . . even the face is hidden; and so what little flesh can be
seen creates a singularly strong impression."[11]

The extraordinary visual effects of Noh theater were not the only
features that held attraction for Noguchi. He was struck by the music as
well. He had always understood the spatial significance of music and in his
work with Graham had responded to the ideas often discussed by Louis
Horst, her chief composer, using the diction of the visual arts. His trip to
Japan revealed to Noguchi the special qualities of the ancient *gagaku*, or
court music, and he had enthusiastically amassed recordings that he
brought back to New York. He even tried to persuade the inventor of
electronic musical instruments Leo Theremin, to base his new music on
gagaku and conceived an idea that would later be well explored by envi-
ronmental artists: he suggested that Theremin place his sounding rods at
different points on the stage so that when Martha Graham moved they
would be activated.

Noguchi's original ideas, assimilating his Noh experience, were insti-
gated by the fundamental coherence of Noh based on the perfectly equal
importance of several arts. He had begun musing about the total theater
years before. As a student of Chi Pai Shih he had already absorbed the
peculiar fusion of means, as brush and hand, space and nonspace, were
brought together in traditional Chinese calligraphy, extending the time-
honored laws of Chinese painting. In studying the evolution of ancient
Chinese principles as they were reflected in Noh theater, Noguchi found
a self that differed considerably from the selves of other sculptors who
were still, in the 1930s, focused on the object divorced from its surround-

ings. His work with Graham released him from such Western bondage and enabled him to put his own stamp on the use of sculpture in theater.

Graham's conception of the dance, with its ritualistic overtones, was perfectly apposite to Noh, and she came close to the quality of *yūgen* considered the highest attainment for a Noh actor. For most purposes *yūgen* is defined as "mysterious and profound beauty," but Daisetsu Suzuki gives a more detailed description of this indispensable Japanese concept:

> *Yūgen* is a compound word, each part, *yū* and *gen*, meaning "cloudy impenetrability" and the combination meaning "obscurity," "unknowability," "mystery," "beyond intellectual calculability," but not "utter darkness." An object so designated is not subject to dialectical analysis or to a clear-cut definition. It is not at all presentable to our sense-intellect as this or that, but this does not mean that the object is altogether beyond the reach of human experience. . . . It is something we feel within ourselves and yet it is an object about which we can talk, it is an object of mutual communication only among those who have the feeling of it. It is hidden behind the clouds, but not entirely out of sight, for we feel its presence, its secret message being transmitted through the darkness however impenetrable to the intellect.[12]

Graham would speak a similar tongue when she remembered Noguchi: "There always emerged for me from Isamu something of a strange beauty and an otherworldliness."[13]

The principle of *yūgen* had been assiduously studied, although sometimes not by name, by countless artists and philosophers in the West since the period of early romanticism—transmitted from Europe to the United States and the readied imagination of Emerson; shunted back to Europe and to Baudelaire; reinvented for Japan itself by Fenollosa and, through him, passed on to the early moderns—and so had descended to Noguchi from many points in his compass. He had, like so many artists, caught glimpses of certain philosophical principles here and there and used them to confirm his own intuitions. At the time he worked with Graham, Noguchi was certainly aware of many of the underlying concepts in Eastern philosophy as they had passed into art, but he had not yet found the means to *yūgen* in his work as a studio sculptor. There, he was still vacillating uncertainly and seeking the means to *yūgen*, or, as it is also called, *myō*.[14] It was to be more than twenty years before Noguchi took as fully his own this cloudy but clear precept and named an important sculpture *Myō*, a stone that was "a dialogue between myself and the primary matter of the universe."[15]

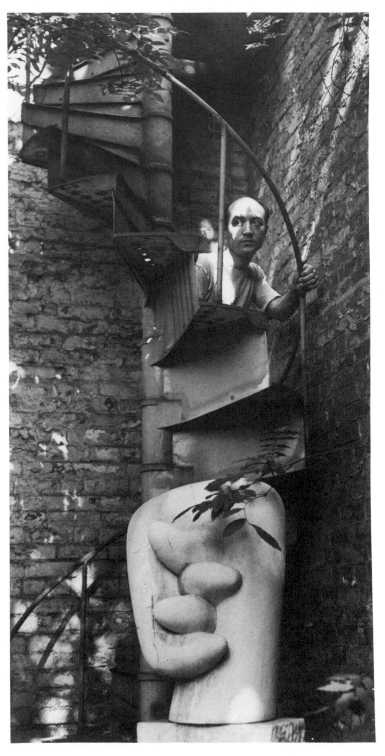

Noguchi in his MacDougal
Alley studio, New York,
in the 1940s, with sculpture
Noodle, 1943–1944.
Marble, 26¼ × 19½ ×
12¼ inches

From
Private
to Public
and Back

DURING THE YEARS between his crucial first collaboration with Martha Graham and his second voyage to the Orient, historical circumstance would pull Noguchi in various and often radically divergent directions. He deeply wanted to be part of the adventure many of his friends were engaged in during the mid-1930s on the arts project of the WPA, but his efforts were fruitless, possibly because he was so well known as a fashionable portrait artist capable of earning a living. Still, he circulated in the company of those who discussed this innovative American social experiment and was a regular at the various meetings of the new configuration, the Artists' Union, headed by Stuart Davis, whom he had known from his days in Paris. Like many artists in New York, he was excited by the news from Mexico, where the mural movement was making international history, and sought out such representatives as José Clemente Orozco and Diego Rivera during their working days in New York. Among the young American artists inspired by the revolutionary activities in Mexico were two young women Noguchi had known in Paris, the Greenwood sisters. The younger, Marion, was only nineteen when Noguchi met her at the Académie de la Grande Chaumière, one of the informal studios he frequented in order to draw from the model. She was vivacious, and even then a rather wild spirit, whose attraction for Noguchi was acknowledged in a 1929 sculptured portrait he made on their return to New York. In 1932 the sisters made the great pilgrimage to Mexico, where Marion, with her strong personality and good looks, engaged the interest of both Orozco and Rivera. She was soon at work on her own mural in Morelia and, by 1934, through Rivera's intervention, had been invited to participate in the decoration of the Abelardo Rodriguez covered market. When Noguchi in turn made his way to Mexico City late in 1935, the Greenwood sisters were delighted and immediately arranged to have him invited to do one of the walls at the market.

In later years Noguchi sometimes spoke self-deprecatingly of his participation in the revolutionary life of the Mexican intelligentsia, but he never denied the exceptional place his eight months of labor on the bas-relief wall at the market assumed in his evolution as an artist of public projects. His social commitment emerged from a genuine feeling of necessity and at the time took on an ideological coloration borrowed from the great and forceful Mexican masters with whom he had daily concourse. Though he later renounced ideological approaches to public sculpture, as did many of his friends (among them Gorky and Davis) who had also

worked for social ends during that period, Noguchi's desire to address himself to the needs of society was authentic and had been germinating for at least five years by the time he rolled up his sleeves for the difficult task in the market. The carved brick and cement wall was enormous—some seventy feet long—and Noguchi's relief incorporated the usual Mexican revolutionary conventions, most prominently a clenched fist, which he later spoke of ruefully. Yet, this was Noguchi's first opportunity to test his command of a large-scale work, and he took it very seriously. As soon as he had completed it, he wrote an article for the Artists' Union's magazine, *Art Front*, provocatively titled: "What Is the Matter With Sculpture?"[1] The artist argued that sculpture should deal with "today's problems," but in his definition of those issues he was careful to include a broad range of such problems beginning with science, both macrocosmic and microcosmic, and going on to life's dream states and aspirations, and including, finally, "the problems and sufferings, the work of the people." He had not entirely forgotten his own preoccupation with cosmic questions when he carved his wall. He had written to Bucky Fuller asking for a brief explanation of Einstein's $E = mc^2$, and Fuller had actually obliged with a fifty-word telegram. Fuller's impress can be read in Noguchi's other points in the 1936 article. He advocates the use of modern means and tools such as the spray gun and the pneumatic hammer and recommends rescuing sculpture from preciousness through the use of "scientific method," the "cheap and quick method" that could produce even rubber or paper sculpture. Finally, he wrote, "It is my opinion that sculptors as well as painters should not be forever concerned with pure art or meaningful art, but should inject their knowledge of form and matter into everyday, usable designs of industry and commerce."

The points Noguchi made in his article were not unusual for the period, but they were somewhat larger than usual in the American context. Noguchi's exposure to cosmopolitan ideas in Europe had broadened his outlook. Between the wars there were countless publications advocating similar views, and at the Bauhaus in Germany, the program Noguchi advocated had been in place more than a decade before the advent of the Nazis in 1933. In addition, his closest associates in New York, and particularly Gorky, had struggled to maintain the tenets of European modernism even as they worked on large commissions addressing "the problems and sufferings, the work of the people." Noguchi's Mexican experience was important to him not only as the fulfillment of a large and economically practical scheme, but also in the spiritual satisfaction of working, as did everyone else at the market, at laborer's wages and no longer feeling "estranged as an artist." He proudly reported in *Art Front* that his mural was part of the "general artistic embellishment of the market by ten workers in the arts" and was "more or less cooperative." The memory

remained. His contentment during that eight-month period always there-
after seemed to him morally significant, and at various times in his life he
tried to conjure similar conditions.

Aside from the exhilaration Noguchi felt in being a useful member of
the community working with "no ulterior or money-making motive," there
were other reasons for his satisfaction in Mexico. Most of the artists in
Rivera's circle, into which Noguchi was immediately incorporated, were
seriously engaged in the study, and in some cases the discovery, of the
monuments of Mexico's magnificent preconquest past. For the Mexicans
this new passion had been inspired by political considerations. They had
to acknowledge the cultural heritage of the Indian population in order to
address the masses in their murals. For Noguchi, these new horizons—the
great pyramids were only a few miles from the market where he was
working—served as one more proof of his intuition that all great sculptural
monuments in human history were related. He would return to Mexico in
later years to visit the places that had inspired him and that had enabled
him to retreat from quotidian demands. More than thirty years later, on
a postcard depicting a great pre-Columbian pyramid, he remarked to a
friend in Jàpan that he felt good "being away from this world."

In 1936, however, back to the world he went—to New York, which
was experiencing a turbulent period of social unrest and was host to
excited debates about the function of the artist. The next few years were
complicated for Noguchi. He tried to find public commissions and tried to
orient himself away from his usual fallback position as portrait sculptor.
His situation was made more difficult by the fact that he could never
manage to insert himself into the burgeoning community of American
artists who, unlike him, were experiencing the cohesion that developed
during the WPA years. The crest of high feeling in the artistic community
was shadowed by a suspicion that the new emphasis on the local scene and
America in general was leading to unpleasant nationalism. Artists such as
Gorky, de Kooning, and Noguchi himself became increasingly uneasy and
redoubled their efforts to avoid the clichés of "American scene" patriot-
ism. Still, Noguchi had not abandoned his ideals of 1936, when, in 1938,
he won a competition to design a bas-relief for the Associated Press
Building in Rockefeller Center. Once again working on a very large scale,
Noguchi used his Mexican experience to good advantage, carving a huge
plaster relief in which workerlike reporters and their iconographic sym-
bols—telephone and typewriter—form a compact, well-designed unit
composed on a dynamic diagonal axis. Noguchi decided to have it cast in
stainless steel (faithful to his earlier recommendation that modern materi-
als be used), which required an enormous investment of physical labor in
welding and grinding the surface.

Exhausted, as he said in his autobiography, he was only too happy to

accept an invitation from the Dole company to visit Honolulu along with other artists, such as Georgia O'Keeffe, who had been asked to register their response to the cultural landscape. These were to be used in advertisements, which Noguchi rationalized by thinking of commercial art as "less contaminated than one that appealed to vanity."[2] This trip would be Noguchi's first direct encounter with Polynesian culture, and he was enchanted by it. He had not forgotten his larger social ambitions; while in Hawaii, he established contact with Lester McCoy, a progressive architect and park commissioner who asked him to design playground equipment for Ala Moana Park. When McCoy died, the project was abandoned, but Noguchi tried once again to persuade authorities in New York to allow him to execute his playground sculpture. He was met with the usual hesitation, this time partly inspired by the uneasy events presaging the Second World War.

Noguchi was not the only artist undergoing a period of restless confusion as the much-feared war against fascism began to seem inevitable. The entire artistic community in New York seemed to be undergoing a sea change. Aesthetic allegiances were shifting rapidly. Noguchi's closest friend among the artists, Arshile Gorky, was one of the most outspoken opponents of the rhetoric that had dominated the mid-1930s. Noguchi himself seemed unable to focus clearly on his personal mission. Few works issued from his studio, and he seemed subject to fits of irritability that impeded his work. Once again he was debating with himself about the nature of sculpture, and this debate he carried to the studio of his friend who, like him, was recasting his approach. They saw each other frequently in 1940 and 1941, and there was certainly mutual influence, as a letter from Gorky to Agnes Magruder, whom he would soon marry, clearly revealed. Dated May 31, 1941, the letter described how Noguchi had dropped into Gorky's studio and the two had gone to the Metropolitan Museum. It is not hard to imagine their spirited exchange in the halls of primitive sculpture. Gorky reported that he looked at primitive statues, "Negro, Yellow, Red and White races" and was at last convinced of the superiority of modern sculpture. One can hear Noguchi's position in Gorky's words:

I had never felt quite sure whether the very conventional form of the primitives, which gives only an enormous sensation of serene joy or exaggerated sorrow—always with a large movement, synthesized and directed toward one end—had not a comprehension more true, more one with nature.

Certainly that was Noguchi speaking. Gorky continued:

Now, when I think it out I see that in modern sculpture the movement without being so big is nearer to the truth. Men do not move in one movement as with primitives; the movement is composed, and different parts of the body may move in opposed directions and with diverse speeds. Movement is the translation of life, and if art depicts life, movement should come into art, since we are only aware of living because it moves. Our expressions belong to this same big movement and they show the most interesting aspects of the individual; his character, his personality . . .[3]

This debate between the primitive and the modern, between truth to nature and imaginative reordering of nature, was going on in many New York studios at the time, and with considerable despair. Noguchi felt so disturbed that he abruptly made the decision to flee, this time to the West Coast. A few weeks after Gorky wrote his letter to Agnes, Noguchi bought a secondhand station wagon, loaded it up with his tools and a few belong-

Ideas for sculpture and portrait of Arshile Gorky, 1947. Pencil, colored pencil on paper, 13⅞ × 10⅞ inches. Isamu Noguchi Foundation, Inc.

ings, and, taking with him Gorky, Agnes, and Urban Neininger, a close friend of the mosaicist Jeanne Reynal, whom Noguchi had often visited before she left New York for California, set out to cross the continent on Route 66. It was a difficult passage. Both Gorky and Noguchi were moody and quick-tempered by nature, and Neininger was a painful stammerer. The aesthetic debate seemed to continue, although Noguchi reported it in terms of a humorous dispute about the clouds "in which he persistently saw an old peasant woman, while I as adamantly insisted on their own abstract beauty."[4] All the same, the route took them through the spectacular deserts of the Southwest, which Gorky's surrealist mentors, particularly André Breton, had long lauded, even before they saw them. They were able to see Indian monuments and artifacts such as kachina dolls, which Noguchi stored in his memory and later alluded to in individual sculptures. There were certainly rancorous moments (in July Gorky wrote to his sister rather bitterly, saying that "It appears that my friends wanted me along for the purpose of reducing their traveling costs").[5] But the friendship survived, based, as Noguchi later thought, on the bond between them, because neither was "entirely American."

By the time the group arrived in California, there were already ominous signs that the war was spreading in the Pacific. Noguchi, who had thought he was going west to establish roots and start a new life, was abruptly brought back to his original problems. When the Japanese bombed Pearl Harbor, he, like most other Japanese Americans, was instantly reminded of his tenuous situation in America. A long history of prejudice that had originated during the first immigration, even before the turn of the century, and had never abated, found its sinister vindication in December 1941. The artists of Noguchi's father's generation had been welcomed as exotic and colorful embellishments of the intellectual world, although even they had encountered less cordial responses among the general public. After the Russo-Japanese War of 1905, a new influx of Japanese laborers, encouraged to emigrate by the depleted Japanese government, prompted California farmers to establish the racist Asiatic Exclusion League. This was followed in 1924 by the infamous Japanese Exclusion Act, accompanied by newspaper headlines demanding the ouster of all "Japs." Until Pearl Harbor, however, Noguchi and other artists of Japanese extraction such as the well-known painter Yasuo Kuniyoshi, had not experienced the full force of racism, having sheltered in the international ambience of the great cities. On December 11, 1941, Kuniyoshi would write to George Biddle, a fellow artist who had been instrumental in the foundation of the WPA arts projects, that "a few short days have changed my status in this country, although I myself have not changed at all."[6]

Noguchi also found himself transformed, this time into an activist:

"With a flash I realized I was no longer the sculptor alone. I was not just American but Nisei."[7] Undoubtedly he suffered a private anguish, for he knew that his own father was an ardent supporter of the Japanese aggression, and he knew, also, that he would be expected, somehow, to declare himself. His first thought was to seek out other nisei artists and writers and to organize them into a group, Nisei Writers and Artists for Democracy, in order to counteract "the bigoted hysteria that soon appeared in the press."[8] Friends were much impressed by his zeal and rather surprised. "Isamu is very busy with the Japanese minority problems," Jeanne Reynal wrote in a letter to Gorky's wife in February 1942, "and is showing great capacities for political organization."[9] Three months later the United States government published Executive Order Number 9066, which would affect the lives of some 110,000 Japanese Americans, many of whom were forced to evacuate their homes and farms in California and were sent to dreadful internment camps. Noguchi's genuine agitation was evident. He left California immediately for Washington, where he hoped to volunteer his services, to make himself useful. "A haunting sense of unreality, of not quite belonging, which has always bothered me, made me seek for an answer among Nisei," he later wrote.[10] It was not only the nisei problem that drew him to Washington, but the war itself.

It was quite accidental that in Washington, as had happened so often in his life, he met yet another fellow visionary, this time the extremely charming and idealistic John Collier, who was in charge of the American Indian Service. The War Relocation Authority had decided to situate one of the "relocation" camps (a euphemism for something more like a concentration camp, as Noguchi would discover) on Indian territory that came under Collier's jurisdiction, in Poston, Arizona. Collier, who had fought for years to improve the plight of the American Indian, saw an opportunity to put into practice an ideal cooperative community. With affectionate irony Noguchi quoted Collier: " 'Though democracy perish outside, here would be kept its seeds,' cried Mr. Collier through clouds of dust."[11]

Collier's dream was persuasive; after a few discussions of ambitious plans for a utopian environment that Noguchi would design, the artist voluntarily interned himself. By May 1942, he was ensconced in the barren, makeshift camp, where he commenced to draw up plans for park and recreation areas and to organize activities for the bewildered, uprooted internees, among them "forays into the desert to find ironwood roots for sculpting."[12] He was excited by his first intimate contact with the tablelands of the Southwest and wrote of the magnificence of the desert, its fantastic heat, its cool nights, and the miraculous time before dawn. Thereafter, he would always think of the desert's vastness in contrast to the confined spaces of Europe. But if at first he was excited by his new life, within weeks he was writing to Biddle, "this must be one of the earth's

cruelest spots."[13] Moreover, it had already become apparent that the War
Relocation Authority had no intention of humoring Collier's vision. Nogu-
chi fully participated in "the harshness of camp life" and discovered, what
surely was for him a new experience, "a feeling of mutuality, of identity
with those interned."[14] All the same, when he understood that his plans
would never be realized, he knew that his presence was pointless.

After considerable difficulty—he had voluntarily become an internee
and the government was not eager to assist his departure—Noguchi left,
once again seeking an effective means of participating in the war against
fascism. He got in touch with Langdon Warner, who by this time was
advising the United States government about Japan and was later credited
with having saved Kyoto from atomic bombardment. He discussed with
Warner plans for an exhibition and benefit for the nisei in March 1943. At
the same time, he called upon other old acquaintances such as A. Conger
Goodyear, with the hope of getting work with the Intelligence Service.
None of his initiatives was successful. Noguchi's "haunting sense of un-
reality, of not quite belonging" would not be assuaged by patriotic war
work, although he sincerely threw himself into the quest for some useful
activity. Acknowledging defeat, he returned to New York, where he had
the great good fortune to find a studio with a garden at 33 MacDougal
Alley. He called it an oasis, and in effect it became an embracing retreat
in which he would once again devote himself to his private life as a
sculptor.

Noguchi resumed his social contacts with artists, many of whom were
not drafted. The city, despite the war, was flourishing with artistic experi-
ment to some degree stimulated by the presence of many distinguished
émigrés from Europe. Noguchi's associations brought him into immediate
contact with the surrealist contingent, most notably André Breton, with
whom Gorky had also become exceptionally friendly, and the sculptor was
soon drawn into the many activities instigated by the Europeans. The
stress on what Breton termed "biomorphism" was beginning to affect the
paintings of artists who would later be called abstract expressionists, and
the few sculptors connected with the group showed new interest in works
by surrealist sculptors, particularly Hans Arp. Moreover, the surrealist
doctrines that advocated the use of found objects, and the incorporation
of suggestion via unlikely juxtapositions, had enlivened the practice of
sculpture. Noguchi was not the only artist who began to use found materi-
als such as bits of string, feathers, and paper in his new work, nor was he
the only artist inspired by the American Indian art of the Southwest. But
he was the only sculptor whose experience had included the art of the
Orient and who could see the new relations of art and object in still
another context. Although his disclaimer of surrealist influence is patently
disingenuous, there was a certain truth in his insistence that his surrealist-

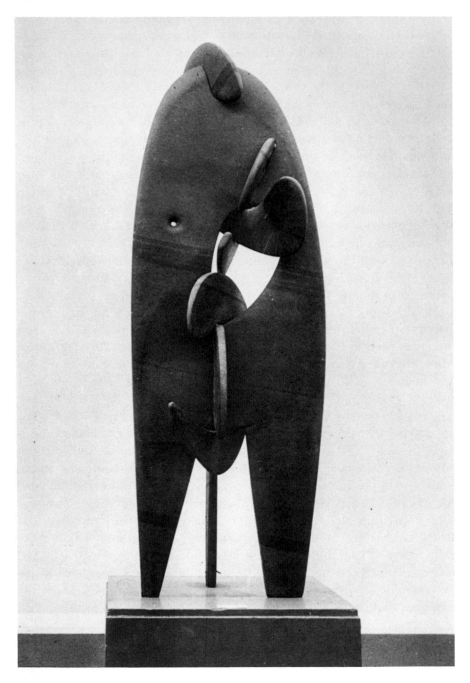

Humpty Dumpty, 1946.
Ribbon slate, 58¾ ×
20¾ × 18 inches.
Whitney Museum of
American Art.
Purchase 47.7

The Seed, 1946. White
Italian marble. Isamu
Noguchi Garden Museum.
Photo: Rudolph Burckhardt

looking sculpture of that period came just as much from the shapes of the
roots of trees in Japanese flower arrangements. The frequent use of bone
motifs, certainly suggested by Picasso, was widespread in the mid-1940s
in paintings by his friend Gorky, the émigré André Masson, the Cuban
painter Wifredo Lam, and the Chilean Roberto Matta, and by native
artists such as Jackson Pollock and Mark Rothko. Noguchi, however, in-
sisted that his bones were just another version of the stick used in Japanese
design. Still, the fact is that for the first time, Noguchi's work consistently
assumed the characteristics of a shared aesthetic, placing him among the
pioneers of a new movement. The development in his work from late 1943
until his departure for the Orient five years later was rapid and provided
him with the first cohesive body of work since his portraits of the 1920s.

Around 1944, Noguchi began to collect bits and pieces of the cheap
marble slabs frequently used to face buildings in New York. These he
carved and assembled using the principle of tension he had tentatively
explored during his first sojourn in Paris. Putting elements together with-
out artificial binders was a practice he had admired in Japan, where the

art of joinery is enshrined in architectural history. At times he carved his
models first in balsa wood, which he esteemed for its quality of lightness
and its transitoriness. Then he would carve, polish, and shape his slabs
of marble to express comparable lightness, arriving at the bonelike or
treelike or anthropomorphically suggestive shapes that answered to the
prevailing surrealist concerns. But they often suggested his other sources
as well. For instance, the 1945 black-slate sculpture in the Whitney Mu-
seum, *Humpty Dumpty* (see page 72), is, in its dominant profile, very
much like a second- or third-century bronze ceremonial bell from an-
cient Japan. Similarly, the elegant interlocking forms of *The Seed* (see
page 73), a white Italian marble piece of 1946, brings together many
associations. It lies on the ground and is composed of only three forms.
Requiring ground-level perception, the sculpture in its knotlike confor-
mation recalls Japanese sources. In addition, the thinness of the slab, its
dismantleable character, and the two-dimensionality of the primary
views bring together lessons Noguchi had absorbed in the East. On the
other hand, the disjuncture of partially biologically derived parts was a
familiar device much used by the painters working toward articulation
of an abstract expressionist composition.

By the end of the war, Noguchi's work was sufficiently integrated
into the vanguard tendencies of the time to move Dorothy Miller to in-
clude him in an important exhibition at the Museum of Modern Art, *Four-
teen Americans*, in September 1946. (Shortly after, *Life* magazine would
offer a feature on Noguchi with the not-very-flattering title "Japanese-
American Sculptor Shows Off Weird New Works.") For Miller's catalog,
published by the museum, Noguchi wrote once again of his larger ambi-
tions, characterizing the sculptor as the one who "orders and animates
space, gives it meaning." His statement that "growth must be the core of
existence . . . for awareness is the ever-changing adjustment of the human
psyche to chaos" aligns him with his fellow exhibitors, several of whom
were already perceived as formulators of a new approach, somehow shap-
ing, if not a movement, at least a point of view.

That Noguchi was at that moment considered part of the group is
evident in the fact that shortly after the MOMA show, Willem de Kooning
arranged an exhibition for him at his own gallery, run by the genial
bohemian Charles Egan, a man perceived as a friend to artists, although
somewhat wanting in commercial skills. The show, late in 1948, was
generally well received, even by critics. They rightfully singled out the
balsa-wood carving *Cronos*, which in its subtly carved flanks and its hang-
ing element showed Noguchi's distinct originality. Noguchi also showed
Night Land, one of his earliest explorations of the idea of a landscape
sculpture, moored only tentatively by gravity and basically floor bound,
and a piece affixed to the wall, composed of slender rods with small

elements caught within them, that he titled *Rice Field with Insects*—a hint of the nostalgia for the Orient gathering in its author's psyche.

Noguchi's memories of his time in China and Japan seemed to surge up even more as he worked concertedly in the theater during this period. His work with Graham often entailed sets derived from mythology and stirred associations both with Greece, his childhood source, and with Japan, as his commentaries on the collaboration, resumed in 1943, indicated. In designing for the theater of the dance, Noguchi's gnawing ambition "to bring things momentarily together" found fulfillment. When he recalled his work for the theater during those years, it was a set he designed for a former Graham dancer, Merce Cunningham, that he thought of as "one of my best contributions" to the world of dance.[15] *The Seasons*, performed in 1947, strongly revived his desultory associations with Oriental aesthetics, for he was thrown into daily concourse with two of New York's most active propagators of ideas from the East, Cunningham and the composer John Cage. Cage had studied the musical systems of the Orient with Henry Cowell as early as 1933, and in 1946, having installed himself in a bare but well-lighted studio on the East River in New York, he seriously examined Oriental philosophy. "After reading the work of Ananda K. Coomaraswamy, I decided to attempt the expression in music of the 'permanent emotions' of Indian tradition," he wrote later.[16] According to Richard Kostelanetz, Cage had already begun to study texts by Daisetsu Suzuki, who would soon appear at Columbia University (1949) to give lectures attended by many artists, poets, and composers in New York's avant-garde. Cage knew about Noguchi from Cunningham, who, of course, had encountered the sculptor during his association with Martha Graham. When The Ballet Society, through Lincoln Kirstein (an old Noguchi patron), commissioned Cunningham to create a new ballet, Cage visited Noguchi in his MacDougal Alley studio and immediately agreed with Cunningham that "Noguchi would be the best."[17]

The motif of the ballet that Cage described to Noguchi that day was to be the seasons—a theme that very much suited Noguchi, who was thinking about Japan. No culture in the world had expressed itself on the subject of the seasons as assiduously as had the Japanese. Moon viewing, snow viewing, and blossom viewing had been celebrated for centuries in poetry, novels, paintings, and garden designs. The temporal dimension is always present in Japanese art, even in the way a brush completes its stroke or a poem shifts in temperature. In photographs of Noguchi's design for the set, it is evident that he was recalling his memory of the silvered sand of the dry contemplation gardens during moon-viewing sessions; these patterns are echoed in his designs for the costumes, striated, as are the sand patterns of the gardens. Among the few embellishments and props are a resurrection of the rope motif spanning the entire proscenium and a cluster of sticks that

suggest the seemingly artless brooms used in the tea ceremony. Noguchi's own description of his project in later years evoked many a Japanese source and was replete with Japanese references. His emphasis on time certainly related his design to Japanese theater, where the tempo so often accelerates to describe the passage of time, and in which the element of darkness is a clear symbolic reference to a ritual text:

> I saw *The Seasons* as a celebration of the passage of time. The time could be either a day, from dawn through the heat of midday to the cold of night, or a year, as the title suggests, or a life-time.
>
> In the beginning there is darkness or nothingness (before consciousness). It is raining as the light grows to bare visibility, to die, and then to revive again, pulsating and growing ever stronger.
>
> Suddenly in a flash (magnesium flash) it is dawn. . . . Birds (beaks for boys, tail feathers for girls) dance to the morning.
>
> The light becomes hotter, the throbbing heat becomes intense, until with violence it bursts into flames (light projections throughout).
>
> Autumn follows, with strange, soft moon shapes, then the cold of winter. It is snowing; lines of freezing ice transfix the sky (ropes), and the man of doom walks into the dark.[18]

Cage remembered with appreciation Noguchi's illusion of snowflakes coming down in winter and the wonderful male masks with beaks on them, conforming to Cunningham's movements to suggest birds: "It was quite wonderful."[19]

One of the signal events in Noguchi's life was his collaboration with George Balanchine and Igor Stravinsky on the ballet *Orpheus*. Here again his imagination veered toward the East, making essential links between Greek and Japanese mythology. In a lavish design, Noguchi brought to fruition many of the ideas he had harbored since his first exposure to Noh and Kabuki—ideas that oddly coincided with Stravinsky's own. Although Noguchi did not follow Stravinsky's score—he always boasted, perhaps with an *enfant terrible* sense of mischief, that he had listened to Arnold Schönberg's *Verklärte Nacht* while designing *Orpheus*—he must have been privy to Stravinsky's intentions. The composer described the death of Eurydice on her way back to earth from the underworld in a 1947 interview: "Nothing in the music has foreshadowed the oncoming tragedy. At the climactic moment I have written only a long measure of silence, following the tradition of the Chinese and oriental theater that certain things are beyond the power of human expression."[20] Noguchi's own conception of the climactic moment was extremely close, and in later years Stravinsky spoke appreciatively of "the transparent curtain which fell over the scene like fog."[21] The first performance, on April 28, 1948, was the crowning event in Noguchi's theater life of the period.

Studies for Seasons,
1947. Pencil on paper,
13¹³⁄₁₆ × 10¹⁵⁄₁₆ inches.
Isamu Noguchi
Foundation, Inc.

Beginning the Seasons,
1947. Pencil on paper,
13¹³⁄₁₆ × 10¹⁵⁄₁₆ inches.
Isamu Noguchi
Foundation, Inc.

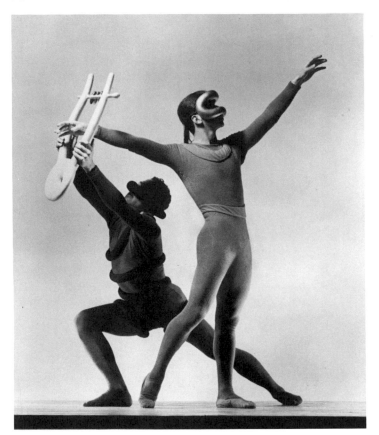

Nicholas Magallanes as
Orpheus and Francisco
Moncion as the Dark Angel
in *Orpheus*, sets and
costumes by Isamu Noguchi,
choreography by George
Balanchine, 1947. Photo:
George Platt Lynes

It was around this time that Noguchi's restlessness returned—a desire
to move on overtook him, assisted by several personal imbroglios and a
tragedy that left a residue of regret that never was to be overcome. In July
1948, Arshile Gorky, beset with problems of health, marriage, and work,
committed suicide. Noguchi was one of the last people to whom Gorky had
appealed, and in various versions of the story, Noguchi always spoke with
emotion, pointing out that he thought Gorky had come to him that fateful
dawn "as to a fellow immigrant out of his past."[22] Gorky's suicide threw
Noguchi into an abyss that set him immediately seeking a way to flee. He
began to sketch a plan for a prolonged journey "to find out, if possible,
what sculpture was fundamentally about, to see for myself its relations to
people, to space, and its uses in the past."[23]
 It is entirely possible that Noguchi felt he had come to an impasse in

his work as a sculptor. Despite his worldly success, and the high artistic echelons into which he had moved, there was always a lingering doubt, rarely articulated. The very few who came close to him were sometimes told "I'm stuck" or "I can't seem to find the way," but in general, he kept his doubts to himself. In 1949, however, his preoccupations were weighty enough to warrant unaccustomed activity as speaker and writer. That spring, he published two statements, both concerned with the definition of sculpture. In the magazine *Interiors* he wrote:

> By sculpture we mean those spatial and plastic relationships which define a moment of personal existence and illuminate the environment of our aspirations. An analogy of this definition is found in the temple sculpture of the past. There the forms— communal, emotional and mystic in character—fulfill their purpose.[24]

In *The League Quarterly* he said:

> Without public enjoyment the very meaning of art is in question. Where once each man's worth found some expression through his hands, his religion, his temple, now there is only mechanization and concepts of power. The blight of industrialism has pushed the artist in us into a specialized corner, and the lot of mankind becomes more and more the spectator. One may say that the critical area of creativity, that of the individual and his ethos, has become so neglected as to jeopardize his existence. . . . After all, culture is the integration of art and life. . . .
> I see sculpture strengthened and finding through it the means of again becoming the great myth maker of human environment where man will find surcease from mechanization in the communion of mysteries and in the contemplation of enjoyment of a new freedom of spirit.[25]

These statements, together with his outline for a book on leisure "which allows for meditation on the meaning of form in relation to man and space"[26] that he submitted in a grant proposal to the Bollingen Foundation, are the nucleus of all of Noguchi's subsequent thought. His 1949 pronouncements were, in effect, a charter for his course throughout the rest of his life. What he needed—what he was wise enough to know he needed—were concrete illustrations to bear out his idealistic theories. He won support from the Bollingen Foundation for what would become a long and exhaustive journey to fabled sites where as he wrote in his grant proposal "the communal, emotional and mystic" fulfilled their purpose.

Bollingen drawing, ca.
1949–1950. Ink on paper,
7¼ × 8¹⁵⁄₁₆ inches.
Isamu Noguchi
Foundation, Inc.

A
''Migratory
Ulysses''

NOGUCHI UNDERTOOK his voyage of discovery in 1949 by beginning at the beginning: he studied and recorded both in sketches and photographs prehistoric caves, menhirs, and dolmens in France and Britain. These dramatic reminders of lost rites would later fuse in his imagination with certain prehistoric Japanese impressions. In Europe he visited the gardens and piazzas of Italy and also the reminders of Greco-Roman splendor. In notes he spoke of Pompeii, particularly the Temple of Mysteries, as a "beautiful integration of painting and architecture."[1] At Paestum he marveled at the vastness of the Temple of Poseidon and remarked on the "sacred relation of man to nature—nature is always clean—there is no such thing as a slum in nature, nor in houses that are nature born."[2] His travels through Italy stimulated his musings on architecture: "The idea of architecture as the theater in which is played the drama of life. The church is a theater. . . . The only important theater of every little town where the people are the actors as well as the spectators."[3] He speculated about the evolution of form from megalithic times to the Renaissance and described his perception of the menhirs becoming pillars and burial mounds becoming stupas. His mind was exceptionally alert during this journey, which took him on to Barcelona to see the creation of the architect Gaudí, and then to Greece where he spent a month exploring. In later years he returned repeatedly to these sites, refining his observations and taking up their challenge in his own grand projects.

Heading eastward, Noguchi gave himself six months to wander as a pilgrim in India, visiting sites that would inspire him for years to come. After, he sought on many occasions to add his own imagination to the prodigies he had seen there, but, except for a portrait head of Jawaharlal Nehru and several proposals sketched out, he never succeeded in working there. From India, he went on to many Southeast Asian monuments, including Angkor Wat in Cambodia. His most enchanting moments, judging by the number of spontaneous sketches, came in Bali, "the island where life and art are one."[4] With his interest in theater, Noguchi found endless spectacles to record, beginning with the famous shadow plays and puppets found in street performances and going on to the more ceremonial affairs where he recorded in lively ink drawings the gestures of the dancers, the position of the drummers, and the costumes and the masks, one of which—a half-face mask—he kept about him for the rest of his life. Noguchi's close study of the integration of art and life in Bali was undertaken in a most serious spirit. He was particularly interested in the perfect

Bollingen drawing, ca.
1949–1950. Ink on paper,
$12^{13}/_{16}$ × 9 inches.
Isamu Noguchi
Foundation, Inc.

Bollingen drawing, ca.
1949–1950. Ink on paper,
$7^{1}/_{4}$ × $8^{15}/_{16}$ inches.
Isamu Noguchi
Foundation, Inc.

coordination of music and dance in Indonesian performances, where a principle he had already noted in Japan—the seemingly timeless or static character—was even more pronounced in the playing of gamelan orchestras. "In Balinese music," wrote critic Jamake Highwater, "there is an outer composition, but there is also an inner pulsation, an inner core of the music's percussive and chordal life." The orchestra, in which each musician plays only one melody at a time, produces subtle and swift complexities, he said, "a unique polyphony as well as a series of massive layers of sound."[5] For Noguchi, the musical paragon was always significant. Massive layers of sound spoke to his imagination.

One of the few furnishings in his last home, a traditional Japanese house on the island of Shikoku, was a magnificent Indonesian instrument like a hanging xylophone. He cherished his impressions of Bali in every detail.

Noguchi's other great Indonesian experience was his visit to one of the world's most celebrated Buddhist monuments, the temple of Borobudur in Java. He had had a long-standing interest in Buddhist art, kindled by his early reading of Tenshin Okakura and revived when he discovered the writings of Coomaraswamy in the 1940s. Even in his early youth he had glanced at Buddhist sculpture. When he was barely twenty he had modeled *Salome* in terra-cotta—a rather banal figure in the stylized manner of the 1920s—which he had set in a flame-shaped wreath as in certain representations of Buddha in his mandorla. But nothing in his background, largely shaped in the West, could prepare him for the overwhelming experience of Borobudur. "Precepts of the Buddha, like the great temple of Borobudur, are a symphony of sculpture," he wrote.[6] Its magnificence left a permanent residue in his structuring imagination. What he saw in Java added a new dimension to his inquiry into the temporal character of sculpture and its meaning beyond isolated sculptural objects. He had already experienced the importance of ascent in Mexico and Egypt, visiting the pyramids, but in Borobudur, the ascension was far more significant for him. The great metaphor in this architectonic ensemble with its punctuating sculptures is that of the mountain—the sacred mountain found in so many ancient cultures and always important to Noguchi both for formal and symbolic reasons. Descriptions of the extraordinary experience of ascending Borobudur abound in an immense literature, some of which Noguchi had read before he arrived in Indonesia. One of the fullest descriptions is in the extended study made by the French Orientalist Paul Mus before the Second World War:

> The Buddhas, at first visible in the niches, then half-hidden under
> the *stupa* lattice-work, the inaccessible statue at the level summit—a *marche à l'illumination,* across a matter less and less sub-

Bollingen drawing
(probably Bali), ca.
1949–1950. Ink on paper,
14¼ × 10⁹/16 inches.
Isamu Noguchi
Foundation, Inc.

Japan drawing, not
dated. Ink on paper,
11¾ × 16⁹/16 inches.
Isamu Noguchi
Foundation, Inc.

stantial, to the anticipated ultimate goal here on earth, a reference
to the moment of final extinction, as the finished *stupa* gives them
to understand. The images which are displayed, on the other
hand, all along the terraces of galleries, would thus be for the sole
purpose of establishing and sustaining the spirit of the lesser ones
in their passage through Rapadhatu. A book of stone, as it has
been called, but offered for meditation, not for ordinary reading.[7]

The approach to Borobudur is as important as the upward climb. Mircea
Eliade described the nature of the gradual initiation:

> The pilgrim does not have a total and direct view of the temple.
> Viewed from the outside, Barabudur looks like a fortress of stone
> several stories high. The galleries which lead to the upper terraces
> are so constructed that the pilgrim sees nothing but the bas-reliefs
> and statues in the niches. The initiation, therefore, is made gradu-
> ally. Meditating on each scene individually, realizing in order the
> stages of ecstasy, the pilgrim tours these two and a half kilometers
> of galleries in unbroken meditation . . . the pilgrim realizes as he
> nears the highest point of the temple that spiritual ascension
> which the Buddha proclaimed as the only path to salvation. . . .
> The temple cannot be "assimilated" from the outside. The statues
> cannot be seen. Only the initiate who goes through all the galleries
> discovers gradually the planes of supersensible reality . . .[8]

The temple is a microcosm of stone, a closed world not unlike the Altar of
Heaven in Peking that had first suggested to Noguchi a "topographical"
dreaming in stone. Noguchi must surely have made the connection in his
mind. In his notes he mentioned reading Osvald Sirén, who, in *A History
of Early Chinese Art*, had described the Altar of Heaven:

> The whole enclosure is of vast dimensions being nearly 6 and ½
> kilometers, most of the space is planted with trees but there are
> also a number of buildings for ceremonial purpose. . . . The circu-
> lar "altar" is arranged in three terraces . . . all the terraces are
> covered by white marble and enclosed by sculptured balustrades.
> . . . The decorative effect of the marble terraces with their richly
> sculptured balustrades, rising stepwise toward the blue sky, is
> dazzling, particularly as their shining whiteness is emphasized by
> the surrounding walls which are red with deep blue tiles on the
> top. . . . No building of any consequence was erected without the
> support of a terrace.[9]

Sirén had taught Noguchi, as he wrote in his notes, that the "early development of architecture is determined by intimate contact with nature. They planned their buildings with relevance to the spirit of earth, the water and the winds."

Now in Borobudur, he would see an extension from nature to culture. The ascension to the highest terrace had a precise symbolic meaning that was a text of Buddha: on the highest terrace the climber reached the Pure Land. The initiates who attain this place, said Mus, circumambulate the terrace annulling the reality below them, annulling the heterogeneous and the diverse. Eliade wrote that the temple was the image of the microcosm, "its concrete model was the bubble of air or water, the 'cosmic egg.' "[10] Buddha maintained that he had broken the shell of the cosmic egg, the "shell of ignorance," and so, oddly enough, did Buckminster Fuller, whose allusions to the cosmic egg were of a different order, but well understood by Noguchi by the time he arrived at the great Buddhist monuments.

The impact of this great stone sculpture would not be forgotten, but at the same time, Noguchi continued to question his own premises. He asked himself if the ideas and aspirations of the ancients could still apply, never finding a wholly satisfying answer. These experiences remained deeply embedded, and from time to time, Noguchi would call upon them—as in his later inventions of ambulating spaces and progressing terraces. Indonesia and India set him ever more obdurately in quest of the appropriate voice, the precise voice that could speak of both the modern and ancient in the same breath and express his own aspiration to create sculpture beyond the institutionalized world of gallery and museum.

Having climbed and descended, sketched and photographed, written notes and pondered extensively for almost a year, Noguchi finally, and with trepidation, made his way to Japan, where he arrived on May 2, 1950. He had been awaited eagerly since March, when the Mainichi newspaper had announced his impending arrival. To his surprise (or at least so he said) the reserve he had felt so keenly during his first visit in 1931 had completely vanished, and he was received with great friendliness. Artists who were eager to connect with the great world, and most particularly with America, thought of him as a famous American artist, but one who had a special bond with Japan. He was besieged—an experience he both solicited and dreaded. The tremendous upheavals that had followed the war had not yet subsided, and Noguchi would benefit from the need the new generation felt to be reintegrated in the world. He saw himself as a "pigeon harbinger after the Deluge,"[11] and in many ways behaved like a missionary, sometimes to the amusement of his more sophisticated new acquaintances. In any case, he was immediately shepherded by the art reporter of the Mainichi newspaper into the art world, where he was surrounded by would-be acolytes and, for a time, experi-

enced the warmth and acceptance he had so much craved during his previous visit.

It is difficult to guess how much Noguchi actually knew about the emotional turmoil his new friends were experiencing; how much he could understand the difficult choices they felt they had to make, or the complexity of the political implications of their dilemmas. With his immense energy he seemed to sweep into their center as a living embodiment of the alluring Western world. His friend Genichiro Inokuma remembered chiefly Noguchi's impatience and his frustration with the slow pace of Japanese life. Despite his obvious wish to claim his Japanese inheritance, evident in his appearance at Inokuma's house in a kimono, he did things quickly, "in the American spirit," and frequently lost his temper at the beginning. According to Inokuma, "If a taxi stalled, he'd say, 'Never mind, I'll walk,' or when a sales clerk was too slow, he would say 'Forget it! I don't want it anymore.' "[12] Hindered by his inability to converse in Japanese, Noguchi spent his first weeks in Tokyo frantically trying to evaluate the situation—his own and that of his artistic acquaintances—and seems to have found much that was very puzzling.

During the first few years after the war, the young Japanese intellectuals had cordially welcomed the end of the prewar nationalism and emperor worship that had been ingrained in their childhood. The novelist Kenzaburo Oë, who was ten years old on the day the emperor announced the surrender in August 1945, remembered listening to the radio while the adults wept: "We were most confused and disappointed by the fact that the Emperor had spoken in a human voice," he recalled. "How could we believe that an august presence of such awful power had become an ordinary human being on a designated summer day?"[13] Oë's translator, John Nathan, commented: "The values that regulated life in the world he knew as a child, however fatally, were blown to smithereens at the end of the war. The crater that remained is a gaping crater still, despite imported filler like Democracy. It is the emptiness and enervation of life in such a world, the frightening absence of continuity, which drives Oë's hero beyond the frontiers of respectability into the wilderness of sex and violence and political fanaticism."[14]

Those slightly older than Oë, who had been commandeered as high-school boys to contribute to the military mission, also looked back with anguish and sometimes with profound bitterness. Many fled Japan for Europe at the first opportunity. Others threw themselves into frantic attempts to catch up, to enlarge Japanese perspectives with the wholesale acquisition of Western culture. Still others felt obliged to respond politically. When Noguchi arrived, in fact, many university students were looking on with great alarm as the democratic system installed by General MacArthur suddenly seemed to turn rightward with the approach of war

in Korea. In their eyes Japan was in danger of becoming an American army base. They were doubly alarmed when the Americans, as they thought, instigated purges of left-wing Japanese intellectuals from public life. This all-too-familiar gesture recalled prewar situations that were decidedly menacing in the minds of the young. In addition, younger artists were uneasy with many of the artistic survivors of the prewar period who had collaborated with the government before and during the war. Foujita, for example, was so much despised for his participation as an illustrator during the war that he had to flee back to France. When Noguchi arrived, ready to approach once again things Japanese and to retrieve the old aesthetic, he encountered a climate in which all things Japanese were looked upon with suspicion, as Professor Shuji Takashina has pointed out in conversation, and had to adjust his own attitudes.

Within a short time in Tokyo, Noguchi chose among those who sought him out, the men of his own generation who had, like him, spent significant periods of their artistic life in Europe, or had at least participated in international currents before the war, or who had been under suspicion during the fascist period. Many of these artists had emerged from the calamitous war still grappling with the problems they had framed long before—problems that had been vaguely germinating in Noguchi himself. One of his new acquaintances—the first serious critic in Japan to write about Noguchi—was Shuzo Takiguchi (1903–1979). Takiguchi, whose resistance had led to his arrest in 1941, was highly regarded as a prominent prewar figure who had steadfastly remained in the vanguard and whose comportment vis-à-vis the government had been exemplary. One certain basis of rapport with Noguchi was the fact that Takiguchi had begun as a poet in the late 1920s with an ideal, which he never relinquished, drawn from the conception of innocence in the works of William Blake. Only the year before, Noguchi had reiterated his own allegiance to Blake, writing about his sculpture *Sunflower* that the title "does not refer descriptively to its form but to the spirit of longing, which I hope it expresses, of Blake's famous poem."[15]

From the Blakean innocence reflected in his early poems, Takiguchi had moved on to another kind of innocence propounded by the French surrealists, who announced their faith in the truths of the subconscious as revealed by automatism. In 1931, Takiguchi had written a passionate manifesto in which he declared: "Poetry is not belief. It is not logic. It is action."[16] He was a zealous commentator, particularly on surrealist poetry and its relationship to visual art, and had translated André Breton's "Surrealism and Painting" in 1930. He had also worked with Paul Éluard, Georges Hugnet, and Roland Penrose to organize an international surrealist exhibition—associations that would bring him closer to Noguchi. Yet, despite his apparently total engagement with European art and his exten-

sive reading in both English and French, Takiguchi had early confronted
the problem of identity. The total submission to Western mores and cul-
ture commanded by the Meiji reforms was troubling even to a declared
surrealist whose articles of faith included a loathing of nationalism. In
defense, Takiguchi began to refer to native traditions, particularly the
evolution of the haiku, and find in them "the spirit of surreality."[17] Like
almost all Japanese intellectuals of his generation, Takiguchi saw Japan as
still hindered by a feudal tradition, yet he searched precisely in the feudal
past for traces of universality. During the dangerous years before the war,
many intellectuals had turned back to the classics, usually the Zen classics,
in the hope of finding analogies between their own tradition and the
abstract and surrealist art they admired in Europe. (It is of some interest
that few of these spokesmen for the twentieth century could bring them-
selves to turn back even further, to Shinto traditions, since the military
cabal had appropriated Shinto and used it to inculcate the myth of unique-
ness—a myth that is still viewed with distaste.)

Besides Takiguchi, there was also Genichiro Inokuma, who was two
years older than Noguchi and had spent from 1938 to 1940 in Europe,
where he met and was guided by Matisse. But the most important encoun-
ter would be with the painter and writer Saburo Hasegawa (1906–1957).
It was to Hasegawa that Noguchi turned, in one of the most important
moves in his life, asking him "to help me travel and re-experience the
beauty of ancient temples and gardens, and to imbibe the tranquility of
Zen."[18]

The first few weeks of intense activity, during which he was constantly
meeting new people and responding to endless questions, had exhausted
Noguchi. But there were more pressing reasons to leave Tokyo. Noguchi
felt more than ever that he was at a personal crossroads; that he had to
find new meanings for his own existence as a sculptor, and he still believed
that the discipline of collecting material for a book would lead him toward
resolution. In selecting Hasegawa as a companion, he chose a fellow artist
who could also be a mentor—a delicate, thoughtful man whose scholarly
bent was pronounced and who had an exceptional understanding of the
passion that drove Noguchi. With Hasegawa, he could be at ease.

Even before they set out together, the two men had found common
ground. It is apparent in Hasegawa's letters to Noguchi that Noguchi had
entered into conversation with Hasegawa on a level that was more serious
than usual. The American artist had been genuinely and profoundly per-
plexed by the Japanese experience during the war, and even more dis-
turbed by the American atomic grand finale. With Hasegawa, Noguchi
could speak frankly, since Hasegawa was one of the few painters who had
been courageous enough to refuse to serve as a war artist and had been
arrested for disloyalty. He had been forced to withdraw to a tiny, primitive

village on Lake Biwa where he lived, as he wrote to Noguchi, a simplified life of absolute pacifism and "resistance through non-resistance." For support he had looked deeply in the Japanese past. "Zen, Laotse, Teaism or Haiku help us—this is my belief through experiences during the last war," he wrote on January 12, 1951.[19] A week later he added: "Rikyu (teaism) and Bashō (Haiku) were always my leaders and I found the spirit of teaism and Haiku in that poor village on Lake Biwa."[20]

Hasegawa's expertise in areas that increasingly drew Noguchi was not the only common ground. Hasegawa had been an explorer of Western aesthetics after his graduation from Tokyo University. He had visited America in 1929 and from there had gone to Paris, where he lived from 1930 to 1932. He was extremely active in Paris, closely studying the work of Piet Mondrian and Wassily Kandinsky and showing in the Salon d'Automne. He knew the work of Brancusi, Hans Arp, and Alexander Calder and was active in the important organization of abstract artists Abstraction-Creation, founded in 1931. These associations endowed Hasegawa with sources almost identical with Noguchi's, which the two discussed intensely.

When Hasegawa returned to Japan he brought with him copies of the magazine published by Abstraction-Creation, eager to introduce his new ideas, particularly about Mondrian, to his colleagues. At the time, he was making objects, assemblages, collages, and photos that reflected his exposure not only to abstract artists, but to the surrealists as well. He also began to work hard to organize other artists into groups that could resist the encroachments of the nationalist government. At the same time, Hasegawa had begun to ponder the significance of his own tradition. As early as 1933, he had reconsidered the work of the classical fifteenth-century painter Sesshū, about whom he had written his thesis in 1926. When, in 1937, the year of the outbreak of the Second Sino-Japanese War, Hasegawa published his important book *Abstract Art*, he had already begun to compare modern abstract art with traditional Japanese practices. In an article published the same year, "To Situate Avant-Garde Painting,"[21] the lines of his own spiritual struggle as an artist took form. He launched his argument with a quotation from Hans Arp: "Art is a fruit that grows within man as a fruit grows on a tree." Then he described the situation of the contemporary artist in Japan who had been forced to make the same "leap" as the economy, when Japan was thrown open to the West. In both domains, he said, there remain vestiges of the feudal epoch. To preserve the perfume and savor of art, artists must take into account the "uncertain attitude that is ours" and overcome their handicap (a word he wrote in English). They must ask themselves: Who am I?

This essential question continued to haunt Hasegawa and his friends and, of course, was very much on Noguchi's mind. The issues Hasegawa

addressed in 1937 had never been resolved and were still anxiously examined by the two artists during their travels around Japan. In the article Hasegawa had attempted to deal with one of the most vexing questions—the difficult issue of "exoticism," the impulse to assimilate foreign influences. In defense of Japanese art, he pointed out that Sesshū only painted Chinese landscapes:

> He went to China, lent an ear to one or two Chinese painters to learn the subtleties of the art of painting, but he also observed, without being distracted, the nature and customs from which this Chinese culture was born and to which he, like his contemporaries, aspired with all his forces; he developed and refined his personality in this milieu and could found the art which was his own, but also that of his time.[22]

Hasegawa thus defended the exoticism of his peers and exhorted them to go the whole way in exploring the abstract art of the West. At the same time, he revealed in this article how much he himself was tempted by his rapidly increasing knowledge of the Japanese classics and how consoling it would be to turn back. He, like others, was seeking refuge from an increasingly poisonous atmosphere: just as his article appeared, the Law of Mobilization was announced, and the government-sponsored Artists for Greater Japan was organized. It is not surprising, then, that Hasegawa fled to the past. He wrote:

> The classics are mirrors. The mirror is only an instrument which permits me, in a concrete way, to look myself in the eye. Bashō, Kamo no Chomei, the Monk Kenko, or Rikyu, Enshu, and the creator of the dry garden at Ryoanji: they all, as do each of us, whether we like it or not, carry the traits of their father, mother and ancestors.[23]

Hasegawa's final admonition to his fellow artists was that in order to grow, they would have to face themselves in the mirror of the classics. Hasegawa's publications were of great importance in modern Japanese art history. As the critic Věra Linhartová pointed out, his principal merit lay in his having formulated the double question that determines to this day the attitude of the Japanese artist: Who am I? and Who are the others?[24] These were questions that Hasegawa was too intelligent to handle lightly and too sensitive to resolve. They remained with him all during the war, and when he met Noguchi, they provided the material for searching discussions.

This Hasegawa, then, was the man whom Noguchi sought out—a man

intimate with the very troubling questions Noguchi constantly posed for himself. Certainly Hasegawa's exceptionally gentle temperament—he was always described by friends as unusually kind, with a strong sense of fun, playing the accordion and singing European songs, at least in earlier years—made it possible for Noguchi to form a real bond, something rare for him. Hasegawa spoke English and French, another basis for a good relationship. In addition, Hasegawa himself was searching for a means out of his many quandaries. The initial journey, which took them to Kyoto, Nara, and a few less frequented sites, where the "classics" had roamed, was important in both their lives. For Noguchi it was to be a singular moment of resolution, providing him with permanent references for future work. For Hasegawa it was also crucial, which was fortunate, since it moved him to write an account that revealed Noguchi's state of mind, his particular interests, and his ambitions at that moment. Hasegawa's account is like a journal filled with direct observations, many of which pertain profoundly to Noguchi's subsequent works.

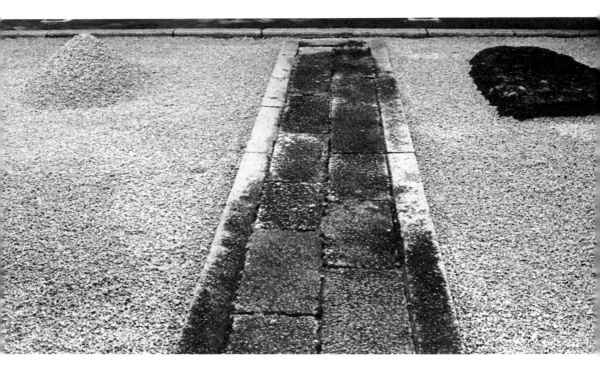

Path and dry garden in the
Daitokuji Temple compound,
Kyoto, 1989. Photo:
Denise Browne Hare

A
Crucial
Journey

FROM LETTERS, memoirs, and above all Hasegawa's accounts, it is evident that this moment in Noguchi's life was exceptionally vibrant for him. He had determined to master the vocabulary of Japanese art and compile a primer for his own use, and he brought to his task heightened energy. Everyone who remembered him during this period remarked on his vitality, his ceaseless activity, and his intense concentration. Although he was only a couple of years younger than Inokuma, Inokuma reported that, for example, when Noguchi stayed in his house for more than a month, "it was like having a boy who was constantly out of control."[1] With Hasegawa, Noguchi marshaled all his energies, impressing him also with his "capacity for deep thought."[2] Although Noguchi always said that he believed art was produced with the "nonmind," his own mind—his Western mind—was supremely active during that crucial junket to the Kansai region. Hasegawa's abbreviated report is filled with references to Noguchi's thoughts during that period and is one of the best sources for understanding his *état d'âme* in the postwar years.

The two set out in early June. Hasegawa described Noguchi's careful preparation for this critical journey. Before they left, Noguchi had reread Suzuki's *Zen and Japanese Culture* and on the train from Tokyo to Kyoto completed reading Bruno Taut's celebrated study of Japanese architecture. This book, which had been published in 1934 by the German scholar who had been the first European to assess the great value of early Japanese architecture, was enjoying a revival in postwar Japan. Noguchi's attention would be evident in later comments, particularly about Katsura villa in Kyoto, which Taut had singled out for a long, ground-breaking study. Noguchi also reread everything by his father available in English. Since the leitmotiv of most of the conversations Hasegawa recounted was to be the essential question, Who are we?, Noguchi reexamined Yone Noguchi's works in the light of the implicit conflict that he was preparing to exorcise in his own life. He owned an edition of his father's essays, *Japan and America*, published in Tokyo in 1921, in which he had underlined passages, in particular one passage with the remark "the key" penciled in the margin:

> From somewhat cynical attitudes, they even looked back longingly toward the period of spiritual insularity of many hundreds of years ago, when our ruling class observed the old homogeneous ethics to their advantage. The Western civilization, generally speaking,

intoxicated our Japanese mind like strong drink; and as a matter
of course, we often found ourselves, when we awoke from that
intoxication, sadder and inclined even to despise ourselves.

The son's mission, he obviously felt, was to restore to the Japanese their
own lost heritage and pride. He spent many hours in discussion with
Hasegawa on the subject. Hasegawa reported, for instance, that while
they were in Kyoto, Noguchi had been asked to write an article for a
general magazine. He asked Hasegawa to draft it and hastily typed a few
pages of his major points. Hasegawa brought him the draft, which con-
tained the sentence:

> I sincerely wish that Japan can avoid a repetition of the senseless
> artistic submission to the West that we experienced during the
> Meiji period.

Noguchi revised the sentence to read:

> I sincerely wish that Japan will re-examine and rediscover its own
> true self in the arts.

Noguchi remarked to Hasegawa that morning, "The situation today is
probably worse than in the Meiji period."[3] The thrust of many of their
conversations was always, from Noguchi's point of view, to juxtapose the
evils of Western materialism with the spirituality of old Japan. Hasegawa
sometimes resisted. In Nara they had what Hasegawa described as a
heated argument. He maintained that, in fact, there were many people in
Japan who were trying to understand and reevaluate their culture. Nogu-
chi retorted: "If that's the case, they should start raising their voices. If
they don't it will have terrible consequences."[4] Noguchi's radical and
somewhat reckless position in that argument, indicated in his final re-
mark—"I want them to do the same thing Fenollosa and Okakura did"—
alarmed Hasegawa. The invocation of Fenollosa, who had so fiercely
defended the Japanese past that he had turned a blind, hostile eye to
contemporary art, was too much for Hasegawa, who always tried to keep
his balance between the past and the present. Still, he sympathized with
Noguchi's state of mind: "Noguchi had a deep passion for old Japan," he
wrote, adding, "He was more pure than I."[5]
 Throughout Hasegawa's account we can see Noguchi responding with
all his forces to various aesthetic experiences, eagerly pursuing confirma-
tion of his vision. If his attitude seemed messianic in his arguments with
Hasegawa, in the actual encounters with works of art he emerged in this
warm account as the "innocent" that a few close friends recognized in

him. Hasegawa described a memorable evening shortly before they left for Kyoto. Noguchi came to his home, evidently a traditional house with a thatched roof, where Hasegawa prepared to show him his treasures. He cleared out a room, put down a red carpet, and unrolled a fine reproduction of a scroll by the great Sesshū. "I cannot begin to express in words how much he admired it," Hasegawa said.[6] He then showed Noguchi a postcard of Stone Age Japanese figurines in the Tokyo National Museum, and Noguchi rushed for his Japanese paper, ink, and brush and began drawing feverishly. As Hasegawa described it,

> That night, even after we were both dead tired, he asked me to unroll the Sesshū again. He pored over it and partway through would say, "I'm going to bed now" but then something else would catch his eye and he'd say, "wait, just a minute" and study it again. As he examined the painting he kept up a running commentary on the brushwork, the "moss spots," the composition, Sesshū's character and artistic energy, and every possible aspect.[7]

This account of Noguchi's response to Sesshū suggests how much his apprenticeship to Chi Pai Shih had conditioned his eye and how important the art of painting was for his development as a sculptor. He was well aware of the immense importance painting had for the architecture and sculpture of ancient Japan, and he was always seeking evidence of the value residing in the conjunction of various arts. In Sesshū's spirited inventions Noguchi could lose himself: a simple turn of the brush, a single stroke piercing the mist in Sesshū's sumi paintings, could establish a total landscape atmosphere, distance, and, above all, a virtual unity. Sesshū, who had begun his career painting landscapes imitating the traditional Sung manner, had completely revised his approach at the age of forty-seven, when he had the opportunity to visit China, where he saw the actual landscapes. He developed a new vocabulary of signs—angular, broadly brushed planes that could establish vast spaces with a minimum of detail. He originated many inventions to modulate space, and these inventions could be considered at once descriptive and abstract. With his training in modern abstraction, Noguchi knew how to value the intelligent reductions of this classic painter, particularly the very late works, the "broken ink" paintings, in which the master, with consummate aplomb, adapted a Chinese technique to express, in the merest drag of a dry brush or a spontaneous splash of a wet one, a Zen sentiment of infinite space, or nothingness. Something of Sesshū's cultured use of direct intuition appeared in Noguchi's own late work, as when, in a single gesture, he cleaved a stone to find its perfect expression, or when he sharpened an expressive profile, and found a perfect angle simply by making the precise bend in his material, as he did in the metal sculpture he called *Sesshū*.

In Hasegawa's account there were many allusions to key figures who engaged Noguchi's interest. Since he was intent on pursuing the Zen legacy in depth, he responded with great attention to Hasegawa's remarks about poets and calligraphers. Their conversations veered from Zen to modern art and back again. Noguchi, Hasegawa reported, liked to talk about Brancusi, Mondrian, Klee, and Miró, and he often mentioned Duchamp. When he introduced Noguchi to the great Zen poet, the monk Ryokan (1757–1831), who was also a notable calligrapher, Noguchi was exceptionally excited and told Hasegawa that Ryokan was just like Duchamp. This odd juxtaposition provides a clue to many of Noguchi's turnings in later years. His view of Duchamp went beyond the usual perception of him in those days as an amusing enfant terrible; for Noguchi, Duchamp restored that aspect of innocence that in his mind was associated with the purity of children. Suzuki described Ryokan as a pure innocent—a fool, but a wise fool who played with children; when playing hide-and-seek with them, he hid himself in a sheaf of hay for hours, being too simple to understand that the youngsters had tired of the game and left. Discovered the next morning by a farmer, Ryokan said: Hush, the children might find me.

Hasegawa's Ryokan, however, was a more complex figure—a distinguished calligrapher and a subtle poet whose "fooling" was exemplary of Zen. This hermit monk, who called himself Daigu—"the great fool"—had fulfilled the Zen ideal by going beyond the limits of all man-made, artificial restraints, as John Stevens wrote.[8] Ryokan's life represents the highest stage of Zen spirituality. Stevens singled out two characteristics: *mushin*, the "no-mind" so often discussed by Zen masters, which he characterized as "the mind that abides nowhere" or "the mind without calculation or pretense," and *mujo*, "the sense of the impermanence of all things." Stevens stressed Ryokan's indifference to conventions and his preference for the free-style *waka* rather than the strictly defined haiku. More often than any other classical poet, Ryokan dealt with the ordinary lives around him, making poems even about his own peccadilloes (there are several laughing poems in which he described his rather frequent overindulgence in sake). But there are also keen and often self-mocking expressions of his love for literature and poetry which, in the Zen spirit, must also be overcome:

> Form, color, name, design—
> even these things are of the floating world
> And should be abandoned.

and

> Who says my poems are poems?
> My poems are not poems.

> After you know my poems are not poems
> Then we can begin to discuss poetry![9]

Noguchi at certain moments in his own creative life also sought to abandon
the conventions known as form, color, design. Certainly at the end of his
life he felt he had in some way gone beyond. At the very end of his last
publication, the catalog of his museum in Long Island City, stands a sin-
gle line worthy of his Zen predecessors: "Call it sculpture when it moves
you so."

At the end of his life Noguchi saw the wisdom of disembarrassing
himself of all fixed definitions, as had Ryokan, but during his travels with
Hasegawa he was still seeking clarification of certain of his own rudimen-
tary theories, among them the importance of play in human affairs. After
Hasegawa had shown Noguchi some of Ryokan's calligraphies and read
him some of the poems, Hasegawa said Noguchi began to express a strong
interest in "fooling" as demonstrated in the works of Ryokan. What he
meant by it, Hasegawa said, was "the state of the child's purity." The
impact of Ryokan did, in fact, make itself visible just a few weeks later,
when Noguchi traveled to the pottery center of Seto to make a group of
spontaneous, often humorous works in terra-cotta—works that would
later be poorly received in the United States, where, in general, the
laughter of Zen masters was not understood.

There was a lot of talk about poetry during the excursions in and
around Kyoto. Hasegawa's reference to the painter-poets stimulated
Noguchi, who had been interested in artists who rendered poems in their
compositions ever since his study in China. He was quite familiar with
Bashō, whose renown in the West had been buttressed by Pound and the
imagists. They had thought of him as singularly modern, finding countless
familiar issues and dilemmas in Bashō's works, not only in the haiku, a
form that he perfected, but also in his prose writings and criticism. This
restless poet had often expressed his deepest inner conflicts in his writings.
In his constant, and carefully documented, wanderings throughout Japan,
he talked about his spiritual struggles in ways peculiarly apposite to the
modern sensibility:

> At one time I was weary of verse writing and wanted to give it up,
> and at another time I was determined to be a poet until I could
> establish a proud name over others. The alternatives battled in my
> mind and made my life restless.[10]

Toward the end of his life, the same sentiment appeared:

> After wandering from place to place I returned to Edo and spent
> the winter at a district called Tachibana where I am still though

it is already the second month of the new year. During this time
I tried to give up poetry and remain silent, but every time I did so,
a poetic sentiment would solicit my heart and something would
flicker in my mind. Such is the magic spell of poetry. Because of
this spell I abandoned everything and left home; almost penniless,
I have barely kept myself alive by going around begging. How
invincible is the power of poetry, to reduce me to a tattered
beggar![11]

Certain of Bashō's principles, recorded by his many pupils and at times
stated clearly in his prose writings, offered inspiring suggestions. There
are, for example, rich possibilities for the abstract artist in Bashō's concep-
tion of *yojo*, variously translated as "additional feeling," "suggesting more
than words say," "resonance," "suggestiveness," or, as one translator
called it, "surplus meaning." Bashō thought that a well-shaped juxtaposi-
tion of natural phenomena would always expand in the reader's imagina-
tion and, in that expansion, would encompass both history and time itself.
He was one of the first Japanese poets to speak directly about hidden
relationships within the few syllables of each stanza in linked poetry, using
diction that Noguchi himself used later—such words as *reverberation*,
shadow, *reflection*, and *resonance*. Bashō's doctrines were known to every
artist in Hasegawa's circle and were frequently cited. Noguchi himself
knew one of the most famous of Bashō's dicta even before the trip: "Learn
about a pine tree from a pine tree and about a bamboo plant from a
bamboo plant."

Among the masters Hasegawa discussed with Noguchi, it seems that
the great man of tea, Sen no Rikyū (1520–1591), came up most often and
in the most diverse contexts. Noguchi had long since learned about Rikyū
when he read Kakuzo Okakura's celebrated work *The Book of Tea*, first
published in 1906. He had also read Suzuki's various descriptions and
interpretations of this towering figure in Japanese political and aesthetic
history. By any standard, Rikyū can be considered a personality that
engaged interest from multiple points of view. His history has been passed
down in countless anecdotes. Noguchi liked stories, liked the "telling,"
and responded to Rikyū both as a romantic figure and as a theoretician.
Being in Kyoto, in the very places where Rikyū had studied and later
worked, was the capital experience that instigated the ceaseless excite-
ment Hasegawa so graphically described. As Hasegawa understood im-
mediately, it was essential for Noguchi to capture these experiences; he
described Noguchi as incessantly seeking the right view with his Leica, or
toting in his Japanese carrying cloth (*furoshiki*) *washi* paper, brush, and
ink stone, to be used in building up his store of impressions, a "record of
what he loved as he walked." "Noguchi's active participation as a viewer
was stressed. What Isamu worked hardest at was trying to capture the

structural beauty which is universal; part of his ideal of the unification of architecture and garden."[12]

In Suzuki's description, which Noguchi had just reread:

> Rikyu studied Zen at Daitoku-ji, one of the "Five Mountains" in Kyoto. He knew that the idea of *wabi* which he espoused in the tea rite was derived from Zen, and that without Zen training he could not capture the spirit of his art. While he was in actual life not a man of *wabi*, "insufficiency," but one endowed with material wealth, political power, and an unusual amount of artistic genius, he longed deep in his heart for a life of *wabi*.[13]

Suzuki, like all other Rikyū enthusiasts, remarked on Rikyū's singular political life and his power for a time over the ruthless and complicated dictator Toyotomi Hideyoshi, who, in the end, mastered the master by commanding him to commit suicide, which Rikyū did. Suzuki's interest lay in the definition of *sabi* or *wabi*, notions that Hasegawa stressed in his account of discussions with Noguchi. Suzuki defined them "as an active, aesthetical appreciation of poverty; when it is used as a constituent of the tea, it is the creating or remodeling of an environment in such a way as to awaken the feeling of *wabi* or *sabi*."[14] Rikyū's ideals have been variously translated. Frequently, they are given in the formula: harmony, reverence, purity, and silence.

For both Hasegawa and Noguchi, schooled in the modernism of Brancusi and Mondrian, the idea of poverty was associated with the notion of essence, or economy of means. Rikyū's vision engaged them as modern artists. Since the kind of journey to the past these two undertook required a submission to pastness, a giving of themselves—that is, their modern selves—to their living experiences with the past, these sightings of Rikyū were exceedingly rich. They found him by seeing his principles activated—shaped and visible—in his works or works inspired by him.

Like many others, Hasegawa had repeatedly pondered the real meanings of the few words always attached to the tea ceremony, above all the word *sabi*. When the two artists visited the Horyuji Temple in Nara where they found the golden hall in charred ruins after a fire, Hasegawa could hardly bear to look at it. Noguchi, however, remarked, "Isn't it more beautiful now?" This, Hasegawa thought, showed Noguchi using quite naturally the principle of *sabi*, as Rikyū had defined it: "When I explained the ideas of *wabi* and *sabi*, while still looking at the ruins—that *sabi* and *sabi-ya* (loneliness) and the word for rust, also *sabi*, are related and bound together in expressing something old, run-down, patinaed, a smile of recognition, of a commonality of belief, came across Noguchi's face."[15] (Donald Keene observed that *sabi* also relates to the word *sabireru*, which

means "to become desolate.")[16] Hasegawa reported that he told Noguchi, "Isamu, you who could see beauty in the charred remains of Horyuji are probably closer to the Japanese love of *sabi* than I am." Noguchi sat quietly for a moment, looking a bit embarrassed, and then replied: "Arp is just as Japanese as anyone in feeling." Hasegawa sadly concluded: "When I heard Noguchi talking about the purity of heart of great modern artists like Brancusi, Mondrian, Miró, Klee, and Arp, I thought that the distinctive form of spiritual expression that was once characteristic of Japan had been transferred to the West, and that Asia and Japan were gradually losing it."[17]

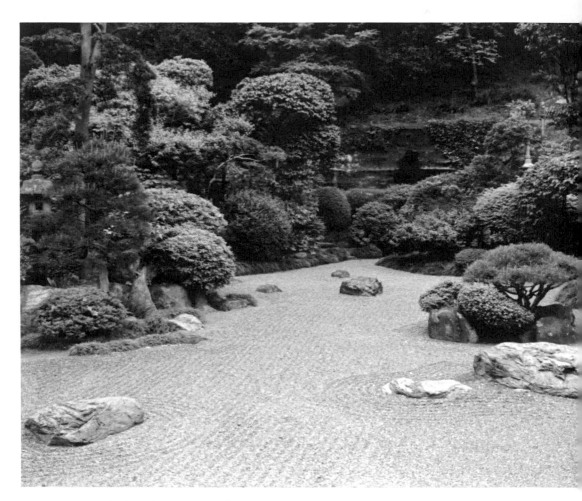

Raked garden on grounds
of Hokokuji Temple,
Kamakura, 1989. Photo:
Denise Browne Hare

The
Tradition
of the
Ever New
and
Ever Old

NOGUCHI SOUGHT two essential confirmations in his second and more thorough explorations of the famous sites in Kyoto. First, he wanted to discover in his own experience the fundamentals of an art that, like theater, presents a "hypothetic whole" or a symbolic moment of unity. Then, he sought the means of realizing his ambition to go beyond the static or isolated sculpture. In the course of observing the magnificent stroll gardens of Kyoto as he moved through them, he would fix forever these tentative ideals. Both the open forms of the stroll gardens and the closed, idealistic form of meditation gardens such as Ryoanji inspired Noguchi with a still greater ambition: to combine them in a new way. The great value of Hasegawa's account lies in the way he stressed Noguchi's sensuousness, inquisitiveness, and ability to be thrilled by the daring inventions of Rikyū or the earlier garden master Sōami.

Noguchi was not the first artist to be enchanted with the small, light structure of the conventional tea house, to study the culture in which such structures appeared (the basically brutal and flamboyant culture of the daimyo epitomized by Rikyū's patron, Hideyoshi), or to note the subtlety with which the individual personality of each tea master was introduced. But Noguchi was certainly one of the first twentieth-century artists to find an original means to adopt the principles and assimilate them to modern practice. He acquired the vocabulary of the tea house like parts of speech. Merely "seeing" the modest structures and their surroundings was not enough. The viewer needed to hold the ritual uses of the tea house in his imagination and provide the invisible links that made the experience a whole. Everything, as in theater, had to contribute to a whole, but the whole could only be formed in the process of savoring the details. Noguchi's first knowledge of the tea room came from Kakuzo Okakura's *Book of Tea*. The scholar wrote:

> The tea room is unimpressive in appearance. It is smaller than the smallest of Japanese houses, while the materials used in its construction are intended to give the suggestion of refined poverty. Yet we must remember that all this is the result of profound artistic forethought, and that the details have been worked out with care perhaps even greater than that expended on the building of the richest palaces and temples . . .[1]

Knowing the details through the ceremony, Noguchi accumulated support for his intuitive approach to sculpture. Later, he applied the

principles to the "oases" he ceaselessly dreamed and, in some cases, actually built. The imaginary form book Noguchi was compiling during this extraordinary trip was richly furnished with impressions from the radical innovation of the tea house—especially the independent tea house pioneered by Rikyū. Certainly the materials in their economy, drawn from the most ordinary Japanese environs and readily available—thatch, mud, bark, reeds, bamboo, wood, paper, and clay—appealed to him and possibly stirred his earliest memories of helping Japanese carpenters when his mother built her house. Rikyū's insistence on the minimum of ostentation in decorative detail pleased Noguchi, who had absorbed similar principles in the studio of Brancusi.

The elaborate demands of the ceremony are met creatively by the shaping hand of the tea master. He it is who carefully and subtly draws the distinction between the outside and the inside, between the worldly and the spiritual. His visitors are the actors in a staged event of which he is the firm director. They progress, stage by stage, from the din and confusion of their life in the world to the closed theater of the tea ceremony. Noguchi's vast delight in this transition, this passage fashioned so meticulously by the creators of tea houses, can be read in many of his own later works. In an unfinished manuscript now in the Noguchi archives, probably written early in 1953 after still another research trip taken with Hasegawa in the fall of 1952, he spoke of his experience of raising the *sudo*, or "gate," made of twigs hinged above and passing beneath "into another world, an inner world or world of dreams." This world is approached sometimes through stands of bamboo or cedar, through a modestly landscaped garden where the stones to be negotiated are set in patterns that slow the visitor's progression. Only gradually does he reach the covered waiting bench where guests arriving for the tea ceremony assemble. From there, he embarks on the path of stepping-stones carefully calculated to alter the gait of the participant. This path is significant largely in its intervals. They illustrate the tea master's principle of asymmetry, achieved throughout these small structures by the most inventive means, ranging from windows that seem to have been artlessly distributed on several levels—some only inches from the floor—to shelves arranged in a stepped pattern that seem a precise model of Mondrian's concept of dynamic symmetry.

There was much for Noguchi to learn in the tea houses and temples and much that struck him with particular force after his own early experiences with theater. He carefully noted the characteristics of various tokonomas he saw. The tokonoma is the recessed area reserved for the display of a vase of flowers or a hanging calligraphy. It is like nothing so much as a theater, the elements of which were already highly familiar to Noguchi. In many later works the principle, if not the actual shape, of this recessed area of shadow, which would set off a small but beautiful ar-

rangement of shapes, prevailed. The broader implications of the tokonoma
that struck Noguchi so forcefully were beautifully expressed by Junichiro
Tanizaki:

> A Japanese room might be likened to an inkwash painting, the
> paper-paneled shoji being the expanse where the ink is thinnest,
> and the alcove where it is darkest. Whenever I see the alcove of
> a tastefully built Japanese room, I marvel at our comprehension of
> the secrets of shadows, our sensitive use of shadow and light. For
> the beauty of the alcove is not the work of some clever device. An
> empty space is marked off with plain wood and plain walls, so that
> the light drawn into it forms dim shadows within emptiness. There
> is nothing more. . . . This was the genius of our ancestors, that by
> cutting off the light from this empty space they imparted to the
> world of shadows that formed there a quality of mystery and
> depth superior to any wall painting or ornament . . .[2]

Familiar as he was with the dance, and the importance of every
movement of the body, Noguchi entered the tea house well prepared. The
entrance in the most radical tea house of Rikyū is exceedingly low, scarcely
three feet high. The way the visitor approaches the step, and then lowers
himself to enter, carries implicit balletic meaning—not just the symbolic
meaning of humility and poverty, but the meaning of altered spaces. Once
inside he examines the arrangement of the tokonoma, also by inclining his
body, before he takes his place for the ceremony. Once installed on the
tatami mats, his eye can wander up to an odd papered window, or down
to a bamboo-latticed window, or he can contemplate a curious architec-
tural feature in most Momoyama tea houses: the curving shapes—often
the only true curve in the structure—of the wooden pillar called a *nakaba-
shira*. These curving beams were commonplace in country buildings, but
as the sole curving member of the tea house structure, they assumed
obscure symbolic meanings. In the predominantly rectangular character of
most traditional Japanese structures, the presence of this single curve and
its subtle modulations of the space are always notable, and Noguchi ab-
sorbed its character as a space modulator. In later works the memory of
this curving beam appears, as in the slight curves that he perfected in his
emphatically hewn stone sculptures. In his last home in Shikoku, a splen-
did traditional house, he was proud of the great curving beam that seemed
to qualify all other spaces.

Noguchi fully savored his experience in Rikyū's tea house, likening it
to a cave—he was always entranced with caves—but adding in the unpub-
lished manuscript that "there is confinement, but no sense of confine-
ment—one may, if one wishes, look out upon a desolate *wabi* garden;

there is a feeling of time's having stopped, of an infinity of winds having weathered and left a shell." He saw the old caretaker as "a character out of myth," but the myth he associated with it came out of his Western tradition: the caretaker was seen "preparing tea with the abstract courtesy extended to weary travelers by Philemon and Baucis." In his leisurely study, Noguchi's interest in the way the Japanese shape things—even ceremonies—extended to every detail. He took great interest in how the mud walls with straw, rotted with age, were supported in the tea house and later in the more elaborate villas and palaces. He was especially sensitive to the ways in which Japanese construction methods, particularly carpentry, differed from Western methods. He felt in these old buildings a sculptural impulse, and later, when Teiji Itoh asked him to write the foreword for his book, *The Roots of Japanese Architecture*, Noguchi agreed largely because Itoh thought of the oldest of Japanese structures as "sculptures."

There were certain observations in Itoh's book that corresponded to Noguchi's way of feeling structure, and certain philosophical conclusions that came oddly near to Buckminster Fuller's views. For example, Itoh wrote about the use of straight lines and curves and that, at some unknown time in the distant past, the Japanese builder began using a ruler called a "flexible rule." It was generally made from a thin strip of wood and could be of any length desired, and its thickness varied. "By applying pressure in varying degrees to the ends of this ruler the master carpenter could produce an infinity of curves." Itoh observed that rope or string was also used in what was called the "slack rope" method. The curves made by either the flexible-rule or slack-rope methods were derived from straight board in the first instance and from a string that began as a straight line in the second. The Japanese, he summarized, felt curves and straight lines to be identical.[3] The curved post of the tea house, then, was not even the product of man's pressure on his measuring instrument but the result of the practiced eye choosing the right form in nature—an idea Noguchi always held, saying that it was not so much what the sculptor *did* as the proper exercise of his selective eye in conducting his work as an artist.

Curves entered the calculations of the great tea masters even in their choice of bamboo, which often stood outside the tea house casting its fragile shadows. Bamboo was ubiquitous in the tea house. It appeared in structural members, but also in containers for flowers—another invention of Rikyū—and in utensils such as the ladle always laid face down in the cleansing basin *(tsukubai)* that stood next to the stone lantern. Bamboo, as Noguchi discovered, is one of the most diversely used plants in the world. Its shoots are still eaten as a delicacy, its wood still used for buildings and fences, its leaves cherished for their soft sounds, its jointed trunk ap-

preciated for its beauty and, in the hands of Rikyū, its utility. It was he who elevated the lowly tea scoop into a poetic sculptural element by carving a gently curved, very slender scoop out of a mere shaving of bamboo. To this object was sometimes added a poetic name to instigate a series of associations.

Rikyū knew how to capture the intonations of nature and phrase them with the precision of the poet. He took the bamboo, studied its inherent structural characteristics, and designed vessels, such as the bamboo vase, with utmost simplicity. He valued bamboo for its sound as well—the slow sighing in summer winds or the orchestral sounds of leaves slapping and branches clacking in a storm or the subdued crack as a dipper is placed on the rim of a basin. These sounds in turn were associated with the sounds of water, either as it begins slowly to bubble in the kettle, or as it trickles in an exterior brook, or even as it drips almost imperceptibly, slowly and deliberately, from freshly arranged flowers in the tokonoma.

The distribution of sound in the most aesthetic or anti-aesthetic of ceremonies is extraordinary and interested Noguchi enormously. His Kyoto visits sharpened his interest in sensory experience that expands beyond the simple physiological act of seeing. His idea of synesthesia, implicit in the teachings of his childhood in the Swedenborgian minister's home, had already grown during his first trip to Japan with his exposure to theater but took on new dimensions in the heightened moment of inquiry during the trip with Hasegawa. Hasegawa's extensive knowledge of both the poetry and painting of the Zen masters enhanced Noguchi's perceptions. When they visited Daitokuji, the huge compound founded by the fourteenth-century abbot Daito Kokushi, Hasegawa no doubt called Noguchi's attention to the famous poem the abbot had written:

If your ears see,
And eyes hear,
Not a doubt you'll cherish—
How naturally the rain drips
From the eaves!

There were degrees to which the synesthetic experience was conjured in the various temple gardens Noguchi and Hasegawa visited. In the more severe meditation gardens there was only the paradoxical or metaphorical echoing of silence. In their presence the slightest rustle in neighboring foliage or the sound of a trickle of water was either magnified or endowed with the poetic property of loneliness, or *sabishi* (the adjective from which *sabi* derives), as in the Bashō poem:

> Loneliness—
> Hanging from a nail,
> A cricket.

"According to the note of someone who was with Bashō when he wrote this poem," wrote Makoto Ueda, "he was staying at a small cottage. . . . Late one night, still lying awake, he heard the feeble chirp of a cricket kept in a cage hanging from a nail on the wall. The 'loneliness' in this haiku, then, is that expressed in the cricket's faint but serene chirp fading into the vast darkness of late autumn night."[4] The enclosed experiences of the meditation gardens sponsored the kind of free association that went beyond the mere inventory of shapes and intervals. Although the famous dry gardens always had a fixed viewing point, the imagination was meant to expand and as Bashō said, "resonate" with "surplus meaning."

The most famous of the dry gardens, Ryoanji, had first captured Noguchi's imagination during his 1931 trip when it had only recently been rediscovered and was far from the pristine condition in which he found it in 1950. Once again Noguchi was deeply moved. In the unpublished manuscript in the Noguchi archives he offered his impressions:

> The garden itself is small, about 24 by 9 meters. Perfectly flat, it is covered with a fine white gravel out of which rise 15 rocks arranged in five main clusters, groups in 5, 2, 3, 2, 3. It is the artistry of this grouping which defies imitation. . . . Framing the farther side of the garden is a fine wall in the Chinese manner, which so successfully defines the given garden space that the trees outside, which have by now grown so large, still do not diminish the scale of the garden. . . . Unlike so many temple gardens which are now somewhat spoiled by encroaching building or vegetation, Ryoan-ji is still to be fully enjoyed, thanks to its wall. In viewing this garden one has the sense of being transported into a vast void, into another dimension of reality—time ceases, and one is lost in reverie, gazing at the rocks that rise, ever in the same but different spot, out of the white mist of gravel. . . . One feels that the rocks were not just placed there, that they grow out of the earth (the major portion buried), their weight is connected with the earth—and yet perhaps for this very reason they seem to float like the peaks of mountains. Here is an immaculate universe swept clean . . .

Certain of the thoughts he articulated in this description remained with Noguchi and became the basis for his own gardens a few years later.

Unquestionably it was a seminal experience; years later, he was still in its thrall. In his autobiography he alluded to the great Zen masters Musō Kokushi and Sōami, who, he believed, had built the Ryoanji Temple garden: "Such masters are the men of Tea. They must have understood sculpture."[5]

Not only did those versatile creators understand sculpture; they were equally adept in the arts of calligraphy and painting. Musō Kokushi (1275–1351), whom Noguchi cited so often in his various writings and interviews, was an accomplished man of the brush whose writings stressed the importance of intuition for artists. He made clear that the creation of gardens was fundamentally intuitive, like the stroke of the ink-laden brush. It was not dependent on "words and phrases," he wrote. The garden was an instrument through which we could give up the attachment to words and phrases and attain the ultimate reality.[6] While Noguchi never succumbed to the lure of an ultimate reality, he certainly drew sustenance from the principles (passed down perforce in words and phrases) enunciated by the Zen garden creators—such concepts as *shin-gyo-so*, or "formal, semiformal, and informal"; and *shichi-go-san*, or the "7-5-3 ratio," used in rock gardens as the ordering principle, often traced back to the idea of the "harmony of odd numbers" discussed in the *I Ching*. The monk Kenkō, who interested Hasegawa particularly, had written that uniformity in everything is undesirable. To leave something incomplete makes it interesting, he said, and gives room for growth. All of these thoughts descending from the distant past stimulated Noguchi in his intense effort to formulate a working thesis for his own life.

In the all-embracing concept of sculpture Noguchi was developing, the role of painting was significant, for not only had he responded vividly to paintings of the Momoyama and Muromachi period, but he had sent himself to school in his early years in China. Many of the effects sought by the garden creators were drawn from their deep engagement with Chinese landscape painting, and with later Japanese modifications. Sōami was a master of the faint coloration added to sumi paintings in representing landscapes, and his garden design is often endowed with the lessons in perspective derived from his brush. Foreshortening, for instance, occurs not only in the arrangement of stones, but in the slight tapering in the wall itself in Ryoanji. The single viewing point—the veranda from which the more austere Zen gardens are to be viewed—is implicit in painting. The essential monochrome of the scrolls with which Noguchi was familiar was a matter of delicate inflections, slight variations in a general tonality that brought them closer to his sculptor's sensibility. His conception of the role of light necessarily derived from his use of tonality. His grasp of the inside-outside contrasts was quickened in certain of the Zen quarters where the subtle allocation of sliding doors or windows allowed for an

almost infinite scale of nuance in the reception of light and shadow. Sometimes the small interior gardens were eloquent teachers. A glimpse through a partly opened shoji instantly suggested a greatly enlarged vista. The sand was raked to suggest water, the stones partly submerged, and an uncanny sense of outer space was suggested within a three-dimensional frame, much as the painting masters suggested great depth with a minimum of means.

These gardens could tell a sculptor like Noguchi much. Even their materials could speak to both him and Hasegawa—artists already exposed to the greatly expanded vocabulary of materials of the modernist. The great masses of azalea bushes, sometimes swelling to volumes that look

Massed azalea bushes
in Shisendo Temple,
Kyoto, 1989. Photo:
Denise Browne Hare

stupendous, are exciting in themselves. A mountain of shrub, or a great wall of impenetrable shrub, with its occasional color accents—a red or white bloom left intact at odd intervals—has both a painterly and a sculptural dimension. Paintings, sometimes permanently visible on sliding doors in these temples, sometimes on folding screens, are consciously used as contributing elements in the whole conception of temple and garden. One can enter a dim room and sense the light emanating from a screen painting, placed deliberately to reflect the landscape of the gardens. This interaction of the painted and the shaped is indispensable to the ensemble and would later be significant to Noguchi, whose interest in reflection was always alive as he worked in his own gardens and even with single stones. The symbolism of pond and mountain or sea and mountains in the stone gardens is highly adaptable.

One of Noguchi's favorite gardens, Entsuji, is also one of the most subtle and most easily compared with painting. This garden of the early Edo period is bound by a wall of dense, severely clipped hedge. The stones are grouped in a pointedly asymmetrical formation, lying half-concealed by moss-covered earth, and they are mimed by clipped, low azalea bushes that cling to their flanks, formed to echo their mountainlike shapes. Looked down on from the veranda, the moss garden with its horizontal configuration becomes at once a foreground, as in a painting, and a landscape in itself viewed from great heights. In guidebooks this garden is singled out as an example of the Zen principle called "borrowed scenery"—an illusionary art of composition that owes much to painting. At Entsuji there are vertical lines—trees—that provide one pictorial axis and the means of suggesting spatial transition. The designer of this garden, at least as it now stands, has most brilliantly placed his trees just behind the hedge fence in all but one instance, and that one, within the hedge, produces the first in a series of foreshortened events: marks in the landscape that move in transition from strict hedge to more natural bushes and trees until finally, in the rear ground, there looms the "borrowed" view of Mount Hiei.

The raked sands in many Zen gardens held another treasure for Noguchi: the presentation of eternal shapes in the most fragile of media—sand. Even more, the shapes of the sand sculptures are clearly meant to reflect light in specific ways and to cast the environing raked sands in certain moments of calculated shadow. One of the sites in Kyoto that Hasegawa said most excited Noguchi was the complex at Ginkakuji (see page 117), where the famous raked garden includes the two sand mounds, one conical and one horizontal, the lower of which is called the Sea of Silver Sand for its heightened light when seen in moonlight. Adjacent to the sand garden, with its irregular lines intended to catch the moonlight, is a pond surrounded by mossy banks and tall trees that reflect the image of the

lovely two-storied pavilion. If Noguchi was inspired by the sculptural beauty of the conical mound, he was probably just as much elated by the pond with its carefully plotted rocks, its overhanging trees and their wavering reflection, and the contrast between real water and imagined water, of man-made illusion and nature itself, only slightly modified by the imaginative hand of the designer, who may have been Sōami.

The surpassing experience for both artists was their day-long visit to Katsura Imperial Villa. Hasegawa wrote rhapsodically about that special day:

> In front of stones, pavilions, sitting the two of us wordless on a clear day during the rainy season—we saw spread out before our eyes a most typical ballet of silence. It scorched itself into our hearts, and we left this impression to slowly work itself into our bodies . . .[7]

Both artists had been schooled in Bruno Taut's vision of Katsura, a view that had undoubtedly been conditioned by his knowledge of modern principles of functional form as taught at the Bauhaus. But in the actual experience, they found still more than formal simplicity. Well before there were published revisions of the Taut point of view, Noguchi had understood the paradoxical aspect of Katsura, a luxurious palace and compound that had been built by nobles who, for political reasons, had been forced out of the government and into the retreat of scholarship and the arts. Their artful bow to Rikyū's tradition of *sabi* was never as pure as Taut thought and had about it considerable disingenuousness or, at least, literary artifice. Their requirement of comfort was never abandoned, though the structures were infinitely simplified. Even their taste for ornament and occasional fantastic inventions in the interiors bespoke their sense of privilege and their freedom from excessive obeisance to the laws of the traditional garden. Akira Naito compared the overall style at Katsura to the early seventeenth-century scroll illustrations for *The Tale of Genji*, with all their symbolism, lavish color, curves, and mostly diagonal composition.[8] The secular foundation of this remarkable palace and its gardens enriched its forms and surely affected Noguchi, who saw himself as a modern man, free of all shibboleths. As the two artists wandered the extraordinary and carefully planned itinerary, with its mandated rests and specific viewing areas, they renewed their debate on the modern as it relates to the old. The stroll garden is no mere garden. It is also an architectural ensemble in which discovery is measured off in a peripatetic experience. It is not hard to imagine Noguchi's intense excitement at Katsura, where everything shifts, rhythms vary, and there is never a single point of view. A painter at his easel stands back and scans, but a sculptor not only stands

Stepping-stones at
Katsura Imperial Villa,
Kyoto, 1989. Photo:
Denise Browne Hare

Raked sand garden
and Silver Pavilion at
Ginkakuji Temple
complex, Kyoto,
1989. Photo: Denise
Browne Hare

back and scans: he must move around his work. A sculptor must perceive
the world from diverse points of view; this is the very nature of his process.
At Katsura, this procedure is infinitely multiplied.

As the two artists moved on the paths leading around the pond, they
felt the silence of the seventeen-acre environment, hearing only the faint
rustle of bamboo grasses or the occasional flutter of low-flying birds. Their
steps were guided by the designer, who had gone to great lengths in
measuring out the distances between stepping-stones or arranging a turn
or a rise in order to expose the viewer to yet another discovery. The
principle called hide-and-reveal is in full force here, where there is not a
step that does not at once hide a prospect and reveal another. As in good
dramas, the largest impression is saved for the climax, reinforcing the
psychological experience of the journey. From across the pond, or above
the gentle curve of a stone bridge, the three principal structures of the
shoin, justly renowned for their zigzag linking, described by Japanese as
the flight of wild geese, are sometimes glimpsed, but only fully revealed

after the meandering stroll. There are a number of celebrated stations referred to as tea houses on this course, although they served more as summerhouses in their time. It was from the verandas of these rustic buildings, obviously influenced by early tea-ceremony structures, that Hasegawa probably elucidated specific views from his extensive knowledge of classical literature. Many of the scenes in this unfolding peregrination alluded to classical poetry, but above all to the immensely important sources in *The Tale of Genji*. Such metaphorical leaps required of the true initiate made a great impression on Noguchi. In his own later works he would sometimes draw on literary passages that had remained bright in his memory.

One of the most enchanting pavilions among those scattered throughout the garden is called the Harp and Pine Pavilion (or sometimes the Pine-Lute Pavilion). Still today, although tourists are herded in bunches to the veranda, the power of the originator's imagination can be felt at work. As limited as this small building is in terms of real space—the tea-

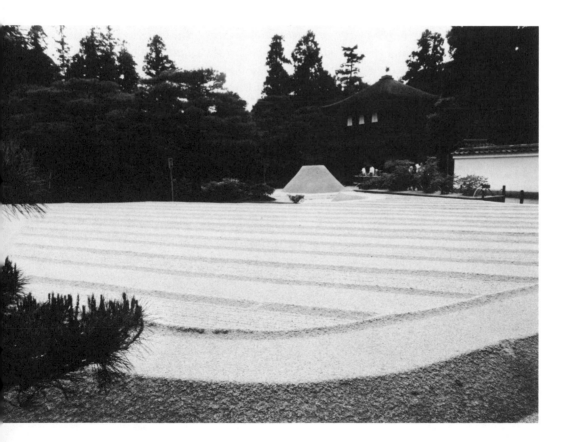

ceremony room measures only three and two-thirds tatami mats—it commands countless views. Only a prolonged stay can reveal all its possibilities.

Noguchi had not known quite what he meant by "leisure" when he started out on his Bollingen grant, but through experiences such as Katsura, he became more certain. In 1952, when he consulted with Daiki Tachibana, the abbot at Tokuzenji Temple in Daitokuji monastery, his intuition was confirmed. In his unpublished manuscript he recorded the abbot's discussion of the concept of *uruoi*, which he translated as "leisure, an extra quality." *Uruoi*, he told Noguchi, is the tea master's search. "It is the quality of shining freshness, it is Hikari (light) like the wetness of stones which have been sprinkled with water. It is modern." The kind of leisure required by the master, perhaps Kobori Enshū, who may have designed Katsura, was precisely what interested Noguchi. In addition, in the Harp and Pine Pavilion, he and Hasegawa could immediately corroborate their belief in the "modern" aspect of Katsura. There, painted on the wall of the larger chamber, they saw a famous and unique checkerboard motif for which no one has found an explanation and which many modern artists have remarked. Vestiges of this and other pavilions at Katsura would emerge in Noguchi's work, ranging from the room he would design only a few months later, dedicated to his father's memory, at Keiō University (especially in a raised platform, as in the elegant rooms of the *shoin* at Katsura) to the painstakingly designed pathways and viewing points in his late garden at Costa Mesa, California.

Of all the benefits of that charmed day at Katsura, Noguchi's summary achievement was to comprehend the importance of the reciprocity of sense impressions—from sounds and sights to poetic metaphors for complex associated feelings. This reciprocity submits to the broader (and far more difficult to define) idea of a compendium of sense impressions fused to create a sense of total space: space as *felt* rather than merely described or circumscribed. Here he would draw upon his Western background as well. The twentieth century had brought intense inquiries to bear on the psychological experience of space. Systematic descriptions of perspective from Descartes on had been enormously modified. Matisse was among the first to express the new way of perceiving space when he spoke, as early

Checkerboard wall in tokonoma at Harp and Pine Pavilion at Katsura Imperial Villa, Kyoto, 1989. Photo: Denise Browne Hare

as 1907, of "feeling" the space behind him as he worked at his easel to be as significant as was the space he was painting before him. The room in which he worked became the universe in which many invisible points were joined. The wall around the window, he wrote, does not create two worlds. Later, the philosopher Gaston Bachelard would make an inspired summary of the experienced spaces, the "lived" spaces familiar to us all, ranging from cellars and attics to seashells and caves, from forest and garden to desert and sea. Bachelard endowed familiar spaces with a metaphorical value that depended on the basic perception of the continuum. Noguchi in his early youth had had an intimation of this way of apprehending, and nothing so much as the ambulatory experience of Katsura bore it out.

For both Hasegawa and Noguchi, this journey and subsequent excursions to an extraordinary past were important in other ways as well. As artists they naturally sought assurance that despite historical or geographic differences, the human imagination everywhere can commune, surmounting differences. Despite differing conventions—for instance, the endless use of the word *aki*, or "autumn," in numerous banal haiku, or the sunsets in equally banal Western lyrics—certain experiences have been shared throughout history, Eastern or Western. Lady Nijō, a thirteenth-century Japanese writer, had speculated whether she was experiencing a "dream within a dream,"[9] as had Pedro Calderón, the dramatist of Spain's seventeenth-century Golden Age. Bashō used literary critical tools identical with those of the West, particularly the modern West, as when he warned a student that his poem displayed "too much craft." The Lake Poets of England noticed the same moving powers in their water landscapes as did the poets describing the luminous rice fields of Japan. Noguchi was in search of such central and universal emotional experiences. By the time he made the journey with Hasegawa, he was in a position to ascertain that his previously nebulous intuitions were verifiable. They would be corroborated during the following two years in visits with Hasegawa to various Zen scholars with whom Noguchi discussed specific issues. For example, he pursued the question of abstract art with the prominent Zen scholar Shinichi Hisamatsu and reported that "Professor Hisamatsu is interested in the development of an absolutely abstract non-referential art but points out that this can only be attained by the man who is developed, that its expression lies beyond even the mode of his painting. *Kanso*, or 'simplicity,' he says in his unpublished manuscript, cannot be attained through willing, but only through 'living.'" In other trips, such as an excursion to the ancient shrine at Ise, he talked with Hasegawa about purity and wrote later of the spirit at Ise of "purity of motive, purity of life, purity of structure." This, in turn, reminded him of Brancusi. He spoke of the wood at Ise planed to a mirrorlike finish in terms

of both its purity of carpentry and its "proportions of a geometry as clear and basic as to be divine. Where the mirror is the symbol of purity, each face of the wood seems cut with the absolute precision of this ideal (how much like the polished mirror surface underneath Brancusi's fish attained with equal dedication; one may speculate upon the peasant identity of his god)." At Ise he turned his thoughts again to the value of tradition, "the ever new and the ever old," and continued his inner debate concerning his own course.

Faculty room Shin
Banraisha at Keiō
University, designed
by Noguchi in 1951–
1952 as a memorial
to his father. Photo:
Denise Browne Hare

Pilgrim
and
Missionary

NOGUCHI PLUNGED back into the perplexing life of Tokyo with re-
newed vigor after his pilgrimage to the past. Contemporary Tokyo was
filled with many voices. So much had to be rebuilt, not only the rubble-
strewn city itself but the culture each artist carried within him. Ruth
Benedict marveled at the Japanese ability to "sail a new course." In *The
Chrysanthemum and the Sword* she noted that only ten days after V-J
Day, the newspaper *Yomiuri-Hochi* could write about the "Beginning of
a New Art and Culture" and say, "There must be a firm conviction in our
hearts that military defeat has nothing to do with the value of a nation's
culture."[1] In the world of the arts into which Noguchi was quickly in-
ducted, the rigid hierarchical structures had collapsed with the empire,
and there was little agreement as to how to reconstitute artistic life. Those
who had survived the war and, in a few cases, imprisonment emerged
with a strong sense of mission that took them in many different directions.
Some immediately attempted to renew their international connections and
to digest Western developments as quickly as possible. Others felt that
their only chance of survival as artists lay in recuperating what they could
from their indigenous traditions. The "old song" of which Kawabata had
written so plaintively seemed to many the only true point of departure.
Noguchi—a successful and widely known artist of the world, whose repu-
tation was frequently discussed in the Japanese press—astounded his
eager listeners with his message: look to yourselves.

In the first weeks, he was much besought and feted. He met countless
artists and writers, but also architects who, being charged with rebuilding
the city, were particularly active and open to his ideas. The artists in
Tokyo knew of Noguchi's work through reproductions, and he had brought
an extensive portfolio of photographs that he showed to a few intimates
almost immediately after his arrival. As a result, the Association of Japa-
nese Artists invited him to mount an exhibition of his photographs. Nogu-
chi, in an access of enthusiasm, offered instead to create an exhibition of
original works "close enough to touch." The invitation probably came at
the end of June, and the exhibition opened August 8 at the Mitsukoshi
Department Store.

The five weeks Noguchi took to prepare the exhibition were filled with
demonic activity. He moved into Inokuma's house, from where they both
issued forth early every morning to work at the provisional research facili-
ties sponsored by the Ministry of Trade and Industry—the Industrial Arts
Guidance Center—in Tsudayama. This experimental workshop had been

shaped by one of Japan's most distinguished designers, Isamu Kenmochi, and was intended to help Japan's industries develop "good design"—a phrase they kept in English, probably adopted from New York's Museum of Modern Art—for the outside world. Noguchi experimented there, building benches and a table, working incredibly swiftly. Not satisfied with showing only these realizations of his conviction that art must move into daily life (as he wrote in his introduction to the exhibition), he rushed to the pottery center at Seto, where he spent a little more than a week of frantic work, creating both objects and sculptures in terra-cotta. His thoughts were racing. As he would write only weeks later, reporting on his exhibition for *Arts & Architecture:*

> I used whatever materials were at hand, mainly the earth itself, or bamboo, or wood, or plaster to show the proportions of an object to be cut in stone. Indeed, when all the possibilities of modern technologies are lost, one returns once more to basic things, to basic materials, to basic thoughts.[2]

Working so intensely, Noguchi was aware of his role as a model to his young admirers. In the same article he said, "They wanted to look to me to show them how to function again after the long years of totalitarian misdirection of all energies." His own energy did, in fact, make a formidable impression and drew the arts communities in several cities—the show traveled—into protracted debates.

Much of the discussion of the show centered on the thirteen terra-cottas. Noguchi had been inspired by his visit to Kyoto. At Seto he worked at high speed putting to work his insights about Ryokan. There was a marked sense of play, both in his approach to his materials and in his motifs, which included an abstract portrait of a policeman, a terra-cotta rectangle from which the policeman's iconographic accoutrements dangle, and another of a child, mounted on two dowels, with his head suspended on strings. There was also a piece called *Kakemono*, a hanging piece in which the shapes of the slender elements are very much like one of Rikyū's tea scoops. Even more allusive was the piece he called *A Bell Tower for Hiroshima*, "in honor of all the people who died in Hiroshima and in other combat, a situation that disturbs me greatly."[3] It is only a sketch, he said, but "something fundamental." Here, Noguchi further explored the idea of light hanging elements that he had first broached in 1948 in the balsa-wood sculpture *Cronos*. The bell tower was constructed by binding with string a fragile structure of wooden dowels on which Noguchi suspended several fantasies based on the shape of the ancient *dotaku*, or bronze ceremonial bell. Rikyū's sophisticated idea of *wabi* and *sabi* stands behind this light yet very serious sculpture. The presence of Rikyū in Noguchi's

imagination during the concentrated visits in Kyoto enhanced the way he worked at Seto, especially the way he freely used great slabs of clay and fired them to produce a rough surface and striking simplicity. Several of Noguchi's large terra-cotta sculptures are daring inventions in which he made a great ellipse out of a slab and either perforated it with horizontal clay dowels or mounted it on asymmetrical feet and left flanks rough to the touch, just as they emerged from the kilns. It was Rikyū who had inspired the potters of his time to banish the high finish inherited from Korea and China in order to allow the vagaries of the fire to produce the humble-appearing, irregularly shaped bowls for the tea ceremony known as raku ware. The first of these famous bowls were specifically intended to embody Rikyū's ideal of *wabi*, "poverty," and he himself supervised their productions. Undoubtedly, most of the sculptures Noguchi showed in 1950 were imbued with a spirit of simplicity that must be attributed to his renewed interest in older traditions.

But sculpture was only a part of the exhibition, which included a miniretrospective in photographs of all his work in the past. And another important aspect of the show, which represented the other two-week period of mad immersion in work, was the model he created with his friend, the architect Yoshirō Taniguchi, for a memorial room and garden dedicated to Yone Noguchi at Keiō University, where Yone had taught for forty years. Noguchi had visited the university, apparently just after his return from Kyoto, and had been introduced by its president, Koji Shioda, to Taniguchi, who was charged with rebuilding much of the destroyed campus. Taniguchi, whose ideal was to integrate visual arts in architectural design in a search "for artistic poetry that has been lost," was so taken with Noguchi that the next day he asked him to collaborate in the design of a building that would house a faculty room and garden, the Shin Banraisha, "where all opinions are welcome." This opportunity could not be lost, and Noguchi decided instantly to complete his model before the exhibition. Taniguchi, in a brief essay in the catalog,[4] described their collaboration with great affection, beginning with a description of the two men climbing the hill to Keiō University under a blue summer sky with swirling white clouds. Noguchi had called it "the acropolis." He then said that although he was to design the building, and Noguchi was to be in charge of the garden and faculty room, the division of labor was not so strictly carried out: "Instead, we worked together in the heat of summer days, through the nights, deliberating over numerous sketches, plans and drawings." For Taniguchi it represented an exploration of "modern structural beauty," but for Noguchi, it would be a chance to put into action all his ambitions, so far never realized, to accomplish a fusion of old and new ideals. The harvest from his recent Kyoto study tour is evident in many details, such as the use of three graduated levels in space, particularly the

tatami-matted platform recalling Katsura, and the tiled wall, also reminiscent of the Katsura summerhouse. The circular fireplace with its pie-shaped sections, spaced far apart for better ventilation, alludes both in its position and its low-slung structure to traditional Japanese fireplaces. He also used flagstones, wood, and bamboo liberally, and the windows, though glazed, slide like shoji. Noguchi's own description, published in a Japanese magazine soon after the work was realized, was explicit:

> The room consists of three surfaces to allow one to sit either Japanese style or Western style. One is a pavement of stones for walking. The second somewhat elevated surface is a wooden floor intended for both walking and sitting. The third surface is tatami. In addition lattice-work seating is provided. This way half of the tatami is kept free of furniture, while at the same time the comfort of sitting down in chairs and moving around freely in the Western style is provided for.
>
> The central feature of the design is a large circular fireplace, five feet in diameter. It is raised on stones arranged like a pie so that air can circulate. When one is sitting Japanese style, it functions as a hibachi table. In preparation for earthquakes, there is a concrete chimney hood supporting the floor. And then on the lowest surface, a small library and a dining table with a tea table and several folding stools will be built.[5]

Noguchi's memorial to his father, he was careful to note in his catalog foreword to the Japanese exhibition, "is not a memorial that exalts a hero, nor is it the object of someone's reminiscence." Rather, it would be a place for students to come to breathe the air, read poetry, and feel gratified by thought and reflection: "I wanted it to be likened to the beautiful Shisendo in Kyoto and exquisite examples in China and other regions that summon the soul and make one rejoice."

In keeping with his reference to the Zen temple complex of Shisendo, where the relationship between the shadowed recess of the principal room, the veranda, and the garden is particularly delicate, and in which the "literary man's" elegant style prevails, Noguchi planned his garden—a rather narrow space—to include a panoramic view that would be seen through a hole in the major sculpture, *Mu*. This sculpture he laboriously produced full-scale in plaster at the design studio, only to find that the elevator of the department store would not accommodate it. The plaster was cut in half, transported, and glued together for the show; later it was cut in stone. This ample work was placed on the cliff facing west so that its broken circle (as he said, like a circle made by thumb and forefinger) could frame the setting sun—certainly a poetic idea he had gleaned

Mu, 1951–1952, in garden of memorial to Noguchi's father at Keiō University. Sandstone, 7½ feet high. Photo: Denise Browne Hare

on his research trip to Kyoto, as was its title, with its allusion to the Zen concept of nothingness.

During this period when, as he wrote, "everything happened at once," Noguchi was in high spirits. He felt needed. He gave advice. He told his new friends that "to be modern does not mean to copy us but to be [your]selves, to look to [your] own roots,"[6] and he showed, by example, how free an artist could be. In the exhibition there was even a work on a blackboard, a drawing of a bell that one visiting artist described: "The chalk lines seemed to be pulling into cosmic space itself. I felt that only someone who was at one with the cosmos could draw something like that, making a vast expanse of black space appear so full."[7] This, long before Sol LeWitt and other so-called conceptual artists had commandeered the common classroom blackboard for artistic expression during the 1960s.

The responses in the art press to Noguchi's tour de force exhibition were mostly rhapsodic. Many commentators could not resist waxing poetic about, as one writer signing only the name Morita put it, Noguchi's purity, as "of underground water . . . the clarity and the cleanliness of pure spring

water." Hasegawa, who seemed to publish profusely, led the defenders, insisting on Noguchi's heritage from Brancusi ("If one loses the spirit of a child, that means one has already died") and sometimes likening it to the spirit of Zen masters such as Bashō.

It was probably around the time of his exhibition that Noguchi met several men who had already emerged in postwar Japan as significant figures, among them the dynamic master of flower arrangement, Sōfū Teshigahara, already celebrated for his baroque sculptures, and the architect Kenzō Tange. They welcomed Noguchi's presence and quickly cemented their friendship by proposing collaborations. Tange and Teshigahara were both engaged in reconsidering their own premises and formulating positions for others to follow. Tange had graduated from architecture school in 1938 with an extensive knowledge of European architecture and a special admiration for Le Corbusier. After the war his interest in Japanese traditions was reawakened. He revisited the ancient shrine at Ise and also Katsura villa and carefully studied traditional Japanese sculpture. He began to talk about the value of ancient tradition for the modern architect. He would later write:

> I hold the view that there have been two strains within Japanese culture, the Jomon and the Yayoi, the vital and the esthetic, and that the cultural development has been the history of their interplay.[8]

Since Noguchi had discovered these founts long before, during his first Japanese visit in 1930, he animatedly shared in discussions with Tange, who also called Yayoi culture Apollonian, and Jōmon Dionysian, or brutal—moving, as did Noguchi himself, from Eastern to Western cultural references with ease. At the time Tange met Noguchi, he was shifting his own allegiance from Yayoi, which he considered "aristocratic," to Jōmon, and there were many discussions about the relative merits of each. It was during this time that Tange was working on his Hiroshima Peace Center and Park. When he saw Noguchi's bell-tower memorial, he consulted with Teshigahara and, at Teshigahara's urging, invited Noguchi to design the two approach bridges to the Peace Park. Noguchi wrote in his autobiography that he had visited Hiroshima "to which I was drawn, as many Americans are, by a sense of guilt."[9] It is likely that his temporary aversion to much that was associated with modern life during that moment of immersion in the past was inspired by his revulsion in the face of the monstrous atomic disaster. The bridge design he saw as a form of expiation: "The bridge with the rising sun was named *Tsukuru* ('to build') denoting life. The other bridge like a boat was *Yuku* ('to depart'). Having built, we die (through holocaust?)."[10] These bridges were Noguchi's first

fully realized projects for urban spaces and had an emotional importance for him.

Ultimately, however, they meant less to him than an important un-realized project, the true symbol of expiation, which would be the *Memorial to the Dead*. Everything converged in this intensely emotional moment when he had just begun to feel deeply engaged with Japan and was made welcome by his peers. When Tange asked him to design the monument, Noguchi must have felt in some obscure way that his suspension between two cultures would be ended. His design, which he reproduced many years later in a smaller version, and which he always knew was one of his masterworks, brought together not only personal emotional events but his recently refined views of historical continuity. When, after considerable discussion with Tange and the Hiroshima mayor, who supported Noguchi, the committee of the Hiroshima Peace Center and Park refused his design, Noguchi assumed, and Tange concurred, that it was because he was an American.[11] Once again, his situation was borne in upon him, and the tenuousness of his newfound relationship made clear. In his last decade Noguchi was still hoping to find the means to complete this significant project, perhaps in the United States, but to his sorrow, he was consistently thwarted. It remained one of his preoccupations until his death.

Even in its museum-scale version, the monument radiates powerful emotion. The vocabulary Noguchi had acquired in Japan works eloquently. The portentous, domelike arch fulfills his conception of "a mass of black granite, glowing at the base from a light beyond and below. The feet of this ominous weight descended underground in concrete . . ."[12] In the photograph of the original model, the massive pillars in the cavelike room below can be seen as the completion of the arch or dome above. Together they form a shape very familiar to Japanese eyes, a shape found in the most ancient iron sculptures, the *dotaku*, a ceremonial bell. Here lies the spirit that Tange called Jōmon—a telluric evocation of the past. Noguchi's use of these heavy cylindrical members might have derived from his first impression of *haniwa* terra-cottas, so powerfully expressive with their firm rounded shapes seemingly rooted in the earth, of which they are made. He did, in fact, remember *haniwa* in his program:

> I thought of sculpture as a concentration of energies. My symbolism derived from the prehistoric roofs of "Haniwa" like the protective abode of infancy, or even equating this with birth and death, the arch of peace with the dome of destruction.[13]

The somber granite, which seems to absorb and obliterate light, rather than diffuse it as stone usually does, rises with immense tensile strength

and is, as he thought, ominous. Burial mounds and dark mountains—part of his recent experience while traveling with Hasegawa—also seem to be condensed in this effort to speak of so much evil and yet articulate hope. Seen as a sculpture, a "concentration of energies" as he said, it takes its place among the few great twentieth-century monuments, even in its unrealized state.

From the moment he returned to Tokyo after his visit to Kyoto, Noguchi seemed bent on finding the means to work in the larger context of public spaces, energetically pursuing every possibility. He had been approached concerning the construction of the gardens for the Reader's Digest Building in Tokyo; characteristically, he rushed back to New York and was able to return to Japan shortly after with a contract. This project was to be his initiation into the ardors of garden design. He saw it as "an opportunity to learn from the world's most skilled gardeners, the common Uekiya of Japan. Through working with them in the mud, I learned the rudiments of stone placing—using the stones we could find on the site."[14] Here he also learned the lesson that he would later infuse with philosophical ambitions when he embarked on his late stone carvings: "There is to each stone a live and a dead side."

During a brief stay in New York in the winter of 1951–1952, Noguchi met the famous Japanese movie actress Yoshiko Yamaguchi and was, for the first time, sufficiently smitten to propose marriage. He was forty-eight years old, but as his friends always pointed out, exceptionally youthful and brimming with energy. Yamaguchi was an enigmatic figure. It is hard to know how much Noguchi actually knew about her past. She had been born in Manchuria of Japanese parents, and at the age of thirteen had made her debut as a singer with the Chinese name Li Xianglan. Shortly after, she became involved in a deception that convinced even Noguchi's friends, some of whom, to this day, believe that she was at least half-Chinese. Because of her ability to pass as Chinese, the Japanese army's propaganda branch quickly transformed her into a Chinese singer who could win the hearts of the reluctant Manchurians. Yamaguchi went on to join a Japanese propaganda-film studio in 1937, "where she was typecast as the Chinese heroine whose misguided hatred for the Japanese always changed to love after she met a dashing Japanese soldier, sailor or pioneer,"[15] as Ian Buruma wrote. After the war, Buruma said, she returned to Japan (but only after being threatened with execution by the betrayed Chinese) and assumed her Japanese identity, although Buruma hinted that it was not entirely comfortable even in Japan for a former Japanese "patriot," and she quickly set off for Hollywood. By the time Noguchi met her, Yamaguchi, known as Shirley in the United States, had already appeared in a film by King Vidor and starred in a Broadway musical and had been squired on both coasts by Yul

Brynner. Some of Noguchi's friends believed that what drew him to the actress was the foreignness they shared. Yamaguchi felt a stranger in Japan, and always deplored her own face, which, she thought, "seemed to contain something universal, separate from the Japanese people. I am sure this accounts for the doubts about my nationality."[16] While in the beginning this universality may have produced the bond between them, it seems likely that Noguchi accepted Shirley as a full-fledged Japanese, which he himself was not. He seemed to redouble his efforts to be fully assimilated in his father's country after his elaborate marriage ceremony in full Japanese dress—a nationally broadcast event in Japan that brought the happy couple a huge glow of celebrity. Noguchi may have felt he had found his place. Or, lacking that, he may have felt he could forcibly make a place for himself once he was married to a Japanese celebrity.

He set out immediately to find a place in which to settle down with his bride. His determination to live the beauty he had discovered in old Japan was apparent in the direction he looked. After a brief stay in Nakano, he "remembered the lovely small valley of rice fields between hills and a cluster of old thatched-roof houses near Kita Kamakura"[17] and paid a visit to the famous old potter Rosanjin Kitaoji, a man of Noguchi's father's generation, who lived there. Rosanjin, who had early called himself *doppo*, "lone wolf," was a source of endless anecdotes in Japan, many of them accenting his irascible and sometimes downright malicious nature and his violent temper. He received Noguchi, however, with exceptional kindness and offered him a two-hundred-year-old farmhouse he had had transported to a hill facing his own home. Here again, there may have been motives based on a sensed kinship: Rosanjin had been the child of a priest who, when he discovered the child was not really his own, had committed suicide. Rosanjin's mother had then abandoned him to poor foster parents, and his childhood had been memorably miserable. Rosanjin's houses were "approached from the east, through a narrow and deep defile in a hillside that had been carved out in the time of . . . the first Kamakura Shogun, during the twelfth century. Within the lovely valley nothing was to be seen but the three thatch-roofed farmhouses that Rosanjin had brought there, the rice paddies with a narrow path running across them, a thicket of bamboo, and a gigantic cherry tree."[18] Noguchi installed himself in the beautiful valley and, "filled with joy and energy,"[19] proceeded with one of his extensive alterations of his immediate environment—he was to do it many times in later years—by carving out of the hill behind his house a studio with a fireplace, improvised earthen furniture, and other unique features. Nearly forty years later Noguchi's friend Inokuma still remembered the remarkable atmosphere Noguchi created for himself:

Noguchi's studio in
Kamakura, 1952–1957.
Photo: Ken Domon

One side of the house was a landscape of the mountain right there.
You could not separate the house from the mountain. He dug
holes, made stairs and worked on the floor. All those activities
seemed like they were part of his artwork. He made a hole to
make a fireplace. He put a light bulb in a colander to make a
lantern. Instead of hanging the lantern, he stuck it sideways to the
vertical surface of the earth wall. There was always some artistic
element with everything he did.[20]

Photographs of the period show how meticulously he created this Japa-
nese atmosphere; how faithful he was to the oldest mores; how intensely
he craved knowledge of the entire experience literally from the ground up.
He would write:

Here in the hillside at the edge of the rice fields have been spent
the days of this year—a segment of Japan. The changing seasons
have now made one round—each day a wonder of discovery to
me, so intimate is nature here, not only to the eye: it invades one's
being 'til the memory of all its various sights and noises are like a
symphony to be heard at all times.[21]

Interior of Noguchi's
studio at Kamakura,
1952–1957, showing
The Policeman, 1950.
Terra-cotta, 14¼ × 8½
× 5⅛ inches. Photo:
Ken Domon

The retreat in Kamakura was to be Noguchi's first reinvention of
an almost vanished Japan, and he lived it fully, at least for the first months.
He donned traditional clothes and insisted that his wife do the same. Years
later Yamaguchi told Noguchi's old friend, the designer Yusaku
Kamekura, that Noguchi demanded that she wear uncomfortable straw
sandals. When she complained, he said that uncomfortable or not, he
wanted her to wear them because they were beautiful.²² Nothing was to
break his enchantment with the spell of the old ways during this period in
his life; in this he was perhaps unconsciously imitating his own father, who
had also retreated to Kamakura. Yone Noguchi had related that when a
friend visited him there in Western clothes, he insisted that he change into
a *yukata* (summer cotton kimono) because "I confess that the poetical
balance of my mind has grown to be easily ruined by a single harsh note
of the too real West."²³ The sculptor son was also in a negative mood
toward the West during the idyllic months in Kamakura. It peered through
in a letter to Jeanne Reynal written from Kamakura on November 2, 1952,
in which he called her recent letter "a cry from the hardness that one
generally associates with America here." He went on to describe the
sweetness of his new life:

> Just now we are sitting in our little garden where we have spread
> mats and cushions to enjoy the autumn sun. Yoshiko san is peeling

a persimmon which grow plentifully in the garden. Before us the rice has now been cut and stacked high on poles. Yoshiko san is planning to make a Chinese movie in Hong Kong during January . . . we expect to be there perhaps a year. . . . I am anxious to get your reaction to my new work—but it's not just work, but work as a reflection of living . . .[24]

Everything about his life in Kamakura suggests not only that Noguchi was eager to make his place in an almost imaginary Japan, but that his conviction that the earth itself held the answers to his problems guided his every move. Even the fact that he went to Kamakura, the site of an ancient, highly civilized culture, was significant. Kamakura had been the source of Zen influence in Japan. In the early medieval period Zen priests had been extremely active, bringing manuscripts and paintings from China and establishing aesthetic principles that would be permanently functional in Japanese cultural life. Situated by the sea and surrounded by splendid mountains, Kamakura had long been a place of retreat for Japanese intellectuals who could find there, only a short distance from Tokyo, the unchanged landscapes the ancient poets knew. There were numerous temples and gardens, among them Hokokuji, founded in 1334 by a poet monk and used as a retreat by modern artists and writers, including Kawabata, who, for a time, lived in the temple compound and named it

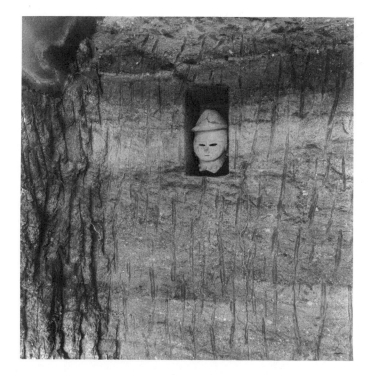

Interior wall in Noguchi's Kamakura studio showing *haniwa* head in niche. Photo: Ken Domon

Yama-no Oto, "The Sound of Mountains." Noguchi's own father had
stayed there. It is not hard to imagine Noguchi's initial delight in ap-
proaching this temple through a narrow, steep passage of natural stone
steps flanked by feathery maples, their small leaves fluttering; emerging
at the top step to walk slowly past the temple; and seeing, with astounding
suddenness, a vision of a great bamboo forest, its bluish haze produced by
closely clustered, towering bamboos. In the glimmering depths occasional
carefully placed rocks, or stone lanterns, could barely be glimpsed. Sounds
of leaves mingled with the sound of water trickling into a single bamboo
trough. Noguchi's thirst for nature could not have been better assuaged.

Noguchi's new household was frequented by his youngest half
brother, Michio, whom Noguchi seemed eager to include as one more
element in his longed-for assimilation into his father's Japan. Gathering
about him both the accoutrements of a Japanese life and his own family
was important to Noguchi during this unique moment. His relationship
with his father's family (his father had eight children after Noguchi) was
tenuous, but this youngest son was an eager disciple and frequently helped
Noguchi with language problems. Noguchi spoke Japanese haltingly,
Michio said, "like a child," and his brother would translate "from Japa-
nese to Japanese." Michio's story casts a faint light on Noguchi's compli-
cated relationship with his father:

> After the war, when I was around fifteen or sixteen, my father
> called me to his house in the countryside on the Kinu River. My
> father, who was around seventy, and to me was a remote figure,
> asked me to walk with him. That was most unusual. I followed
> him, and we walked to a big temple. He said nothing for a long
> time. We found some old wood and we sat down. "Michio," he
> said, "you have a brother in the United States. If he ever comes
> to Japan you must be good to him."[25]

"I was greatly shocked," Michio recounted, "I had been raised as a
military boy." When, in 1950, Michio read about his brother's arrival, he
sought him out, as he said, to carry out his promise to his father. Noguchi
may have seen in this nineteen-year-old survivor of the war the raw clay
that could be shaped in the new image he conceived for Japan at this
missionary moment in his life.

Once the house and studio were organized, Noguchi set to work at his
usual accelerated pace, fashioning hundreds of clay pieces that were fired
in Rosanjin's steep kiln, and a few in the kiln of another master, Kaneshige
Toyo, who worked in the south with Bizen earth. After some months,
Noguchi was offered one of the first exhibitions at the newly opened
Museum of Modern Art in Kamakura. This was the first museum in Japan

to initiate a program modeled on the West, specifically on New York's Museum of Modern Art. It had been conceived by the artists and intellectuals who lived in the area, whose plan was swiftly carried out. By the time Noguchi settled in Kamakura it had already opened its doors but was still attempting to formulate its goals. His presence and the fact that he had already exhibited in New York's Museum of Modern Art stimulated the local community. The importance of this museum cannot be stressed too much. It was founded during a time, as the current curator remarked, when "Japan was passing through a difficult period immediately after its defeat in the Second World War, when the meaning of the nation's modernization was being sharply questioned."[26] Its program, as summarized in a 1987 guide to the museum, reflected the dilemma. On the one hand, it intended to

> introduce the modern art (including contemporary art) of Japan and the world to the public in order to promote mutual understanding among mankind, and at the same time, to define the place of contemporary Japanese art within the context of international art.

On the other hand it would

> introduce historic examples of the art of Japan and the world in as systematic a manner as possible, seeking out man's rich legacy from a contemporary viewpoint and establishing a solid place for this tradition within the hearts and lives of contemporary viewers.

The modern tradition had been slow to take root in sculpture in Japan and had lingered, as Noguchi had noticed with distaste during his 1931 visit, in a Rodinesque backwater. There were very few sculptors adequate to the new challenges posed after the Second World War. It is not difficult to imagine with what alacrity the new generation seized upon the work of Noguchi and why the Kamakura exhibition was to be so influential in the evolution of modern Japanese sculpture. Noguchi brought with him an impressive knowledge of the entire history of sculpture everywhere in the world and, above all, of the vanguard sculpture in the United States. He was already well known both in Europe and the United States for his innovative experiments, and his fame had preceded him in the Japanese press, eager to reestablish cultural connections with the West.

Now he astonished his young admirers, who themselves were bent on joining the world, by retreating to the countryside and affirming loudly the cultural values of a past they had learned to view with great suspicion. Moreover, he was using traditional materials and techniques. But, as is

still evident today, Noguchi's fund of references was sufficiently large to permit him the greatest freedoms. He had pulled from his earthen materials a kind of modern art that no one in Japan had imagined possible. In fact, no one among the many potters' groups, including those in Kyoto that envisioned a renewal of pottery in the modern spirit, had yet attempted to make sculpture—individual pieces with no other raison d'être than to express the artist's vision—in humble clay. It was only after Noguchi's example that a few hardy spirits entered the arena. "It was one personality that exercised a powerful influence on the birth of artistic pottery with his works in terra-cotta," noted the critic Yoshiaki Inui, singling out Noguchi for that special honor.[27]

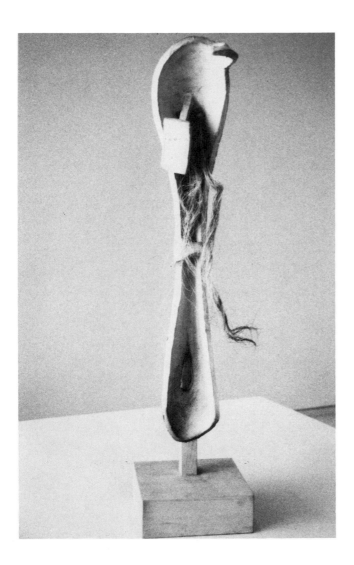

Ghost, 1952. Ceramic, rope, and wood, approximately 22 inches high. Collection Hiroshi Teshigahara, Tokyo. Photo: Denise Browne Hare

What the Japanese artists saw in the Kamakura museum exhibition (September 23 to October 19, 1952) was a harvest of images achieved with techniques Noguchi had explored with an avidity that impressed even the old master Rosanjin, whose technical expertise was freely given. Noguchi was quite literally playing with fire, discovering the great range the high-intensity kiln of Rosanjin would make possible. "The earth itself is the agent which guides me," he wrote in the catalog. "And the fire of the kiln burns away my petty pride." He used countless clays that Rosanjin liberally stored in huge wooden bins in earthen tunnels between his house and the kilns. He experimented with simple glazes, some of them in hallowed traditions such as Oribe. He combined raw slabs of clay in ways that had never been tried, allowing for accidents in firing with almost reckless confidence. He referred to Japanese sources, as Rosanjin understood, in order to "create his own distinctive forms"[28] and not to imitate an obsolete past. Those references were often extremely witty. For instance, in one of the pieces he exhibited, *Ghost*, he tied an unglazed, looping vertical form to a light wooden stand with a rope. From its curled, shell-like arabesque trails another rope, untwined, like the beard of an ancient sage. Japanese viewers—great lovers of ghost stories—could easily make the appropriate associations.

The piece *Sunflower*, with its conical tapered stand of wood, looked Oriental, but to the Japanese it looked Western. It turned out that Takiguchi was right. Hasegawa had already noticed that in Japan, where Noguchi had been welcomed with such unbounded enthusiasm, he was engulfed only months later "in a sea of misunderstanding."[29] In the United States it would be the same. When, in 1954, Noguchi exhibited a number of pieces from the Kamakura exhibition at the Stable Gallery in New York, they were generally denigrated, seen as artless and unduly playful, and even as coy. His success as a sculptor in Japan was limited to a few exceptionally discerning artists and architects. As Inokuma pointed out, his influence was largely felt in the area of design, not in pure sculpture. "Isamu's sculpture was far too abstract for most Japanese at that time—they were not ready for his sculptures yet."[30]

Gardens for UNESCO,
1956–1958, Paris. Photo:
Isamu Noguchi

The
Way Back:
Paris and
New York

WHEN NOGUCHI immured himself in his Kamakura studio there were intense bouts of work. The improvisational character of the clay pieces, however, allowed him pauses during which, as Tange recalled, he would dart into Tokyo to participate in contentious discussions of Japan's aesthetic destiny.[1] His first garden project, the Reader's Digest Building in Tokyo, in which he had worked "in the mud" with professional gardeners, had filled him with ambition. During the Kamakura interlude, he had devoted himself to the exploration of the ephemeral, the light, the improvisatory, and had embarked on his long experiment with the lightest of light-bearing fixtures: the lantern-style lamps that he called Akari after the Japanese word for "light." In them he had made it his obligation to respect the flexible nature of paper and its myriad reflective capacities. These works had sometimes assumed the character of sculpture, particularly in the hanging versions in which all the possible forms Noguchi had found were simplified to suit the function of illumination. Already implicit in the Akari is the need for a totally controlled environment. (No exhibition of these lamps lined up side by side can give any idea of their originality. They are best seen in the home, where they punctuate domestic, shadowed spaces, ideally in Noguchi's own environment.)

After a time, Noguchi's life with lightness and ephemera began to seem less than complete. He was, or had been, an international artist and thirsted for greater challenges. As much as he longed to be totally integrated into Japanese life, he always secretly acknowledged his dilemma. He had a natural instinct to move out, anywhere into the world, as Baudelaire said, but out. Soon an impressive opportunity offered itself in the form of an invitation from architect Marcel Breuer to make a small garden—a roughly triangular area at one end of the main Secretariat building for UNESCO in Paris. Strengthened by an imperious inner demand that he put his long meditation on the public role of sculpture to the test, Noguchi took a quick look at the site and with one sidelong glance noticed another large area that he instantly coveted. He boldly proposed that he be given both spaces to work with, and he would create a way of connecting the two UNESCO office buildings and the two spaces he had already colonized in his mind. He was asked to make a model and shortly after, surprisingly, given the signal to proceed. Even in his own account, the story of the UNESCO project was the story of Noguchi storming ahead with amazing aplomb, with daily extravagant expansions of his ambitions. He rightly called it what it was: a learning experience. "Only the doing

142

can teach. A job is a lesson, not to be learned otherwise, a great job a great lesson."[2] There were to be many obstacles, and much resistance to his energetic will, as well as many exasperated collaborators. But he charged ahead with his project, which would allow him to use every chapter in the mental primer he had compiled during the three previous years.

He managed to seize two discrete areas: one, the original patio of the delegates; the other, a large sunken area on the side, which began to take form in his mind as a garden. At first he was authorized to design a walk as he had proposed, which he conceived of as a path connecting the two buildings "like a bridge or garden viewing verandah, or like the Hanami-chi or flower path of the Japanese theater."[3] There would also be a cascade of water and a flowing pond in the sunken area. But, as his brother Michio said, "You know Isamu, his habit is always escalation."[4] Very shortly after he began pacing out the site in Paris, Noguchi began to elaborate his model so that the area below could be transformed into a major sculptural effort "through the introduction of rocks and so forth."[5] The "rocks and so forth" were to grow eventually into a full-blown effort to adapt the ancient principles of the Kyoto gardens to the modern situation of Paris—not an easy task and not completely realized, but a great lesson, as Noguchi suggested, for the future.

Strolling through the UNESCO gardens today—for they were specifically intended to be stroll gardens in which the details would reveal themselves only as the spectator navigates the somewhat complicated spaces—one can feel the two valences pulling away from each other in

Gardens for UNESCO, 1956–1958, Paris. Photo: Isamu Noguchi

Noguchi. On the upper patio the sharp stone benches and almost modern-istic design give a rather stiff feeling to the space and certainly do not suggest the graciousness of comparable Japanese spaces. On the other hand, the garden, with its rounded grassy mounds and its stones now shaded with moss, does. Looking down on the sunken Japanese-style garden, one sees a palisade of stone in which large and miniature stones do, indeed, take on the metaphoric role of mountains. Breaks in mood are now softened by years of growth of birches, cherry trees, and pines, but still there is something of anachronism, willful traditionalism that impedes the total success.

The fact is that the legacy of cosmopolitanism that had first charged Noguchi's spirit in his early days in Paris was still active and was certainly kept alive by his new associations there. At the time—1956 to 1958—the first generation of postwar Japanese artists had recently arrived in Paris to test their powers of assimilation. They were eagerly made room, and several of them, still in their twenties, easily entered the life of the newly energized Parisian avant-garde centering on the idea of *l'informel*, the French version of abstract expressionism. In all of Paris there were only some two hundred Japanese and among them only a couple dozen artists, who all knew each other and who were all, in one way or another, attempting to confront the problem of identity. Most of them had been in high school during the war and were in full reaction against the militaristic tradition. And yet, the issue of their foreignness was always with them. Still in his Japanese mood, Noguchi's clear intention to turn the UNESCO project into a living model of how the ancient and modern and even the Eastern and Western might coexist gave him a special place in this expatri-ate community. Young artists such as Hisao Domoto and his artist wife, Mami, watched attentively as Noguchi stormed on, miraculously, as ev-eryone had to admit, in order to bring his Japanese experience to bear on the great metropolis.

Noguchi told the complicated story with characteristic understate-ment. There was no budget for rocks, or for any trees either, forcing Noguchi into frantic efforts to realize his vision. He "rushed off" to Japan, where, in Tokyo, he managed to interest the Japanese government. He then took himself to Kyoto for help. There he was to have a cardinal experience—one that had many consequences in his later life—in his encounter with Shigemori Mirei, whom he described as "a man of tea (reflective taste)" and knowledge, having produced twenty volumes on gardens, and a master garden designer. It was Shigemori who took Nogu-chi to the island of Shikoku, where he was to make his first attempt to extract the precise stones he needed for his plan from a fast-rushing brook in a ravine in the mountains. This arduous task, requiring both specialized knowledge and instinctive judgment, represented for Noguchi his true

initiation and set the course for many subsequent encounters with rock
and water as the source of inspiration. He reported in his autobiography:

> It is remarkable how smoothly the whole operation took place.
> Collecting the rocks; setting them up in a trial area in Tokushima;
> getting the water basins (chozubachi) and stepping-stones in
> Kyoto; quarrying the Fountain Stone in Okayama; quarrying and
> carving on Shodo shima (island) the stone bridge, the various stone
> lanterns, and stepping-stones.[6]

All this was done before any money had been collected—a daring habit he
kept all his life that sometimes brought him to grief. Still, thanks to his
Japanese friends, eager to have their presence strongly represented in
Paris, eighty-eight tons of stone were duly shipped to France. This hauling
and shifting of huge masses of stones halfway across the world would
continue throughout the rest of Noguchi's life as he managed, with charm,

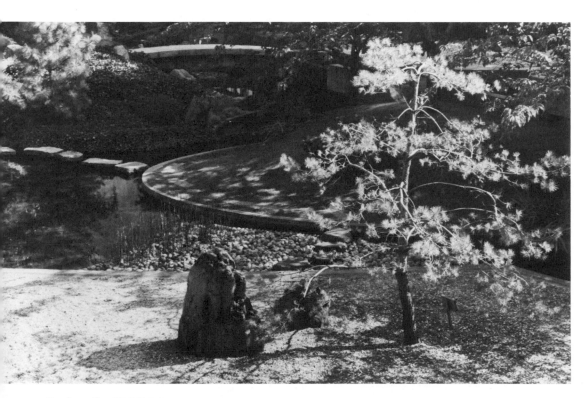

Gardens for UNESCO,
1956–1958, Paris. Photo:
Isamu Noguchi

cunning, and passion, to persuade donors and architects of the absolute
necessity of the right stone for the right purpose.

There were endless difficulties once he returned to Paris, some of
them quite comical, others more serious, having to do with the perpetual
wrangling with bureaucracy. One problem was with the workers. Noguchi
was given a team of Argentine laborers who spoke neither French nor
Japanese and were certainly not familiar with the techniques of Japanese
gardening. Friends remember his black mood as he struggled with his
problem (which was certainly compounded by his own relative lack of
experience). He asked for two gardeners from Japan, who arrived that
spring and began to put things in order. In the fall, Touemon Sanō, a
sixteenth-generation garden designer from Kyoto, arrived with seventy
cherry tree saplings and varieties of dwarf bamboo, camellia, and decora-
tive maples. The encounter between the orthodox traditionalist Sanō and
the somewhat groping cosmopolitan sculptor Noguchi was dramatic.
Nearly forty years later, Sanō still remembered the almost daily conflicts
that arose as they worked side by side. From Sanō's point of view, Noguchi
never properly understood the function of Japanese garden theory and
was always controverting its principles. Noguchi, he explained, had spent
too much time in Tokyo with its extravagant and showy gardens.[7] Sanō's
own taste was for the gardens attributed to the seventeenth-century mas-
ter Kobori Enshū. There both the dry stone garden and the planted garden
work in subtle harmony—stone, gravel, wall-like hedge—and the art of
the gardener, particularly in working with the principle of hide-and-
reveal, is brought to perfection.

When Sanō recounts his troubled working relationship with Noguchi,
his temper flares to this day. It is easy to imagine, when he speaks, how
they argued for a week about the placement of a single rock or shrub, how
the two cultures clashed. For Sanō, as it becomes clear in his exposition,
Noguchi represented the "scent of power" and the "display of wealth" he
associates with Tokyo. Kyoto, he explains, was poor in the old days, full of
"sadness, loneliness and deprivation." There, in the Edo period, the tax on
houses was based on width of frontage, so people built narrow and deep.
A town house, for instance, had (and in many cases still has to this day)
a front section for business, a middle section for living, and a back for
privacy. In between these sections were small gardens and often a long,
narrow alley to a tea house in the back. This spirit was obviously in conflict
with the architecture of the UNESCO building, which was concrete, and,
as far as Sanō was concerned, could never be the site of a Japanese garden.
Moreover, he says, what Noguchi wanted to do was to make the leftover
spaces green—too green for Sanō's taste because "the Japanese spirit is
not to show your hand. Hide it and make it stronger." Noguchi always
wanted to make everything prominent. Nothing could be disguised or

hidden (and especially not his sculptures): "Noguchi-san wanted to show his hand." As Sanō suspected, this was, of course, the Western side of Noguchi's temperament. Moreover, Sanō could not understand Noguchi's Western working methods. Noguchi had spent time in Tokyo in Tange's studio drawing up meticulous plans. Sanō found this incomprehensible: "Japanese gardens are not built that way. The place of each rock must be felt out—a plan on paper never works."

Sanō likes to recall the most passionate moment during their working relationship. In his Japanese way Sanō had placed shrubs that half hid the sculptures. One day Noguchi came running, shouting: "What are you *doing* to my sculptures?" and violently kicked the shrubs, displaying the quick temper Inokuma remembered during the days in the craft workshop. Sanō and Noguchi also fought for hours over the issue of the stone lanterns, which Sanō wanted to place traditionally in a half light, filtered by leaves. Noguchi won the battle, but not before he had once again kicked out at the shrubs. They struggled as well over such details as the use of water. According to the rules, water must appear to flow, but in the UNESCO garden it appeared motionless. "Isamu makes motionless things that appear to move and vice versa. The things in Japanese gardens that should be motionless Isamu reverses." Sanō was particularly incensed by the dominant sculpture, the so-called source stone from which water cascades. Noguchi had chiseled the character for "peace," *wah*, in reverse. For Sanō, the UNESCO garden "was not what you would call a good experience," he said, but he learned a lot about what was different in their cultures. So, apparently, did Noguchi, for he never again attempted to embrace orthodoxy even partially in his large projects.

For all the problems, the UNESCO project was important for Noguchi, not only in his acquisition of skills but in the opportunity to refine his aesthetic principles. He was still living a half-Japanese, half-Western life, even in Paris. He frequently repaired to Domoto's studio to eat Japanese food, talk about "home," and debate their equivocal situation. Being removed both from Tokyo and New York lent a certain objectivity to Noguchi's musings. His association with the younger artists, who were at once exhilarated at being present in the formation of an avant-garde movement and intensely anxious about their own traditions, was useful to him. The same questions that had once haunted him now haunted this new generation, but under different circumstances, to which he was sensitive. Domoto, for instance, was twenty-seven when he took up his ten-year residence in Paris in 1955. He had had a traditional formation artistically and was absolutely stunned, as Noguchi had once been, by the innovations in Paris. Yet, as nearly all the Japanese who had fled the disturbing postwar atmosphere, he was not entirely willing to relinquish his ties with the East. Instead he sought, like Noguchi, to find a kind of fusion or,

rather, to invent one. In this he was cheered on by other Japanese intellectuals who arrived in Paris either to study or to catch up with postwar currents. The dialogue between East and West that had preoccupied the French for centuries was taken up again. Both French and Japanese critics sought to enlarge the terms of their discourse during those years of intense intellectual activity. A figure such as Michel Tapié, who, in the late 1950s, would take his idea of *l'art autre* to New York and, along with it, the Japanese artists he championed, was already actively engaged in finding supranational grounds for discussion. For the French, the Japanese in their midst proved the universalist implications of their new "informal" movement. For the Japanese, the proof was more difficult. The sharp rents in the fabric of their cultural history, from the Meiji period on, had undermined their confidence and forced upon them difficult choices. They worked in Paris, but they worried about Japan.

When, for instance, Toshimitsu Imai had his first exhibition at the Galerie Stadler in 1957, Shuzo Takiguchi (who four years before had written extensively about Noguchi) wrote in the catalog foreword that Imai's art moved toward the sources, the primitive elements of Japanese art. He invoked the "extra-plastic innerness of prehistoric Jomon pottery" to describe Imai's painterly adaptations of the Parisian "informal" currents.[8] The following year Shuji Takashina, then a young art critic, wrote of Domoto that even though he utilized the Western procedures of oil painting, he never entirely renounced the techniques and materials of traditional Japanese painting, and in the play of voids, planes, and transparencies was "profoundly Japanese."[9] These and other critiques of the period indicate the fear of loss of identity that stalked the Parisian colony of Japanese artists.

Noguchi, whose identity was beclouded anyway by his dual origin, had more to lose. There was always his American identity, and his identity as a world citizen, that he could lose if he went too far in his Japanese revival. Even as he worked in Paris, he thought about other projects. His personal life was a source of grief, since his marriage to Yamaguchi had ended in divorce in 1956. His commitment to the garden as a total sculpture was not completely satisfying, so he found the occasion to plan works with individual sculptures in mind. "My solace has always been sculpture."[10] On his trips to Japan he stopped off in Greece, where he found a worker who would rough out individual pieces in Pentelic marble, which he would ship to New York for later working. He had also gone to Gifu, where his Akari were manufactured, and found a worker who could help him in a series of iron-cast sculptures. These were also shipped to New York, and Noguchi followed soon after, in 1959. "After all," he wrote, "New York was my reality, the surroundings familiar, the materials available common to my living."[11]

Noguchi, *oiseau de passage,* found New York again, but felt like a stranger. The art world had long since begun its feverish cycle of "isms"— something his aristocratic instincts always found distasteful—and was turning away from anything that suggested a flow of traditional values. The artists of Noguchi's generation were well established but nervous in the face of new enthusiasms, which included the burgeoning pop art movement. It took a certain bravado, then, for him to stage his exhibition at the Stable Gallery in 1959, which he thought of as an homage to Brancusi. The Brancusi inflection resided mostly in his choice of stones (although there was one work that insisted on comparison with Brancusi's *Endless Column*—a motif to which Noguchi would return later with greater success). In almost all the works exhibited there were visible signs of his Japanese sojourn, an aesthetic that was taking permanent shape. Noguchi, like other masters of the twentieth century, particularly the founders of modern art, concentrated on finding principles that could give a certain constancy to their works no matter how diverse and inventive they were. The principles that shone forth in this exceptional exhibition were made firm in the course of his yielding to what he had absorbed in the East. There were three different reflections of his recent experiences, the first of which was the way he contrived to give an Eastern cant to the Greek marbles by the simple expedient of mounting them on stained wood. Smooth stanchions reminiscent of Japanese architectural members supported several white marbles. Others were displayed at ground level, insisting that the floor, so important in the Japanese perception of space, be granted its role in shaping the ambient spaces of sculpture. One of many variations on the skewed, rectangular stone mass, for instance, sat astride a simple wooden crossbar on the floor. Tilting into a virtual square, this anamorphic distortion of a fundamental geometric shape, with its circular aperture, drew upon Noguchi's encounters with the fundamentals of Japanese design, as well as his appreciation for the principled simplicity of Brancusi. Another of the Greek marbles, carved meticulously to suggest its inner light—Noguchi cultivated the rough faults in his marble to con-trast with the sensuously curving members—was titled *Woman with Child,* probably after the fact. The central girdling rectangle here brings in a host of Japanese associations, from its obi shape to the myriad forms of tying, bundling together.

The second group of works fetched back from Noguchi's Japanese experience were executed in rough granite and show him experimenting with the Zen concept of rough and smooth. In these sculptures he con-trasted the sharp cuts of machine tools with rough edges in order to reveal the many propensities of stone, which can at once throw light from its surfaces and eclipse it in its depths. Sharp cuts were relatively familiar in Japanese funerary sculpture—shocks to the eye like the sharp clap of the

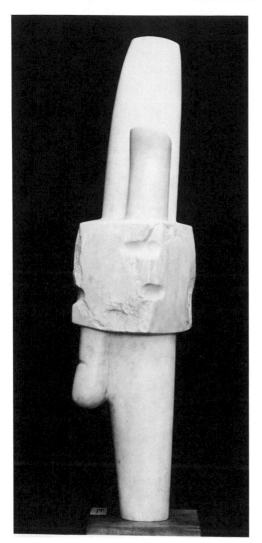

Woman with Child, 1958.
White marble, 44 inches
high. Contemporary
collection, Cleveland
Museum of Art

Woman (Rishi Kesh),
1956. Cast iron, 14½
× 18¼ × 8⅝ inches.
Photo: Rudolph
Burckhardt

Okame, 1956. Bell bronze,
9½ × 10⅛ × 4 inches.
Collection Hiroshi
Teshigahara, Tokyo.
Photo: Denise Browne Hare

initiate's hands as he summons the gods—and Noguchi at this stage was relatively conventional. Only later would he delve into the chthonic realm of near formlessness. In 1959 he was still in search of the means of cajoling the stone's secrets to emerge. The exhibition was an announcement of his determination to pursue what to many of his critics—and there were many, as always, in America—seemed an anachronistic goal.

The third group of works were even more insistently archaic. They were the iron castings he made in Japan, full of deference to the strength and beauty of the old Japanese iron pots. The pieces varied in tone: some were in the rude, robust spirit of Jōmon, others in the willed simplicity of the ritual tea ceremony. "With but a single kettle one can make tea . . ." He had not forgotten Rikyū, in whose time the iron pots for the bubbling water were used as part of the ceremony and were given importance in the total aesthetic. Noguchi liked and quoted Rikyū's suggestion that heavy utensils should be skillfully lifted so as to appear almost weightless and, similarly, that light utensils should not be carelessly waved around but thoughtfully handled, as if they possessed secret weight. Noguchi's iron castings bore the voice of Rikyū into the present, especially those shapes that carried the memory of Japan, such as bell shapes, and those that played upon the idea of weightlessness and were suspended from the wall. One of the most memorable pieces (and one that Noguchi himself

cherished and placed carefully in his last home in Shikoku) was titled
Woman (Rishi Kesh). The grainy surface of iron suggests the quality of
age, so important to the tea masters, while the lightness of the modeling
suggests the paradox necessary for the poetic dimensions of tea. Yet,
Greece is there too. The feeling for drapery, with its wetly clinging grace,
can come only from Noguchi's contemplation of Greek marbles. On the
other hand, there were solid iron pieces, such as *Tetsubin*, to suggest the
total heaviness of the earth from which iron derives.

Noguchi was, indeed, very much taken up with the tea paradoxes, and
was experimenting widely with the notions of weightlessness in weight.
During the time of the Stable exhibition he had again been composing
works in balsa wood with light, hanging elements that might swing free or
would at least suggest that the work of the wind could affect the piece's
movement in space. *Mortality*, which was exhibited three years later in a
paradoxical bronze cast, is a solemn construction of a standing shaft and
five swinging vertical elements, carrying with it a host of associations. The
delicately balanced, pending forms suggest the ticking of the cosmic clock
(shades of Bucky Fuller) and, also, sounds. The measures of music—the
silences and rhythmic occurrences of abstract sound—are inherent in this
conception. The jointed forms that swing free invoke at least the expecta-
tion (time) of a gong sound or the muted music of Eastern temples. The
grave atmosphere created by *Mortality* is assured by Noguchi's use of a
very deep patina, almost black, typical of the ancient iron castings of Japan
as they age. The heavy lintel clamped to the summit of this sculpture bears
down on the fragile members below and indicates Noguchi's profound
assessment of the principles of Japanese structuring.

In 1962 Noguchi further refined his approach to the balsa-wood
sketch. *Solitude* is based on the same principles but is simplified. Instead
of being hidden by a rain of hanging elements, the shaft—long, slender,
its facets meeting in softened contours—is exposed. The capital in this
piece is not weighty but, rather, in its asymmetrical relationship to the
base, proposes further elaboration of the surrounding space. The swinging
elements are reduced to two of unequal lengths that hang immobile,
though the eye knows they can stir. The spaces between their slightly
curved contours are excitingly narrow, and the interval between them and
the supporting vertical is a provocative splinter of light. The paradoxes
inherent in this piece are elusive. They partake of Rikyū's stringent re-
quirements, but they also lead into contemporary concerns that would
soon be expressed by other sculptors who, like Noguchi, were moving out
from the static sculptural tradition.

There was one other experiment with lightness at this time, which
Noguchi described in his autobiography in an aggrieved tone. When he
returned to New York, he had been struck once again by the imperious

American preoccupation with new materials and technology. He was eager to try his own hand with the new light metals that had become almost the exclusive medium of contemporary sculptors. New York always brought him into the futuristic world whose first citizen was Buckminster Fuller, and Noguchi could never resist for long the inspiring rhetoric of Fuller, echoed in Noguchi's own statement: "new materials remake the world." The world, Noguchi wrote as he discussed that period in his life, is "one of molecular structure and sub-atomic particles" and "it is the world of the airplane, of speed—my world."[12] He wanted to get back in touch with that world and with the industrial apparatus that he thought of as "the real America." Fortunately, he knew Edison Price, who manufactured lighting equipment and had the proper machine tools for the handling of light metal. Noguchi persuaded Price to allow him to use his factory after hours and persuaded Shoji Sadao, the young architect who had begun his career as Fuller's assistant, to work beside him long into the night while Noguchi created a large group of sheet-aluminum sculptures. His explanation of his procedure during this brief but productive period indicates how much his Japanese inquiry tempered his approach:

> By way of self-imposed limitation I insisted on deriving each sculpture from a single sheet of metal—a unity, I thought, was achieved thereby. We impose our rules of value. I wanted to deny weight and substance.[13]

True to his own rules, Noguchi made paper models from which these light metal works were derived. The folding and infolding definitely suggest the special Japanese sensibility that knows the structural potential of cut paper—a sensibility rather foreign to America. As with the Akari, these sculptures found little approval, and as Noguchi bitterly reported in his autobiography, he had a hard time finding a gallery willing to exhibit them. In his mind, they were the appropriate expression of his affection for the economy and inventiveness of Japanese aesthetics and, at the same time, a daring departure from the traditional sculptor's materials. Even more, they reflected Noguchi's stubborn desire to avoid the reigning idiom, which, at that time in New York, was articulated solely in welded sculptures. To New Yorkers, Noguchi's metal cutouts were either too commercial or too much like origami. Once again, Takiguchi had been right: Noguchi's work in the United States was always perceived to be too Oriental, or pseudo-Oriental, which was worse, and in Japan, too Western. All the same, the issues Noguchi raised for himself in this sortie into the use of the industrial process and modern materials continued to interest him for the rest of his life and also continued to draw criticism.

A hint of his initial inspiration occurs in the titles for these 1958 works

Sesshū, 1959. Anodyzed
aluminium, 108 inches
high. Wadsworth
Atheneum. Photo:
Rudolph Burckhardt

in aluminum. It is clear that in a work he called *Sesshū* he meant to capture the fragility of Sesshū's breathlike brush as well as the strong angularity of implied planes. The two-dimensionality or frontality of the painter is transformed into three dimensions in suggested and minimally articulated planes, scarcely hollowing the environing space. Here, the versatility of the Japanese screen—as divider, or as backdrop in the tokonomalike space of a chamber—is called into play. These sculptures address themselves more to the artful illusion of depth than to the weighty intrusion into space. Still other pieces refer specifically to another great artistic invention of Japan, the sculpturelike kite whose presence is lighter than air. Noguchi was perhaps too early, for within a few years, the entire New York gallery scene would be replete with kitelike sculpture made of light materials suspended or standing in fragile, scarcely differentiated spaces.

Despite his disappointment about the reception of his metal pieces and a certain feeling of displacement (by 1959 the artists of Noguchi's own generation had long since removed themselves from bohemia and no longer forgathered in chummy situations like the Club), he was invigorated by the atmosphere, or at least challenged. He thought, once again, that his real place was in New York. In 1961, with characteristic impulsiveness, he bought a factory building in Long Island City in Queens, which he proceeded to fashion into a permanent workshop and residence. This site, now incorporated with the Isamu Noguchi Garden Museum, was to facilitate his larger ambitions.

Noguchi at work at the
Henraux quarries in
Querceta, Italy, ca. 1970.
Photo: Arnold Eagle

The
World
in a
Single
Sculpture

DURING THE FIFTEEN YEARS since the war the intellectual climate had changed. When Noguchi settled into his Queens studio, he could count on a more knowing and more receptive audience, or at least one far removed from the bigotry of "once an Oriental always an Oriental." Although during the extended period from the Second Sino-Japanese War through the end of World War II, the Japanese, as Noguchi said, had gone down, down, down in terms of cultural respect ("In my father's time Japanese were celebrated as demi-gods"), after 1945, American institutions hastened to rectify misapprehensions. While Noguchi had been trying to get a foothold in Japan during the early 1950s, New York had been busy catching up. As Noguchi's friend Joseph Campbell pointed out, before the war there was not a single American university with Japanese studies, while immediately after, everyone scrambled to establish Japanese departments. Daisetsu Suzuki's *An Introduction to Zen Buddhism* appeared in English in 1949, followed by Suzuki himself, who began to give regular lectures at Columbia University. It was during the early 1950s that Zen Buddhism became an almost fashionable preoccupation among artists and musicians. John Cage held soirees at his Grand Street loft, entertaining painters, sculptors, and musicians with anecdotes from ancient Chinese and Japanese sources. The young vanguard was much preoccupied with koans and the *I Ching*, or *Book of Changes*. The painter Mark Tobey, who had long been familiar with the Orient and had been Noguchi's fellow exhibitor in *Fourteen Americans* at the Museum of Modern Art in 1946, had prophesied this resurgence of interest in the Orient:

> America more than any country is placed geographically to lead in this understanding (of the East) and if from past methods of behavior she had constantly looked toward Europe, today she must assume her position, Janus-faced, toward Asia, for in not too long a time the waves of the Orient shall wash heavily upon her shores.[1]

The waves from the Orient reached the Museum of Modern Art itself in 1949, when the Department of Architecture began a series of exhibitions of Japanese house design culminating in 1954 with the installation of a complete traditional house in the museum's garden. That June, the museum also staged an exhibition of contemporary abstract calligraphy

from Japan—a show considerably aided by Noguchi, who had encouraged Hasegawa and his friends to pursue their interest in trying to express mood rather than meaning in exploring the ideogrammatic sources, and who had energetically pleaded their cause in New York.

Noguchi, in fact, had influenced aesthetic change in both directions. When he made his first postwar visit to Japan, he had brought with him nine photographs of paintings by Franz Kline, a friend who exhibited in the Egan Gallery during the late 1940s. Hasegawa was enthusiastic and arranged to have them published in the first issue of a new magazine largely devoted to the new calligraphy, *Bokubi*. In his commentary, Hasegawa had pointed out the affinities between Kline and the Japanese contemporaries and had even discussed Jackson Pollock, whose line he compared to the traditional *kyōsō*, or "crazy quick stroke," of old Japanese calligraphy. In the same issue, Sikiryū Morita (probably the same Morita who had written so lyrically of Noguchi's Kamakura exhibition) firmly declared: "It is most necessary for us to follow the spirit of Mr. Kline."[2]

All during the 1950s New York had been actively informing itself about the arts in Japan. Curiosity about Japanese aesthetics extended to the films of Akira Kurosawa, whose first postwar film, *Rashomon*, released in 1950, had made a stunning impact. This was followed in 1952 by *Ikiru* and *Seven Samurai* in 1954. In the more serious discussions of Kurosawa's films, there were inevitable allusions to both Japanese literature and traditional art forms such as scroll painting and Kabuki theater. These discussions were aided by new editions of Japanese classics that began to appear in the 1950s, including Arthur Waley's translation of *The Tale of Genji* and a serious analysis of the book by the critic Parker Tyler in the *ARTnews Annual* of 1958. Although Kurosawa's radical technique—an extension of Sergey Eisenstein's theory of montage—was understood to be related to Western film experiment by most knowledgeable commentators, they increasingly looked to Oriental traditions to explain Kurosawa's shifting perspectives and his startling use of the close-up. Certain of the critics had been fortunate to have traveled to Japan, but others seized the opportunity to amplify their research into the traditions of Japanese theater when the Azuma Kabuki theater arrived in 1954, the Gagaku dancers in 1959, and the Grand Kabuki troupe in 1960.

Another source of news from Japan was the tireless aesthetic entrepreneur from Paris, Michel Tapié, who had begun an intense campaign during the early 1950s to effect a rapprochement between the French and the Japanese avant-garde. After an extensive visit to Japan in the mid-1950s, Tapié brought Sōfū Teshigahara, whom he called the greatest living Japanese artist, to Paris, where, in July 1955, he drummed up sufficient excitement to lure *Time* magazine to write that Teshigahara was "the Picasso of flowers." In 1957, Tapié brought Teshigahara to New York,

where he exhibited his baroque driftwood sculptures and eccentric flower arrangements at the Martha Jackson Gallery. He appeared with an entourage dressed traditionally, stressing his double allegiance to tradition and the avant-garde. Teshigahara impressed young New York artists, as did the Gutai group, also shepherded by Tapié. The Gutai group was sponsored by a rather remarkable man of Noguchi's generation, Jiro Yoshihara, who had had a long prewar experience with Japanese avant-garde groups. He had come to feel, as did Tange and Teshigahara, that the only way for Japan to emerge from the stagnation of the fascist years was to look back to the pre-Buddhist sources, the fierce and free tradition of the Jōmon. He encouraged young Japanese artists to stage wild events, often in outdoor settings, meant to provoke staid audiences in Osaka. These were parallel to the semitheatrical events in New York called "happenings," but even more extravagantly uninhibited. Unfortunately, the kind of spontaneous theatrical amalgam of the arts for which the Gutai became notorious in Japan was not exactly exportable, and the exhibition in 1958 in New York consisted largely of automatistic exercises in paint that looked all too familiar to New Yorkers, who were already turning away from action painting. Still, some idea of the group's unorthodox use of mime, dance, and drama could be seen in videotapes accompanying the exhibition and piqued the interest of young New Yorkers.

The cumulative effect of these many artistic importations during the 1950s was to open New York to strong influence from Japan. For Noguchi this was to be a mixed blessing. Critics could respond to what they saw as Japanese elements in Noguchi's sculptures with more knowledge, but at the same time, they often criticized him for his eclecticism, sometimes even accusing him of artificially infusing his basically Western approach with Japanese niceties. Considering that Noguchi was by 1960 a seasoned artist in his fifties, with an international reputation, the paucity of serious commentary is rather striking. Other American artists of his generation could, by the 1960s, boast extensive bibliographies, far surpassing in volume and substance Noguchi's own.

The critical reserve already apparent in the 1950s remained constant, curiously, throughout Noguchi's career and was at least in part a reflection of his own readiness to depart, both physically and stylistically, from New York. What many of his critics failed to understand was that his displacements—from his studio in Queens, to Japan, to Greece, to Italy—functioned as might a colon in a long-running sentence. They brought him fresh insights into his own process and constantly new thoughts about how he could modify it. The sight of a magnificent new tool or a strange landscape was enough to ignite imaginative action. But all along, he carried certain principles with him and strived to realize them in many different ways. His individual sculptures during the 1960s can be seen, in

retrospect, as expressions of a few cardinal principles examined, as a sculptor does, from many points of view. In 1962, for instance, he reviewed his earlier distaste for cast bronze and decided to install himself in Rome, at the American Academy, in order to explore the medium in a new way. When he entered his new habitat in the old palazzo that is the academy, with its cool stone floor, something from his past meditations on weight and weightlessness, and the principles of Japanese masters such as Musō Kokushi, stole into his thoughts, resulting in a group of floor sculptures that he would exhibit the following year at the Cordier & Ekstrom Gallery in New York. In the catalog, Noguchi wrote simply: "These studies are based upon a concern for gravity and man's relations to the earth." The pieces had been fashioned in Rome, with a full sense of the great bronze tradition encountered in monuments throughout the ancient city. Yet, many of them bore in their titles Noguchi's memory of Japan—titles such as *I am a Shamisen* and *Lessons of Musōkokushi*. For those privy to Noguchi's personal biography, another title would be significant: *Seen and Unseen*. The title of Yone Noguchi's first book, published in English in 1897, had been *Seen and Unseen, or Monologues of a Homeless Snail*.

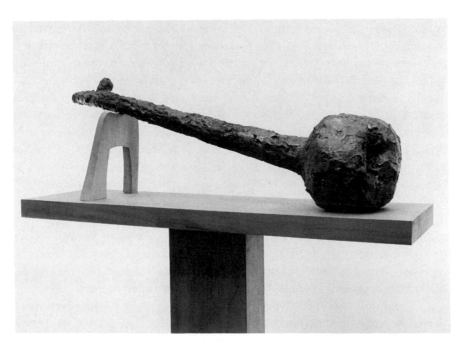

I am a Shamisen, 1962. Bronze, 12½ × 39½ × 11⅛ inches. Isamu Noguchi Foundation, Inc. Photo: Rudolph Burckhardt

Noguchi had shown increasing interest in his father's work during his postwar visit to Japan and perhaps "Homeless Snail" seemed to him an appropriate epithet for himself. On the other hand, seen and unseen elements are inherent in Japanese garden philosophy. Fond of paradox, Noguchi had shaped wet clay to resemble casual stones, sometimes modeling them with his bare feet. When cast, these works—among them a group of three stony black shapes supine on the floor that he called *Garden Elements* and the circular *This Earth, This Passage*—present equivocal visages as he intended. Man is at once of the earth, Noguchi believed, and apart; at once like the accidental shapes, the rises and falls in topography, and totally removed—a thinking animal endowing each phenomenal experience with a meaning beyond the senses. By placing the almost inert shapes on the floor, Noguchi forced his viewers to assume, as do the Japanese, that the floor is essential, the very ground of our living space and, therefore, of our being.

From his early years, Noguchi had felt the floor as a springboard of human motion. Through the soles of his feet he had felt the throbbing of the dancers' feet as they navigated the space of the stage, always in touch with the boards, seeking to contravene gravity. By forcing the viewer of his sculpture to look down at disparate and occultly related elements, he demonstrated his premise that our own grounding is naturally shaped by the space beneath our feet. We look down at these full shapes and perceive the metaphor of the earth's crust with its varied topography—an image that yields itself to any wanderer who, step by step, makes his way over an unpredictable surface. The lessons of Katsura were certainly implicit in these pieces, but so were the lessons of Brancusi and the modern movement that stressed simplicity above all. The Japanese aesthetic that he had studied so closely was to serve as a frame, a way of enclosing the insights he had already achieved in the white studio of Brancusi. As a sculptor, he had undoubtedly had a great emotional response to the act of peering down from a veranda at a stone garden—a framed picture in three dimensions. And by inquiring about the principles from which these gardens evolved, he found a way of ordering his own sense impressions and impulses. But finally, the Japanese system would be occluded with his own Western principles that he had shaped, in the working of individual sculptures, for more than twenty years.

Throughout the 1960s Noguchi sought to integrate his diverse formative experiences in individual sculptures. Paris, the Orient, Greece, Italy, America in turn inspired him. Increasingly he would seek the way through the working of stone—the medium, as he said in his last years, that was the most challenging and that could best express his intuition of the "congealment" of time. His interest in the inherent qualities of stone had been initiated during the great voyage after the Second World War and

had never abated. Already during the early 1950s he had begun foraging in quarries in Greece, Italy, and Japan, carefully exploring the distinct qualities of stones of diverse sites, shaped by diverse natural forces. In 1953, while he was preparing an ill-fated project for Lever House, he wrote frequently to the architect Gordon Bunshaft about his early search for the right stones in Italy. Then, from Greece, he reported on a quarry from which the stones of the Parthenon were said to come: "This marble is certainly superior to all other marbles. It has a translucency the Italian marble lacks, a certain warmth and nobility we associate with classic Greek."[3] He was concerned at the time with the "weathering quality" of the stones and, wherever he went, inquired meticulously. Thinking in terms of stones altered Noguchi's vision and his approach to sculpture. He was obliged to take into account their history as products of great spans of time and an infinite number of hidden forces.

During his work at UNESCO Noguchi had met Henry Moore, who had urged him to visit the Henraux quarries in Querceta, Italy, where he himself worked. Noguchi took Moore's advice during the summer of 1964 and immediately found himself at home. He wrote to his close friend Priscilla Morgan that it was a sculptor's paradise. Querceta and the stone-cutting village of Pietrasanta were of particular significance because it was here that Michelangelo himself had instituted the quarrying of marble where once Roman engineers had failed. Michelangelo's fretful letters from Pietrasanta tell of the numerous trials he endured there, trying to extract what he always called "living" rock from the "solid marble mountain" called Altissima. His letters from Carrara, Pietrasanta, and Lucca recount difficulties ranging from labor problems to that of laying new roads on which to transport his treasures or finding appropriate barges. In 1518 he wrote, "I have taken on the bringing of the dead to life in wanting to tame these mountains."[4] Michelangelo's feeling that he must "tame" the mountains extended to his work as a sculptor of stone, which he more than once referred to as "rebel stone" and the "unwilling stone." When he scrambled up the sheer face of Altissima, he had needed to lay bare, to penetrate the secrets, to divine the nature of stone. This primary urge was familiar to Noguchi, who understood why Michelangelo needed to lay his hands on freshly quarried stone, so different in quality from the aging blocks found in the world's warehouses. Michelangelo's idea in the famous sonnet "Non ha l'ottimo Artista" could address any sculptor in stone. In Henry Wadsworth Longfellow's quaint translation:

> Nothing the greatest artist can conceive
> That every marble block doth not confine
> Within itself; and only its design
> The hand that follows can achieve.[5]

Noguchi at work at the
Henraux quarries in
Querceta, Italy, ca. 1970.
Photos: Arnold Eagle

From 1963 until 1970 Noguchi went to the Italian quarries regularly, renewing his affection for the marble Brancusi himself had taught him to respect. In Querceta he found perfect technical facilities, well-trained assistants (unlike Michelangelo, whose woes were always compounded by incompetent assistants), and, above all, newly developed power tools. Here were possibilities never dreamed of by Michelangelo or even Brancusi, who were limited to the old tools—the claw, the hand chisel, and the point. At Henraux, Noguchi marveled at the giant power tools that could cleave and bore enormous masses of marble with their diamond points and that revealed new potentials he would eagerly exploit.

Marble never entirely yields; it has an interior life that the wise sculptor knows must be respected. It is a metamorphic stone that has been crystallized over centuries by heat, pressure, and aqueous solutions in its interior environment and by surface atmosphere, temperature, and incoming fluids. It is full of accessory minerals such as quartz, mica, and flakes of granite: a complex creation of earth and time. Artists love marble for its unpredictability and the fact that light can penetrate its surface for almost two inches and is reflected on the surface from crystals lying deep within the mass. Interestingly, these crystals of calcite transmit more light in one direction than the other. He who cuts deep must sense his direction well if he is to get the luminous surface his material promises.

The works Noguchi produced during the 1960s in Italy capitalized on the precision power tools that could slice marble in faceted geometric forms or bore great clean holes in its heart. There was also the excitement of ascending Altissima to find and shatter an obdurate rock, bring it down to the workshop, and, as Noguchi says of *The Roar,* "meet its challenge."[6] Here Noguchi incorporated the clear grooves produced by the machine with the seemingly fortuitous shape the initial shattering process produced. The natural skin of the rock is honored over much of its surface, but its inner light is suggested in the subtle textures produced by Noguchi's own hand tools, textures that release minuscule points of light and tell of his prescience. During the same sojourn at Querceta in 1966, Noguchi shaped *Green Essence,* a cascading shape that he divined from his green serpentine marble, leaving its roughness almost undisturbed but scoring its flanks with the sharp grooves of the mechanical instrument, force and counterforce, doubled by his inspired use of a slab of highly polished aluminum for its support. Noguchi's own comment in his museum's catalog was:

> Serpentine is a tough and fibrous marble. Its vigor shows because of this—as found in the accidents of its being and its making. Its history remains in the drill holes, nature, skin. We participate in

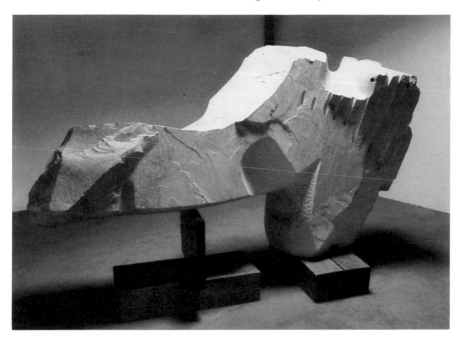

The Roar, 1966. White
Arni marble, 52¼ ×
91 × 24 inches. Isamu
Noguchi Garden
Museum. Photo:
Erick Johnson

the rawness left alone. This is an early precursor of much of my
later work where I attempt to respect nature, adding only my own
rawness.[7]

Shortly thereafter, Noguchi produced other precursors, by experi-
menting with what he called the "structural" use of marble that he had
long before, in the mid-1940s, explored when he carved stone slabs instead
of blocks and fitted them together without adhesives, using only tension
and gravity. Perhaps these earlier experiments were related to his child-
hood experiences in Japan, when he was apprenticed to a carpenter, or
perhaps it was the traditional Japanese approach to sculpture that often
began with the use of two or more stones. Noguchi now experimented
with fitting stones together, using the new and powerful adhesive, epoxy
glue, and interior rods. Around 1968 he began to experiment with jointed
arrangements of alternating elements—a dark marble section adjoining a
light marble—bringing them to a highly polished finish. The assembled

elements were formed to suggest eternal circles or spirals, fragments of organically maturing forms, or geometrically eccentric shapes such as a skewed cube. Sometimes he played against gravity, sometimes he defied perspective, adding a note of anamorphosis as in both *The Spirit's Flight*, one of many plays on the helix, incorporating the ancient Greek technique of entasis, and *The Opening*, a post-tensioned asymmetrical arch with a knee-like curve. The European elegance of these polished marbles is apparent, but there are other sources: Noguchi owned an Indian swagger stick on which alternating colored stones were strung and glued on a rod. In addition, the whole modern tradition of assemblage stands behind him. In antiquity sculptors also used joined stones, but the joints were always concealed as much as possible. Half the arguments about the *Laocoön* centered on the question of how many blocks the artist had concealed. Noguchi's method, on the contrary, stressed the joints and the disparateness of the stones, but in his refining, he sought the alternating light quality within the different marbles. With the additive technique he was able to make odd points of jointure and curious, even humorous shapes. He could design with or against the grain, choosing his elements for their appropriateness. With the new tools, Noguchi could empty the interior of a marble block, using the smooth interior walls. Then he could utilize the cylindrical pieces of the core in other works. In many of these post-tensioned pieces there are organic suggestions. *The Bow*, for instance, with its suggestive title calling to mind *Zen in the Art of Archery*, turns and flexes on its horizontal axis like a living limb and springs upward like a growing thing, recalling the Japanese gardener's anthropomorphism and the old metamorphic myths that inspired Noguchi as he worked with Martha Graham. Growth and natural tension are as implicit in these assembled marbles as is the domineering will of the artist to make a thing discrete from nature.

Noguchi's other direction with stone evolved directly from his experience in Japan, where a few years before he had begun exploring the land for its stones and examining the way the ancient Japanese had utilized them. His attitude toward granite and basalt, the substances he would increasingly favor toward the end of his life, was shaped in the course of his wanderings and by many cultural forces, but it was in Japan that it reached maturity. There was something chastening about his experiences with these obdurate materials that he courted. Their resistance inspired him. The quest for the right stone, as he had already discovered during his quarrying for the UNESCO gardens, has about it something heroic that appealed to the man who, as a child, had been nurtured on Greek myths. Describing how he had persuaded his patrons in Texas that his commission had to be accomplished in Japan in 1960, Noguchi relates an experience very like Michelangelo's in Pietrasanta:

... through good fortune and proper introductions, I found myself halfway up Tsukuba Mountain looking at great granite boulders. There was no road, other than a trail up the rocky woods. However, by then I was so enamored of the gray-green granite that there was nothing to do but to build a road for the distance of half a mile down which the rocks could be skidded. The biggest was over twenty tons, which suggests the amount of work involved.[8]

Mastering these enormous artifacts of nature was an exciting prospect for Noguchi, and he always spoke with great animation when describing these experiences. He associated these stones, which are the very inner life of the Japanese terrain, with many earlier observations, most of all with the time they bespoke—both time as measured by man's experience and geologic time. They symbolized beginnings for him, and as for all who are attracted to myth, beginnings are both personal—that is, the events of one's childhood—and cosmic. He certainly was speaking as much of himself as he was of Brancusi when he wrote in 1976 that Brancusi had come to Paris to learn but had brought with him something more than learning:

The memory of childhood, of things observed not taught, of closeness to the earth, of wet stones and grass, of stone buildings and wood churches, hand-hewn logs and tools, stone markers, walls and gravestones. This is the inheritance he was able to call upon when the notion came to him that his art, his sculpture, could not go forward to be born without first going back to beginnings.[9]

Going back to the beginnings, to his own origins, Noguchi inevitably thought of granite and basalt in relation to his Japanese heritage. Cultural attitudes toward stone are significantly different in Japan. During his first visit after the war, Noguchi associated with artists and architects whose attention was focused on the most ancient Japanese traditions, who had, for obvious reasons, sought to return to the oldest and most unsullied principles in their culture. The architect Kenzō Tange was deep into the study of the ancient shrine of Ise, in the course of which he reviewed the oldest myths and their symbolic representations. In the passionate book he later wrote about Ise, Tange spoke of the way the Shinto worshipers had characterized nature spirits by connecting two rocks with a sacred rope of rice straw. He wrote of the earliest Japanese inhabitants:

Man trembled before the incomprehensible forces that filled primeval nature and space. They were believed to permeate palpable matter and formless space (collectively *mono* in Japanese).

Hence the word *mononoke* came into being, to describe what we could also call *Mana*. . . . Man came to see in natural rocks and stones the coalescence of *mononoke,* and a symbol that made primordial space comprehensible.[10]

Noguchi's desire was to lay bare the essence of the stones he found in Japan without disturbing their natural rawness, their rugged sheaths. He took pleasure in the basic tool—the granite ax—that shatters the mass decisively but unpredictably. In its very name, granite suggests its characteristic: graininess. It was in developing contrasts of rough and smooth grains that Noguchi perfected his techniques and carried out the most important act for him, that of *dis*-covering. Again and again he referred to the slow and difficult process by which he learned his stones and found the appropriate way of altering their natural formation. One of his key experiences, it seems, was in working the piece he called *Myō*, which he began in 1957 and didn't complete until 1966. In his museum catalog Noguchi twice spoke of *Myō*, musing about natural boulders of hard stone—basalt, granite—and their age. "But," he asked, "are they old as sculpture? One day about thirty years ago I split one. Eventually I was able to make it

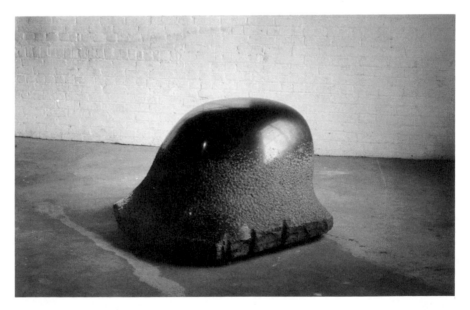

Origin, 1968. Black African granite, 23 × 30 × 32 inches. Isamu Noguchi Garden Museum. Photo: Erick Johnson

mine, a 'sculpture' of my time and forever."[11] Further on in the catalog, in a discussion of *Deepening Knowledge*, a basalt piece sheathed in warm, rusted-iron colors and, in its deep-cut heart, a rich gray, he again harked back to *Myō:*

> I had come to think that the deeper meaning of sculpture had to be sought in the working of hard stone. Through this might be revealed its quality of enduring. The evidence of geologic time was its link to our world's creation. To seek such a sculpture of time takes time. *Myō*, for instance, took nine years, 1957–66. Not for labor but for inadequacy of my imagination.[12]

When he spoke of his Japanese stones Noguchi was always reminded of the earth and time and origins. During the years after 1960, many of his sculptures were meant to embody these ideas. When Martin Friedman, director of the Walker Art Center in Minneapolis, asked him to discuss some of his germinal sculptural themes, Noguchi talked about emergence, "emergence out of the earth, you might say." One of the pieces he discussed is the magnificent black granite *Origin*, which, no matter from where it is viewed, convincingly emerges from the ground as though it had always been rooted there. He told Friedman:

> It is a broken rock, then it became a more precious thing. It is both determinate and indeterminate. It is a basic form—like a natural form except it is obviously man-made. It is related to its surroundings but it is alone. It is not part of a composition, but becomes part of everything else. It is a key piece.[13]

This piece becomes part of everything else through Noguchi's decision to burnish its curving domelike crest to the degree that it takes the light of the sun as would a mirror or a water surface. Both mirrors and water are intimately connected with Shinto mythology, and it would not be difficult to imagine Noguchi's reference to the release of the spirit, the *kami*, from this weighty stone. His earthbound essays during this period were frequent, and there were numerous forms to which he referred as "ground pieces." Among them were horizontal compositions, hugging the earth, that alluded to landscape or to the ink stones of the calligraphers or to the poetic and sensuous idea of a ground wind. *Ground Wind* is a granite sculpture in seven parts, basically a twisted pylon, which, resting in the small garden in Noguchi's Shikoku house, seems to complete the expression of the wind that picks up a form as it bowls along the ground and alters its topology. Other variations on the kinship of stone and earth include a number of experimental variations on the *tsukubai*, the conven-

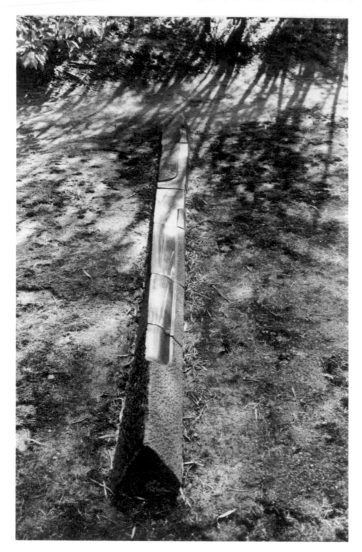

Ground Wind #1, 1969, in Noguchi's garden in Shikoku. Granite, seven elements, 6¼ × 47 inches. Photo: Denise Browne Hare

tional stone basins in Japanese gardens, which Noguchi transformed into fountains. There were also a few utilitarian projects, such as a 1966 bench in two parts—a low-lying invention that harks back to his early experiments with marble slabs held by tension and gravity alone but that, in its full proportions, speaks more to Noguchi's later feeling that he had to honor nature while yet wishing, as he literally expressed it in one of his titles, *To Intrude on Nature's Way*. Noguchi's increasing use of stone as his best means of expressing an ever-widening point of view was apparent when he held his first museum retrospective in the United States at the Whitney Museum of American Art, April 17–June 16, 1968. He told John Gordon, who curated the exhibition, that he felt caught between the two

poles of Greece and Japan; the United States "is the arena where the battle is being waged."[14] The presence of his large stone sculptures was powerful; even critics who had long resisted Noguchi had to concede that these were the work of a mature master. The old complaints about elegance, eclecticism, decorativeness, and *Japonaiserie* appeared in some of the reviews, as usual, but they were now tempered by authentic awe before the new stones, certainly unlike the work of any other living sculptor.

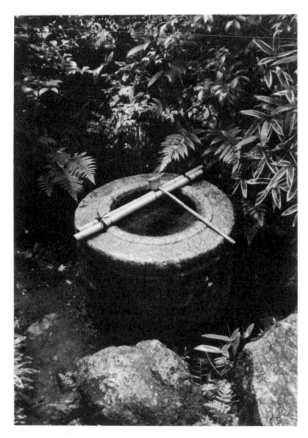

Tsukubai in temple compound of Daitokuji, Kyoto, 1989. Photo: Denise Browne Hare

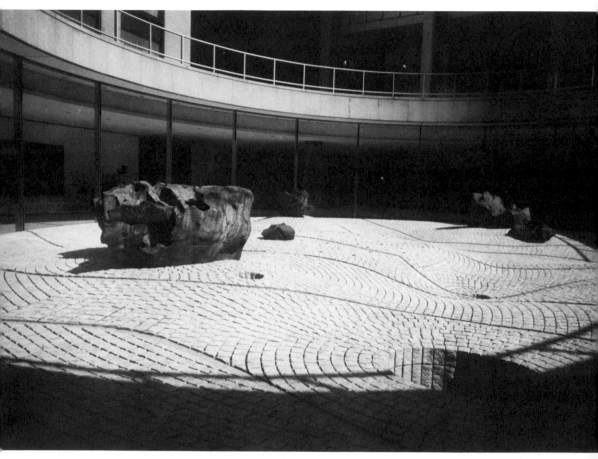

Sunken garden for Chase
Manhattan Bank Plaza,
New York City, 1961–1964.
Diameter 60 feet.
Photo: Arthur Lavine

Great
Beginnings
and
Grand
Projects

NINETEEN SIXTY was my year of great beginnings," Noguchi said toward the end of his life.[1] During the previous hectic decade he had established his vocabulary, sometimes by trial and error on a grand scale, as at the UNESCO site, sometimes in the confines of his studio. He had revisited great sites in Europe and Asia and examined various principles at work in them, and he had begun to discern with considerable precision his own driving passions. The complicated course of the UNESCO project had taught him much about his own capacity to manage the realization of large-scale works, and by 1960 he was actively seeking opportunities to bring to fruition long-harbored ambitions. For the next decade he would be engaged in several major projects in which he would empower the principles he had been shaping for so many years.

One of the first of these was to prove a source of prolonged frustration and eventual failure. For some thirty years Noguchi had been seeking a commission to do a sculptured playground. He had made several imaginative models and had approached the city of New York on several occasions, always to be met with unceremonious rejection. Now it was the city that approached him, and with both caution and unreasonable optimism, Noguchi undertook to persuade the obdurate bureaucracy to accept his vision of a graded playground with his old dream of elaborate earthen pyramids, step formations, mounds, and sculptured slides. Although he produced five models in five years, and engaged in elaborate negotiations with the city, in the end the whole effort came to nothing, as he bitterly remembered in his autobiography.

Still, the experience was crucial in his intellectual and spiritual life, for it brought him together with a great architect whose lyrical vision deeply affected him. Louis I. Kahn was perhaps the sole living American architect whose way of thinking about his art was profoundly akin to Noguchi's own. Kahn's vision of the sanctity of nature, much like that of Noguchi's beloved Blake, corresponded to Noguchi's own feelings. Both artists were sensuously aware of nature's continuum; both strove to reconcile vast stretches of history and man's imagination with the demands and actuality of contemporary life. Both were convinced—unlike many of their contemporaries—that "we live to express," as Kahn put it:

> I only wish that the first really worthwhile discovery of science
> would be that it recognizes that the unmeasurable, you see, is
> what they are really fighting to understand, and the measurable

is only a servant of the unmeasurable; that everything that man makes must be fundamentally unmeasurable. . . . At the threshold, the crossing of silence and light, lies the sanctuary of art, the only language of man. It is the treasury of the shadows. Whatever is made of light casts a shadow; our work is of shadow; it belongs to light.[2]

Around the same time, Noguchi wrote: "There is a difference between actual cubic feet of space and the additional space the imagination supplies. One is measure, the other an awareness of the void of our existence in the passing world."[3] Noguchi and the slightly older Kahn had arrived at the same philosophical place.

Kahn's reverence for light as the shaper of all things was, of course, particularly satisfying for a sculptor. His many ways of speaking of light and silence, his belief that "natural light gives mood to space by the nuances of light in the time of the day and the seasons of the year as it enters and modifies the space,"[4] his frequent allusion to a "fusion of the senses" in which he discerned tonality in architectural spaces and felt he composed music, reflected attitudes that Noguchi had studied and secured for himself during his probing in Japan and elsewhere in Asia. He saw in Kahn a kindred spirit as well as a mentor. Mutual respect is evident in a letter Kahn wrote to Noguchi in August 1965, when their project in New York had already been terminated. Kahn wrote that he had been asked to do a master plan for Gujarat in India, and he had suggested Noguchi for the possible development of the riverbanks that "have fantastic configurations which in some places are crumbling and should be reshaped in rough masonry to firm them in their present position. . . . I believe it is a wonderful opportunity to work with nature and ride with its blows."[5]

After Kahn's death Noguchi found a way to pay him homage at the Kimbell Art Museum that Kahn had designed in Fort Worth, Texas, which Noguchi called "that most beautiful of buildings." There he installed four brooding basalt sculptures on the vast lawn adjoining the museum, forming a perfect complement to its vaulted splendor. Undoubtedly Noguchi's long experience with the hypothetical space of the dance theater aided him in the placement of these stone accents in Kahn's scheme. He seems to have measured out the sight lines, as he would in a theater, so that visitors moving around the building would be guided back again and again to the structure itself.

During the years that Noguchi and Kahn were contending with the city of New York, Noguchi had many other projects underway, most of them brought to him by Gordon Bunshaft, chief designer and architect at Skidmore, Owings & Merrill. Their first project had begun in the mid-1950s when Bunshaft commissioned Noguchi to design the spaces around

his building for Connecticut General Life Insurance Company. Bunshaft
had shown great skill in successfully mediating numerous conflicts that
arose between artist and patron. He was a firm believer in the integrity
of the artist. He knew that the work of a collaborating sculptor should be
initiated at the beginning, at the planning stage, so that his contribution
would not be a mere embellishment but, rather, a functional part of the
overall design. And he knew how to deal with Noguchi. As Martin Fried-
man pointed out, Bunshaft's positive role in these important projects of the
1960s must be stressed.

> It was his idea to have a sculptor design a total space adjacent to
> and interacting with the building as a means of humanizing the
> ground level areas around it. . . . Defining the physical limits of the
> project, serving as interpreter of the clients' needs, and projecting
> his own definitive views, Bunshaft constantly urged Noguchi to-
> wards inventive solutions for these spaces.[6]

Noguchi's year of "great beginnings" began with Bunshaft's invitation
to design a plaza for the First National Bank in Fort Worth. The contract
was drawn up in 1959. Noguchi proposed to use two kinds of stone: one
giant granite boulder and fifteen natural green stones of metamorphic
schist and striations of quartz. He envisioned three planting areas with
Texas flora, including an "arid" garden of yucca and mushroom cacti with
the smallest of three sculptures—six feet high—on it. Noguchi's experi-
ence of questing for stones in the swift-flowing rivers was not forgotten;
he once wrote, "Beautiful stones are always found where there is beauti-
ful clear water." His great pleasure in what he called "fishing for rocks"
was conveyed in a letter to his friend Priscilla Morgan dated May 5, 1960:
"With me nothing happens, but rocks. A reflection of my rocky heart.
. . . The best rocks are always found near a clear brook or spring water,
with an indescribable view as at Tsukuba Mountain, where the flowers at
this time of year are delicately emerging." In his autobiography he wrote:
"I managed to convince everybody that the Fort Worth sculptures could
best be done in Japan. As a result I went there and a week after arrival,
through good fortune and proper introductions, I found myself halfway up
Tsukuba Mountain looking at great granite boulders."[7] There was no road
on Tsukuba other than a trail through rocky woods; with the bravura of
Michelangelo, Noguchi decided that there was nothing to do but to build
a road for the distance of half a mile, down which the rocks could be
skidded. This extravagant adventure was patiently endured by the pa-
trons, as was Noguchi's insistence later that each rock must be in place
before he could decide on the planting. Meanwhile, an unpleasant cam-
paign was instigated in the press by local patriots in a tone that could not

fail to disturb Noguchi and open old wounds. The motto of his antago-
nists was "Buy American." The bank, with admirable forbearance, first
resisted in silence, but eventually had to point out that Noguchi was
American.

The elaborate correspondence on this project suggests that Noguchi
was eager to control each step, from the decisions concerning the planting
to those concerning weight bearing (he cored the largest sculpture in
Japan) to arguments about streetlights and night illumination. In addition,
he considered the specific location (the American West) and claimed that
the three Tsukuba granite sculptures—twenty, twelve, and six feet high—
were partly inspired by American Indian totem poles (although their
regularity in juxtaposition of rectangular and tubular forms suggests far
more a Japanese origin).

In many ways the Fort Worth project was a prelude to Noguchi's most
important works in subsequent years, bringing together concerns he had
pondered long before. The idea of a plaza as a kind of theater and a unifier
of varied elements into a single sculpture began to crystallize in this
assignment, in which Noguchi's sculptures were conceived as a unity. He
tried to explain to journalists when the Fort Worth plaza was completed.
He said the plaza was

> like a crest of a wave. The crest does not exist by itself. It is a part
> of the wave, and the wave is made up of foam, water, air, eddies,
> whirlpools. All of these are part of the wave and the wave itself
> is related to the rest of the water. So is this piazza one sculpture
> with a number of elements . . .[8]

The idea of several elements in one, of the theatrical piazza, would
find consummate expression in one of Noguchi's next projects—certainly
one of his most splendid creations—the sunken plaza for the Beinecke
Rare Book Library at Yale University. Again, Gordon Bunshaft had called
upon Noguchi for this important commission. Bunshaft himself was unusu-
ally excited by the prospect, as Noguchi recalled, remarking that the
architect looked upon the Beinecke Rare Book Library as "a once in a
lifetime opportunity to make something great and lasting."[9] Noguchi took
the assignment very seriously and worked out two preliminary schemes,
both inspired by the sand mounds he had admired in Japanese temple
gardens. (Both were discarded.) From the beginning, he had in mind to
make a contemporary sculpture composed of several elements that would
function psychologically, as did the contemplation gardens in Japan. But
as he worked, he remembered also the astronomical gardens of India,
which he had so carefully photographed in 1949, and the formal paving
patterns of the great piazzas in Italy. Gradually, he fused these anterior

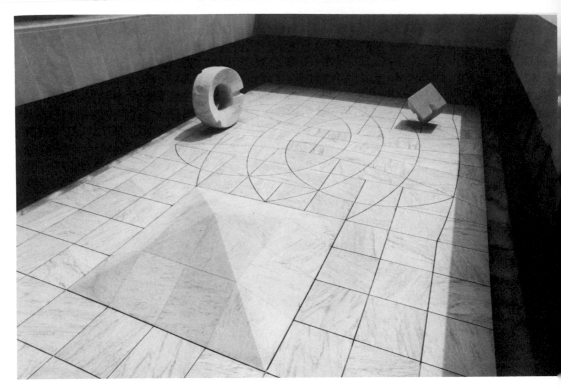

Sunken garden for
Beinecke Rare Book and
Manuscript Library,
1960–1964, Yale
University. 40 × 50 feet

impressions and began to invent for Yale what he later called "a dramatic landscape, one that is purely imaginary; it is nowhere, yet somehow familiar. Its size is fictive, of infinite space or cloistered containment."[10]

Without question this project reflects Noguchi's abiding interest in classical sculpture and his desultory returns to Greece, where he haunted the marble quarries and stone dealers' shops. It is one of the two valences that consistently drew him: one toward geometry and purity, the other toward heterogeneous nature, pondered and respectfully re-presented as art. Early in his deliberation he had decided to use marble and after some hesitation went to inspect the quarries in Vermont, where, to his delight, he found a fine-grained stone with very faint pearly veins that suited his vision of a unified sculpture of elements.

These hunts for stone must not be underestimated. Noguchi used to talk about how this or that encounter would "get me going." One of the most significant ways he got himself going was by visiting the sites where

living stone resided, where he could guess and divine its properties. His formative urge was often instigated by the sight of a great outcropping of stone or a hint of a marvelous interior beneath the skin of recently quarried blocks. His frequent returns to Italy, most particularly to the sites that once saw Michelangelo stalking his elusive prey, always stimulated him. His mounting excitement when he saw emergent marble blocks on his inspection tours of the marble yards was often the source of his larger undertaking.

To fathom the magnificent ambition that underlay the Yale project, it is important to bear in mind the long meditation on the potential of stone that began with Noguchi's discovery of the art of Brancusi, moved on to his consideration of the whole world's history of stone carving, and circled to the commanding figure of Michelangelo. Noguchi's references to Michelangelo were significant. Unquestionably Querceta, Pietrasanta, and Michelangelo's mountain, Altissima, made deep and lasting impressions on him. But even more important was Michelangelo's work as the greatest of carvers, in which Noguchi could discern the hand of the artist in minute details where the claw chisel had left its mark; or in the way the master unerringly used his chisel to furrow the folds of a garment in long, beautiful strokes. Moreover, Michelangelo's belief that within the stone there lay the essential form, given by nature and impossible for an artist to conceive on his own, is reflected in many of Noguchi's statements. The Neoplatonic mysticism that led Michelangelo to brood on the gulf between spirit and matter, and his efforts to reconcile them in a work of art, are at the heart of a legacy that passed all the way into the modern period. Noguchi in his early application for a Guggenheim grant—when he was only twenty-one years old—already spoke of seeking "a fine balance of spirit with matter."

For Michelangelo there was no other way for an artist to release the concept from within the stone than the long and exacting procedure of his own tools. Not long after he died, as Rudolf Wittkower said, "a process set in, in the course of which the modeler (the artist who handled wax and clay) became the sculptor and the original sculptor (the one who works the stone) was eventually turned into a mere craftsman or technician. A gulf opened between invention and execution."[11] That gulf, with a few notable exceptions, remained until the advent of the moderns, and the renewed interest in *taille directe* largely inspired by Noguchi's master, Brancusi.

When Noguchi was first smitten by Brancusi in the 1920s, he had already vaguely heard that the modern movement dedicated itself to going back to the origins; to using the examples of the so-called primitives; and to applying the notion that direct carving was more authentic than modeling. He had already acquired the modern contempt for the academic approach in sculpture—above all the pointing process in which machinery was used to enlarge and fabricate sculptures first modeled in clay. This

contempt was generally shared by the avant-garde Europeans who did not
spare Rodin from their gibes. Yet, no sculptor in the modern movement
could get out from under the towering shadow of Rodin, not even Bran-
cusi, who had avoided the master, saying, "One cannot grow in the
shadow of great trees." Rodin's conception of sculpture, totally original
and based on his conviction that there were a few geometrical forms from
which all nature proceeds, was fundamental even to Brancusi's approach.
Rodin had been explicit about his break with conventional approaches to
sculpture; in the early 1900s, everyone knew his views, which were widely
published. He insisted that a sculptor must always consider a surface as
the extremity of a volume; that instead of regarding parts of the body as
more or less plane surfaces, the sculptor must imagine them as projections
of internal volumes. His figures, he said, were not made of surfaces but
"grow from the inside out, just as life itself." The notions of organic
growth from an interior axis, and of form as radiating from a center, were
central to Brancusi's life's work and the work of many subsequent and
diverse modern artists, including Noguchi.

Noguchi's own attitude toward Rodin may be guessed from the fact
that he kept in his library a 1912 edition of Rodin's paean to the *Venus of
Milo* in the Louvre. Certain passages are marked; from the context of
Noguchi's interests, I believe they are his own markings. For example:

> What is divine in you is the infinite love of your sculptor for nature.
> More ardent and above all more patient than other men, he was
> able to lift a corner of the veil too heavy for their idle hands
> . . . the realities of nature surpass our most ambitious fancies. Our
> thought is but an imperceptible point in nature.

And perhaps remembering Michelangelo:

> Man is incapable of creating, of inventing. He can only approach
> nature, submissively, lovingly. For the rest, she will not disappear
> from his sight; he has but to look, she will let him see what by force
> of patience he has arrived to understand—that only.

Rodin rapturously described the splendor of the statue's body, her belly,
"large like the sea," and continued:

> It is the rhythmic beauty of the sea without end . . .

And the following passage could not fail to move Noguchi:

> The ancients have obtained by a minimum of gesture, by the
> modeling, both the individual character and the grace borrowed

from grandeur that related the human form to the forms of the universal life. The modeling of the human being has with them all the beauty of the curved lines of flowers. And the profiles are secure, ample like those of great mountains; it is architecture.

He also marked the sentence:

The great artists proceed as nature composes and not as anatomy decrees.

Finally, the penultimate sentence:

Approaching her step by step one imagines that she has been gradually modeled by the continuous effort of the sea.

It is true that Rodin was essentially a modeler, and that his stone sculpture, hardly touched by his hand, is never as convincing as his bronzes. Brancusi's disdain for Rodin's way of working—he loathed clay modeling and referred to clay as "biftec"—was often expressed. But his respect for Rodin was profound, undoubtedly grounded in his understanding the organic flow of nature as the primary source of Rodin's imagery. He echoed Rodin when he said: "It is not the exterior form of things that is real but the essence of things. Acknowledging this truth, it is impossible for anyone to express something of the real in imitating the exterior surfaces of things."[12]

Noguchi's short apprenticeship with Brancusi brought him to the issues that were to become fundamental to his life's work. He had to work them through and, as he often said, reject Brancusi as Brancusi had had to reject Rodin—which is to say, only partially. In an interview in 1975 he was asked what qualities in Brancusi's work first served as an orientation for him. He answered:

Well, the non-representational element. His sculptures were not entirely non-representational, but they were at least not derived from imitating a figure. They came out of the material. At the time there was a lot of talk about "taille directe" but his work was more than just "taille directe": the concept itself came from the material, from the nature of the material. His work came from the creativity of the hand, how you hold a saw, what kind of saw you hold . . . you can't separate concept from technique in the work of Brancusi.[13]

Noguchi's reminiscences of Brancusi always mentioned that Brancusi had taught him how to use tools. The importance of tools in Noguchi's life

transcended their obvious utilitarian purpose. As a small child his mother had assured his acquisition of the knowledge of tools by apprenticing him to a carpenter. Those tools of his childhood he brought with him to America and cherished all his life. In Paris, he learned about the weight and shape of each stonecutting instrument, usually the most basic, that had been used since antiquity. He went to great trouble and expense to gather a set of tools similar to Brancusi's, and the story of his loss of these tools is always told mournfully. He thought of tools as his entrée into the living heart of nature, and the process—the long hours of rhythmic chipping, hewing, polishing—as an almost ritualistic necessity toward the unveiling of truth. "My regard for tools," he said in a lecture in the early seventies in Pittsburgh, "stems from both the Japanese attitude toward tools and from Brancusi. The Japanese saw pulls instead of pushes. I admired the delicacy and lightness of Japanese tools."[14] In a late interview he alluded to Japanese attitudes, "the simplicity, the elimination of wasteful approaches," and said, "You see, for instance, I admire hashi (chopsticks) more than silverware. I think they are rational."[15]

But a tool is not a means to an end for Noguchi, rather it is a means of entry. It was while he was working, he always said, that ideas came to him, and working often meant the wielding of tools and hard physical labor—the kind of intense and rhythmic activity he had observed in Brancusi's atelier. Remembering his old friend Gorky, Noguchi told an interviewer: "He was always polishing the floor at his home. He polished it so often that the floor was shining very beautifully. When I asked him why he did such work, he answered that good ideas came to him while he was doing such menial work."[16]

The Yale project had been preceded by a New York exhibition Noguchi had called an homage to Brancusi—an exhibition of individual marble sculptures that were the fruit of his adventures in Italian quarries and the techniques he had learned as a youth. The love of marble and its interior light, its delicate texture and fine consistency, lingered as he contemplated the new assignment. From the beginning he had intended to bring his hand to bear despite the demands of such large-scale composition. His contract with the Vermont marble company stipulated that they would "fabricate the stone to within one-eighth of an inch" and that Noguchi would complete each element "by his own labor."[17] That labor included at least five exploratory stone renderings of the work's sun element, which came to take on cosmic implications and which he later connected, across the continent, by his mind's eye, with a great carved black sun for Seattle. This white sun in Yale radiated infinitely.

Noguchi had intended "to evoke a dramatic landscape . . . purely that of the imagination. It is nowhere, yet somehow familiar. Its size is fictive, of infinite space or cloistered containment."[18] The experience with Bran-

cusi was at work even here. The sunken garden is conceived at two levels, just as Noguchi said Brancusi's sculptures were, since the base was as much a part of the sculpture as the carving it supported. A base, Brancusi always said, is merely a convention, an artificial horizon. At Yale, the work is the totality of gleaming marble. The marble frame—the balustrade above, from which a spectator looks down—echoes the quadrature of the sculpture court below. Within this overall form, there are several registers—horizons with differing functions. The horizons are, as Noguchi said, fictive, and are perceived as are low-lying horizons of landscape when seen from above, perhaps from a mountain crest. Below, at the level of the garden, the readers in the book stacks see a landscape almost at their feet, with shifting perspectives and transformations wrought by the light from above. The Japanese concern with that which is at one's feet is very much at work here. Sitting behind the glass-walled enclosure, one experiences the pyramidal, cubic, and circular forms as if they grew from the slabs of the court—slabs that Noguchi planned with geometric rhythms in faintly scored, interrupted sequences that pick up the subtle asymmetry of the dominant shapes he created. From below, one is reminded that Noguchi had always had an affinity for enclosures that were well-like, that, in their subterranean darkness, called up to light. (As early as 1946 he had told critic Thomas B. Hess, "Seeing stars from the bottom of a well can also be a sculpture.")[19] At the same time, the experience unaccountably shifts from the feeling of being in a well to that of being at the edge of a great Italian Renaissance plaza. The marble pavement of intersecting circles and squares extends the prospects to, as Noguchi said, a fictive infinity. The arcs and straight lines, like magnetized filings, radiate to give the illusion of a great expanse, one portion of which is dominated by the pyramid rising in almost perfect symmetry to catch the sun in all its seasons, while off center and close to the glass wall is the giant pierced disk that Noguchi called the sun; or zero or energy; or "the nothingness from which we come and to which we return." The carving here is subtle. As the eye glides over its surfaces the circular center appears to become an oval. With his characteristic interest in cosmic mechanics, Noguchi made of this circular shape a crucial gathering point for all the shapes in the ensemble: the sharp edges of the cube on its point and the gently slanting walls of the pyramid seem to refer back to the continuous circling motion of the great disk. The inner light of the white marble travels, fuses, echoes from the four corners of the quadrilateral space.

Noguchi said on one occasion that his first thought for this stone garden had been of the mounds of white sand at Ginkakuji Temple in Kyoto, where one mound is pyramidal, meant to catch the oblique light of the moon and reflect it. The idea of reflection here can be extended to its metaphysical dimension, but it is also just as certainly earthly, endemic to

the sculptural experience. At Yale, Noguchi's task was to make a cloistered space, but one that encompasses time, as do the rare books within the library. The glass walls, which at different times of day pick up and reflect the forms and their shadows, were taken into consideration. Noguchi always agreed with Brancusi that sculpture had to find a way to magnify itself, to grow in the eye of the beholder. Moreover, the mirror, a fundamental element in Eastern philosophy, always attracted Noguchi. Reflections abet Noguchi's need to work with several elements. As he told Martin Friedman, they accumulate energy between them, they call to each other, and "pretty soon, there's a kind of hum because of this vibration that is occurring between objects and between the spaces and presently there is a kind of magnetic gyration into which you are then caught."[20]

In another of Noguchi's important collaborations with Bunshaft—the sculptured water garden for Chase Manhattan Plaza in New York City—there is a similar concern with a concatenation of elements, but the approach is the culmination of several years' preoccupation (heightened during the UNESCO experience) with the meaning of stones in the Japanese garden.

While the Chase project was in progress, Noguchi spent a summer in Rome, where he made the floor-level sculpture of stonelike bronzes that he titled significantly *The Lessons of Musōkokushi*, named for the man whom he called "the legendary master of Zen whose stone arrangements are the most esteemed."[21] Noguchi's exposure to the Japanese garden had come early, during the 1930 trip, but each subsequent visit, starting in 1950, brought him closer to the philosophical basis, the real meaning of Musō Kokushi's contribution to Japanese aesthetics, first through the good offices of Langdon Warner, who had accompanied him on an excursion to Nara. Warner was a professor of Oriental art history at Harvard and a disciple of Okakura. At the time of Noguchi's visit to Japan, Warner was probably gathering material for his book *The Craft of the Japanese Sculptor*—a simply written and exceptionally authoritative book still used today. Warner undoubtedly called Noguchi's attention to a fourteenth-century portrait in wood of Musō Kokushi showing his clever ascetic face in such lifelike detail that it may well have been taken from life. It might have been Warner, too, who related some of Musō Kokushi's attitudes toward nature, which Noguchi would later seek to clarify for himself through discussions with resident monks.

Certainly the evolution of Noguchi's theory of gardens was inflected by his serious study during the 1950s. He had access to translations of fragments of Musō Kokushi's texts, and it is not impossible that at the time he was contemplating the Chase project Noguchi was familiar with the ideas in Musō's best-known literary work, *Muchu-mondo*. In it the priest

described with some sarcasm (this was the man whose signature late in life meant "simple and artless old man") the kinds of people who create gardens. There are those "who in their hearts have no particular liking for landscape but ornament their residences because they wish to be admired." Then, there are those who seek to amass fine stones and remarkable trees in the same way they cling covetously to a thousand things. Musō prefers those simple beings who do not prize the "dust of the world" but play the flute at springs and stones. Although they are not profound searchers after truth, they are "the lovable ones of this earth." Musō saved his highest approbation for those

> for whom the sight of mountain and water dispels sleepiness, comforts loneliness and sustains their search for truth. They differ in this from the love of landscape felt by the majority. This must truly be called honorable, yet because they still draw a distinction between landscape and their way of truth, one cannot really call them seekers after truth. But those who feel mountains, rivers, the great earth, grasses, trees and stones as their own being, seem it is true, by their love of nature, to cling to worldly feelings, yet in this very thing their real search for truth is revealed. . . . So they are perfect examples of the fact that real seekers after truth love landscape.[22]

Noguchi himself had sought to express the feel of mountains, rivers, earth, grasses, trees, and above all stones, as his own being. Stones were lodged in his imagination. Stones in water—a specialty of the poets of Japanese gardens—had fascinated him during his first journeys away from Tokyo between 1950 and 1952. In his photographs of the 1950 trip to Kyoto, there are countless views of stones placed in ponds or emerging like mountains from smaller bodies of water, as well as a number of photographs of *tsukubai*, "the traditional hollowed stones," as Noguchi noted, "into which water trickles. They are used in a Japanese garden as both visual and aural objects of pleasure."[23] Now, once again he conceived a project that would bring him back to the adventure of fishing for stones in the swift-flowing rivers of Japan.

For the Chase plaza, Noguchi had in mind both dry gardens, such as Ryoanji, where the water is metaphorically suggested by raked sand, and water gardens, as in Katsura, in which stones are carefully placed to suggest literary associations. The allegorical implications of the seemingly natural disposition of stones were always important. In Noguchi's mind, stones were easily translated into mythic symbols. In one of his most amazing theater works, the decor for the 1948 ballet *Orpheus*, there was a scene that prefigured his imaginative program for the Chase garden. In

his autobiography he succinctly declared that never was he more person-
ally involved in creation than in *Orpheus*, the story of an artist:

> Even inanimate objects move at his touch—as do the rocks, at the
> pluck of his lyre. To find his bride . . . he descends in gloom as
> glowing rocks, like astral bodies, levitate . . .[24]

The idea of levitating rocks had lingered, although by the time he
commenced the Chase project, they had also become instruments of his
defiance of the Japanese addiction to nature. "The chief interest here," he
wrote later, "is the use of rocks in a non-traditional way."[25] For all that,
Noguchi's fine sensitivity to the great Japanese traditions is at work in the
Chase garden. His careful selection of stones from the Uji River—stones
shaped not only by wind and water, but by the sand that rushes at their
flanks and works, as does the marble sculptor's abrasives, to smooth out
rugged shapes—was certainly in the great tradition of stone connoisseur-
ship. On his 1950 trip with Hasegawa he had shown exceptional interest
in the ink paintings of Buson, a poet-painter of the Edo period whose
observation of rock formations was remarkably keen. In 1783, the last year
of his life, Buson had painted a six-panel folding screen depicting only
rocks, which, as John Rosenfield and Shujiro Shimada pointed out, hover
"in an almost cosmic space, with a feeling of neither gravity nor mass."[26]
This screen was much admired by postwar Japanese artists, who quickly
grasped the fertile imagination at work. Floating unmoored on the paper
screen, the rocks are metaphoric and astoundingly modern in feeling.
They are literally abstracted from nature and given a new, totally original
identity that must have excited Noguchi greatly. (It is of some interest that
Buson had most probably begun as an actor; that he had mastered the art
of Chinese poetry while still young, and that in his late thirties, he had
undertaken an intense study of Chinese painting.)

But Buson was not Noguchi's only source: there was his long con-
course with surrealist artists who had always shown a strong interest in the
properties of stone. Max Ernst, several of whose books Noguchi had
acquired during his first sojourn in Paris—books that remained in his
library—described a visit with Alberto Giacometti to Maloja, Switzerland,
in 1935:

> Alberto and I are afflicted with sculpturitis. We work on granite
> boulders large and small from the moraine of the Forno glacier.
> Wonderfully polished by time, frost and weather, they are in
> themselves fantastically beautiful. No human hand can do that. So
> why not leave the spade work to the elements, and confine our-
> selves to scratching on them the runes of our own mystery?[27]

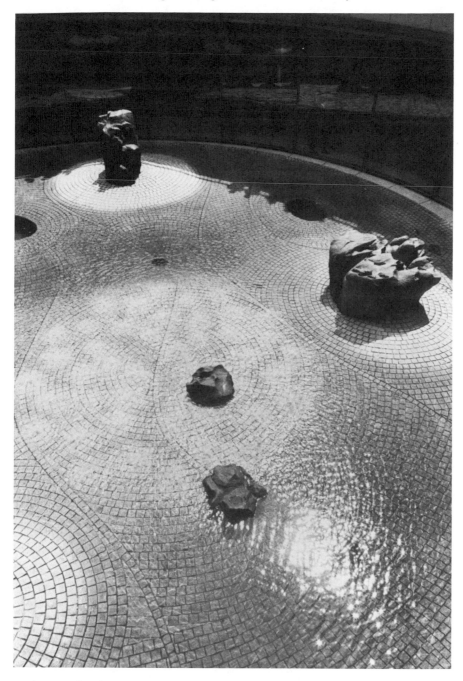

Sunken garden for Chase
Manhattan Bank Plaza,
1961–1964. Diameter 60
feet. Photo: Arthur Lavine

When Gordon Bunshaft asked Noguchi's advice in planning the excep-
tionally large public space for Chase Manhattan Plaza, the sculptor imme-
diately proposed a sunken garden, which, like his Yale piece, would be
seen from above by anyone who happened to be strolling in the Wall
Street district, and also from below by employees and users of the banking
offices. The main building was to have a number of stories below ground
level, and the banking offices circling the sunken garden were to be sixteen
feet below ground level. As always in such huge undertakings, there were
endless negotiations, discussions, adjustments, and counterproposals that
tried Noguchi's patience. He was craving the stone quest. Well before the
contract was signed, he took himself off to Japan for the rock expedition.
His efforts, as he told Friedman, almost failed, for in the year it had taken
for the bank to make its decision,

> the great big stone (which is the most beautiful thing) was sold and
> I had a hell of a time trying to get it back again. It had been
> shipped to the other end of Japan by somebody who had pur-
> chased it. I used every kind of pull to get it back.[28]

Not only did he make all the complicated arrangements to wrench these
wonderfully shaped basalt rocks, carved by the elements, from the river
in Japan and bring them to New York, but Noguchi also participated in
each step of the shaping of his garden. He even carefully supervised the
details of engineering (how to lay the concrete base to support such
weights; how to shape the undulating circular bed on which they would
repose; how to position the rocks according to the engineered plan). When
the great stones were delivered, Noguchi spent days on his belly, his
knees, his back, with his measuring rod, assuring the exact placement for
his levitating rocks. It had been fairly clear that during the winter the
garden would be dry, its pattern of gentle swells in the pavement suggest-
ing water "like the contour raking of Japanese gardens, but they go back
more to their Chinese origins of stylized sea waves."[29] Its dry stones were
meant to be at once metaphors of mountains and a single abstract sculp-
ture. In the summer months the pool was to be fed by a central fountain
made up of forty-five vertical pipes that would be programmed to produce
massive spray, a bubbling effect, and many other water-play variations.
Two of the smaller stones would have holes drilled in them from which a
slight film of water would emerge and slide down their flanks. For the
water's almost silent movement, Noguchi found a fine metaphor: he said
it was "sort of a grace note."

There were many conflicts about the garden. At one point Noguchi
was engaged in an almost comical struggle to force Chase to remove
unwanted goldfish. But finally, this garden, a prototype in its use of so

Noguchi at work at
Chase Manhattan Bank
Plaza, ca. 1963. Photos:
Arthur Lavine

many elements—sound, water, volume, flickering lights, elements both sculptured and natural—would serve as a proving ground for many of Noguchi's subsequent grand projects. It was in many ways his first completely controlled experiment with the old idea of "the total work of art" in an urban environment.

The setting for what is Noguchi's most remarkable garden—the sculpture garden for the Israel Museum in Jerusalem—was so spectacular that when he first saw the site it roused in Noguchi visions that swept in from all the sources of awe he had known in his past travels. He thought of it at times as his own Acropolis; at times as a total sculpture, or a parable of the cosmos. So grand in its scope from the very beginning—from the moment Noguchi laid eyes on Jerusalem, a city to touch his heart in its fundament of stone and its pervasive glow of warm ocher—this project he knew would entail great patience with endless problems. The story of its evolution is fraught with distressing conflicts, but it did get done and was a source of pride to Noguchi. In the earliest statement of his plans, Noguchi opened: "Jerusalem is not a city, it is a place of the emotions." Unquestionably, this was one of the most emotionally charged commissions Noguchi had undertaken since his Hiroshima project. With his dual approach—to the living earth as we walk it, and to the imaginative constructions man has devised to explain the mysteries of existence—he was stirred by the associations the name Jerusalem evoked as much as by its remarkable topography. He was, after all, a lifelong student of William Blake, whose vision of Jerusalem, in which he talks of "the precious unhewn stones of Eden," finishes with the cry "All human forms identified, even Tree, Metal, Earth & Stone . . . And I heard the name of the Emanation: they are named Jerusalem."[30] Noguchi was also a lover of the great stony vistas of the world, the prodigies carved from stone depths, such as the magnificent temple hewn entirely from living rock in Ellora in India. He had marveled when confronted with the massive terraced rice paddies in the mountains of China—their curving palisades, like a whorl of a seashell, and their supporting walls of cinnabar. He had been moved during his first trips to Italy by the curving retaining walls carved of tufa, the elliptical architecture of the ancient Etruscans in Cerveteri, and by the "vastness of the Temple of Poseidon" at Paestum, revealing "the sacred relation of man to nature."[31] And he had shared with Louis Kahn a deep respect for the Greek vision expressed in the Acropolis. (He had referred to the site of his very first large project, his memorial to his father, as his "acropolis.") These were all sources of emotion for Noguchi. But there was another.

In many interviews, Noguchi referred to his feeling of kinship with the land and people of Israel. He told Martin Friedman that his going to Israel was in a way like going home, "seeing people like myself who craved for some reason or other a particular spot on earth to call their own. . . . The

Billy Rose Sculpture Garden,
1960–1965. Israel
Museum, Jerusalem.
Photo: Isamu Noguchi

Jew has always appealed to me as being the endless, continuously expa-
triated person who really did not belong anywhere. That is the way the
artist feels."[32]

In a searching interview late in Noguchi's life (April 28, 1985), the
Israeli novelist Matti Megged elicited a more complex statement. The
sculptor told Megged that he tried "to build an oasis for myself and for
people close to me. I always wanted to go beyond art objects. I wanted to
reach what may be defined as a way of life, a space of life, or even a
ghetto, closed and defended from the world." Noguchi spoke of "the
permanent contradiction between belonging and non-belonging, between
the wandering artist who doesn't belong to any place, and the desire to
find balance between organic forms and geometrical organization." He
repeated what he had told Friedman, but with an additional and crucial
increment, the restatement of the Orpheus myth:

I came in some respects as one who returns home. I knew there
were people like me who wanted to shape a certain part of the
earth that would be theirs. I wanted to discover anew the myth of
Orpheus—up and down, inside and outside—a myth not *bound* to
any space but attached through the stones from which it was
born.[33]

Perhaps these deep and important associations were the reason that
Noguchi, by nature impatient, was able to sustain the running battle with
his patron, Billy Rose, and also the reason that he established such close
relationships in Israel. From the outset, he had a cordial relationship with
Teddy Kollek, later mayor of Jerusalem and his staunchest supporter.
Intelligent, diplomatic, vigorously committed to the new Jerusalem in the
making, Kollek frequently smoothed the way for Noguchi and remained
committed to the sculptor's original vision to the end of Noguchi's life.
(The thorny issues stayed alive to the finish, with Noguchi struggling to
keep his "sculpture" intact while others sought to modify it.) Letters in
Noguchi's archives suggest that he formed personal relationships (rela-
tively rare for him) of considerable depth and that he showed great com-
passion when news of Israel's calamities in the wars reached him. He took
very seriously his role on the international committee of advisers for the
master plan for Jerusalem. No doubt his initial encounter with Kollek in
January 1961 spurred him on, for Kollek had the kind of determined
enthusiasm that could sustain grand visions.

Noguchi first met the showman and entrepreneur Billy Rose in the
1950s, when Rose had approached him to create a sculpture garden for his
own home in a suburb of New York. When his house burned down, Rose
decided to donate his collection of modern sculpture, together with funds
for its installation, to the museum in Jerusalem. Noguchi was wary when
Rose proposed the sculpture garden to him, knowing Rose's reputation for
unpredictability; but when he went to Israel in January 1961 to explore
the terrain, he was captivated by the rock-strewn hill that would offer him
five virgin acres for his inventions. His imagination was kindled when he
was told that the biblical name of the hill was Neveh Shanaan, translated
as "quiet habitation" or "place of tranquility." Almost immediately he
conceived of the means to turn the crest of this unnegotiable hill of stone
into five acres of "walkable space through the device of large, curved
retaining walls, which are like great wings seen from the University, or
like vast ships' prows from within the garden."[34] These great rubble walls
would fulfill his old dream of carving mountains (he had been, after all,
Borglum's apprentice) and revive his early notion of *Play Mountain* and
Monument to the Plough. Moreover, his long romance with walls, begun
during his *Wanderjahre* in Europe and Asia, had not yet found full expres-

sion. Although his earlier studies, particularly during his sojourn in Japan, when he photographed with precision many variations of fitted stone patterns including walls and stairways, had found initial articulation in miniature at UNESCO, never had he had such lofty and unlimited spaces to shape. The rare light of Jerusalem, indescribably beautiful, inspired him to create strong sculptural forms that yet recalled the ancient walls farmers had always used to shore up hilly fields. Noguchi immediately saw that here, at last, he could make what he called "a play between the sky and the horizon" with his retaining walls, and always the most important reference would be to the sky.

The duality of his thinking, which he always recognized as endemic to his personality, here found a happy simplicity in the juxtaposition of sky and earth, man's invention and nature. (This duality would find a rather too-explicit expression in his gardens for IBM in Armonk, New York, where Noguchi made two separate areas, one with a rather traditional arrangement of almost natural rocks and the other with a futuristic reference to man's invention, complete with a low-lying black dome inscribed with mathematical formulas and a sunken concave fountain suggesting a dish for some electronic device.) In Jerusalem, Noguchi found what Louis Kahn had called "a wonderful opportunity to work with nature and ride with its blows."[35]

In 1964, when the five walls were almost complete, Noguchi noted that "fundamental to the design is my regard for the sanctity of the place, the earth and the sky above. I wished to raise a song of praise to the place. The earth itself would be the means."[36] His conception had evolved slightly, as he wrote: "I wished to retain this dialogue of earth and sky, with no symmetry other than those given by the walls nor any arbitrary paths to break the swell of earth. For this reason the plant areas and the planting are asymmetric." Still, Noguchi began to realize that this earthy, pathless asymmetry might not be adequate for the conventional sculptures, some of them relatively small, in Rose's collection. He was beginning to work out his idea for the formal plan with its geometric dividers, which at that point he referred to as "some large base elements." The walls and the pathless areas of gravel and plantings were conceived in what Noguchi liked to call a non-Euclidian garden concept, a counterpart to the Euclidian geometry of the architecture. But something more was needed—the sculpture court, its roofless rooms, and the covered sheds for sculpture that could not endure the weather. With these new thoughts he began to run into problems with Billy Rose, who balked at the extra expense. Much wrangling took place, not only over the limits of Noguchi's mandate, but over money-saving measures proposed by Rose (such as asphalt instead of gravel, and fewer olive trees). Tenacious as always, Noguchi fought the good fight and, for the most part, won. By 1965, for the

official opening of the museum, presided over by a visionary worthy of
Noguchi, Willem Sandberg—a Dutch apostle of the most daring modernist
trends, a superb designer, former director of the Stedelijk Museum, and
courageous underground fighter against the Nazis—nearly everything es-
sential was in its place, including a magnificent horizontal granite foun-
tain, like an ancient vessel, at the crest of one of the wavelike rubble
mounds. For this strong piece Noguchi had searched in Israel's ancient
sites in the southern region around Eilat. He wrote to his occasional
assistant, the sculptor Gene Owens, in January 1964, enclosing a photo-
graph of great prowlike rock formations presumed to be King Solomon's
mines. "Here I am at the end of the world looking for a piece of red granite
right behind the extraordinary formations . . ."[37] This inspired sculpture
was a crowning feature for the majestic hill he had so ingeniously shaped.

Noguchi's *Fountain* and
view of surrounding
mountains, Billy Rose
Sculpture Garden,
1960–1965. Israel
Museum, Jerusalem.
Photo: Isamu Noguchi

Straddling this ancient Judean hill is a museum of more than twenty pavilions designed by the architects Alfred Mansfeld and Dora Gad. It covers some twenty-two acres. Encircling it are other equally venerable hills, some of which are adorned with stone retaining walls (straight, not curved, as Noguchi stressed) trailing around the hills in rhythmic sequences, as they have appeared in many other ancient places Noguchi had seen. Olives and Jerusalem pines sway slightly in the perpetual breezes at the heights, playing against the often blanched sky. When the garden is approached from a distance, Noguchi's inspired judgment is apparent from every vantage point. Within a large radius of many kilometers the carved mountain is visible, and as visitors move in closer, they can perceive details, sensing the way Noguchi shifted earth and rock to build his artificial pyramidal shapes and his rounded mounds as echoes of the neighboring hills. The Japanese conceit of borrowed scenery is brilliantly adapted here. For the exhibition spaces, Noguchi designed a grand plaza opening out from the museum buildings to the descending curving platforms. Large sculptures, such as Henry Moore's *Figure in Three Pieces*, are posed against the Jerusalem horizon at the crest of one of Noguchi's prowlike walls, while smaller sculptures are set against varying walls, some rectilinear, some curved, some triangular, in the area Noguchi designated as Euclidian space. This court of screenlike backdrops for smaller sculptures always troubled Noguchi, who kept trying to modify the spaces with planting. But on the whole, the totality of his creation in Israel profoundly satisfied him. He said of this "ghetto, closed and defended from the world," this "oasis," that it would be "a space of life, a way of life," seeing it as "some monadic theater, a world that exists, grows, and changes from its own force."[38] The monadic theater, a hypothetical place that in itself can reflect the entire universe, a *theatrum mundi*—had existed for some years in Noguchi's imagination. In Jerusalem it became a reality.

Portal, 1976, Cuyahoga
Justice Center,
Cleveland. Steel pipe,
35 × 40 feet

Cosmos
out of
Chaos

WHEN THE MUSEUM in Israel was dedicated in 1965, Noguchi was sixty-one years old. Ten years later, on May 3, 1975, during an anniversary celebration in Jerusalem, he stressed the importance of this unparalleled opportunity in his life, posing the rhetorical question: "How many chances does one have to do such cosmological work, let alone earthworks?" Anticipating his own future direction, he declared: "What is needed is a larger definition of sculpture and a larger motivation. The artist is just a conduit." The Jerusalem experience had called upon all of Noguchi's rich resources and sharpened his focus on the philosophical implications of his life's work. More and more the "cosmological" perspective conditioned his approach. Judging by his various discussions, it appears that Noguchi's view of cosmos had begun to take form during his 1950 visit to Japan, during which he and Hasegawa had discussed both Zen ideas of cosmology and those of Paul Klee. The Swiss painter had again and again spoken of the artist's obligation to wrest cosmos out of chaos, declaring that every point is potentially cosmos, every seed is cosmos. Klee wrote: "I begin logically with chaos, that is the most natural and I am at ease, because at the start I may myself be chaos . . . 'cosmogenetically' speaking, it is a mythical, primordial state of the world, from which the cosmos develops."[1] Noguchi—with his sustained interest in origin myths; his occasional meetings with Joseph Campbell, whose passion for comparative mythology attracted him; his wandering to the sites where a cosmological intention had brought forth great monuments; and his search in Japan for aesthetic meanings congruent with his Western formation—had greatly clarified his own artistic questions by 1965. His development, as he often said, had been spiral, and his spiral had always brought him to the axial idea of a *theatrum mundi*. Like Yeats's gyre, Noguchi's spiral—or his helix or double helix—was a relatively vague, virtual figure; a kind of phantom talisman that hovered over his creative life, protecting his ideal of a "monadic" work. Not only was the notion of a *theatrum mundi* his spiritual habitat, but it also provided the overarching idea within which he could live out Blake's admonition to see the world in a grain of sand. This, in turn, was close to Chuang-tzu's vision and the parables of the more lively Zen masters of Japan. As Chuang-tzu had recommended, all his life Noguchi had wandered, not with any fixed purpose, but with the desire to find confirmations of his deepest intuitions concerning the universe. If, when he was in his seventies, he could speak of the artist's being "just a conduit," it was the culmination of a long inner debate in which he

arrived, as had Klee, at cosmos. He had listened to Buckminster Fuller for years discoursing about the "cosmic egg," and he relished the parallel with Blake's mystical diagram of the "Mundane Egg." When scientists at the State University of New York at Stony Brook told Noguchi that he had, in one of his sculptures, unwittingly produced a perfect model of the newly discovered DNA formula, he was ecstatic. When he thought about Brancusi's *Endless Column*, he thought of its nonmateriality, its "anti-materialist origin," which he could easily compare with ideas he had gleaned in conversations with modern Zen masters in Japan.

As he circled the globe each year, stopping off in Greece, Hawaii, India, Nepal, and Italy, Noguchi made imaginative connections, and each time deepened his knowledge. Sometimes after a particularly stimulating experience, as in India for instance, he would live for a time with the imagery and then pass on. The subterranean connections, however, were always there. India remained an important spiritual source (one of the sculptures in his Whitney retrospective in 1968 was titled *The Gunas*, for the three qualities of Sankhya philosophy: tension, purity, and goodness), but it was Japan that offered him what would be, for the rest of his life, his reigning metaphor: the garden. During the 1960s he spent more and more time in Japan, where he renewed friendships with men as active and driven as himself. His old associate Kenzō Tange was by now world renowned, as was Sōfū Teshigahara and his son Hiroshi, who won many honors with his film *Woman of the Dunes* in the mid-1960s. The designer Yusaku Kamekura was celebrated in Europe, and artist friends such as the Domotos and Inokuma had also made their mark both in Europe and the United States. Noguchi's frequent visits encouraged his friends to draw him into the increasingly rich Japanese cultural life. He was amenable. In 1964 he carved a powerful tribute to his own strongest impressions and the current ideas he shared with these friends—a piece he called *Jomon*, which stands invincibly on its strong columnar volumes, its profiles as distinctive as a calligraphic character. Tange had just published his book on Ise, in which he had discerned the two strains of ancient Japanese culture, Jōmon and Yayoi—"the vital and the esthetic"—and when it appeared in English in 1965, he gave Noguchi an inscribed copy. Eight years later Noguchi spoke of the period: "All my friends from Tange to Teshigahara always talk of themselves as being Jōmon and not Yayoi, Yayoi being the first evidence of the sort of refinement the Japanese are capable of."[2] These friends were vigorously engaged in the struggle to define themselves as both Japanese and international, returning constantly to what Noguchi called "pre-Japan" for inspiration, and he joined them, at least now and then.

Many of Noguchi's most important works of this period are based on his realization, sometime in the late 1960s, that his most potent medium

Hiroshi Teshigahara and
Hisao Domoto in Kyoto,
May 1986. Photo: Denise
Browne Hare

henceforth would be stone. After establishing himself in a quarry studio
in Querceta, where he had found excellent equipment and skillful assist-
ants, Noguchi turned to Japan, seeking a permanent workplace. He had
decided to make the enormous *Black Sun*, commissioned by the city of
Seattle, in Japan and began looking for a suitable atelier. Inokuma, a
native of Takamatsu in Shikoku, suggested Mure, a stonecutters' village
adjoining Takamatsu. Noguchi had long before explored Shikoku during
his first stone expedition for UNESCO and eagerly returned with introduc-
tions through Inokuma to Governor Kaneko and to Tadashi Yamamoto, a
young architect working for the prefecture—a striking giant, a former
Olympic champion, whose vast exuberance appealed to Noguchi. Like
many others in Japan, Yamamoto knew Noguchi's name primarily because
of the Hiroshima project which had been widely publicized. He was well
aware that the sculptor's presence in Shikoku would be important. He
listened to Noguchi's requirements—a studio, accomplished assistants,
and a house—looked at the small model of *Black Sun*, which Noguchi
wanted to create in huge dimensions, and thought immediately of Masato-
shi Izumi, the twenty-five-year-old son of a family of stonecutters, who
had grown up learning how to extract stone from nearby quarries and how
to make lanterns and tombstones.

Izumi had never been exposed to modern sculpture but was innately
sensitive and quick to perceive. He recently remembered how the idea
of carving *Black Sun* excited him: "I felt I understood." The immediate
affinity between the old master artist and the master craftsman estab-

lished a new epoch in Noguchi's life. Izumi naturally assumed the position of assistant to Noguchi's *sensei,* but he knew his own value as a stone expert, and Noguchi respected him for it. Izumi threw himself into the task of meeting Noguchi's every requirement, right down to the appropriate house for living, which Yamamoto described with gales of laughter:

> Izumi and I went looking for an old house. We heard about a samurai house that had to be sacrificed because they were going to widen the road. The house was in bad shape. Rain came in. But it was a beautiful traditional house. We took Isamu to Marugame and I said, "This is a nice warrior's residence." Isamu said, "I don't want to live in a haunted house." But Izumi and I said, "Let's bring it back anyway, piece by piece." When Isamu saw it assembled he began to like it and began to have ideas about how to change it.[3]

Thus was made Noguchi's second, and this time successful, decision to establish his own oasis in Japan—although even this decision was based on an odd arrangement: the land remained Izumi's as did the buildings on it, although both studio and house were spoken of as Noguchi's. Inokuma, who had sheltered Noguchi in Tokyo during his first postwar trip, liked the coincidence that Noguchi wound up living in his own hometown: "I guess we were meant to influence each other. If I didn't meet him, his life would have been very different."[4]

Masatoshi Izumi, master stonecutter in Noguchi's house in Mure, Shikoku, May 1989. Photo: Denise Browne Hare

From the moment Noguchi settled in Mure, he opened himself again to the lessons of ancient Japan, retracing his steps and carefully reconsidering what he saw. Certainly Japan exercised a great influence of the kind Paul Valéry defined when he spoke of "the progressive modification of one mind by the work of another."[5] One could say that Noguchi underwent the progressive modification of one culture by the work of another. Valéry, who was valued highly by Noguchi's friends in New York in the late 1940s, had also written on numerous occasions of his basic belief that nothing can be attained "through the realm of thought alone"[6]—a belief to which Noguchi subscribed wholeheartedly, and which shared a common ground with many Oriental approaches to the arts.

Black Sun, a Brazilian granite masterpiece nine feet in diameter, was completed in Shikoku by 1969. Noguchi's casual remark about seeing the black sun in Seattle across the continent from the white sun in the Beinecke Rare Book Library in New Haven revealed the true nature of his cosmic perspective in his mature years. No matter what he undertook, Noguchi had in mind what he would later call "the sculpture of space," which was, in effect, a great universal, or cosmic, garden metaphor.

During the next few years, he renewed his acquaintance with Kyoto, Kurashiki, and Nara, studying once again the old stories (because the literary element in many major Japanese gardens, but most particularly Katsura, was significant and spoke to Noguchi's taste for poetry). There are photographs by Noguchi dated August 1969 of the grounds of Katsura; grave markers he came upon during his wandering in old Japan; rocks reflected in the man-made ponds at Tenryuji, a Kyoto temple; and various stone walls, including the elegant patterns on the rice warehouses of Kurashiki. There are also new studies of scenes and actors of the Noh and Kabuki theaters, including an excellent photo of an actor applying his makeup, recalling the careful notes Noguchi had made in 1952. He made repeated visits to Kyoto, where by this time his friend from Paris, Hisao Domoto, had reinstalled himself, vowing to find his own tradition in his own space. He visited temples and conversed with monks. He talked with Hisao and Mami Domoto of his childhood and his earlier visits, and like them, he lamented the transformation of the ancient gardens into commercial and thoughtlessly used places. He had preserved his ideal Japan formed by childhood memories, but he also understood that it was imaginary. The vision of his childhood—that part that he had isolated and made idyllic, with whispering bamboo in gardens, cicadas singing, stones speaking, and his own hands caressing delicate Japanese tools—was impinged upon by his new experiences. Of that he was well aware. Still, in 1976, he could remember Brancusi in a public lecture, not so much for his radical innovation as for his faithfulness to an important tradition. Brancusi, he said, came to Paris to learn,

But he brought with him something more than learning: the memory of childhood, of things observed not taught, of closeness to the earth, of wet stones and grass, of stone buildings and wood churches, hand-hewn logs and tools, stone markers, walls, gravestones. This is the inheritance he was able to call upon when the notion came to him that his art, sculpture, could not go forward without going back to beginnings.[7]

The wet stones and grass were what beckoned Noguchi at this time, while he was reconsidering his early notion of leisure. When he had applied for a travel grant in 1948, he had said it was to prepare a book on "leisure (which allows for meditation on the meaning of form in relation to man and space)."[8] Around the same time he wrote an essay, "Towards a Reintegration of the Arts," in which he declared in the opening sentence:

> In the creation and existence of a piece of sculpture, individual possession has less significance than public enjoyment. Without this purpose, the very meaning of sculpture is in question. . . . Our reaction to physical environment may be represented as a series of hazy but continuous esthetic judgments. Such judgments affect even the control of our emotions, bringing order out of chaos, a myth out of the world, a sense of belonging out of loneliness . . .[9]

Noguchi worried about the loss of leisure—his peculiar way of referring to the way people thoughtfully respond to great created spaces—and again and again sought to refine his own definitions. The meaning of childhood, to which he often referred as an important factor in created environments, such as playgrounds, and as a fateful source of inspiration, was woven into his musings on the idea of play. He thought of play in the complicated context that Johan Huizinga had established in *Homo Ludens*, a book written before the war but published in English in 1950. "Inside the play-ground an absolute and peculiar order reigns," Huizinga wrote. "Here we come across another, very positive feature of play: it creates order, *is* order."[10] Exploring the ancient Greek philosophers, Huizinga pointed out that knowledge and science in ancient Greece were not the by-products of an educational system; rather, "For the Greek, the treasures of the mind were the fruit of his leisure."[11] This concept, close to the oblique teachings of the poet Ryokan, became increasingly important to Noguchi. If he entered into discussions with Zen priests, as he did in those years, it was as much because of his basically Western views of play as order as it was because of his sustained curiosity.

As a matter of fact, Noguchi's excursions into Zen Buddhism were desultory and not always in the questing spirit. There were other issues involved, stemming from traits of his own personality—the stubbornness and rebellion that so many friends have remarked. Noguchi was lining up on the side of his Japanese friends who were fighting a rearguard action against the onslaught of the new generation—or at least a segment of that generation—that was energetically rejecting *Japonaiserie* and "Japanism" in favor of an international viewpoint. Nothing much had changed, it seemed, in the way the arts were organized in Japan. There were still all sorts of artists' groups being founded and dissolved, each based on some minor disagreement about aesthetic principles. There were still, also, official organizations that sponsored either "Japanese" or "Western-style" art and passionate arguments were carried on between proponents of the one or the other. A significant number of artists had attracted international attention during the 1960s; had traveled in Europe and the United States; and had even participated in the great art compendiums, such as the Venice Biennale. Many of them had ruthlessly discarded aspects of their own training and culture. Even the critics, among them Yoshiaki Tono, who was well known in the West, were frantically pumping their bellows in order to spark new movements in Japan, movements that would be easily assimilated by the trendsetters in Europe and America. To these critics, Noguchi's work was *retardataire*. He represented, as Tono had written, "*Japonaiserie* made in America." Many Japanese, recalled Noguchi's brother Michio, thought Noguchi's sculptures were imitations; "you can see them anywhere in Japan," they said. They wanted something new, and they wanted it new enough to impress the others—those outside with whom their relationship had always been ambivalent.

The hunger for novelty, while a familiar vice in the West, was regarded by many Japanese traditionalists as alien to their culture. This was selective viewing, for the quest for novelty has intermittently accompanied Japanese culture ever since the first anthologies of poetry were assembled in the mid-eighth century. Arthur Waley, in his introduction to *The Pillow Book of Sei Shonagon,* explained that to the Japanese of the tenth century, "old" meant fussy, uncouth, disagreeable. "To be 'worth looking at' a thing must be *imamekashii*, 'now-ish,' up-to-date."[12] Tono, in an article written in 1966, was outspokenly partisan. All that wasn't *imamekashii* he disdainfully dismissed:

> We are amused to find that many foreigners still see our mysterious old-Empire as a museum in which Mt. Fuji, *ukiyo-e* (old woodcuts), stone gardens, calligraphy and Zen Buddhism (shall we add transistor radios and electric-eye cameras?) are beautifully displayed. . . . But we, the Japanese of today, are not the bleary-eyed, bowing custodians of that old, mythical museum.[13]

He speaks of foreign visitors who are distressed not to find the exotic, except

> when they come across some calligraphy-like works of the softly colored and hazily formed abstract paintings that are dim and indistinct as the dusk on a sleepy spring day. Such Japanesque painting, however, whether produced consciously or not, is a kind of retrogressive art, grown under glass, an attempt to carry over into the present the remnants of a past that should have died out completely.[14]

Oddly, Tono did not seem aware that his passionate rejection was a rather pale echo of the radical cries of the first generation of Japanese futurists that formed their groups in the 1920s in the wake of Filippo Marinetti and the Russians.

What to certain artists and critics of the young generation, represented by Tono, was regressive, to others was, on the contrary, logical and even avant-garde. Noguchi and his friends, both of his own generation and the generation of their sons, were well acquainted with the changes wrought by new technologies. To them, computers and electronic tools were not so extraordinary or, rather, revolutionary. They were well prepared to accept the improvements offered by advanced technology. But they were apprehensive about the effects of the heedless repudiation of history. If Tange and Teshigahara turned back to prehistory, they were also well aware of the importance of historical continuity. Their attempts to integrate that which was constant in the long aesthetic tradition of Japan were based on the belief that a healthy organism must be endowed with memory—a belief Noguchi shared. His own development of a vocabulary in which the forms not available in his native language of the West were drawn from the East, his ready adaptation to the circumstances he encountered in many lands, and his imaginative responses to those circumstances endeared him to only a few contemporary Japanese. Beginning in the late 1960s, he was met with a certain degree of indifference in Japan and, in some instances, with hostility, not only as a *gaijin* but as an indomitable force sustaining values that others wished to ignore or reject. He sensed this, but did not retreat.

He was, as always, both stubbornly bent on his own objectives and open to new experiences. Noguchi was not simply a twentieth-century version of that great fabulist Lafcadio Hearn, whose considerable talents as a writer were devoted to the defense and description of a Japan that not even in the Meiji period, during which he wrote, had survived the subtle erosion initiated by the arrival of the black ships, as the first Western arrivals were called. Noguchi engaged in a difficult balancing act in which the world's new technologies were juxtaposed with the best of many

synthesized traditions. This became visible when his old friend Yoshirō
Taniguchi, with whom he had collaborated on his father's memorial in the
early 1950s, asked him to make a sculpture for the new National Museum
of Modern Art in Tokyo. Buckminster Fuller's spirit as a *bricoleur* (or, as
Noguchi said, an inventor in the American manner of "making do in an
inimical world by a new and better way of making a mouse trap")[15] rose
up in Noguchi, who, faced with á lack of funds, found an ingenious way
to proceed. In 1964 Japan, impressed with its own miraculous prosperity,
hosted the Olympic games, for which vast urban projects had been pre-
pared, among them a new system of highways and overpasses. Noguchi
benefited from the ample supply of steel girders; he built his sculpture in
1966 as a sort of inverted torii with diagonally sliced finials shooting into
the sky, painted (and many times repainted, always with Noguchi's partic-

Gate, 1969. Iron, 407 ×
114½ × 177½ inches.
National Museum of
Modern Art, Tokyo.
Photo: Denise Browne
Hare

ipation) to catch the attention of those passing beneath along Tokyo's most
crowded major arteries.

The steel sculpture for the Museum of Modern Art in Tokyo was the
beginning of a highly productive period for Noguchi. He was soon asked
by another old friend and associate, Tange, to undertake an elaborate
composition of fountains for the Osaka World's Fair, Expo '70. For once
money was not a problem. Tange gave Noguchi a free hand and the
sculptor seized the opportunity to experiment with long-held ambitions to
alter, and bring into the modern era, the universal idea of fountains. "I
approached the work as something to challenge the commonly held idea
of fountains as water spurting upward," he wrote in his museum catalog.
"My fountains jetted down one hundred feet, rotated, sprayed, and
swirled water, disappeared and reappeared as mist."[16] The elaborate
technology required for these water sculptures presented no difficulty;
Tange had organized a consortium of fountain makers to execute Nogu-
chi's plans. Noguchi used simple geometric forms—squares, circles, and
cylinders—making his fountains part of a worldwide tradition and, in fact,
probably closer to the French tradition of son et lumière than to the
Japanese. He himself said his work derived from "an old Roman concept."
Here, his sense of theater stood him in good stead. The spectacle was
tremendous, according to numerous eyewitnesses awestruck by the pat-
terns of mist, the exciting sounds of the rush of jets, and the scintillating
reflections produced by the interaction, like dancer's movements, of light
and water. His friend, the painter Gordon Onslow-Ford, marveled at
these water sculptures: "Instead of dominating his material by carving,
shaping, chipping, he had found a way to collaborate with nature. His
water sculptures come closer to the Beginning, in which man will create
as an instrument of nature."[17]

This project, all the same, was certainly not derived from Noguchi's
musing, concurrent with its creation, on the use of water in ancient Japa-
nese gardens. His next project with a Japanese architect, however, was
heavily inflected with thoughts activated by his renewed study of such
gardens. In Paris he had begun his reanimation of the traditional stroll
garden. In New Haven he had thought of both Italian piazzas and Japa-
nese contemplation gardens. Now, when the architect Shinichi Okada
asked him to design the garden for the Supreme Court in Tokyo, Noguchi
seemed to hark back to his first impression of the stone contemplation
gardens in Kyoto. In the wide enclosed area between the judges' meeting
room and the courtroom Noguchi created once again a slightly sunken
garden with glass serving both as a well-like enclosure and a reflecting
surface, similar to the Yale and Chase projects. But here, in the sober
circumstance of an official building facing the Imperial Palace, Noguchi's
conception was of a muted, very solemn space. His working title for it was

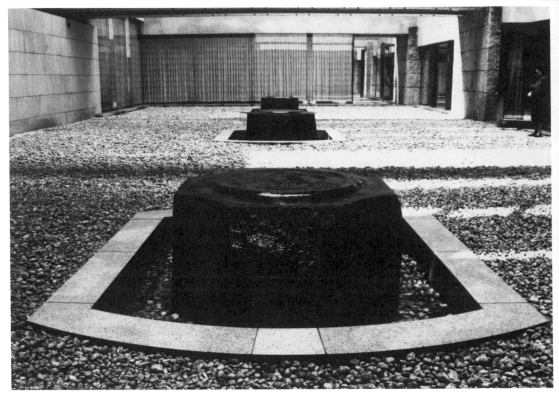

Supreme Court Building
Fountains, 1974, Supreme
Court Building, Tokyo.
Six black granite wells.
Photo: Denise Browne Hare

Tengoku (Heaven)
1977–1978, interior
garden, Sōgetsu Flower
Arranging School, Tokyo.
Photo: Denise Browne Hare

Illuminating Well. At times he suggested that he got his ideas from Egypt—specifically from the "graves for cows found in the grottoes of Egypt," as he told an interviewer in Japan.[18]

In the large space allocated to him, Noguchi framed a two-court, symmetrical garden in which he placed six (or, rather, five and a half) brimming black granite fountains that form a somber cortege down a center axis. The feeling of absolute symmetry is mitigated, however, by the use of large sea pebbles in one court and paving stones in the other; by the subtle variations in the black-to-white color scheme produced by the shifting light of the sun; and by the flux of slowly emerging waters. There is a whole subrhythm of reflections here. Taking the traditional *tsukubai*—the hollowed stones into which water trickles in traditional

Japanese gardens—and reversing the principle, Noguchi used modern devices to create a source from the stone's center. Izumi, following Noguchi's instructions with precision, carved the stones with a slight curving surface in order that the water could wet their surfaces evenly. The stones are only partially polished. The rough-toothed, curving walls echo the pebble motifs of the floor. Here, in the austere silence of a place designated to serve justice, Noguchi has suggested the stern principles that he hoped would guide the judges in their deliberations: purity and balance. As he told his friends, these were the two ideals he had sought to embody in this most solemn of all his grand projects.

Soon after the Supreme Court garden was completed in 1974, Noguchi was called again by Tange and by his old friend Sōfū Teshigahara, this time to design the entry lobby for the new, rapidly expanding Sōgetsu school of flower arrangement in Tokyo. Noguchi's friendship had extended by this time to Sōfū's son Hiroshi, who remained a close associate for the rest of Noguchi's life. It was Hiroshi's idea to have an auditorium below ground level in which he and his avant-garde friends could hold film

showings, performances, and lectures. Tange designed the auditorium in such a way that its upper balconies projected into the vast lobby in a stepped sequence, "like a ziggurat," as Noguchi once said. Noguchi was presented with the problem of transforming this somewhat awkward intrusion in the entry areas into a space suitable for exhibiting the wildly baroque innovations of the old master flower arranger. In his characteristic, cryptic way, Noguchi described his decision to make a hill, relating the project to nature and respecting, thereby, Teshigahara's aesthetic. "Railings were replaced by boulders, the steps were realigned to meet the water flow and the ceiling was opened up with squares of sky."[19] It took enormous ingenuity to enhance the given structure. Noguchi availed himself of water as a fluid element binding form to form. He used contrasts between rough and smooth surfaces, sometimes burnishing them with a translucent skin of water in order to evoke nature and the traditions from which Teshigahara had derived his style. Perhaps unconsciously, Noguchi went so far as to echo Teshigahara's markedly expressionist temperament, using great slabs of rough-hewn granite that clash like temple cymbals and serve as foils for the ephemeral plant arrangements. A distinct baroque accent here is unique in Noguchi's oeuvre and perhaps derives from his deep respect for Sōfū Teshigahara. In general he shunned overtly baroque expression and had long harbored negative feelings toward the style, as a note from his early wandering through Italy suggested: "The Baroque overwhelms structure beneath the movement of its mountains of flesh and scrolls. It is a movement irrelevant, irreverent and boisterous."[20] Yet, in the Sōgetsu design, Noguchi was obliged, in effect, to overwhelm structure and, in the process, bordered on the boisterous in the effusion of stone forms, carved details, and contrived perspectives.

All during this period—that is, from the late sixties to the late seventies—Noguchi journeyed back and forth between the West and the Orient. If at times, as when he undertook to find the appropriate tone for Teshigahara's lobby, he stressed the Japanese intonation, he nonetheless had his mind on the greater synthesis that he sought with increasing urgency in his late years. Late years they were, but Noguchi, who would dance to disco music for hours at his eightieth birthday party at Sōgetsu, was brimming with energy. His lean body was as tense as ever, his step as brisk, his eye as quick to move from one vision to another. His meditation on the inherent qualities of stone was sustained both in Italy and Shikoku, but so was his interest in finding new means and new materials. Sometimes the inner history of his synthesizing imagination is directly readable in individual pieces of the period. *Fudō*, for instance: Noguchi carved the compact form in pink granite in Japan in 1966—a strange form, recalling in its emphatic curves his old tribute to Jōmon. For the base, which, as he later said, was not meant to be separate, he came back to New York, where he designed the tall, elegant, stainless

Fudō, 1966–1967. Pink
granite with stainless
steel base, 69 × 16¼
× 16¼ inches. Photo:
Erick Johnson

steel support—a triangular shape narrowing to a rectangular crest that the stone straddles. There is an air of frontality quite consistent with much Japanese sculpture, and the shape of the steel base viewed head-on assumes the high stylization that can be seen in some of Kōrin's paintings of robed aristocrats, or of the seated, and always displayed frontally, figure of Kōbō Daishi (ca. 774–835), who sits in a triangular pose of contemplation, hands folded. (Noguchi's father had written a monograph on Kōrin. Kōbō Daishi had brought Buddhism to Japan as the founder of the Shingon sect, and his sculptured figure is seen in many of the temples Noguchi visited.) At the same time, the mirror-finish steel has its inevitable reference to Noguchi's experiences in New

York, where planarity, induced by the nature of steel plate, dominated contemporary sculpture for many years.

Another instance of Noguchi's fusion of diverse experiences and impulses, of ideas nurtured in places far removed from one another and yet incalculably related in his imagination, is embodied in a commission he received to do a large sculpture for the Cuyahoga Justice Center in Cleveland. Thinking about a large shape that would suggest an entry to a building that houses not only the courts but also a jail, Noguchi returned to his long-standing interest in how to characterize the void. "I have carried the concept of the void like a weight on my shoulders," he would write in his museum catalog. "I could not seem to avoid its humanoid grip. It is like some inevitable question that I cannot answer."[21] In 1970 he had made *Walking Void #2*, a looming black figure that assumes different shapes as the viewer walks around it. Here his early experiments with the calligrapher's brush seem to have fed his imagination, for the stone turns, suggesting a great space within, as might the spontaneous brush of an expressionist calligrapher. Soon after, back in Italy, Noguchi was tempted again to find the answer, this time exploring his post-tensioned composition of marble and suggesting discontinuity instead of sinuous containment in its planar terminal shapes. Finally he created the glowing version *The Void*, in which the warmth of Portuguese Rose Aurora marble transforms the sculptural inner space into a Mediterranean vision of measured intervals reminiscent of Paestum rather than Japan.

With these experiences behind him, Noguchi, in one of his characteristic feints, undertook to transform yet again both the sensuous character of the experience and its symbolism by thinking in an entirely different scale but, above all, in terms of radically different material. For the Cleveland project, which he felt must be monumental in scale, economy—both in its mundane sense and in its artistic value—became important. Having used builders' materials already for the gatelike structure in Tokyo's museum, it was not difficult for him to imagine another construction material, this time huge industrial sewer pipe, forty-eight inches in diameter. He imagined a great form written in air almost like a calligraphic character, but generating numerous virtual spaces and shapes, and suggesting, as it was finally called, a *Portal*, a "gateway to hope or despair."[22] The powerful cylindrical limbs are sculpturally traceable to Noguchi's earliest admiration for *haniwa* sculptures, in which the cylinder is the fundamental form-giving unit. But the looming presence, painted matte black, is drawn, after all, from the materials of modern building and bears that origin too in its heart. The piece was installed in Cleveland in 1976. Standing thirty-five feet high, it is certainly more American than Japanese in feeling, as can be seen when it is compared to the piece in the Tokyo museum (page 208). There was a

great public controversy; debates and letters in the newspapers; and, finally, a defense written by the curator of modern art at the renowned Cleveland Museum, Edward Henning, who called attention to the symbolism of using steel pipe in an important steel-producing center and gave historical examples ranging from the Arc de Triomphe to the torii gates in Japanese temples as points of reference.[23]

Noguchi's method of free association and his instinctive feeling for appropriate imagery took him a step further in yet another project where the notion of a portal would be transformed into a doorway to the sky. Soon after he began the Cleveland piece, he received final approval for a major work to be placed in the municipal center of Honolulu. Since his first visit to Hawaii, when he had been asked by the Dole Pineapple Company in 1939 to do one of their series of advertisements, Noguchi had loved to return there. He felt quite at home in Hawaii, where he saw affinities with the many people who, like him, shared two heritages. His father had been interested in Hawaii while he was living in San Francisco, where he had met Robert Wilcox, the adventurer who attempted a revolution to restore Hawaii's native monarchy. (It seems, however, that Yone Noguchi visited Hawaii only in 1941, when he spent a semester teaching at the University of Hawaii.) Noguchi's own interest was probably inspired first by his contact with the painter and archaeologist Miguel Covarrubias in Mexico in 1936, and later by Jean Charlot, painter, playwright, and student of indigenous Hawaiian lore. In addition, Noguchi spent time with Joseph Campbell, whose wife, the dancer Jean Erdman, was born in Hawaii. Both of them were keenly interested in local Hawaiian myths and mores. When Noguchi visited for the first time he was an assiduous explorer, going, for instance, to search for Georgia O'Keeffe, who was also there, and discovering on the island of Maui stunning terraced walls from ancient times as well as impressive circular cinder cones from eighteenth-century volcanic eruptions and the beauty of silversword cacti growing in the floor of their craters. He had been angling for a project in Hawaii for years and had once, in 1939, almost persuaded Honolulu to do one of his playgrounds. Finally, the municipality commissioned him to make a sculpture in a grassy space between new buildings of a rather nondescript character. Noguchi had visited the sacred place in Kukaniloko where the so-called birthstones of Hawaii reside and had been inspired, probably before he settled down to plan the required sculpture, to create a small study of a vast circular enclosure, designed to preserve the sanctity of the site. (The sacred stones are only about three feet above ground. They are called birthstones because members of the royal family traditionally repaired to Kukaniloko to bear children. There is a central stone for the woman in labor and a group of stones circling it for the high chiefs.) As friends remember, he pressed the project upon anyone he thought could bring it

Sky Gate, Honolulu
Municipal Area,
1976–1977. Painted
steel, 24 feet high.
Photo: Craig Kojima

to fruition. He failed in this instance, but it is likely that his vision of a
sacred circle affected his final decision about the sculpture in the urban
anonymity of downtown Honolulu. Luckily, the grassy sward, with its
shade trees, was in a relatively quiet enclosure. People circulating in the
business district would see it out of the corner of their eye, so to speak. As
they approached, they would see progressively revealed the full splendor
of the twenty-four-foot-high sculpture titled *Sky Gate*. Using the same
sewer pipe he had adopted as a sculptural material in Cleveland, Noguchi
altered its nature completely, modifying what in the Cuyahoga Justice
Center was ascetic into an undulating circular crest—near the sea, open
to the sun, and related to the omnipresence of circular craters in Hawaii.
It was another way of addressing the issue of cosmos, and one that has the

local intonation of a place Noguchi saw as halfway between his two traditions.

When he was invited finally to do a large plaza, something he had yearned to undertake for years, it would be for a city in his own country, and as always, Noguchi was able to deal with the specific place, its circumstances and local traditions, by drawing on his by-now-voluminous anthology of spatial experiences. The unparalleled opportunity to gather all his thoughts about the problems of the modern urban center came in the form of a commission in 1971 to create a fountain for the Civic Center Plaza in Detroit, funded munificently by a bequest from Mrs. Horace E. Dodge in memory of her husband and son. The committee that selected Noguchi included architects, museum curators, and prominent citizens, all of whom had been appropriately alarmed during the upheavals of 1968 and saw in the rehabilitation of an inner-city waterfront area a possible panacea to Detroit's profound malaise. In most accounts of Noguchi's participation, which lasted from 1971 to at least 1981, too little attention is given to his deep commitment, which sprang from a long-standing concern with social justice. The fires that burned so many decomposing centers of America's cities, the uprisings of the downtrodden that characterized America in the late 1960s, had not left Noguchi indifferent. It was certainly as much his compelling desire to make a contribution in a difficult social situation as it was his artistic needs that caused him to throw himself into the Detroit project with passionate attention.

Noguchi had studied the public spaces of the world, always with a questioning eye. He had sought the concretely functional and the psychologically functional wherever he went. The plaza, he knew, was more than an artistic form, and its furnishings, such as statues and monuments, served a symbolic purpose. He was well aware that his own century had lost invaluable qualities when it ignored the vital function of symbolism. His search for coherence, for cosmos, had always brought him up against the indifference sponsored by the enshrining of technology. As Octavio Paz had written around the same time, expressing almost identical sentiments:

The heaven and earth that philosophy had emptied of gods are gradually covered with the constructions of technology. The difference is that these works don't represent anything, and strictly speaking, they say nothing. The Romanesque churches and Buddhist stupas and the Mesoamerican pyramids rested upon an idea of time and their forms were a representation of the world: architecture as the symbolic double of the cosmos. The Baroque palace was the monologue of the curved line breaking and re-making itself, the monologue of pleasure and death, of the presence that

is absence; the Hindu temple was a sexual vegetation of stone, the copulation of the elements, the dialogue between *lingam* and *yoni* . . . our aircraft hangars, railway stations, office blocks, factories and public buildings—what do they say? They say nothing: they are *functions*, not meanings . . .[24]

Noguchi, always aware, even of his friend Bucky Fuller's technological exaltation, sought to marshal the energy of modern technology into a new realm in which it would retrieve values he felt to be essential; that had to do more with meaning than with function. His enthusiastic use of the most elaborate electronic technology available for his Osaka fountains prepared him for this greater task, which he saw from the beginning as one of creating meaning. The huge fountain that streamed into his imagination from the day the commission came through would serve as a center, a symbol of the urban organism; an *axis mundi*, so to speak, with appropriate modern lineaments. When he presented his earliest conception to the Fountain Selection Committee in March 1973, his lyrical tone was exultant:

> The great fountain, projected to be the most significant of modern times, will rise from the plateau of primal space. It will be an engine for water, plainly associating its spectacle to its source of energy, an engine so deeply a part of Detroit. It will recall and commemorate the dream that has produced the automobile, the airplane and now the rocket, a machine become a poem.[25]

It did, in fact, become a poem, but it was to be a poem of several stanzas. Soon after the decision to undertake the fountain, Noguchi found himself becoming increasingly interested in the total plan for the eight-acre area on the riverfront. The chief architect, Robert Hastings, invited him to participate in all phases of the planning. Fortunately, Shoji Sadao was at Noguchi's side throughout the process, drawing up the plans, negotiating with the many different agencies involved in such a vast municipal project, acting as mediator when Noguchi ran afoul of his collaborators or was unduly impatient. The final plan for the entire plaza, according to Martin Friedman, was largely determined by Noguchi's conception. Friedman recounted how, as was always the case with Noguchi, the plan evolved and changed in great leaps as an originally one-level plaza developed into a two-tiered conception. He quoted Noguchi as he presented his ideas to Detroit's newly elected mayor, Coleman Young:

> He saw what we were doing, our models, our plans and so forth. The first thing he said was, "Well, where's the ethnic festival?"

You see, the ethnic festival was something that had been going on
for years along the river. I immediately said, "Well, downstairs,
Mr. Mayor."[26]

The only problem was, Friedman wrote, no downstairs had been planned.
Noguchi promptly regathered his forces. He had already envisioned the
kind of symbolic space that once Brancusi had created in Tirgu-Jiu and had
proposed to erect a lofty pylon in stainless steel, one hundred and twenty
feet high, that would provide the site with a towering entry symbol and
subtly complete the shape of his grand fountain sculpture. The whole was
to be an almost, but not quite, symmetrical rounded plain, with a fountain
structure that, even without the extravagant water play, was a powerful
form. (Noguchi, in his chameleon way, had first used the image of the
pylon to great effect in a forty-foot black-granite version at the outer entry
to Tange's Sōgetsu building, saying that it related, there, in Japan, to the
traditional *tokobashira*, the ritual post in Japanese houses.)

In a draft of his presentation to the Detroit Common Council, Noguchi
spoke of revealing "the special genius of a place" of which "we are but the
agent." In the case of Detroit, it would be the powerful Detroit River,
toward which he proposed to create a "curved horizon." Circumstance
had forced him to reorient the axis of the entire plan on a diagonal, with
the pylon its fulcrum, making for "its most magnificent entry." The Dodge
Fountain, however, would remain the focal point, which, in one of the
many symbolic images he proposed, would take "more the form of a bird
rising, more American Indian in a way, though it still retains an evocation
of the airplane and jet propulsion."[27]

Noguchi designed many functional details, ranging from a semicircu-
lar amphitheater to an ingenious screen—a comely white wall—for film
projections, to spaces for ice-skating and areas allocated to festival func-
tions. The dominant image, however, is provided by the phenomenal
fountain, its powerful design of a ring on cylindrical legs standing astride
a spacious, stone-paved plain. Approaching this volatile central image,
spectators seem to know that there is an event of great theatrical moment
about to occur. Noguchi had conceived of an elaborate program of water
play that ranged from an initial, rather modest surge upward from a
massive and simply cylindrical granite basin, which, in progressive plays,
is soon joined by a great deluge, complete with rushing sounds as the
water hurtles downward to meet the columnar force. The convergence of
subtle modified streams produces billows of spray and an effusion of outer
mist, like an aura, that delights and transfixes visitors. Moreover, Noguchi
contrived to have the water fall on the stone terrace without boundaries,
modifying his sculptural effect by allowing the stone floor to darken with
moisture. In summer, this becomes a play area, with adults as well as

children shedding clothes and shoes and frolicking in the water garden. At night, a program of shifting lights creates different patterns within the water, optimally fulfilling the theatrical program.

Writers commenting on the Civic Center Plaza have insisted on stressing what they continue to call Noguchi's "futuristic" approach, mostly with veiled disapproval. Yet, here Noguchi had fulfilled many of his most cherished ideals. The plaza is still used by Detroit's troubled citizens, who have come to see the fountain and pylon as symbols of their city. It has, as intended, given life to an abandoned and dangerous area. The interplay of human beings using carefully designed spaces and created forms, which

Horace E. Dodge
Fountain, Philip A.
Hart Plaza, Detroit,
1972–1979. Photo:
Isamu Noguchi

are meant to give meaning rather than mere function, has been largely successful. Most important, Noguchi at last satisfied his inner vision of a virtual space serving, in itself, as a vast sculpture. The critic who complained that Noguchi's "metaphysical speculation unfortunately yielded to futuristic technology"[28] was mistaken. Detroit's plaza entered into Noguchi's metaphysical speculation appropriately and in keeping with ideals he had formulated decades before.

Ancient building type in
the Grand Shrine of Ise,
Mie Prefecture, 1989.
Photo: Denise Browne Hare

Toward
the
Resolution
of Spaces

THROUGHOUT HIS segmented life, punctuated by incidents of disparate character and essays into diverse ways of thinking—from the vagaries of American transcendentalism to the conundrums of Zen; from almost Platonic speculation to the most practical rationalism and American pragmatism—Noguchi conducted his search with the instinct of a born sculptor. For him, the central question was always the nature of space. Not the scientist's measured space or the mystical space of the *exaltés*, although both interested him. Rather, he participated on a high level in the twentieth century's artistic quest for previously uncharted spaces. To understand the pattern, or flow of his life's work, it is important to bear in mind at each turning that he was born into an era in which the ways of apprehending space were being examined intensely from many newly established disciplines. There was an upheaval in intellectual history at the turn of the century. Artists born thereafter were beneficiaries of the insights of the psychologists, including their discussion of perception (particularly of the notion of Gestalt), and of the anthropologists, who described the great diversity of worldviews available in human society and the ways other cultures participated in and conceived space. It was well accepted by the time Noguchi began to think of sculpture that there was a psychological spatial dimension. It was also understood that, as Stéphane Mallarmé had said, an artist lives by the exercise of his imaginative faculty "in the theater of the mind." Finally, the artists who had, by both intuition and intellection, explored new ways of perceiving had put their findings into practice. At the time Noguchi was born, artists such as Matisse and Picasso had begun to articulate the essential shift in perspectives. Matisse would soon declare that he had discovered a continuum, a spatial infrastructure through which all visual experience would flow. He said again and again that what interested him was the whole, and that the relationships among things were more important than the depiction of discrete objects. When he was eighty-two he reiterated: "You must not say that I re-created space starting from the object when I 'discovered' the latter: I never left the object. The object is not interesting in itself. It is the environment that creates the object . . . the object is an actor: a good actor can have a part in ten different plays . . ."[1] Matisse had been sensitive to the implications of philosopher Henri Bergson's theory of time, which altered the notion of space by defining its vital character as flow, as against the artificial stasis of clock time. Matisse and many of his generation grasped the significance also of the great scientific revolution brought

224

about by Einstein's theory of relativity. Guy Davenport perfectly con-
densed the nature of this generation's assimilation of Einstein's intuitions
when he spoke of James Joyce:

> In curved Einsteinian space we are at all times, technically, look-
> ing at the back of our own head. (There's *Mich*, me, in with Marx
> and *fox* and *moose* in the *Mookse* of Joyce's Eins within a space
> and a wearywide space it wast ere wohned a Mookse.)[2]

In the realm of artistic theory, the Western view had been greatly
modified when the great French thinkers (mostly poets) had eagerly risen
to meet Wagner's challenge embodied in the idea of the *Gesamtkunst-
werk*—the "total work of art" in which all the arts would participate, and
in which all the senses would be roused. Implicit in Wagner's theory was
a conviction that had had a long history in Western thought: the arts
spring from a single source, and a work of art can be an emanation of that
source in every sense. Synesthesia, the fusion of the receptivity of all
human senses, was an ideal that accompanied the arts throughout the
nineteenth century, and in the twentieth, became an unquestioned com-
ponent in the way space was experienced and described. By the time
Noguchi came along, it was well understood that sounds are experienced
both aurally and spatially; that the arrangement of masses or the descrip-
tion of lines partakes of what Baudelaire spoke of as "musicality"; and
that the human body, like everything else in the universe, is governed by
biological and physical laws that were greatly modified by scientific theory
in the late nineteenth century.

When Noguchi explored Eastern views of space, he brought with him
his firm grounding in modern art, the heritage of the many Western artists
who had already cast their eyes toward the Orient, seeking both affinities
and fresh ways of thinking about their own artistic problems. Some were
rebelling against Western intellectual provincialism; Goethe, for instance,
admonished his readers to look further:

> So der Westen wie der Osten
> Geben Reines dir su kosten
> Lass die Grillen, lass die Schale
> Setze dich zum grossen Mahle.[3]

European artists of the twentieth century agreed with Goethe, and when,
in 1913, there was a great exhibition of Muslim art in Munich, they flocked
to see it and were quick to understand the implicit lessons of different
spatial organization in such objects as Persian miniatures. If Noguchi
sought answers to his own problems as a sculptor, exploring in great detail

the arts of Asia and meditating on the nature of space, he was pursuing a path that others had trodden before him. But his immersion in the aesthetics of Asia was informed by his own unusual artistic breadth and his participation in art forms such as the dance, in which the spatial problems are necessarily relative and in which, as Matisse pointed out, it is the environment that creates the object.

When Noguchi undertook his concentrated study in Japan in the early 1950s, he was seeking the antecedents of his own slowly formed vision of a total space that would, in all its elements, embrace all the senses. In 1952, for example, when he was attending as many Noh and Kabuki performances as he could, he had translated for him small handbooks published in Japan at the time. From his annotations it is clear that he was studying Japanese classical theater not out of a curiosity roused by its exoticism but rather in order to enhance his own sense of the theater as a controlled space and a site for synesthetic experience. Much in his past as a collaborator with dancers and actors prepared him for this scholarly examination of a unique and venerable art form.

Theater, said Noguchi, was a "ceremonial, and the performance, the rite."[4] In these handbooks he could follow the various specialized crafts that contributed to the theater, from mask carving to wig making; his attention to details is apparent in his notations. He was interested in the sequence of photographs and explanations of the makeup procedure, which, even in photographs, show a decidedly sculptural approach to the transformation of the face. His old interest in the mask as a contribution to the ritualistic aspect of theater was reanimated.

Noguchi was especially interested in the *aragoto,* or so-called rough-style Kabuki acting, in the dramas of violent action and was stirred by the stately containment of the fight scenes and the sharp musical accompaniment by the *hyōshigi*—rectangular blocks of wood that clack insistently during fierce combats. He made note, also, of the term *mie,* sometimes translated as "pose" but really far more symbolically explicit, as he understood. In those abrupt stops, time is suspended as the actor creates his *mie,* the pose that, as Donald Keene observed, "visually sums up the total reaction of the character to the significant dramatic situation."[5] The entire image seems sculpturally conceived. The sharpness and contrived eternity of that prolonged moment of summary was something Noguchi sought in his individual sculptures. In his notes he also recorded comments by major actors, one of whom spoke of the "musical beauty" of Japanese theater: "One might call it the fundamental rhythm or melody residing in the spirit of the Japanese."[6]

In addition to the books on Noh and Kabuki, Noguchi studied a pamphlet on the Bunraku puppet theater, which undoubtedly held great interest for him. Puppets are, after all, essentially sculptures, and their

manipulation partakes of a sculptural sense of space. In his early ceramics, there is often mimicry of the puppet's aspect and a suggestion of its jointed composition. By 1952, Noguchi's own view of theater had evolved to a fair approximation of the aesthetic propounded by the great late-seventeenth-century puppet playwright Monzaemon Chikamatsu, who wrote:

> Art is something which lies in the slender margin between the real and the unreal. . . . If one makes an exact copy of a living being . . . one will become disgusted with it. Thus, if when one paints an image or carves it of wood there are, in the name of artistic license, some stylized parts in a work otherwise resembling the real form . . . while bearing resemblance to the original, it should have stylization; this makes it art, and is what delights men's minds.[7]

To delight men's minds in the slender margin between the real and unreal had been Noguchi's objective over a long period. He had early identified his wish to find a sculptural equivalent to the "total void of the theater space" that he could animate by various means and, above all, could control. His ambitions were keenly whetted by his youthful exposure to major dance innovations. In that respect, he was unique among sculptors, highly responsive to the radical means developed—through bodies, music, choreographic composition—to create a whole. In many ways Noguchi can be compared to an inspired theatrical inventor, a kind of combination of Edward Gordon Craig and Vsevolod Meyerhold, both of whom sought to reinvent theatrical space and expanded the usable spaces of the cubic stage by creating accessory spaces, moving laterally, vertically, and on different horizons. Noguchi's early concourse with Michio Itō and, soon after, with Martha Graham gave him access to many directions in the arts that would not have been apparent to a conventional sculptor.

Graham's own formation had included not only exposure to Oriental music, which was frequently employed by Ruth St. Denis, with whom she began her career, but also a stint with Michio Itō, and the patronage of Frances Steloff, founder of the Gotham Book Mart, who paid for her first recital. In the late 1920s, Steloff's shop was filled with books on Eastern speculative philosophy, which was then very much on the minds of New York intellectuals, as was the anthropological study of primitive cultures. Graham herself had traveled to the American Southwest to see American Indian ceremonial dances, which greatly inflected her work, and she had, as a child in California, known both Chinese folk dancing and Spanish dance ritual. All of these ceremonial alternatives to conventional Western dance were to surge into the radical innovations Graham offered year after year, and they presented Noguchi with inspiring possibilities. And, since the modern tradition had already proclaimed the importance of

original works—that is, works that speak of origins, found largely in so-called primitive cultures—the mythical was very much present for Noguchi, a familiar of Graham's, long before it became the focus of his fellow plastic artists in New York. The use of symbolism derived from myths would distance the theater of the dance from both balletic and mechanistic modernist conventions, giving collaborators in the dance theater possibilities of far wider scope, similar, as Noguchi would discover, to those of the Japanese classic theater.

Over the years, wherever Noguchi drifted, he always made a full circle, and one of the points that he touched again and again was the preserve of the symbolic, the means of characterizing space in the abstract. Even in his concourse with Buckminster Fuller, he found points of convergence. In Fuller's sometimes fantastic way of symbolizing the entire universe in single figures—the helix for instance—Noguchi found a reference point.

Fuller had carried along his personal heritage as the great-nephew of Margaret Fuller, Emerson's intellectual friend. Hugh Kenner pointed to Buckminster Fuller's rhetorical and visionary tradition deriving from transcendentalism in yet another circle (strongly influenced by Eastern philosophy) and quoted Emerson: "Things admit of being used as symbols because Nature is a symbol, in the whole and in every part." Kenner also alluded to another, even more suggestive passage in Emerson:

> Have mountains, and waves, and skies, no significance but what we consciously give them when we employ them as emblems of our thought? The world is emblematic. Parts of speech are metaphors, because the whole of nature is a metaphor of the human mind. The laws of moral nature answer to those of matter as face to face in a glass. . . . The axioms of physics translate the law of ethics. Every universal truth, which we express in words, implies or supposes every other truth. *Omne verum vero consonat.* It is like a great circle on a sphere, comprising all possible circles . . ."[8]

Kenner remarked: "A sphere inscribed with great circles and yet many-sided; Emerson might have been glimpsing the Geodesic sphere from which the famous Fuller domes are sliced."

For Noguchi the philosophical line, no matter how wide its arc nor how much it wavered, went from his childhood exposure to Swedenborg's theory of analogy, to Emerson and Blake, to Fuller, to Zen. Perhaps even more than from Fuller's transcendental proclivities, Noguchi's feeling of kinship with him derived from his friend's most engaging vision of rearranging how we think of space. Hugh Kenner cited an amusing occasion:

"I don't know why I am talking to you," said Bucky, "because you are all so ignorant." He was trailing his coat before a roomful of scientists. Their ignorance consisted in knowing that the earth rotates, and yet saying that the sun rises and sets; also in knowing that the earth is spherical and yet speaking the flat-earth words "up" and "down."[9]

The problems of up and down had revealed themselves to Noguchi during his first youthful voyage to the East, where he could not have failed to notice how much of life was lived at ground level, or looking down, and yet how much the arch of the sky entered daily lives in ceremonial ways. Later, when he worked with Martha Graham, he became acutely aware of the importance of the floor as a kind of primal ground from which all forms would rise. He often watched rehearsals and classes. He noticed how much Graham stressed floor exercises and the training of the back and torso from the seated position. In Graham's school, the barre was no longer used as a horizontal mooring for the vertical body. Moreover, her accent on asymmetrical formations that would shape the spaces of the stage in unaccustomed ways would make a deep impression on Noguchi. The composer Louis Horst, who collaborated with Noguchi and Graham, wrote notes that suggest how much Noguchi may have assimilated there in the Graham studio: "*Strange space design* is achieved in the body and by foreswearing the symmetric in gesture or in posture." Horst also stressed the affinities of modern dance with archaic dance forms.[10] Associating the symbolic with asymmetry became an almost natural reflex for Noguchi, as when, for instance, at Yale he made his sun forms and cubes slightly asymmetrical.

Noguchi's long association with Graham drew him into many experiences that would later flow into his overarching metaphor of the garden. Among them were his works with Merce Cunningham and John Cage, both of whom were directly inspired by what they had learned of Eastern aesthetics (including, possibly, the custom in Noh and Kabuki for actors, writers, and musicians to work separately toward a final unity), and his collaboration with the dancer Erick Hawkins, who also, later in his career, evolved a philosophy of art that came close to Noguchi's own. Hawkins's frequent collaborator, the composer Lucia Dlugoszewski, attempted to sum up the choreographer's conception of a new theater by speaking of what he called "perfect nature":

Nature understood in a totally new dimension where a total, unifying, non-artificial, directly experienced, harmonious order as well as the delicious sensuous spontaneity, the unplanned playful surprise and diverse abundance occur at absolutely the same time . . .[11]

Erick Hawkins and Stuart
Hodes in *Stephen
Acrobat*, set by Isamu
Noguchi, choreography
by Erick Hawkins, 1947

The paradoxical use of nature, which is, after all, "natural," as a basis
for the artifices of theater (or sculpture or the other arts) is fundamental
to Noguchi's approach. However, his interest in fountains, stones, walls,
trees, and grasses as sources for the synesthetic experience was not merely
an interest in nature but a means of expanding the spaces he sensed to be

available to an imaginative artist. As he put it in his autobiography: "There is a difference between the actual cubic feet of space and the additional space that the imagination supplies. One is measure, the other an awareness of the void."[12] The natural elements, grass, bamboo, winds, all exist in Japanese classical theater, artfully presented in the verses, occasionally the props, the actions, the dances, the music. They are not merely metaphorical. In the deepest sense they are experienced. They are the spaces that Gaston Bachelard designated as the "lived spaces," the spaces of the imagination.[13] These spaces, released from Pascal's *esprit géométrique*, both envelop and flow from the imagination and are known to us all, although better understood by poets and artists. Bachelard's descriptions of such spaces, "lived" in the imagination, include several different orders, such as the spaces of attics and cellars, of seashell and tree, cupboards and drawers, cave and sanctuary. Noguchi had isolated for himself certain childhood memories much in the way Bachelard suggested that childhood spaces are "inscribed" in us. There were fences, trees, walls, stones, and a house in Noguchi's infant life that would become archetypal in the way Bachelard spoke of archetypes—as categories of essential and emotionally invested spatial experiences. When Noguchi traveled around the world in the late 1940s, he had been drawn to consecrated spaces, including the sheltered space of secret sanctuaries and caves. He had once made a special trip to the Dordogne River valley in France to see the limestone caves at Lascaux, and he had also seen Altamira in Spain. In his notes he wrote of the depicted animals "charging down a landscape of rock whose horizons drop off beyond the measure of our time."[14]

The issues of time, of measure, and of the space that encompasses both time and measure were not abstract issues for Noguchi. He intuitively grasped the Pythagorean premise that, as Kandinsky would say, all art ends in number. And Noguchi had also grasped the dialectic opposite. He was, like many other artists, preoccupied with what can only be called the incommensurable. Both find their place in his view of cosmos. Much of his wandering in Japan was a function of his sense of myriad paradoxes perceived in the solutions certain inspired Japanese creators, both of gardens and of theater, had proffered.

He knew through his early studies in the British Museum the detailed and symbolic systems of measure devised in ancient India, and he had been intrigued enough to make notes on translations of Sanskrit indications of measure for every portion of the body, as well as for architectural details. He had certainly been impressed, as had so many other Western artists, by the human scale of Japanese measurements; by the way people paced out their spaces using units such as the tatami mat, a measure clearly drawn from human proportions. In Japanese architectural systems

there was a natural emphasis on the flow of spaces—which twentieth-century architects such as Frank Lloyd Wright studied closely—and there were extremely flexible rules about measuring. The module of the tatami mat was modified according to the system of the particular structure. Above all, there were highly sophisticated systems of measure born of Zen philosophy, such as the asymmetrical formation of a stone path, which guided the movements of the human organism, revealing the total space only as the body passed through its designated route.

Certain features Noguchi discovered in Japan took root in his overall philosophy of space. In the UNESCO garden, in a rather rudimentary form he had adapted the Kabuki theater ramp, the *hanamichi,* as the flowing element, joining details of water, flora, and stone. Later, his observations became more subtle. He had noticed, as had many others, the strange transformation of the Noh mask when used in the theater space. The mask when held in the hand is an impassive and almost expressionless object. The moment it is donned, and the actor's head is inclined slightly or turned almost imperceptibly, the mask becomes an animate, immensely compelling element in a mysterious metamorphosis that Noguchi would later seek to invoke in individual stone sculptures. Certainly his apprehension of sound as sculpture was initiated in Japan as he paused in gardens to listen to the trickle of a bamboo fountain or the flow of a brook from one sculptural point to another. Even the sharp stops in certain of his stone sculptures may have derived from the shock in Japanese theater when the great drum, the *o-daiko,* booms out an overture or prepares the mood for an entrance.

Noguchi's thought about the role of space in his life's work was gathering cohesion steadily as his study in Japan intensified. When he responded to an invitation from George Devine and John Gielgud to design *King Lear* in 1954, his recent experiences there were evident. He saw the play in essence as a story of change and growth. "Nothing stays put," he wrote, "either in place or in characterization." He envisioned the play as a "continuous and actual drift of locale and mood" and emphasized that he had followed the scenic changes in the text: "They are integral to the significance of the play: the shifting stage of life within the larger framework of nature—nature which permeates the shadows and fictions of man's willful passions. All is relative, there is really no time and no place, each is part of the other."[15] In the same text, he alluded to Lear's loss of everything, leading him to awareness, as in the teachings of Buddha. He also described the moving and floating sets he designed as similar to giant kites in the air, "unreal and yet formal like a pack of cards." Japan was on his mind, not only in his conception, but in the colored collage designs in which his costumes are draped on significantly Oriental and stylized figures whose heads are clearly Noh masks.

Royal Shakespeare
Company's *King Lear*,
set and costumes by
Isamu Noguchi, 1955.
Photo: Particam Pictures

A few years later, Noguchi was asked to write the foreword for a
magnificently produced book on Japanese architecture. He took the occa-
sion to speak of some of his own preoccupations, contrasting the Grand
Shrine of Ise with the later meditative gardens.[16] The roofs at Ise, he said,
rise out of the landscape. "Their enclosure is like a sanctuary. The fact of
enclosure, not the bare space enclosed, is significant." In the Zen and tea
gardens, which Noguchi saw as having to do only with privacy and individ-
ual communion, the "ideal landscape . . . is composed of elements depen-
dent upon and enhanced by each other in asymmetrical counterpoint."
Both of these spatial experiences—the one in which enclosure creates a

space of symbolic emptiness, and the one in which the space is measured out in musical, asymmetrical counterpoint—were essential in his vision. He kept widening his circle of inquiry, making more and more analogies with other experiences, and seeking to isolate the essentials in his own intuitive path.

In this intensified endeavor during the years after the grand projects of the sixties and early seventies, Noguchi found spiritual allies among a new generation of Japanese artists that had rediscovered the inspiring presence of a unique artistic past. These were the sons of the first post-war generation—that of Kenzō Tange and Sōfū Teshigahara—that had earlier attempted to integrate the great aesthetic of the past into modern life. The next generation—men who had been children during the war and whose educations had taken place in the postwar climate in which local traditions were often rejected—began with defiant avant-garde positions, aligning itself as much as possible with Paris and New York. A few artists, however, eventually recognized the futility of assuming others' identities and began to give their attention to the exceptional aspects of their own art history. Noguchi had already called its own past to Japan's attention in the 1950s. These young creators gravitated to him and formed a circle of which Noguchi had the rare pleasure of being an important, influential center.

One of his most intense encounters was with the composer Tōru Takemitsu (born in 1930), now an internationally esteemed figure. It is not surprising that Noguchi posited much significance in this friendship, as did the far younger Takemitsu, who had been only fifteen years old when the Second World War ended. Noguchi had always been sensitive to music and frequently used musical analogies when he spoke of his own work, as when, for instance, he spoke of visiting his sculpture garden at Chase Manhattan Plaza on a quiet, somewhat windy Sunday and noticed that the great building "emitted an eerie music."[17] Or when he wrote of an early project, in 1933, that he wished to make a musical weather vane that would produce sounds like that of an aeolian harp, noting that the idea may have come from his stay in China, where small flutes made of gourds were attached to pigeons who made a *whooing* sound as they flew about. Or when he called certain effects "grace notes." Early in his Japanese experience he had begun to attend to the aural aspects of the gardens. In 1950 he had written a brief article on his first expedition, "My Quiet Trip to Japan," in which he apparently referred to his visit to Shisendo, a Kyoto villa by then turned into a Zen temple, with marvelously massed azalea bushes—great rounded mountains against raked sands—that gradually move toward natural shrubbery and then to the lofty trees climbing Higashiyama. One of the important features of Shisendo is the *sōzu*. In the current pamphlet handed to tourists it is described:

The incessant and monotonous murmuring of a little waterfall
deepens quiet still more—accompanied with the intermittent, yet
punctual sound of clacking which comes from a "sozu", a sort of
water-work scarecrow set up down the garden [*sic*]. The sozu is
made of bamboo devised so as to make a piece of bamboo stalk
strike a rock in a mountain-streamlet automatically by the gravita-
tional power of the very running water that gathers into the stalk,
and it was popular among the neighboring farmers in the days of
Jozan as an agricultural appliance to frighten deer and wild boars
away from their fields.

Noguchi, it seems, delighted in the *sōzu*, for he received a letter soon
after he published his article in *Bungei Shuniu*, September 1950, from one
Shigeomi Otomo, dated October 14, 1950—a letter he carefully kept for
the rest of his life. In it the author speaks of the bamboo water pipes at
Shisendo mentioned by Noguchi and points out that Japanese classical
music keeps similar rhythmic intervals. He urges Noguchi to become
acquainted with the *biwa* and mentions the principle of *ma*, that difficult
concept of space that later another younger friend of Noguchi's, the archi-
tect Arata Isozaki, would characterize as a simultaneous elision of space
and time—time and space measured in terms of intervals.[18]
Noguchi's sensibility was attuned to the riches in the tradition of
Japanese music and its sources in nature. His rapprochement with Take-
mitsu from the beginning would be a highly valued relationship. Despite
the differences in age and origins, there were affinities. Takemitsu's for-
mation in certain ways resembled Noguchi's. He had been a child during
the war, when Western music, except by Japanese allies, had been forbid-
den. "At the time I decided to become a composer, I hated everything
Japanese," he says. "I was thirsty for Western music because it was
forbidden."[19] He began, almost self-taught, with an intense interest in
avant-garde Western musical experiment, familiarizing himself with all
the innovations of the 1950s—the experiments with electronic music; the
so-called aleatory composers; serial music; and new graphic notations. At
the age of twenty-one, he founded an experimental workshop, and his
exploration of the vanguard Western idiom was thorough, much as Nogu-
chi's had been when he was in Paris in the late twenties, at the same age.
Takemitsu said that one day, by chance, about ten years later, he realized
the importance of his own tradition. (In a conference at Hakone, which
Noguchi also attended, in October 1982, Takemitsu said: "I am very
grateful to John Cage, because for me Japan was an order to be denied
until John Cage opened my eyes to the beneficial heritage of Japan. He
himself was influenced by Zen and Daisetsu Suzuki, and I had been
influenced by, if anything, the West.")

Takemitsu discovered, as he has said on many occasions, that as a Japanese he had inherited a sense of space and time that was different from that of the West. He began to study Japanese music in the 1960s with a new attitude toward its emphasis on timbre—a proclivity he recognized in himself possibly derived from his Japanese formation. Japanese music, he said, is based on tone, color, and texture, rather than on melody. It aims to capture "the resonance of all the *world* in the resonance of one small note."[20] The "world," Takemitsu increasingly stressed, was the world of sounds derived from nature. But his view of nature, like Noguchi's, encompassed more than the sighing of trees, the movement of water, and the songs of the cicada, although all of these elements figure in his music. It was a highly developed, philosophical concept that had been drawn not only from direct experience, but from the large constructs, such as Fuller's cosmic egg, that Takemitsu had examined in his travels throughout the world. Like Noguchi, he set off frequently on journeys with an expectancy of enlightenment.

When asked to specify the difference between Japanese and Western music, Takemitsu smiled, raised his delicate hand, and made an undulating gesture, describing perhaps a mountain, as characteristic of Japanese music: "Western music is *plus* space, ours *minus*."[21] He spoke of his own "sound stream." The image he described with a physical gesture has been expressed in his compositions clearly enough for the composer-conductor Lukas Foss to characterize Takemitsu's music as a form of landscape painting. Takemitsu, who called Noguchi a spiritual brother and father, said that his music was decisively influenced by Noguchi's work and, even more, by Noguchi's attitudes of living as an artist: "As an artist he was beyond nationality; the works were beyond sculpture; he was metaphysical and spiritual, his eye was always seeking to see something essential." It was Noguchi's vision of the garden and admiration for Musō that led Takemitsu to think, himself, of music as an environment, and to talk about "walking through a music garden." (He pointed out that the name Musō contains *mu*, "dream," and *so*, "window.") Perhaps what drew them close was the fact that Noguchi, as Takemitsu said with emphatic delight, could love both William Blake and Japan. Here, poetry, shared by the two artists, and essential to all Japanese arts—gardens were as literary as music was in ancient Japan—was acknowledged by the composer whose own works were often suggested by literature, including the writings of such Westerners as Herman Melville and the Dada poet Tristan Tzara. Furthermore, Takemitsu was always willing to acknowledge the sharp contradictions in his own moves as a composer—conflicts that he felt inevitable and even salutary—and he saw similar contradictions in Noguchi's long life and constant movement. He pointed to the anomalies in modern life and its seeming progress, saying, "We understand the rela-

tionship of the microscopic DNA molecule to the larger world we live in, but we know little of the power that moves us, the unknown that draws us to music, the mysteries of art." Takemitsu's music, as Noguchi realized, is an attempt to express his emotion before such mysteries, and in its delicate gradations, its allusions to the finest of natural phenomena such as filmy spray, a line of trees, mountains and birds in flight, Noguchi recognized certain of his own images.

Takemitsu's *compagnon de route*, Hiroshi Teshigahara, just three years older than he, also began with a rebellious rejection of traditional Japanese attitudes in the years after his graduation in 1950 as a student of painting. "In Japan there was a traditional vertical order," he explained, "and after the war, that was broken."[22] He and Takemitsu were of the generation that most keenly desired the break. Hiroshi (as he is known, to distinguish him from his father, Sōfū) began making films in the 1950s and even made his way to New York to shoot one of them. His predilection, among Western art movements, was for surrealism, in which he saw "an art that was closely intertwined with the life of the artist." Hiroshi was exposed to Noguchi's work at an early age. It might well have been Noguchi's extravagant experiments with clay, many of which were in Hiroshi's father's collection, that inspired him to begin making the sculptures and vessels that Noguchi would later describe as "earthen wares of extreme originality and anguish of form."[23] At the same time, Hiroshi was making his tense, starkly composed films based on the novels of Kobo Abe, the most celebrated of which, *Woman of the Dunes*, gained him international renown at the age of thirty-six. For this, and for all of Hiroshi's films, Takemitsu composed the score. Their artistic ideals have, to this day, kept apace, and the evolution of their approaches to their art has been parallel. Takemitsu wrote of the exigencies of composing for Hiroshi's films: "Every small space in every shot seems to be filled with some metallic substance of a high density, giving the viewer an impression that transcends the original meaning of plot or character. . . . The images themselves reverberate with a distinct and fertile sound, and the music can play only an adjunct role, bringing into sharper focus the sounds that the images emit."[24] Takemitsu's natural synesthetic diction here underlined the affinities between the two artists and their relationship to Noguchi's ideas, encountered most directly during the late 1970s when the friends began to find projects on which to collaborate.

As Hiroshi recalled: "It was bleak after the war. Then came Isamu, half-Japanese, half-foreign—everything changed."[25] He said this with a slight smile, his well-shaped head inclined, his back straight. In fact, both he and Takemitsu believed that Noguchi had a great impact on their own evolution. As Hiroshi moved into his career, he became an active proponent of the Western avant-garde, inviting notables from Europe and the

United States, among them John Cage and Merce Cunningham, to per-
form in the theater of his father's school. Gradually, he moved to a recon-
sideration of his own artistic heritage. One of his first steps was to establish
himself in Echizen, in Fukui, a place once known for its exceptional
earthenware, and build a new kiln where he and invited friends could
make experimental clay sculpture and where, it seems, he began to medi-
tate on the retrieval of a great tradition that he associated with Rikyū.
Each of these moves would bring him closer to the aesthetic of Noguchi.
Then, when Sōfū died in 1980, and soon after the daughter who was to
have taken over Sōgetsu also died, Hiroshi stepped into the unexpected
role of master of the ikebana school. Meanwhile, he had refined his own
position, and his view of art came increasingly closer to that of Noguchi,
particularly in his attitude toward nature. From the beginning he insisted
that ikebana was, as his father had proved, an art form distinct from, even
in collision with, nature. "We have to extract from the material a form
which it could never possess in nature. . . . Not to stick inseparably close
to nature but to admit nature into one's expression as it is refracted
through a medium of some sort: this is the way."[26] A few years later, when
he had already performed prodigies with his bamboo compositions—great
forests of glistening bamboo arches, tunnels, and caves—he came even
closer to Noguchi's view. In describing his preoccupation with Rikyū (he
had once told Noguchi: "You are the Rikyū of the twentieth century"),
Hiroshi said:

> Rikyu was an incredible person. He created the tea ceremony, he
> created the architecture of the tea house, he created the Japanese
> garden, to be viewed from the tea house. But it's not only that.
> What he did was like theater: in a closed space he is on stage,
> making tea; he invites you; you drink the tea; it's theater. You
> don't do this in everyday life; you go to a specific place created for
> this purpose. What Rikyu did was total art. He initiated a new
> state of mind.[27]

Hiroshi's friendship with Noguchi ripened, and in 1980 the two exhib-
ited together at Sōgetsu, each bringing his notion of "total art" to bear.
Five years later, Hiroshi collaborated with Noguchi's younger colleague
Arata Isozaki, an architect who had admired Noguchi from his early youth
when he was an apprentice to Kenzō Tange and helped with some of the
UNESCO drawings. Isozaki was directly involved with Noguchi's Expo '70
project in Osaka. "Sure enough," he later wrote, "a veritable fountain of
ideas issued forth—cascading fountains, upsurging fountains, configura-
tions that defied accepted notions of hydrodynamics—all bearing the
stamp of Isamu's sculptural genius . . . this wizard Noguchi never failed

to astound me and elicit admiration."[28] Isozaki's evolution, like Take-
mitsu's and Hiroshi Teshigahara's, had brought him from an initial rapt
attention to Western architecture and art to a renewed interest in his own
tradition. In 1978, he created a remarkable exhibition, *MA: Space-Time
in Japan*, for the Festival of Autumn in Paris, which was later shown in
New York at the Cooper-Hewitt Museum. In it he presented a number of
concepts from ancient Japanese traditions that indicated how the idea of
"space/time," so new to the Western way of thinking about the arts, had
always been fundamental to the Japanese imagination. His clear exposi-
tion remains one of the most valuable summaries of an aspect of Japanese
tradition that could be adapted by contemporary, forward-looking artists.
Isozaki displayed a deep understanding of the way man's perception of
space developed through the ways he devised to divide and shape his
environment. The manner of dividing depended on the views of nature
and the cosmos that prevailed at any given moment. The careful examina-
tion of so many ancient ways of dealing with space informed Isozaki's own
work, freeing him at around the same time that his friends were freed
from youthful distaste for Japanese customs.

Noguchi's concourse with these younger men became increasingly
cordial, and his own Western traditions were more and more refracted in
the light of the nature-oriented views developing among them. They were
in agreement that there were certain worldwide affinities. Long before,
Hasegawa had had extensive talks with Noguchi about Klee, whose views
helped Noguchi to clarify his own. What could be closer to Noguchi, and
even his younger colleagues, than Klee's remarks in 1923:

> For the artist, dialogue with nature remains *a condition sine qua
> non*. The artist is a man, himself nature and a part of nature in
> natural space. . . . A sense of totality has gradually entered into the
> artist's conception of the natural object.[29]

Isamu Noguchi in Mure
studio, Shikoku, 1986.
Photo: Michio Noguchi

"We Are
a Landscape
of All
We Know"

IN HIS LAST YEARS Noguchi redoubled his effort to create an environment for himself—a theater of his life in which he would be simultaneously actor, director, and spectator. The final landscape would speak of all he knew. In the largest sense, it would be a studio: the space that generated all that he considered essential in his life. One of his deepest impressions had been of Brancusi's studio at the Impasse Ronsin. He spoke often of its almost sacred atmosphere; of its suffused whiteness as symbolic of Brancusi's own purity; of the feeling that the deepest meaning of Brancusi's life was ensconced in this atmosphere that he had created for and through his work. In his later years, Brancusi himself said to a biographer, during a studio visit: "One always wants to understand, but there is nothing to be understood. Everything you see here has a single merit; it has been lived."[1]

Noguchi's compound on the island of Shikoku was to be his last creation of a personal environment, saturated with both emotional and intellectual history—his own cosmos, removed from the chaos of the world, even the world of the city of Takamatsu, rapidly encroaching on his little village of Mure. When he had first decided to build a retreat on Shikoku, he had been enchanted with the timelessness of the landscape. In May 1968, he had written happily to Gene Owens: "I've been at it, the big stone, which takes shape on some earth fill in the bay of the village of Aji on the island of Shikoku in the Inland Sea. Indescribably beautiful at this time of year—or anytime still, for it is not spoiled. The houses are as they have always been."[2] Shikoku, for Noguchi, held multiple sources of satisfaction. It was the backdrop for many of the most haunting scenes described in the epic *The Tale of the Heike*. It had maintained, at least in the countryside, its medieval customs. And it was endowed with vistas that had never changed. A 1907 guidebook described the plain of Takamatsu much as it is today, "fringed toward the sea by several volcanic cones" and surrounded by higher mountains in which "the eye is delighted by a vigorous growth of deciduous trees, where horse-chestnuts and magnolias are variously intermingled with beeches, oaks, maples, ashes and alders."

To exist in an atmosphere of "what has always been" appealed to Noguchi's mythic sensibility, that side of him that craved to know and rehearse the exquisite purity of origins. His effort in Mure was to invent such an atmosphere. He well knew it was a dramatic artifice; a work, in fact. It was not a withdrawal from the world. He did not wish to "flee from

the Burning House of this world," as the Buddhist priest Kenkō exhorted his acolytes. Rather he was creating a space in which everything he had ever imagined could be authentically lived. He had confronted issues and made his choices. Each time he added a flourish to his space, he was shaping something of his own. Noguchi was well aware of Japanese critics who were condescendingly amused by his traditional installations. "A Japanese would never live this way," he said. "I can do it because I am not Japanese."[3]

In Mure, Noguchi could select, detail by detail, the materials that would fulfill his emotional needs. Although Takamatsu, a rather disheveled industrial provincial city, was sprawling out to his village with ugly supermarkets and mawkish imitations of American highway furniture, he found the means to turn his back, quite literally. His two-hundred-year-old house, modified ingeniously for modern life, faced the distant mountains, hovering over the rice fields and falling toward the sea, and was framed closely by a great wall and a stand of bamboo beyond his veranda. Choosing each element over a period of years, Noguchi shaped his place as a sculptor, adding a void here, a volume there. Perhaps his most felicitous find was what was to become his main studio: another venerable structure of adobe and wood of extraordinary harmony in its proportions. This reconstituted godown, or storage house, with its classic simplicity— the cut of the sliding doors; the perfect horizontal molding, repeating the firm horizontal of the molding beneath the roof and the classical ridge cresting its tiles; the discreet granite stone base from which all members, including the beautiful pillars in the interior, rose—is of a breathtaking beauty. Noguchi's choice of this particular building was guided by his long-standing admiration of Japanese architecture, which, as he once said to me, "Always contains a stone, then a column stands on it, and the column is supported by a triangular structure in wood—the entire structure can be regarded as a beautiful sculpture." Not only is the interior of this converted godown a functional working space, but its soft glowing white exterior is a perfect backdrop, the exactly appropriate setting for his sculptures. In the shifting light of the interior, he could play with the real and the virtual by sliding a door open inches or feet. The walls, scored with a generous grid of squared timbers to support the adobe, provide a quiet counterpoint. The proportions, established in the flexible building patterns of hundreds of years ago, are reminiscent of the highest power of early modern art with its geometric weighing out, but were reached, as Izumi pointed out, by the standard methods of the old Japanese, measured out in modules *(hangen ikken)* on the ground. "Modern architects," he said, smiling, "have a much harder time."[4] This building, like the others on the property, was the result of one of Noguchi's forays into the countryside, seeking the elements for his vision. Once it was conveyed to the prop-

Approach to Noguchi's
two-hundred-year-old
house in Mure, Shikoku,
1989. Photo: Denise
Browne Hare

Front entrance to
Noguchi's house in Mure,
Shikoku, 1989. Photo:
Denise Browne Hare

Noguchi's studio and
sculpture garden in Mure,
Shikoku, 1989. Photo:
Denise Browne Hare

erty—with immense ingenuity and effort—it was sited by Noguchi toward
the favored, timeless backdrop of mountains and sea and enclosed in a
magnificent rounded stone wall some seven feet high. Many devices
Noguchi had observed in villas and temples were subtly introduced: the
play with inside and outside, with light manipulated by the touch of a
hand, moving doors and windows into varying positions, and the wonder-
ful harmony of materials—full-bodied wooden vegas and columns, some-
times curving, against the warm interior tones of adobe in which glints of
straw delicately punctuate the light.

Noguchi began modifying and shaping this place at the end of the
1960s. Once, remembering the principle of borrowed scenery, he and

Izumi decided to make an auxiliary mountain. "In 1983, during the ty-
phoon season, we built a usable and spectacular garden by scooping out
the middle of an extremely steep embankment," Noguchi wrote.[5] "The
surrounding mountains Yakuri and Yashima may be seen within this con-
text as sculptures." From the moment this "garden" existed, Noguchi once
again saw other possibilities, and stones were hauled for a corner here, a
platform there—like the old viewing verandas—a planting of the finest

bamboo grass, or wildflowers; another smaller storage building, a *kura*, again set in the context of house and studio and providing yet another theatrical flat for the animation of his sculpture; there was no end to the modifications he undertook with such great delight. Mure was the perfect example of the sculptured space that held the implicit germ of its own growth.

The road to Noguchi's place was strewn with stones, both natural and worked, in this village of stonecutters, and his days there were given to a contemplation of stone in its real and venerable life and in its metaphorical implications. Nature itself—the great firs climbing the mountains and the cultivated fields lying beyond his walls—entered his meditation. He had needed the reality of stones, trees, clay (in the adobe walls), mountains, and water for his increasingly self-contained vocabulary, just as his friend Takemitsu, who had withdrawn to the volcanic mountains of Nagano, where once Noguchi briefly had a studio, needed them. Takemitsu: "The place where I work is located in the mountains in a forest. I live there; I

Ground floor interior of
Noguchi's studio in Mure,
Shikoku, 1989. Photos:
Denise Browne Hare

encounter nature's rich and bountiful variations. In my work and as I live, I seek to be informed by nature."[6] For one of his compositions, *Tree Line*, written in 1988, shortly before Noguchi's death, Takemitsu wrote: "The tree line in the title refers to a row of acacia trees luxuriously growing near the mountain villa which is my workshop. . . . The work was written as an homage to these graceful yet dauntless trees."[7] Similarly Noguchi, mindful of Yashima and Yakuri, strove to reduce to an artistic essential the undulating profiles of the stones that are mountains. In his terse summing up in the last museum catalog, Noguchi had written: "It is said that stone is the affection of old men."[8] And, in an interview in April 1987, he had said of stone that it is a "direct link to the heart of matter—a molecular link. When I tap it, I get the echo of that which we are—in the solar plexus— in the center of gravity of matter. Then, the whole universe has a resonance."[9]

Still, the links Noguchi sought were not exclusively resident in stone. He was invincibly curious. He rambled around Shikoku, catching faint glimpses of the past that would be allied with his present in the mill of his imagination. High above his studio in the forested silence is a temple to which pilgrims make their way in their white costumes, sounding their small bells. The clap of their hands summoning the gods in that silent place is as sharp as the *sōzu* at Shisendo. Noguchi would ascend to the temple from time to time in the cable car, hovering over the magnificent green canopy of ancient trees, observing in the distance the sparkle of the sea. (He always timed his sojourns in Shikoku for the green seasons.) At other times he would contemplate the mountains when they were fog shrouded, and only a delicate fringe of the giant cedars and pines—the woods from which his studio and house were constructed—softly brushed the sky. Or he would visit the lower temple, Shido-ji, with its ancient stone garden and graveyard. There he relished the "resonance" of the stone tombs, renewing his study of their structure and meaning. In his youth, he had made careful studies of the earliest Japanese stone sculptures—the three-tiered, male-female Asuka stones with their incised petroglyphs representing mountains and their provision for running water. Now, at Shido-ji in the ancient tomb—the *shumisen* of four mounted stones—of a fabled pearl diver, he found still other resonances. This legend of a girl who dove for a pearl and slit her breast to hide it is the inciting stuff of myths. Noguchi was profoundly affected by it, mentioning it often. These old graves, he explained, were made like receptacles. The people were buried sitting, and the stone still contained their spirit. Noguchi responded, as he said in the Bruce Bassett film, to the "potent idea" of a personage residing in the stone and to the aging of the stone. The moss clinging to its curving flanks gave him the sense that all returns to nature. "Nature and its cycles prevail."[10]

The past at Shido-ji was not the only past he could touch in Shikoku. The cycle of ancient festivals could still be followed there, and he could, with his fervent imagination, catch the life of the spectacles that had once transpired there centuries before. His need to travel back to beginnings, expressed throughout his life, had been apparent ever since his sojourn in the fastness of Brancusi's studio. Noguchi knew that his study in the British Museum was not enough, and to the end of his life he ventured out, searching for the living presence of those mythical times.

In Shikoku, somewhat remote from the breakneck tempo of modernization in and around Tokyo, there were still vivid pageants. He loved the Kompira festival, and according to his friend, the photographer Shigeo Anzai, he would spend hours on his feet, watching well past midnight. "He liked best of all to watch the man with a very tall pole as he lowered it and threw it to another guy to catch," Anzai recalled, adding that as they drove around in the countryside together Noguchi always looked for new ideas to modify: "He loved so many things, even small shrines, even a common small tree and a stone."[11] By moving through this Japanese landscape Noguchi could put himself in touch with the forces that have shaped the great arts. To actually experience the resurrection of ancient rites was of primary importance. Langdon Warner described very well the emotional impact of a festival he witnessed at the Kasuga Shrine in 1907, saying he was "transported back fifteen centuries and more." He went on to say:

> The God (symbolized by a mirror) had been brought down to a temporary shrine in the middle of the night, and in front of it was a flat grass mount. . . . Huge iron baskets full of flaming pine and cedar knots blazed about the mound, and overhead the sky was purple-black and set with a million polished stars . . . all of a sudden, four figures came out of the shadow. They had on brown robes with long yellow trains and black Druidlike caps. Then there was the sound of shrill pipes and flutes and the solemn soft boom of a drum. . . . The four dancers stooped down, and rose, and stamped and swayed in rhythm—sometimes lifting their arms to the stars, sometimes lying prone on the sod. The dance is called "Earth throughout the Ages" and I felt that I was watching the primeval rites of an elder people who knew and spoke with their Gods.[12]

Noguchi had always sought such initiating experiences, and he, like his friend Martha Graham, had acquainted himself with living rites all over the world whenever possible.

His seasons at Shikoku were in harmony with nature's rhythm, al-

though Noguchi kept strict working schedules. In Mure, surrounded by the solicitous and impressively sensitive Izumi family and by responsive assistants, Noguchi seemed to want to reinvent a Japan he had once known; a child's idyllic Japan that his selective memory harbored all his life. Even those rapid short steps of his—a trotlike gait that never failed to impress visitors—may have been the residue of childhood patterns. His preferred way of sitting, arms folded, head up, in the posture of the old sages depicted during the Muromachi period, could well have been acquired during the imitative childhood stage in the well-remembered seaside house at Chigasaki. (His friend Hiroshi Teshigahara assumes the same posture.) Other childhood patterns, such as his affection for hard surfaces, and his constant reference to the floor, were resurrected in his old samurai house. There, he composed his ground-floor living room with low seats and had a favorite spot, back to the wall, from which he could

Interior of Noguchi's house in Mure, Shikoku, showing two of his Akari lamps, 1989. Photo: Denise Browne Hare

Sleeping quarters in Noguchi's house in Mure, Shikoku, 1989. Photo: Denise Browne Hare

peer out onto the veranda and enclosed garden. Characteristic of Noguchi, that place, in which he always took his meals, prepared in the most delicate Japanese manner by the Izumi women, concealed the hi-fi equipment. From its vantage point in the evenings he faced the black square of the shoji panels open to the night, and if it was raining savored the sounds of the bamboo stand in his garden. At such times Noguchi donned traditional dress, as did Izumi, and as no doubt his faintly remembered father had, in his earliest childhood memories.

Even in his chance encounters during that period, Noguchi was researching—literally re-searching. The young musician Christopher Blasdel met him deep in the mountainous Shikoku countryside. Noguchi and Izumi, out on one of their old-house hunts, stopped at a small inn to explore its architecture and came upon Blasdel performing on his *shakuhachi*, the ancient bamboo flute, for a dancer. "Noguchi was as surprised as I was," Blasdel said, "and he stayed, listening, until midnight."[13] Through Blasdel, who had come to Japan in 1972 to study traditional music, and who made his way through the complicated "social-political guild system" in the traditional arts, the "pyramids in which everything—power, money, recognition, and responsibility—funnels to the top," to become a recognized performer, Noguchi came closer to the court music that had always interested him. Blasdel performed for him and also discussed the sonic properties of stone with him (Shikoku stone, Blasdel said, is like a xylophone) and listened. Like Noguchi's other young friends, Blasdel accepted

his counsel. An American in Japan has complex problems that Noguchi understood all too well. "I don't belong in America or Japan," Noguchi told him. "And neither do you." Once, Blasdel played a traditional piece and then an improvised modern piece. Noguchi thought the modern piece was wonderful. "I asked about the traditional piece," Blasdel reported, "and he said, 'Well, you proved you could do it.' "

(That Noguchi never fooled himself about his own Japanese adaptations was obvious. At Joseph Campbell's eightieth birthday party, Noguchi encountered Jamake Highwater, a writer of indistinct American Indian descent who became an expert on ritual and dance, and said to him: "Hello, Mr. Highwater, I know: I am not a Japanese artist and you are not an Indian writer—I'm as much a tourist in Japan as you are on an Indian reservation."[14] Another time, when he was asked to write a catalog preface for Li-Lan, a young American painter whose father was Chinese and mother American, and who for a few years had been married to a Japanese artist, Noguchi wrote: "Li-Lan belongs in the same way as I do to that increasing number of not exactly belonging people. I understand her sense of isolation." Noguchi's own sense of isolation diminished in his last years. More and more he was sought out by younger artists and intellectuals, and he felt, both in the United States and in Japan, that he was increasingly accepted.)

By establishing himself in Shikoku, at least for three-month intervals twice a year, Noguchi not only re-created an imaginary Japan lodged in selected childhood memories (blended, probably, with descriptions he found in his father's poems and articles), but he put himself in a heightened state in which he could reconsider the aspects he most admired of historical Japanese culture. For instance, he had been obliged to consider the character of Japanese paper from the moment he first embarked on his marketing of the Akari lamps. But when, in the late 1970s, he was asked to write a foreword for a book on *washi* (the Japanese word for "paper"), he immersed himself in his memories and commenced his essay: "Among my earliest recollections of childhood in Japan were the many gifts of handmade *hanshi* paper that tradesmen left at New Year's time." He continued:

The white paper that ushered in the year would be useful throughout in innumerable ways. What would the Japanese household do without this paper? It is the source of light. The shoji screens must be repapered each year or mended. Gifts must be wrapped in it and tied, when important, with the ceremonial red-and-white cord also made of paper. Cakes on any elegant occasion are served on it, as in the tea ceremony.[15]

After an almost scholarly review of the history of *washi*, Noguchi turned to his own use of paper and bamboo in the Akari, concluding:

> How could I have conceived such possibilities except through a knowledge of the qualities inherent in washi. I hope I may have extended its appreciation through the light and shadow it casts. This is what comes from old tradition, the use of washi and the making of lanterns, which extends its life into the needs of our time.[16]

In some ways Noguchi's forays into his childhood during those last years, and his increasingly firm belief that "to go back is to go forward in a way because if you go back to bedrock then you have something to stand upon,"[17] resembled the act of contemporary pilgrims, donning their white camouflage and reenacting rituals that could restore to them the lost harmony they perhaps thought they had known in their childhood. Tanizaki's penetrating novel *Some Prefer Nettles* had expressed the hidden uneasiness of such latter-day pilgrims and also the needs from which their rehearsals of the past emerged. The difference was that Noguchi's bedrock, like the great stone platform on his property above his house, with its created burden of a simile for a stone mountain, was for him the means of prodding his own inventiveness, of going forward. To this end, he returned often to Kyoto, touching down in the places that had so early bestirred his inventiveness and lingered in his memory. He would discuss with Hisao Domoto, who now resided permanently in Kyoto, the conflicts both artists experienced. They sat drinking sake late into the night, reinforcing each other's beliefs that somehow the precious part of the Japanese past could be fused with forward-looking, entirely modern artistic conceptions. Early the next morning, Noguchi would usually set off to visit the sites that had been of importance to him during his scholarly trips in the early 1950s. He returned to the temple complex at Daitokuji, where once he had stayed for a time, taking up again his old conversation with the Abbot Kobori about the role of Zen in art and examining again, in one of the subtemples, the sumi paintings of misty mountains in the tokonoma, painted perhaps six hundred years before in China and brought to the room that was specially designed by the great Kobori Enshū, the seventeenth-century tea master and garden designer. Noguchi had been there earlier with the old master Daisetsu Suzuki, whose views had contributed to the formation of Noguchi's aesthetic. Suzuki's writings were rich in synesthetic theories of both East and West. By the time Noguchi revisited these cherished sites, the lesson had long been thoroughly assimilated.

After Daitokuji, Noguchi would often visit one of his favorite temples, Entsuji, where the moss garden was indelibly marked in his memory as the

symbol of time. His visits, at this stage of his life, were no longer study trips; rather, he went like the artist in Yasunari Kawabata's *Beauty and Sadness* who visited the Moss Temple to sketch its stone garden, "not that she thought she could paint it. She only wanted to absorb a little of its strength."[18] For Noguchi, these returns were a way of drawing spiritual strength and a tangible sense of history. In one of his November 1962 letters to Priscilla Morgan, he described visiting Ginkakuji again, where "I lost myself in thoughts of all the perfect days such as this it has known."

Noguchi's meditations on time were repeatedly phrased in the language of figures of his youth. In his introduction to the catalog of his exhibition at the Minami Gallery in Tokyo in 1973, he once again opened by saying he was reminded of how "time and places formed me and of my own roots here in childhood." He observed that his own past quickly receded before the new; that he was "caught in the common dilemma of artists," and said, "We are no longer sure that time flows in one direction only." Entsuji was an important place to alight to reassure himself. There, looking down into the garden about four feet below the veranda, he saw how the moss-shaded stones were asymmetrically grouped; how the azalea bushes served as echoes, flanking the stones and miming them; how the clipped hedge wall, with one tree cunningly planted within the garden wall and others just behind, formed the transition to more natural bushes and trees and finally was the agent, bringing the "borrowed" scene of Mount Hiei into the focus of the scanning eye. Here the low-lying stones were truly embedded and grew from the earth, and the subtleties of their tonal relations as they fused with the mossy empty spaces, or contrasted with the low and sculpturally clipped echoing bushes, spoke to Noguchi's increasing interest in the kind of art that is almost not identifiable as art; that is so close to the functions of nature that only the most discerning eye can detect the artist's highest expression.

Noguchi's excursions into the past—his own and that of Japan—were not untroubled. What he called the common dilemma of artists was always with him, and if, at times, he sounded a note of plaintive nostalgia, it was quickly suppressed or surpassed. There can be no denying that Noguchi, and even some of his younger colleagues such as Domoto and Hiroshi Teshigahara, had moments of genuine despair as they saw the best of their past disintegrating. Such dispiriting emotions were also a part of a certain cyclically renewed Japanese tradition, quite explicitly described by Kenkō Yoshida in the mid-fourteenth century in his famous book *Essays and Idleness:*

> In all things I yearn for the past. Modern fashions seem to keep on growing more and more debased. I find that even among the splendid pieces of furniture built by our master cabinetmakers,

those in the old forms are most pleasing. . . . The ordinary spoken language has also steadily coarsened. People used to say "raise the carriage shafts" or "trim the lamp wick", but people today say "raise it" or "trim it".[19]

Like Kenkō, Noguchi found modern fashions all too often debased, but unlike him, Noguchi carried within him the American habit of looking forward. For Domoto or Teshigahara, who reread Okakura and Suzuki during those years, just as Noguchi did, the problem was not quite the same. As Domoto said, it all depends on how you read them: "We didn't believe that the past had to be destroyed for the avant-garde to exist."[20] Teshigahara added, "For us it wasn't just a question of copying the past. There is the Japanese curiosity, the cultural element; the habit of reshaping and using for our own benefit what we find both in our past and in the other cultures we assimilated."[21] The landscape gardener Touemon Sanō, during the same conversation, added: "Take the *tobi-ishi*, the stepping-stones: now we do them wider because women no longer wear kimonos. To set the stones right in the old days, they had to gauge how the kimono would open attractively. Now pants and skirts, the Western way, make it awkward."[22]

Noguchi's problems with tradition were not quite so specific. Nor was his desultory interest in the more esoteric and spiritual side of the Zen tradition so easily translated into his work. He was a bit like Emerson, who, when Thomas Carlyle charged him with what Emerson called "I know not what sky-blue, sky-void idealism," retorted that he was probably even more deeply infected than Carlyle thought, though he did not blame himself for his reveries, "but they have not yet got possession of my house and barn."[23] Noguchi's house and barn were still, in their deepest shadowed corners, too much rooted in his formative American experiences to permit him to rest easy with his renewed discoveries of his Japanese past.

In fact, during those last years when his life in Japan assumed so much importance for him, Noguchi had not ceased examining other pasts; he revisited all his primary sources in India, Greece, and Italy and added yet another: ancient Peru. In 1982 he decided that he and Izumi would have to see Machu Picchu. Indefatigably they inspected the massive architectonic forms of this great acropolis. They examined unimaginable feats of geometric volumes carved into living rock. They saw walls composed of enormous chased stones, ingeniously fitted into asymmetrical patterns. They saw mysterious shapes, such as the zigzag ditches carved out of sloping rocks. They saw endless inventions in the way the numerous mysterious stairways were carved. They noticed deliberate juxtapositions of worked and unworked stone. They even saw an unmistakable solar observatory, similar in design to the one that had once made Noguchi

marvel in India, but here wrought in the stone mountain itself. These two cutters of stone were eager to inspect the ancient Incan inventions of stoneworking and noted carefully the cant of edges, the ingenuity in the chasing, the sharp definitions within volumetric conceptions. Noguchi, of course, understood the link with other sacred places he had known, but the scale of this heightened sculptured mountain was like nothing he had ever seen before. "When I travel," he had once said, "I travel to see sculptures with their incense about them." This incense was to remain in his memory, and his works after 1982 were visibly influenced. The impact of Machu Picchu can be read in many of his stones after 1982—works such as *Personage I*, which Noguchi spoke of in terms of its economy, saying it was "close to the essential sculpture I strive for."[24] The memory of his experience in Peru is also implicit in a wall composed of great natural rocks he and Izumi built in Mure after their return.

The visit to Peru instigated still other meditations on the meaning of stone sculptures. Noguchi again spent time near Michelangelo's mountain, peering up to its crest where a great white form, sometimes appearing to be a thick mist, slid like a torrential mass of skeletal stone down into the wooded slopes—the site of centuries of quarrying. He would ascend the mountain on hot days, peer below into the wave upon wave of deep ravines, and find a spiritual coolness above. The winding approach to the crest of Altissima is today as remote from the modern world as it always was, sponsoring reflections of a grander order than does the world below in Pietrasanta. Here Noguchi thought again about Michelangelo and continued his speculation about a single sculpture that he had not forgotten since he first saw it in 1949: the *Rondanini Pietà*. This much-debated sculpture, on which Michelangelo had worked only hours before his death, held a singular force for Noguchi. In his last years he referred to it often, admiring above all its inwardness, its power declared as much through its unfinished condition as through the magnificent shaped forms that Michelangelo had chiseled and brought to polished completion. In the introduction to the stone sculptures in his museum catalog, Noguchi significantly spoke of the dialogue in stonework of "chance no chance, mistakes no mistakes" and stated that "no stone becomes immutable before its final consecration." Until then, he wrote, matter remains primal and open: "Even in his old age, Michelangelo reworked his sculpture of ten years earlier, transforming it into the *Rondanini Pietà*."[25]

Back in Mure, it seems, Noguchi's last works were the result of much meditation, much deferring. Sometimes a stone would lie mute for years while he contemplated its shape and sought an entry into its heart. Many partially sculptured stones stood waiting, their skins scored with tentative chalk marks or an occasional slash of a chisel made personally by Noguchi. He would stalk his prey—the inner spirit of which he spoke increasingly—

sometimes from season to season. At the end of his stay, he would take away with him in his inner eye the lineaments of a certain stone, and rush back, sometimes months later, convinced that he had found his point of entry. The architect Tadashi Yamamoto recalled fetching Noguchi from the airport, listening to him speak in the car about his work, and watching him dash into his house, the instant they arrived at Mure, to don his work clothes.

Those years were crowded with stones. In Mure, Noguchi sounded all the notes on his expansive scale, working on small, barely noticeable stones visible only to one who purposefully looked down (in many of these the principle of the garden artist called hide-and-reveal is interiorized, comprised within the single stone). There were also culminations of long-pondered problems, such as the huge *Energy Void*, which Izumi summarized by calling attention to its lesson ''that we must never remain still.''[26]

Entrance to Noguchi's Mure,
Shikoku, studio with view (center)
of one of his last completed,
untitled sculptures of 1987.
Photo: Denise Browne Hare

This piece is known in Mure as the *Gate of Heaven* because, as Izumi related, the visiting painter Sam Francis dreamed about it one night as a gate of heaven and Noguchi did not correct him. In Noguchi's stone repertory in Mure can be seen many variants on ideas begun long before and rendered to perfection in his final years. Basins, landscapes, vertical columns, anthropomorphic verticals, flying images, and supine images proliferate. There are innumerable essays in contrasts of high finish to rough and in color intonations, from earth hues to sea hues, from fire to water. In these contrasts, observations Noguchi had made long before on the subtleties of Japanese aesthetics are put into practice. (When, for instance, a master artist of the past, who was often gardener, poet, and painter in one, wished to work with reflections, he would frequently use not only the mirroring qualities of water in carefully designed ponds, but he would double the effect by placing painted screens on the back wall of his pavilion that reflected yet again the scene presented through the

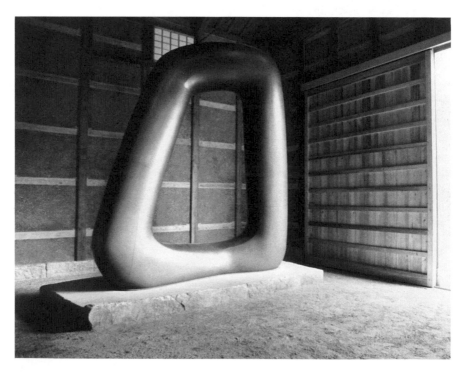

Energy Void, 1971, also
known as the *Gate of
Heaven*. Swedish granite,
12 × 10 feet × 21 inches.
Photo: Denise Browne Hare

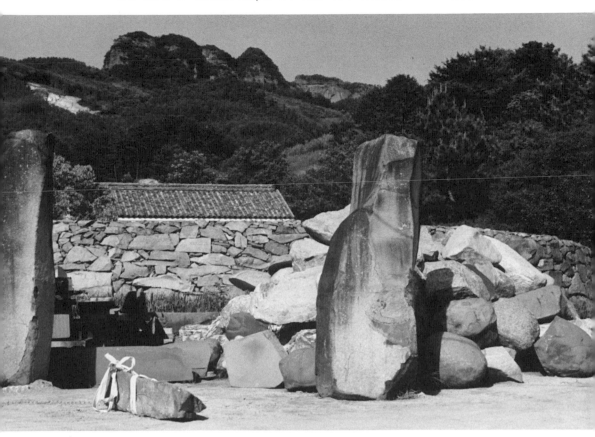

Curved outer wall of
Noguchi's Mure studio
yard looking toward Yakuri
and Yashima mountains,
Shikoku, 1989. Photo:
Denise Browne Hare

veranda shoji.) Noguchi's feeling for tone and color, so apparent in these
late works, was derived from his journeys with Izumi to quarrying sites,
always in striking settings, and also from his long immersion in Japanese
painting, from the tonal language of the old calligraphers to the brilliant
colors of the Muromachi period screens and the traditional scroll painters.

How the lifetime of sense impressions entered Noguchi's works at the
end can be seen in Mure in many examples. There are, for instance,
numerous basin forms, ranging from variations on the traditional *tsukubai*
to less obvious but clearly derivative water-bearing shapes. Stone and
water are mythically allied, and naturally associated by a master crafts-

Outer wall of Noguchi's
sculpture compound in
Mure, Shikoku, 1989.
Photo: Denise Browne Hare

man such as Izumi, who said, "Stone in nature is the thing which un-
dergoes the least change, and water the most change—because of this
contrast they belong together." In Mure, there are many stones that
assume the shape of basins or suggest by their shallowly scooped surfaces
that they have been worn away by water. There are others that in their
metamorphic suggestiveness invoke their timbre; one can hear the rever-
beration of sound as one looks. As he spoke of these, Izumi recalled the
sound of the Incan flutes at Machu Picchu. The motif of water occurs in
many of the foot-level sculptures that assume the characteristics of land-
scape. A keen-eyed visitor can see, for instance, Noguchi's play on his own
name (which means "water entrance," according to Izumi), a work of Zen
simplicity lying low on the ground, with the trace of a rice field suggested.
(Rice fields were endlessly inspiring to Noguchi, who loved their mirror
character, their perfect accents and interchanges with the sky.) Certain of
the horizontal stone sculptures, often carved in the local granite, invoke
the containment Noguchi had studied in archaeological museums in Japan,
particularly of the stone sarcophagi found in cairns—severe, low, sculp-
tured shapes as geometric as the stones of Peru. His invocation of ancient-
ness can be seen in Mure in several stones that he retrieved in old stone

yards—granite stones that were cut three hundred and fifty years before and left unfinished. Noguchi would haul them back to his studio and watch them—one, for instance, with two mysterious square cuts, their edges rounded by time, he mounted on a gray granite slab and pondered how to modify it. (Izumi's comment: "There is no end to this one.") Improvisations prompted by such finds were a part of Noguchi's life in his stone fantasies.

In the yard adjoining the studio are a number of column-type sculptures (see color section) that, over the years of experiment, Noguchi had perfected. Here again the cultural references of decades are fused. In a work of warm, deep gray basalt with light gray flecks of light in the craters of the roughened ends, Noguchi polished the faceted central column to accent its entasis. A similar piece is discussed in the New York museum catalog with reference to Greek temples and the entasis of their columns, but also with reference to the helix, "a spiral [that] produces the same

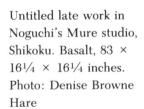
Untitled late work in Noguchi's Mure studio, Shikoku. Basalt, 83 × 16¼ × 16¼ inches. Photo: Denise Browne Hare

effect when applied to a geometrical column such as a square, an octagon or a pentagon." Noguchi added an important comment: "As is well known, all nature tends to a helix—from the flow of water, to wind, tropical storms, or the flow of blood."[27] This piece in Mure, however, has other connotations as well. The overall shape suggests a Japanese scroll with its handles (or even the Jewish Torah scroll, which Noguchi knew well from his Jerusalem experience). About scrolls, Izumi commented: "There are important things written in them," and he went on to describe how Noguchi could detect the "important things hidden within stone" and could express the stone's "true nature."[28]

Noguchi's transformation of a column was not always vertical. The variation of *Ground Wind* in his closed garden is an example. This jointed black granite piece, with its helical turning, is a metaphor for wind, but it is also a reminiscence of the essential nature of bamboo, jointed yet flexible, responsive to the elements. But many works in Mure that suggest the same associations as this ground-loving piece stress instead the element of verticality. Noguchi had not forgotten the majesty of ancient stupas, some rounded, others with geometric severity. Nor did he forget his desire—with a bow to Brancusi—to extend the central axis of his sculpture to the vault of the sky. There are endless columns in his imagination. There are also self-contained pieces, especially among his metaphorical mountain sculptures, in which the sky is beckoned to reflect itself, and its arcing shape mimed. One of the late pieces is a reprise of the 1968 *Origin*, but this time, the black basalt mountain shape, with a few roughened pit marks at its base, sits, flush, on a square Aji granite shape, two sides smoothed, and two left rough. The basalt crest is polished to receive the intimation of sky and water, but there are ocher and reddish flecks that return one's thoughts to the earth itself. This piece, made of two units, has an amazing presence in its powerful reserve. Its almost impassive demeanor is impassive in the way a Noh mask is: the slightest turn on the part of the viewer and it is animated as if by magic.

The same quality of energy kept in reserve can be found in an important late work that sits like a Buddha on a great granite slab—except that it sits on a diagonal axis, which contradicts the Buddhalike composure. This piece, which combines several elements, while keeping the lineaments of a natural boulder, is richly suggestive. Noguchi, a natural colorist, has preserved the tones—deep grays, deep blacks, foaming whites, and rusty iron—of the original stone. The whitish films bespeak neighboring stones in the heart of the mountain from which it was quarried. From every viewpoint, the cuts, sometimes indicated with the holes made by the drill to cleave the rock, are calculated to reveal light and shadow, natural texture and artifice. Granite is an igneous rock. Noguchi, always mindful that *igneous* means "of the nature of fire," used the flecks of mica know-

Untitled, 1987. Indian
granite, 42 × 33 × 17½
inches. Photo: Denise
Browne Hare

ingly to produce facets of light. The whole is an ensemble of forms
wrought by the correct gestures of the granite ax, yet somehow, in its
fitting together, it seems a single source of energy—lines, facets, textures,
volumes brought together, or "congealed," as Noguchi used to say when
he explained the element of time in his works. The genius of this concision
is equal to that of the traditional Japanese dance, in which the sound of
the samisen rises like a thin line above the voice of the singer, while the
dancer's hand motions seem to move out from his body and return. Three
strands—dance, song, and instrument—are woven into a tapestried effect
of total unity. This allusion to the dance is not entirely fanciful. Noguchi
himself had once said something about Martha Graham that well applies
to this sculpture: "I remember Martha Graham saying that in dancing she
never opens her hand but closes it in and this retains energy—it doesn't
flow out indiscriminately; it flows back into her."[29] Similarly, the round-
ness of this stone flows back into itself, while yet suggesting many hidden
sources of energy.

 Not all of Noguchi's hours in Japan were spent in the isolation of his
studio. There were important occasions that brought him to Tokyo, where
he always stayed at the same inn and always found the time to dine with
his closest friends in the best traditional restaurants. There he would

Akari in Noguchi's house
in Mure, Shikoku, 1989.
Photo: Denise Browne Hare

continue his conversations, begun long before, and express his anxiety
about the new Japan and its cultural attitudes. He clearly articulated the
issues that preoccupied him during a conference called "Japan–U.S. Cul-
tural Relations: Present and Future," held in October 1982 at Hakone:
"The changes that have come over Japan are so complex that I am unable
to either condemn or praise them, or even enjoy them. I feel saddened that
Japan does not seem to have the awakening to Japan that Americans have
had." He thought that Japanese artists were less free than Americans to
develop as individuals. "Here, in as much as they are artists, they are
individuals, and yet they are constrained by the fact that they are Japanese
and that they are in this sort of single-vision where it is only to the future
that they look and not to the past . . ."[30] Noguchi shared with his closest
friends—such artists as Teshigahara, Takemitsu, Kamekura, Tange, and
Isozaki—a concern that the single vision would cripple the evolution of the
arts in Japan; make them, as Noguchi used to say, as thin as a strip of film.
These highly creative friends were engaged in acts of retrieval that would
not inhibit their sense of themselves as modern artists. With them, Nogu-
chi felt a kinship, and toward the end of his life, they collaborated on
several significant projects.

Isamu Noguchi: Space of Akari and Stone, installation at Seibu Museum, Tokyo, designed by Isozaki Arata, 1985. Photo: Michio Noguchi

One of the most satisfying was an occasion that brought Arata Isozaki, Teshigahara, and Noguchi together as a team, presenting Noguchi's stones and Akari at the Seibu Museum of Art in February 1985. It was no easy task. In principle, the conjunction of paper light-bearing objects with dense and weighty stone was inherently expressive. In practice, as Isozaki discovered, it was a most difficult proposition. Both he and Teshigahara were well attuned to Noguchi's temperament and understood very well the sources in poetry and myth that inspired him. For the paper lamps, which Isozaki had initially spurned (he was reminded too much of the stale tradition of the Bon festival, with its strings of lanterns), Noguchi had established his own poetic history, beginning, as was so often the case, in a mythical voice. In 1954 he had described his 1951 trip to Gifu to see the cormorant fishers with poetic heightening:

> Each night, at an hour set with the changing darkness of the moon, the little Ayu fishes swim out into the fast crystal flow of the Nagara river. . . . First we go up stream and board pleasure boats. In the distance, fires dance upon the waters, which, fast approaching, are seen to blaze from the prows of long slender fishing boats. We hear the cries of the black cormorant birds, the shouts of the bird master, and his drum-like thumping on the sides of the boats. Presently they are upon us, the tethered birds diving, the flipping fish in their beaks. . . . It is like a chariot race of birds in which we take part, caught in the excitement, drifting along beside the busy fishing in our lantern bedecked boats . . .[31]

The Gifu lanterns, he went on, are esteemed for their quality: fine paper and slender spiral bamboo ribs. Inspired by his nocturnal adventure, Noguchi set about designing new lanterns that would, as he said even then, bring alive "the countless nuances of other times and places which otherwise are likely to pass away everywhere under the impact of our 'Western' progress."[32]

Noguchi's salvation of tradition by adapting it to modern needs impressed his young colleagues, for they had a similar mission. Isozaki, with a few rough notes handed to him by Noguchi, surveyed the exhibition space and immediately associated it with the Shokintei arbor of the Katsura palace, intuitively selecting one of the most enduring of Noguchi's Japanese affections. "Naturally," Isozaki later wrote, "the overall scheme had to mirror the lake and gardens surrounding the original arbor."[33] Isozaki brought in stones, spread a sheet of water, and, where the garden faded into mist, hung curtains of sheer gauze. His theatrical staging included a translucent grid netting, a witty re-creation of the famous checkerboard walls at Katsura.[34] The challenge was to create a suitable

atmosphere in which both past and present seemed at one; in which the ephemeral, beloved in Japanese tradition, subsisted side by side with the eternal; in which the special qualities of natural materials such as bamboo and *washi* and stone would be equal to the new qualities of modern corrugated zinc, with which Isozaki had constructed special spaces to enhance the sculptures. Rikyū's *sabi,* Katsura's artful elegance, and Noguchi's own ways of resurrection worked to make the exhibition a signal success, perhaps a turning point for Noguchi in Japan, where, finally, he would be recognized as an old master full of young ideas.

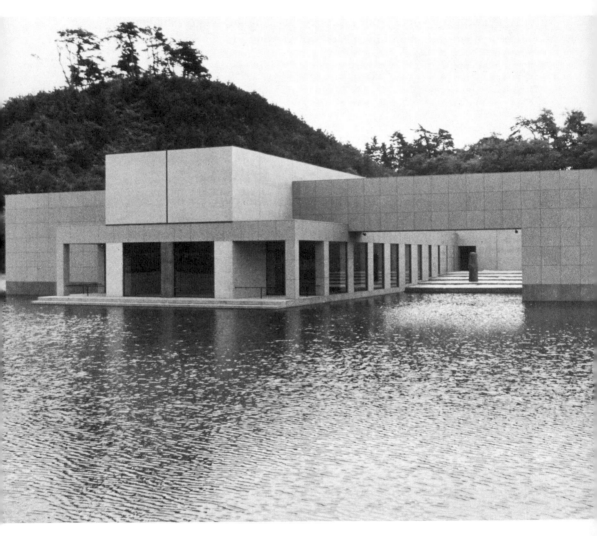

Domon Ken Museum
Garden, 1984, architect
Yoshio Taniguchi, Sakata,
Japan. 30 × 36 feet.
Photo: Isamu Noguchi

Last
Metaphors

IN A TRANSCONTINENTAL telephone conversation a few months before his death, Noguchi spoke enthusiastically of a new project he had recently undertaken. After a very slight meditative pause, he remarked, "I'm nearing the limits." The project was to design a space "almost as big as Central Park." During the conversation Noguchi reiterated his will to "make sculpture part of a large scheme." That scheme, he sometimes hinted, might be beyond his or any other artist's comprehension; might, in fact, be the source of tragic defeat, a punishment for his sin of pride. But hubris or no, Noguchi persisted. He continued to seek opportunities to amplify his garden metaphor; to encompass—with works—his vision of great, girdling horizons that swept around the world, framing his whole life's experience. He kept moving through the world seeking embodied confirmations of his basic premises. During his last summer, for instance, he made an excursion to Giverny to see Monet's gardens, parts of which were fancifully based on Japanese gardens. Noguchi was not wholly impressed, and turned to another visitor, saying, "Stones are the bones of the garden, flowers its flesh."[1] He obviously had returned in his imagination to the more satisfying gardens of Musō Kokushi, whom he was quoting. That same year he visited Paros and the marble quarries, reveling in the descent into the stone realm that was "so very deep." Wherever he went his mind was on a dozen different projects, including the completion of his own museum in Queens, which he thought of as a "counterpart," an integral aspect of his total personal environment that included the studio in Shikoku. Years before, he had spoken of the "time" of sculpture, which is, by nature, "radiant." He had said that perhaps it was not correct to call his works gardens: "They are, rather, compositions in the topological space."[2] When Noguchi used the term *topological*, he was not speaking of a geographer's space, but rather the more mysterious mathematician's space. His figure of speech conveyed his vision of a whole that he carried, like a perfect brush drawing, within his imagination.

As the circle of his imagination expanded, Noguchi was fortunate to find sponsors willing to let him tempt the Fates. His last decade was crowded with grand projects. His spaces, as his old friend Tange said after Noguchi's death, were always sure. "He had a perfect sense of scale."[3] The phrase "sense of scale" is all too often, particularly in architecture criticism, proffered glibly, as though everyone knows what it means. But a sense of scale is not one of the five with which each person is endowed, but rather a rare quality that combines all the senses with a great fund of

culture. The scale of an Egyptian or Mexican pyramid is certainly different
from that of a Japanese garden, yet each has its measure, as Noguchi
knew, in an illusory sphere of measure, to which the beat of the human
pulse, and the gait of a human walk, and the geometric structures con-
ceived by man all contribute. Senses must be trained, analyzed, expanded,
fused—actions Noguchi had taken for so long that scale became second
nature to him.

During his last decade, he produced for Tange a stunning piazza in
Bologna that proved his genius for proportion and scale. Tange had been
commissioned by the city to design a new complex of office towers, thea-
ters, and shops in the Fiere district, a few kilometers from the ancient
center. Some of the larger buildings were intended to echo the proud
towers of medieval Bologna. Tange had made vertical core structures
around an open space that greatly needed articulation. Noguchi, who had
always loved Italian piazzas and had once described Piazza di San Marco
in Venice, which he visited in 1949, as a "gigantic drawing room where the

Piazza, Fiere di Bologna,
1979, architect Kenzō,
Tange, Bologna, Italy.
Granite, 52½ feet long

outside permeates the inside,"[4] designed what he called "a gate" to draw together the pedestrian plaza space. This was, in fact, a magnificent horizontal beam of granite on a pyramidal base, with a gently graded, low stairway approach. Beyond is an octagonal depression designed for performances. The horizontal circular beam of jointed stone drums functions much as do foreground figures in Renaissance paintings—as a *repoussoir*—but also as an announcement of the space to be sensed around it. The scale, as Tange said, is perfect.

In the late projects, Noguchi's care, his thoughtful conception of illusory space that amplifies the real space and gives it form, his theatrical sense that goes back to the calculation of sight lines and human scale in the bounded situation of the theater, all attest to his desire to enunciate his personal philosophy in terms that can be sensorially comprehended by others. He had built up a view of existence through intuitive actions—his works—that coincided with a strong intellectual current that had permeated the world after the Second World War. His feeling that he moved in a medium called space that could be assigned a specific human value was instinctive, and he felt, as he once said in a lecture, he could communicate that value. "I see my neighbor," he said, "but I don't see myself." The circumambient space in which his neighbor moved would always be an imaginary horizon toward which he gravitated. Sometimes he called it a frontier.

Pressing toward the outer boundaries was not always simple. Several of Noguchi's late grand projects were fraught with exasperating problems. In 1978 he secured two commissions that would bring him into vexing conflicts with local communities and try his patience enormously. Shoji Sadao's participation on every level helped considerably. The two, artist and architect, confronted each emergency together—and there were many. For Houston's Museum of Fine Arts, Noguchi was asked in 1977 to design a sculpture garden. It would be a nine-year trial. His earliest conception included a wall of varying heights, in keeping with his feeling that a garden is a place separate from other places. It was met with a disturbing clamor from elements in the community that objected to the excluding function of a wall. Noguchi redesigned the garden several times, always finding resistance from one or another sector, until finally he invented a space full of changing relationships among the partial walls within, to serve as settings for sculptures and the partial walls surrounding. Noguchi resolved contradictions, as he said, in a way pleasing to himself: "It is not exactly open, and yet anyone who cares to do so can walk right in from almost any direction . . . there is a kind of conversation going on, a very quiet conversation between walls and spaces, people and sculptures."[5]

The other difficult grand project was even more complicated. The city

of Miami approached Noguchi in 1978 to design a waterfront complex to be known as Bayfront Park. The challenge was welcomed by Noguchi, who saw an opportunity to put all his experience in Detroit, where he had only had eight acres to cover, into a still more impressive scheme that would cover twenty-eight acres. Things went relatively well in the beginning, when he was even able to persuade the city to remove an old library that obstructed his plan. But soon he was confronted with changing administrations, new commissioners, and a cast of what seemed to be thousands who thought they could design what they needed better than the man charged with the job. Noguchi's constant visits to Miami to resolve the endlessly petty disputes were a source of great disquiet to him. Nonetheless, he managed to finish more than three-quarters of the park during the decade before his death, including a large amphitheater, a rock garden, and a tower equipped with laser beams. At the time of his death, he was embroiled in still another conflict, this time with the mayor himself. The *Miami Herald* reported in December 1988 that his final addition, the *Challenger* Memorial for the astronauts, might never be completed as he designed it. "He envisioned a towering double helix surrounded by a forty-foot wall with an opening in the middle, for the south end of the park. The double helix is under construction but the wall may never be built. . . . Mayor Xavier Suarez, who opposed the wall, met with Noguchi and reached a compromise: the double helix would be built without the wall, and the two would meet in January to see if the wall was needed." Noguchi died before the famous meeting, when a mayor would take it upon himself to usurp an aesthetic decision. But as this is written, Shoji Sadao, who understood Noguchi's "way of working with shapes," is battling through.

Sadao is also taking on the tremendous task of completing the largest park of all at Hokkaido, the one to which Noguchi referred when he said he was "nearing the limits." Noguchi had been immensely excited at the prospect and had envisioned a great black granite spiral slide, on the model of the white marble one he showed at the Venice Biennale in 1986, against the white winter's snow of the northern site. The huge sculpture was completed, but the remainder of the project remains for Sadao to bring to fulfillment. Noguchi regarded Sadao as "true collaborator in a mutual exploration in the building of spaces as sculpture."[6] Sadao will complete Noguchi's last works.

Not all the last grand projects were so frustrating. Noguchi's last completed public space in the United States, *California Scenario* in Costa Mesa, California, was achieved relatively harmoniously in spite of its rather complicated schema. It was commissioned by Henry Segerstrom, a wealthy developer of an individualistic bent, who gave Noguchi more or less carte blanche. Sadao called Segerstrom "a very good client. . . . At the

California Scenario,
1980–1982, outdoor plaza
and sculpture garden,
Costa Mesa, California.
1.6 acres

beginning of the project Segerstrom said, 'I want an artistic dictator and
you are it.' "[7] Descendant of a family from an old California farming
community in which lima beans were one of the chief crops, Segerstrom
was receptive to Noguchi's mythologizing. He, too, had a sense of his
native earth and a certain anxiety about the encroachment of industrial
parks in the San Diego area. Noguchi, in turn, was stirred by the prospect
of making a monument in the place of his birth. Asked at first, in 1980, to
design only a fountain for a small park surrounded by commercial build-
ings, Noguchi, in his usual style, suggested rather that he take on "the
whole cubic space."[8] Segerstrom agreed, and Noguchi set about making a
completely enclosed space into a work of art that would sum up his life's

convictions. He drew up what he called the *California Scenario* for the 1.6-acre space—an outdoor plaza and sculpture garden—with six major elements including symbols of the desert, forest, farmlands, and water sources. Every inch of the space was to be designed by Noguchi, and he paid attention to every detail, right down to the design of ashtrays.

In Costa Mesa, Noguchi's fundamental vocabulary—geometric and organic stone figures, shaped plants, and flowing water—is brought into harmony by means of a spectacular white wall serving both as a backdrop and as a barrier beyond which there is only sky, as borrowed scenery. Every inch of the relatively small plaza is calculated to produce an illusion of space and depth. Noguchi's play with perspective, always subtle, occurs not only in the slightly distorted geometric stones that rest on warm, pinkish terrace stones, but also in the clustering of the paving stones themselves, which lead the eye on to the boundaries in diminishing lines artificially created by their pattern. Each circular and each triangular form contributes to the visual extension, far beyond the real latitudes. To emphasize the potential largess of this park, Noguchi designed a meandering water course, originating in a triangular sculpture looking like a variation

The Spirit of the Lima Bean, 1981, in *California Scenario*, Costa Mesa, California. Granite, 144 inches high. Photo: Shigeo Anzai

on the Jaipur observatory. This elegant structure produces a waterfall, which in turn moves in a winding stream, like a babbling brook, throughout the space. Jaipur is not the only memory Noguchi called upon. In a mound of natural rocks fitted ingeniously, contour to contour, he recalled Peru and also, as he said in the title, *The Spirit of the Lima Bean.*

Costa Mesa is filled with metaphors that hold nature and culture in suspension. Culture is defined in the shapes only man can imagine—the triangle and the circle. They are clothed in stone, as is a magical truncated pyramid designed with anamorphic distortions that make the piece seem to blend into a miragelike illusion of vast space. Nature, on the other hand, is allegorized in such details as a sand mound, seen almost grain by grain in the high western light, planted with natural but rhyming shapes chosen carefully—round cacti like pincushions and spiky cacti like swords. Nature is also honored in the much-pondered, selected found stones that Noguchi invariably placed on occult axes. Some of these stones are low-lying and motherish, some erect like menhirs. Throughout, Noguchi chose the most delicate of western stones—pinkish, ocherish, orange—radiating their former lives in the sun-swept desert, to thread his metaphors together and dominate the whole scheme.

Nowhere has Noguchi drawn more subtly on the two most important formative experiences in his life: his work in the theater and his study of the Japanese stroll garden. It was in the theater that he discovered that a sense of vastness could be accomplished by simple means, as he said, in the placement and proportions of things and by the lighting. In Japanese gardens he learned the countless tricks used to suggest distance in very small areas. "Generally speaking," he wrote in 1968, "these illusions are created through an isometric triangulation so that the eye is constantly carried from one to the other."[9] In the California garden, only a stroll accomplishes the artist's mission, for each detail is conceived as a relation. Moreover, as in a Japanese garden, the person experiencing its vistas must navigate the spaces as if he were at once at ground level and above, looking down. The very gait of the spectator is guided, and he is directed to look at ground level as he perambulates. All the same, he is moving within that cubic space, conceived to function in much the way the theater functions. The spectator becomes the actor, animating Noguchi's imagined space. The stage, he always said, was not merely space, but a space of life. When dancers move around his sculptured objects, he once explained, "they are moving in their own space and through our eyes we are moving with them. . . . It is the double life we lead when we are in the theater."[10] This double life is invoked in Costa Mesa, where a human shadow at any time of day steals out of the given total cube and into the illusory and metaphorical space Noguchi lived. *"Créer,"* said Camus, *"c'est vivre deux fois."* Noguchi rightly called this masterwork a scenario.

Isamu Noguchi
Garden Museum,
Long Island City,
New York

Two views,
Isamu Noguchi
Garden Museum

Grand Shrine at Ise,
Mie Prefecture

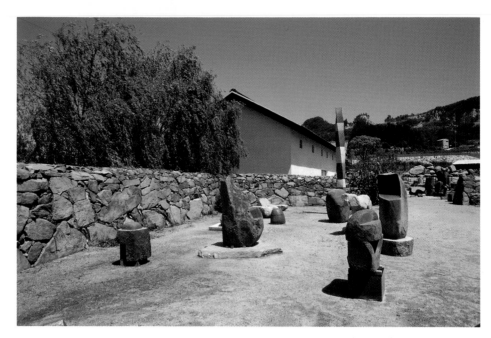

Sculpture yard and
mountains at Noguchi's
studio in Mure, Shikoku

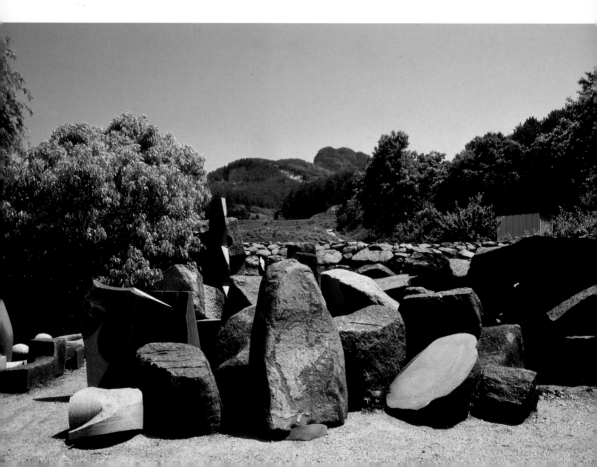

Above: Stone platform
by Noguchi on grounds
of his Mure, Shikoku,
compound

Below: Rocks and
Noguchi's favorite view
of surrounding mountains
at his compound

Noguchi's outdoor
sculpture yard with
walled enclosure in
Mure, Shikoku

Late works in yard in
front of Noguchi's studio

In Noguchi's sculpture yard,
Mure, Shikoku

The scenario for *Momo Taro*, a piece commissioned by the Storm King Art Center in Mountainville, New York, was of a different order. The art center, which is primarily an outdoor sculpture park in a splendid setting of rolling hills, offered Noguchi a site and agreed to accept whatever he proposed. Noguchi, pacing the terrain and gauging its points of vantage, found the precise place to center his thoughts: a gentle, small hill that commanded views of dales, other hills, woods, and sky. "It was the hill that got me going," he used to say. Not that the hill was perfect: before he started searching for the perfect stones for his conception, he had already determined that he would change and enlarge it so that the compass of his piece would function as a magnet. He rushed to Japan where he would perform one of his favorite rituals: stone hunting. Izumi had canvassed the island of Shodoshima shortly before and reported that he had spotted a huge stone. Noguchi, now in his late seventies but undaunted, climbed the mountain and was thrilled to find a huge boulder of his favorite white granite. As it was far too large to convey to his studio, the workmen split the stone on the spot. According to one of Noguchi's accounts, there was a hollow within, and the workmen immediately exclaimed, "Momo Taro!" In another account, they only identified the old Japanese legend when Noguchi began carving a circular cavity in one of the halves. In any case, while it was the hill that got him going, it was the happy association with an old origin myth that kept him going. It is clear that Noguchi brought to his task the lessons he had learned in sacred places. These places were often elevated, and the sculptures they bore were often symbolic crests. Holding in his mind the green mound in Mountainville, Noguchi adjusted its contours in his imagination and worked to another scale. The piece, comprising nine elements, would be seen differently from each point of the compass, but always it would seem a natural gathering in a particular landscape.

The presence of the myth of Momo Taro in his mind conditioned his thoughts. In the old style of *monogatari*, meaning "a telling of things," the story told of a young hero, Momo Taro, who emerged from a peach to slay a local demon. Noguchi thought of Momo Taro as the offspring of the sun god, just as in Greece Hercules was the son of Apollo: "Tales like this are part of the myths of the establishment of a country, the myths of creation." In *Momo Taro* the rock proposed itself to him as a sun and also as a mirror. It is sited on a diagnoal axis so that its concave center peers up to the mirroring sun. Its deeply carved hollow is ovoid, also suggesting creation, and invites entry as a protected, sacred space. There are many possible associations, one of which is with the old Japanese drum, hollowed from wood. The resonance of the granite is surprising. When Christopher Blasdel performed for Noguchi in the heart of the sun stone, the sculptor was overjoyed.

Relating to this central sun image are eight other stones, some left almost in their native condition, some slightly carved or scored, and one—the other half of the original rounded boulder—echoing the oval of the sun stone. Others are like overturned runic seats for some esoteric ceremony. As the viewer ascends, they seem to close in on themselves, but once he is in their midst, they open to a magnificent prospect, sweeping around this centered hill of which they are now a part. The horizontal elements insist on the whole being seen as both a part of the natural setting and an inspired composition.

Noguchi thought of his piece as "a place to go . . . a metaphor for man as an end and a beginning . . . a mirror to the passage of the sun." In this rotation of thoughts, Noguchi was not lacking in humor. There is playfulness in the idea of a fantastic legend; a sense of fun in the way the rough and the smooth, the defined and the amorphous, play against one another. His old affection for Ryokan had not diminished. Such humor as is found in Zen koans resides somehow in this splendid piece. In fact, in his last years, despite many frustrations, Noguchi's wit emerged regularly. In his last exhibition at the Arnold Herstand Gallery in New York in 1988, he showed several parodic sculptures carved in sheet bronze on the theme of the Korean carrot; one of which, titled *Korean Carrot, the Sadness of Being Somewhat Human*, recalled Hokusai's satires. (I think of one Hokusai caricature in particular that shows a rival artist in ridiculous rain gear painting on a huge white radish.)

Noguchi's most harmonious collaboration occurred when Yoshio Taniguchi, son of the architect Yoshirō Taniguchi, with whom Noguchi had first worked in Japan, approached him to design a sculpture court for a memorial museum dedicated to Ken Domon, a renowned photographer who had willed his life's work to his native city, Sakata. Taniguchi, who had been trained as an architect in the United States, had long desired to approach Noguchi, whom he had met as a boy of thirteen. Watching in the background as Noguchi worked with his father, and knowing the whole circle of friends—Ken Domon, Sōfū Teshigahara, and Kamekura among others—Taniguchi was particularly sensitive to Noguchi's ideas. When he was commissioned by the city of Sakata to create a museum in which some seventy thousand works by Ken Domon would be exhibited and stored, he immediately thought of Noguchi. The site was splendid—a park about four kilometers from the city surrounded by rice fields, beneath a small mountain and a forest, fronting marshy ground that could be transformed into an artificial pond. Taniguchi made a preliminary model and immediately arranged to visit Noguchi in Shikoku. He described a typical encounter:

> That evening I asked him to design a sculpture garden for the museum. He said, "Why should I?" I said, "Do it for me." You

know, Isamu never said yes right away. Then he said, "I'm very expensive, you know." I didn't want to press too much that evening, and we had dinner with sake and stayed up late talking of other things. The next morning, at six a.m., I heard a noise. I opened one eye and saw Isamu with his scissors cutting up my model. I kept quiet for a while, and then he realized I was awake and said: "I've decided to do it for you, and besides, I knew your father." Then I asked him to design the site for his sculpture, and he said the object was not so important. If the space was good, anything would fit. We visited the site together a number of times, and always he made suggestions, although he warned me, "I may destroy your building." I said, "I don't mind." I always asked his opinion, and he always gave me the right answer.[11]

It is not difficult, in view of Taniguchi's unusual deference, to understand how Noguchi warmed to the project, as did Hiroshi Teshigahara, who designed a dry waterfall landscape on the slope behind the museum and an artificial, landscaped hill; and Kamekura, who designed the plaque at the entry and the circulars and tickets. This collaboration of old friends was a rare pleasure for Noguchi after the tribulations of so many of his other architectural projects.

There was much in the landscape to inspire Noguchi, even the journey from Tokyo—a four-hour train ride along the mountainous coast of the Sea of Japan, with fleeting vistas of deep ravines, their apertures shimmering with rice fields; small fishing villages with ancient thatched-roof houses hugging the shore; and fantastic, sometimes conical rocks rising from the sea, miraculously caparisoned with conifers. Then Taniguchi's fundamental idea—to design an absolutely discreet, classical building of granite with, as he wrote, a path as the organizing principle—bestirred Noguchi's associations with ancient Japanese juxtapositions of nature and architecture. Nothing suited him better than that the entire museum, with its intermittent views of water and garden and park, and mountain, seen both from within and without, be designed as an abstract path, a way and idea that, as Taniguchi stated it, would contrast the soft flowing lines of the landscape with the sharp angular lines of the building. "I try *not* to introduce any particular style," Taniguchi said, "not even Japanese ideas of proportion and light. My work is very abstract and can be reduced to the simple square and circle."[12]

Taniguchi's low-lying structure, with a beautiful long wall emphasizing its memorial character and a bridge joining the two sides of the park over the pond, was nonetheless a remarkable evocation, perhaps unconscious, of certain classical Japanese principles. Even the rectangular and square granite slabs on the sides and facade of the building echo old measures, while the frequent transitions from one level to another are

distinctly Japanese. Details, such as the smooth granite on the outer walls, and the rough surfaces on the inner walls, also recall the subtle dialectical aesthetic of centuries before. Even Taniguchi's use of diminishing perspective, in the windows of the long gallery moving toward a verandalike structure overhanging the pond, recalls Katsura, but without sacrificing its own clear spirit of modernism.

Noguchi's garden connects mountain, museum, and water and is the essential component of the total design. His conception is delicately shaded, reticent. The resolution of the space, which is at once interior and exterior, acknowledges that a balance is necessary between what man can create and his dependence on the wellspring of nature. In effect Noguchi produced a three-walled, open-air room, with a terraced floor of rough granite levels that descend very slowly in rhythmic steps. Taniguchi's bridge becomes from certain viewpoints the symbol of a fourth wall, or creates a window, so that Noguchi's recessed garden is seen much as one sees a tokonoma in a traditional Zen hall.

The unique Japanese tokonoma had fired Noguchi's imagination on several occasions. He poeticized and altered its original function and extrapolated several whimsical conceptions. During his early study tour in 1950–1952, he had noted the importance of the tokonoma in Japanese architecture, which he said could not be overestimated:

> Looked at superficially, it might be called waste space, but actually it gives a far greater sense of space than it consumes. In a way it might be called a reflection indoors of the garden, a window as it were. . . . There is an unused space involved, a void which invites the imagination into communion with a mood . . .[13]

When he hewed his first studio in Kamakura from the mountainside and arranged adobe walls within, he wrote a rather confusing account that nonetheless gives an idea of how he could amplify and make entirely personal an old convention. He described a bedroom area in his studio with its own tokonoma that, although tiny, "serves the purpose in providing that extra sense of space. This flanks a mud-walled area and forms, also, a kind of tokonoma in that it serves as a place to hang a picture."[14] Noguchi expanded his metaphor still further by describing a freestanding pillar—the only painted object in the room—of bright red: "This serves to set the whole earth wall apart as a sort of tokonoma where fire is the picture." In the Domon Ken Museum, Noguchi was highly conscious of the tokonoma's function as an "unused space, a void which invites the imagination into communion with a mood." Seen from a distance, this simple absence in the lateral facade of Taniguchi's building reads both as a suggestive void and as an animated center from which spaces can flow;

Domon Ken Museum
Garden, 1984, architect
Yoshio Taniguchi, Sakata,
Japan. 30 × 36 feet.
Photo: Isamu Noguchi

as a tokonoma, in effect, but a tokonoma no one had ever imagined before.

The gently graded granite steps, in turn, are animated by water that steals almost silently to a final, delicate cascade, barely ruffling the surface of the pond as it falls. Perhaps Noguchi remembered a phrase that he often liked to quote from Louis Kahn: "The flow of water determines architecture." Certainly he bore in mind the great impressions left with him after his first tour of the gardens with Hasegawa, who had often discussed the function of water with him. In 1951, Hasegawa wrote about water in a letter to Noguchi and quoted Lao-tzu: "Water seems to be the weakest being. Water obeys the forms of vases, square, round, or any other form. Water penetrates into the lowest parts of the earth and the

Domon Ken Museum
Garden, 1984, architect
Yoshio Taniguchi, Sakata,
Japan. 30 × 36 feet.
Photo: Denise Browne Hare

power of water is the strongest on earth.''[15] In Noguchi's garden there is
both silent water and active water—an old Japanese garden principle. But
in this, perhaps the most sensuous and at the same time most simple of his
water gardens, the water shows its power as an organizing principle with
unparalleled efficiency.

Taniguchi had conceived of the museum as a kind of caesura between
mountain and water and had wished it to be "half almost buried in the
ground—a static space that never changes—and half floating on water,
changeable.''[16] Noguchi picked up the threads and wove, into the central
court, all the dominant motifs. He planted a stand of bamboo trees at one
corner that serve both as sculptural principles in their verticality, and
volatile sources of ethereal sounds. He chose a single sculpture—a local
granite, menhirlike stone with delicate gray-to-ocher tones, which is only
partially shaped by his chisel—to stand off center (but uncannily, as one

moves, it becomes the center). This is an ambivalent symbol of both man and nature—a silent witness, a gnomon, a sentinel, a point from which the viewer can seize all the conjunctions of mountain, sky, and water. In its lonely presence and self-containment, this sculpture, with its base always washed by moving waters, comprehends all of Noguchi's most pondered ideas and values at the end of his life. It strives toward the ideal of the natural—the almost artless presence of nature. But it also carries in its minimal but crucial carved articulations something of Michelangelo's pathos in the *Rondanini Pietà*, of which Noguchi had been thinking in his last years, in its slight indication of a tragic weight, its slightly inclining axis, its pending earthward, its diagonal cut—the sole accent functioning very much as do the polished thighs, suspended and speaking of gravity, in the *Pietà*. At Sakata, Noguchi succeeded in extracting from his whole life's responses to sculpture, by the most subtle and universal of means, cosmos out of chaos.

Overview of Isamu
Noguchi Garden
Museum, 1989. Photo:
Denise Browne Hare

Conclusion

I ONCE TOOK a stroll with Noguchi in his museum garden in Queens. As we paused to consider the various sculptures, he mused about his creative life: "I have come to no conclusions—no beginning or ending." When I thought about it, I saw the elliptical aspect of his life—all the circling back, the connecting up of disparate sources. There could be no division of his work into this period or that, this phase or that, although there were certainly prolonged moments of intensified interest. Noguchi, like all artists who have sought to surpass even themselves, felt himself drawn on and knew instinctively that there was some unique course taking shape as he moved through his life. He also took a certain pride in daring to deviate from his own premises. Weeks before his death in one of those long-distance telephone calls from Japan, he said, "You know, I go this way and that—it's not just the past with me; there's a good deal of opening forward, too."

Both his looking back and his looking forward, in the telling, took on mythopoeic overtones. Noguchi so often referred to poetry and myth, which he saw as fulfilling the same important function in life—the condensation of universal meaning. Unquestionably he turned to myth as the means to express his vision of the *theatrum mundi*. For the sake of the myth, the unity compressed into the notion of a *theatrum mundi* is regarded as lost or unattainable. But theater is theater, and Noguchi understood that he could, in fact, retrieve or attain the vision, but only through his ongoing work. His mythic allusions merely enhanced a poetic insight. He was far from being a mystic. It is true that he was always attracted to ideas of the spiritual, but he stopped short of religious conversion. Like others of his generation, he was a skeptic, but a skeptic with a longing to believe. He was thorough in the way he explored certain esoteric philosophies and religions, such as Zen, but he could not submit to any limitation other than that which he could create himself with his hands. He was a modern and, to a large degree, a man of the West steeped in the Platonic tradition of unresolved dualities. He used to say, "There are two parts in all our natures." He could never become a Buddhist because, as Octavio Paz says, "What Buddhism offers us is the end of relations, the abolition of dialectics—a silence that is not the dissolution but the resolution of language."[1]

Following the crisscrossing of Noguchi's remembered moments and noting his lifelong interests, I came to think of him as an authentic romantic. His preoccupation with William Blake from early childhood to the end

of his life was not trifling. I don't think I ever had a serious conversation with Noguchi, in all the thirty years I knew him, in which he failed to mention Blake. Like Blake, he thought of the five senses as an opening to the world and balked at pure intellectual abstraction, although he was mightily tempted. In his old age, Blake was described as "energy itself" by his student Samuel Palmer, and worked unremittingly. But as he himself wrote: "I labor incessantly and accomplish not one half of what I intend, because my Abstract folly hurries me often away while I am at work, carrying me over Mountains and Valleys, which are not real, in a land of Abstraction where Spectres of the Dead wander."[2] There was a lot of abstract imagining hurrying Noguchi over mountains and valleys, too, and his returns to the earth were as important to him as Blake's returns to his sunflower and stream. "Seek the dead center of gravity," Noguchi told himself in a note written in 1986.[3]

Noguchi's faith in the importance of memory also falls within the romantic's compass. He would enshrine certain memories or shape them artfully so that they could be retrieved, revivified in works. His mythologizing of his own life was apparent and no doubt is open to many interpretations, including those of psychobiographers. Yet, as I went through the

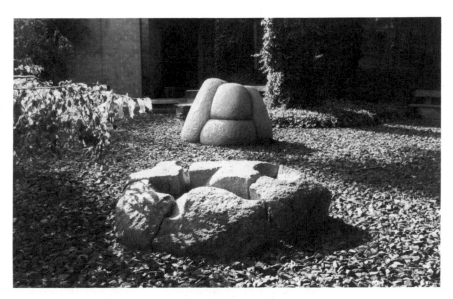

Overview of Isamu Noguchi Garden Museum. In foreground: *The Big Bang*, 1978, granite, five elements, 79 inches largest dimension. In background: *The Illusion of the Fifth Stone*, 1970, Aji granite, 54½ inches largest dimension. Photo: Erick Johnson

written documents of Noguchi's life—the interviews, writings, letters, my own notes on conversations—and noticed his increasing involvement with his father's traces, I was not tempted by the standard Freudian interpretation. Noguchi was an inveterate transformer, not only of the details he could conjure of his own early life and origin, but of everything that crossed his path. The history of Yone Noguchi was like an ember within, always ready to flare up, always subject to transformation, and almost always sounding in the voice of myth. Noguchi's quest for his father took far more complicated forms than the obvious (the obvious being, for instance, his choice of a few, very few, older men as mentors and friends, or his physical journeying to the stones once trod by his father). He was asking for more than the restoration of a rejecting father. He was asking, as Wallace Stevens asked in "The Irish Cliffs of Moher":

> Who is my father in this world, in this house,
> At the spirit's base?

As Stanley Kunitz said of this poem, in which Stevens took us to the cliffs and said of the landscape that it was "A likeness, one of the race of fathers: earth / And sea and air," Stevens has moved us beyond the personal into the grandeur of abstraction."[4] Noguchi's seeking to make a true connection with his remote father may have begun with a simple emotional need, easily identifiable, but it brought him beyond the personal.

How richly Noguchi could embellish his story is revealed if we follow just one of his interests partly instigated by his desire to know his father. In his mind Yone Noguchi was associated with both the modern avant-garde and ancient Japan. Yone's persona as a poet in English and a friend of the great modern experimentalists, especially Pound, loomed large for Noguchi. Michio Itō had given him a letter of introduction to Pound when he went to Paris as a youth, but he had not used it. But in April 1927, when he went to London to study Oriental art in the British Museum, he indirectly crossed Pound's path when on his very first night he encountered Nina Hamlet, who told him about Henri Gaudier-Breszka, one of the youthful bohemians whom Pound had recruited for "our lot" when he was intent on launching a meteoric movement. Noguchi was naturally interested in the chaotic young sculptor who, as he later wrote, "was trying to find a more direct and straightforward relationship between structure and raw material."[5] Noguchi's interest was not only in the way Gaudier defied the canons of stone sculpture, but in his life itself, which he called "the stuff of which myths are born." When he returned to London in 1933, he read Pound's 1916 book on Gaudier and reported many years later that his "interest really caught fire." His reason is significant:

What struck me most about Pound's book was the fact that it
expressed a poet's view of a sculptor. My own father happened to
be a poet, so for me this view held great significance.[6]

More than thirty years later, after Pound had been released from deten-
tion and had settled in Venice, Noguchi finally met him. When Pound
discovered that Noguchi was a sculptor, he took him back to his apartment
on the Giudecca and brought out all Gaudier's letters and sketches for
Noguchi to see. After Pound's death, Noguchi was asked to help arrange
the grave monument that would display Gaudier's famous stone portrait.
He came to Venice and designed a round stone base that would "symbol-
ize the world," and, as he worked, he said to his friend Priscilla Morgan,
"I really don't know why I'm here, unless of course because my father was
a poet."[7]

Noguchi also associated many of his experiences with his early memo-
ries of his mother, and particularly her interest in Irish poetry. He was one
of the many American artists who dipped into Joyce at frequent intervals,
finding solace in his internationalism and his proud sense of artistic exile.
If, in relation to Yone Noguchi, the sculptor son was like a Telemachus
who dreams of a reconciliation that is never wholly believed, with his
mother, Noguchi was somewhat more at ease. His memories were en-
sconced in certain references, selected always for their meaning in his
present. His frequent allusion to Greek myth derived from the maternal
attentions in his early childhood, which he did not hesitate to call "arche-
typal memories." William Blake, to whom his mother had introduced him
very early, would become one of these archetypal memories that would
serve him throughout his life as touchstones. He clung to the early emo-
tional responses Blake had elicited and was always trying to reinitiate
them in his work. But he also sought to expand his knowledge of Blake,
collected books about him, and discussed him frequently—particularly in
his last years—with kindred spirits such as Takemitsu. Finally, he was, I
think, more like Blake than like any Oriental sage, and conformed to poet
and critic Kathleen Raine's view of Blake:

For he believed the purpose of poetry and the arts to be the
awakening of recollection, the Platonic *anamnesis*, the normal
function of the arts in every human society whose basis has been
metaphysical.[8]

It was very important to Noguchi to sense a metaphysical foundation
on which he could build, and he posited his faith in his intuition and in the
"direct experience" that would reveal the presence of a philosophical
foundation. One has to assume that all the judgments, momentary deci-

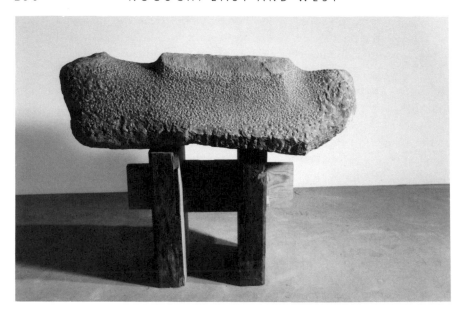

Time Thinking, 1980.
Basalt, 15 × 48 × 17
inches. Isamu Noguchi
Garden Museum. Photo:
Erick Johnson

sions, and revisions have been made from the cumulative questioning of existence. All through his life Noguchi made brief forays into what must be called philosophy, but only in order to confirm the intimations of a meaning garnered through direct experience in the world. He was moved by Van Gogh, for instance, because he thought that Van Gogh did not set out to make masterpieces, but only to catch something of the world as he saw it. "I thought it was extraordinary that he, this man who had entered into a state of separateness alone with his universe, could depict it like that as his own sort of trance. I think these are the moments when a man goes beyond the common interpretation of things and sees it directly."[9]

Noguchi thought that everything we see is merely "a film" or "information" until it is milled in the artist's imagination. The senses, he said, are tactile, not informational or verbal, and would provide the experiential "comfort of the world." There have been artists who for centuries have been trying to tell their interpreters and historians that not everything can be accounted for by the mind. Whether they called it intuition or imagination, these artists sensed themselves to be both agents and instruments of

the forces of nature and providers of what Noguchi often called the constancy of art. Noguchi joined them. His drive and inventiveness were derived from this fundamental faith, as was what is sometimes called his visionary tendency. He could begin, for example, with a consideration of the column in Greek architecture and be "hurried," as was Blake, to a wider vision. "If I were an architect," he said in 1982, "the ultimate building I imagine would have no wall, no roof but columns. Instead of a roof, there would be something like electricity between columns which would shield rain, for example."[10] Nature always tempered his approach; nature, which, as he said in his thoughtful analysis of Lear, "permeates the shadows and fictions of man's willful passions."[11]

Noguchi's own passions were markedly willful. Those who knew him used that word to describe him—or sometimes, the word "selfish." In his personal relations he seemed ill at ease and sometimes unpleasantly insensitive. His character, to many who knew him, seemed somewhat flawed, at least on the level of human relations. I will cite only one of many criticisms I heard while discussing Noguchi with those who knew or worked with him. "I admit he was difficult," said one of his more patient art dealers. "He was ungenerous, he was supremely, sovereignly selfish, he was unrewarding of others." He noted that:

> Isamu had enormous charm but when he was preoccupied or irritated, or had a scowl on his handsome face, one did not even like him. However, when the sun came out, as it were, and the smile lighted up his remarkable features, he seduced you back into loyalty and affection.[12]

There were many, all over the world, who could have said the same, and who, despite everything, remained loyal—especially women. How much Noguchi's suspicious nature was formed by his unhappy childhood, his abandoned state in his vulnerable years, his shock at being sent away from his mother so early, his view of himself as a "loner" and a "waif," I leave to the art historians who have more faith than I in the connection between personal circumstance and art. His willfulness was probably necessary to accomplish his vision. Shoji Sadao, who understood him so well, has described Noguchi's demonic drive; his need to forge on in spite of all difficulties. If there was the slightest possibility of a large project, Sadao recalled, Noguchi would always visit the site. "It was never a question of how much money he got. If it interested him, no matter whether he got paid or not, he would go ahead and start work even without a contract."[13] This led to many difficulties, but it was characteristic. Noguchi himself felt driven, and, at times, unbearably so: "How few of us ever really stop to ponder, or have the courage to simply stop the

infernal momentum which we take to be a direction. The trouble is we are burdened with ourselves wherever we go."[14]

Certainly part of Noguchi's restlessness, his "infernal momentum," could be ascribed to his uneasy sense of not belonging anywhere, his desire to resolve his double origin. But finally, I think, these personal details give way before his artistic ambition. As an artist he lived, in his person, a long tradition of East-West confluence and may someday be seen as the culmination of a very long process, beginning during the early Renaissance or even before. One of his most perceptive early critics, Thomas B. Hess, said, "The East and the West have been fused in his art as they were in the Romanesque basket capitals, or in the late poems of William Butler Yeats."[15] Those who could understand Noguchi's enterprise best were the occasional fellow artists or enthusiasts who had wandered in comparable directions. Dorothy Norman, for instance, who had met him while assisting Alfred Stieglitz in 1927 or 1928, insisted that Noguchi "knew who he was." Like her, he felt a tremendous attraction to India. Norman, who became an intimate friend of Jawaharlal Nehru and Indira Gandhi, said that she shared with Noguchi a feeling that Indian culture "was the other half of life."[16] The dancer Erick Hawkins understood Noguchi's spirit and admired him "because he made things just for their own *suchness*—a Buddhist term—the same as Brancusi."[17] Then there was Buckminster Fuller, who repeatedly cited Noguchi as the one whose judgment he esteemed and trusted above all. These were Americans who had overflowed national boundaries to reach for what Fuller called a global vision. For them, East and West were no longer the simplicist stereotypes of the era of Madame Butterfly. There were younger artists, also, who had boundless respect for Noguchi, and who acknowledged enthusiastically his role as a pioneer.

The photographer Shigeo Anzai said that "Noguchi used his situation of two heritages to be Noguchi." He also noted, shrewdly, that when Noguchi considered ancient Japan, "he used a filter."[18] He softened and excluded what he didn't like or didn't need. And there was much that Noguchi objected to in modern Japan. He felt no more comfortable there than he had anywhere else in the world except in his private oasis. His criticisms ranged from the old complaint, already voiced by Bruno Taut in 1937,[19] that the Japanese were susceptible to what Taut called kitsch and "vulgar trash," to the more recent observation that the Japanese were too ready to abandon their own best traditions for the worst of the West.

> I feel saddened that Japan does not seem to have the awakening to Japan that Americans have had. . . . Here, inasmuch as they are artists, they are individuals, yet they are constrained by the fact that they are Japanese and that they are in this sort of single-vision

view of the world as William Blake would say of Isaac Newton, the single vision where it is only to the future that they look and not to the past . . .[20]

Noguchi had winced, as had Taut before him, when he saw modern Japanese deviations from the fine taste he associated with his childhood. (Taut had given as one of many examples imitations of bamboo painted on modern iron fences.) Yet, Noguchi still felt that Japan had something important to teach: a sense of time "which is not only one-directional, but in all directions—radiant." In his Kyoto Prize Memorial Lecture, November 12, 1986, he summed up his credo:

The past is ourselves; going inside ourselves, we go into the past, because there is a memory inside. Going out, we go to the future. There is no memory there, so it's very questionable. We do not know what is out there, but inside of us, we know what is there. . . . We know by instinct. If we study the past, we study ourselves . . .

In his own precarious teetering between tradition and the world, between past and future, Noguchi found his center of gravity by creating what he called his "sculpture of space," which very often took the form of grand projects designed for public use. In this, too, he extended a slowly evolved concept that has its roots in the late eighteenth and early nineteenth centuries, and that he was among the first to realize in the twentieth century. This is the idea of the blending of all the arts into a new form that Wagner called the *Gesamtkunstwerk*, but that was already dimly formulated during the time of William Blake by the German Phillipp Otto Runge. Runge believed in a fusion of all religion, theology, and mythology in a single chapel—the Chapel of the Living Spirit—in which huge paintings would surround the viewers, and carefully orchestrated choral music would expand their capacity for contemplation. Noguchi's sculptures, whether individual carvings or garden ensembles, were a means to having meaning, and he never shied from literary, mythological, and poetic references or from the clues offered by the work of imaginative dancers. His admiration for Japanese court music, *gagaku*, was partly based on his intuition that his approach to the spirit was similar. *Gagaku*, as one author has written, "is a block of sound. It does not move but allows other things to move through it."[21] Orchestrating the movement of various elements, and the responses of various senses, became Noguchi's most compelling ambition, which he himself never felt wholly realized. The things that would move through his "blocks," as in *gagaku* music, would be as difficult to name as poetic sentiments, and, as he said very late in his career, almost

invisible. He sometimes spoke of working "the possibility of possibilities."

None of Noguchi's close friends ever doubted his genuine interest in social issues and his deep revulsion against war and its consequences. As difficult as he might be in personal relations, and as whimsical, in larger issues he was consistent. His eventual commitment to the garden as the special form to express his view of existence was always moored in his desire to affect people's lives. I myself witnessed his special delight in Detroit when he saw his park—conceived, in the diction of the period, as a people's park—used by a diverse ethnic population, mostly poor. I was also privy to his unwavering attitude against instruments of war, and his unfortunately unfulfilled hope that the monument to the dead of Hiroshima—to all the dead victims of war—would one day be installed somewhere in its full dimensions. His genuine anguish during the war in Vietnam was apparent, for instance, in a letter he wrote on September 14,

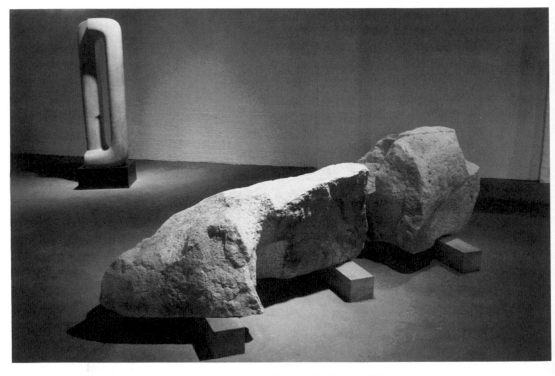

Transfiguration of Nature (Shizen No Henka), 1984. Mikage granite, two elements, 24 × 61 × 30 inches, 30 × 63 × 33 inches. In background:

In Silence Walking, 1970. Marble, 62⅝ inches largest dimension. Isamu Noguchi Garden Museum. Photo: Erick Johnson

1972, to the Reverend Anthony J. Lauck, who directed the art gallery of the University of Notre Dame in Indiana, concerning a sculpture the university had recently acquired:

> *Okame* is the mask worn in "Kyogen" which is a part of the Noh plays. This is the slapstick part of the Noh, and the *Okame* mask itself of that of a rather bumptious country woman given to ribald repartee.
> As you can see, I have made my *Okame* all bandaged up with one pathetic eye and no longer humorous. I did it in memory of all the *Okames* that must have had a similar or worse fate thanks to our kind consideration to end the war. What bitter commentaries may be made for the people of Vietnam if there were any here to know their true face.[22]

One could say that he perhaps felt this more keenly, knowing that some members of his father's family had perished during the Hiroshima fire storm. But Noguchi spoke here as an American and joined quite a few other American artists in their horror and shame. When he said "our kind consideration" he meant it, in all its bitterness, from an American point of view.

Like anyone else with a long creative life, Noguchi's voiced thoughts sometimes seemed contradictory, and that, too, I have come to see as the strong Western concomitant in his artistic formation. It was not a question of race or birth. His friend Takemitsu was as Western in a certain sense as he was. They both felt that their work emerged from tension. Takemitsu spoke of the importance of "irresolution" in his creative life, and many of his remarks reflect the existentialist preoccupation with ambiguity. Noguchi, in the romantic tradition, believed that struggle toward balance was in itself valuable. He also thought of art as having the power to make people ponder and the power to disturb them. "I sometimes think that my particular advantage, whatever it is, has been this factor of disturbance and conflict, that I live between two worlds and that I am constantly having conflicts of East and West, past and present."[23] His struggle was to bring himself to go beyond art—or at least the way art is defined in what he saw to be a corrupt world bereft of sacred values. His striving for essence, begun during his sojourn in Brancusi's white studio, was in effect a striving for truth, for the really necessary:

> The work that contains only what is really necessary would scarcely exist. It would almost disappear, in a sense it would be an invisible work. I have not yet reached that point. But I would like to go so far. Such a work would not claim itself to be art.

It has nothing conspicuous and might look as if it simply fell from
heaven . . .[24]

I find in many of Noguchi's statements the sensibility nurtured by the
early nineteenth-century romantic poets when they spoke of the poetry of
wind harps. And they, of course, were not far from the Japanese musicians
who thought that the sound of the samisen was most beautiful when it was
like the song of the cicadas, as Takemitsu has said. Noguchi was also a
romantic in his acute feeling of loss—his yearning for other times in which
the monumental had real meaning; in which great works were one with
the theogonies that spawned them. He set out on the archetypal journey—
not consciously but also not unaware of the great mythological tradition
respected by the early moderns such as Baudelaire and Rimbaud who had
fed into his own early sources—with a hunger to find true beginnings. For
all his practical skepticism, he could recognize and be moved by them. In
casual conversation, Noguchi's enthusiasm for certain sites was unmistak-
ably spontaneous and came from deep and long-cherished ideals. "There
is this word which I understand is used in the Islamic world, *barraka*,
meaning coming upon for the first time after a long and tedious trip. You
find this amazing sight which you have suffered a long way finding, and
it is like a spring and an opening. . . . Of course it takes the view to define
it, the view with such expectations and some knowledge . . ."[25] Noguchi
would have been pleased to know that in Hebrew, the word *barak* means
"lightning," for what he yearned for was the suddenness that Joyce de-
scribed in his special theory of epiphany.
 The meaning of his life's work was important to Noguchi even though
he could never convince himself that he had come to conclusions. There
were certain qualities that he alone had contributed to modern sculpture,
but they were often not understood. I feel that he had a special way of
thinking about weight and weightlessness that comes through in his last
works as totally original. It was a way of thinking shared by artists in other
arts, especially the dance, but unique in the visual arts in Noguchi's work.
He stands to modern sculpture the way Merce Cunningham stands to the
dance. Cunningham wrote of the history of modern dance:

> Some of the space-thought coming from the German dance opened
> the space out, and left a momentary feeling of connection with it,
> but too often the space was not visible enough because the physical
> action was all of a lightness, like sky without earth, or heaven
> without hell. . . . One of the best discoveries the modern dance has
> made use of is the gravity of the body in weight, that is, as opposite
> from denying (and thus affirming) gravity by ascent into the air, the
> weight of the body is going with gravity, down . . .[26]

Because the meaning of Noguchi's life's work is the history of a search pursued with driving diligence, he has often been misunderstood and certainly undervalued. The critic Benjamin Forgey suggested that "his importance as an artist—not to speak of his greatness—has been only grudgingly acknowledged. It is as if there are too many Noguchis to hold in the mind."[27] Noguchi confronted many defeats in his artistic life that he always overcame by his persistence, but he could never overcome the resistance often registered in the American press. His very last exhibition—two exhibitions held simultaneously at the Pace and Herstand galleries—in June 1988 drew a review in the *New York Times* that, although slightly less blatant, echoed the earliest reviews of his career. Even at this late date, he was seen as an artist operating in the gap between East and West.[28] Such misunderstanding, I believe, reflects only on the very culture that Noguchi sought to surpass, the cliché-ridden, nationalistic, materialistic culture that he wished to supersede with a new conception of sculptured space. As he said, "Call it sculpture when it moves you so."

Chronology

1904–1917

Born in Los Angeles, November 17, 1904, to Japanese poet Yone Noguchi and American writer Leonie Gilmour. Moves to Japan in 1906; attends Japanese and Jesuit schools. Sister Ailes, born in 1912.

1918–1922

Sent to Interlaken School near Rolling Prairie, Indiana. School becomes army training camp; attends public high school in La Porte, Indiana, having been befriended by former Interlaken director, Dr. Edward Rumley. Rumley arranges apprenticeship with sculptor Gutzon Borglum, who says Noguchi will never be a sculptor.

1923–1926

Enrolls in Columbia University as premed student. Takes sculpture classes at Leonardo da Vinci Art School; encouraged by director Onorio Ruotolo, decides to become a sculptor. Mother returns to United States after seventeen years in Japan. He exhibits in academic salons; frequents avant-garde art galleries (Alfred Stieglitz's An American Place and the New Art Circle of J. B. Neumann and the Brummer Gallery, where he is impressed by Brancusi show). Sets up studio at 124 University Place.

1927–1929

Receives Guggenheim Fellowship for trip to Far East. Goes to Paris; serves as Brancusi's studio assistant for some months. Makes wood, stone, and sheet-metal abstractions that he exhibits upon his return to New York–first one-man show. Makes portrait busts to support himself; exhibits them successfully. Meets R. Buckminster Fuller and Martha Graham.

1930–1932

Returns to Paris and travels to Peking via the Trans-Siberian Railroad. Stays several months studying brush drawing with Chi Pai Shih, and then goes to Japan. Impressed by *haniwa* and Zen gardens; works in clay with potter Jinmatsu Unō. Returns to New York; exhibits terra-cottas and brush drawings. Develops contacts with socially conscious artists; first involvement with theater.

1933–1937
First designs for public spaces, monuments, and a playground, *Play Mountain* (all unrealized). Works briefly for Public Works Administration. Exhibits project ideas and socially conscious sculpture. First theater set, *Frontier*. Does portraits in Hollywood to finance stay in Mexico; executes mural about Mexican history. Returns to New York.

1938–1942
First fountain, Ford Fountain. Wins Treasury Section competition for Associated Press Building plaque. Designs playground and playground equipment (unrealized). Drives cross-country with Arshile Gorky. Voluntarily spends months in Japanese-American relocation camp, Poston, Arizona, in order to create landscape environments (unrealized).

1942–1948
Returns to New York; takes studio at 33 MacDougal Alley. Makes mixed-media construction, "landscape" reliefs, series of carved/constructed stone slab sculptures, self-illuminating pieces (Lunars). First manufactured furniture and lamp designs, distributed by Herman Miller and then Knoll. Extensive involvement with theater. First major exhibitions since 1935. Designs public spaces and a monumental earth-work, *Sculpture to Be Seen from Mars* (unrealized).

1949–1952
Receives Bollingen Foundation Fellowship to research book on leisure. Travels throughout Europe, Middle East, and Asia, and documents journey with photographs and drawings. Does last portraits. In Japan, marries the actress Yoshiko Yamaguchi, whom he had met earlier in New York. Does first realized garden, Reader's Digest, and interior (at Keiō University). Begins designing Akari. Works with potter Rosanjin Kitaoji; sets up studio on his land in Kamakura. Exhibits ceramics in Japan.

1952–1956
Commutes between New York and Japan. Separates from wife and they are later divorced. Designs United Nations Playground and first plaza, for Lever House (both unrealized). Exhibits clay sculptures at Stable Gallery; Eleanor Ward remains dealer until 1961. Exhibits Akari at Bonniers in New York. Does series of cast-iron pieces in Japan. Continues involvement with theater. Begins series of sculptures in Greek marble.

1956–1961
Continues Greek marble pieces. Executes the gardens for Connecticut General Life Insurance Company, which include a large sculptural grouping called *The Family*, the first in a long series of realized environmental projects that also initiates his work with architect Gordon Bunshaft of Skidmore, Owings & Merrill. Concurrently does UNESCO gardens in Paris. Exhibits environmental designs and iron and marble sculptures in New York. Works in sheet aluminum. Exhibits metal and balsa-wood pieces at Cordier & Warren Gallery. Arne Ekstrom remains his dealer until 1974. Executes first plaza, for First National City Bank, Fort Worth. Establishes studio in Long Island City, New York.

1962–1966
With architect Louis Kahn, designs series of models for Riverside Drive Playground (unrealized). Executes gardens for Chase Manhattan Bank, New York City; Beinecke Library, Yale University; IBM; and the Israel Museum; as well as first realized playground, Kodomo No Kuni in Tokyo. Does series of floor sculptures and multipart

bronzes exhibited in 1963. Begins working in stone quarries of Querceta, Italy. First one-man show in Paris, 1964, at the Claude Bernard Gallery. Exhibits series of marble and granite pieces in 1965. Last stage set designed in 1966.

1967–1970
Exhibits stone/metal sculptures. Whitney Museum of American Art retrospective in 1968; concurrent exhibition of brush drawings. Publishes autobiography, *A Sculptor's World*. Makes public sculptures for New York: *Red Cube;* Spoleto, Italy: *Octetra;* Seattle: *Black Sun;* Bellingham, Washington: *Skyviewing Sculpture*. Executes fountains for Expo '70, Osaka, Japan. Exhibits Akari and striped marble pieces made in Italy.

1971–1979
Establishes studio in Mure on Japanese island of Shikoku. Exhibits in London, Zurich, and New York galleries. Begins ongoing series of granite and basalt sculptures. Executes major plaza in Detroit (Philip A. Hart Plaza) including large-scale fountain, and several fountains for Supreme Court in Tokyo, Society of the Four Arts in Palm Beach, the Art Institute of Chicago. Does first United States playground (Playscapes in Atlanta, sponsored by the High Museum) and several pieces of public sculpture: *Void*, Pepsico, Purchase, New York; *Shinto*, Bank of Tokyo, New York City; *Landscape of Time*, Seattle Federal Building; *Sky Gate*, Honolulu Municipal Building; *Heaven*, interior garden and granite pylon for Sōgetsu Flower Arranging School, Tokyo; *Momo Taro*, Storm King Art Center, New York; *Spirit's Flight*, Meadows Museum, Dallas; proposal for garden at Houston Museum of Fine Arts. Acquires building across the street from Long Island City studio and renovates it for additional storage for his work. Exhibits sheet-metal sculptures at the Pace Gallery and Akari at the Museum of Modern Art. Major traveling exhibition of landscapes and sets initiated by the Walker Art Center. First monograph *Isamu Noguchi* by Sam Hunter, published 1978.

1980–1981
Documentary film about artist and work made by Bruce Bassett, shown on PBS. Whitney Museum of American Art exhibits landscape projects and theater sets, *The Sculpture of Spaces*. Joint exhibitions at the Pace and Emmerich galleries to celebrate seventy-sixth birthday. Show includes new stone sculptures and table/landscape sculptures. Complete catalog of work written by Nancy Grove and Diane Botnick, published 1980. Establishes Isamu Noguchi Foundation, Inc. *Shinto* is dismantled by Bank of Tokyo. *Memorial to Benjamin Franklin*, a large-scale public sculpture proposed in 1933, is reproposed to the Philadelphia Museum of Art for the city of Philadelphia by the Fairmount Park Art Association. *The Spirit of the Lima Bean*, a granite sculpture, is erected as first part of an overall landscape project in Costa Mesa, California, *California Scenario*. Three basalt sculptures erected at the Cleveland Museum of Art. Proposal for a plaza with sculpture for the Japanese American Cultural and Community Center in downtown Los Angeles. Proposal for twenty-eight-acre park for the redevelopment of Bayfront Park in Miami. Acquires corner property adjacent to his building in Long Island City. Proposes an extension to the Vernon Boulevard building.

1981–1983
Work is started on what becomes the Isamu Noguchi Garden Museum. Noguchi designs new building extension and enlarges the garden. *California Scenario* is completed. The plaza and the sculpture *To the Issei* for the Japanese American Cultural and Community Center in Los Angeles is completed. Makes a series of twenty-six hot-dipped galvanized steel sculptures in editions, working with Gemini G.E.L. in

1982. Work is completed on museum in April 1983. Work is started on garden museum at Noguchi's studio in Shikoku, Japan. *Constellation for Louis Kahn,* a major public sculpture at the Kimbell Art Museum, Fort Worth, Texas, installed in 1983. Water garden completed for the Domon Ken Museum in Japan, summer 1983.

1984
Receives honorary doctorate from Columbia University. Searches for a site for his *Memorial to the Atomic Dead,* originally proposed in 1952. *Monument to Ben Franklin* installed. Noguchi receives the New York State Governor's Arts Award and the Japanese American Citizens League Biennium Award. Celebrates his eightieth birthday in Japan with an exhibition of his Akari at the Sōgetsu Kaikan in Tokyo.

1985
January exhibition of Akari and new stone sculptures at the Seibu department store in Tokyo, installed by Arata Isozaki. In May, the Isamu Noguchi Garden Museum in Long Island City is formally opened to the public. Continues work on Bayfront Park in Miami and the sculpture garden for the Museum of Fine Arts, Houston. Receives the Israel Museum Fellowship in Jerusalem. Noguchi is invited to represent the United States at the Venice Biennale in 1986 to be curated and organized by Henry Geldzahler and P.S. 1. Begins work on a large marble slide and new Akari designs for this exhibition.

1986
Exhibits seven large stone sculptures at the Pace Gallery in April. Sculpture garden for the Museum of Fine Arts, Houston, is completed and dedicated. The American Pavilion at the Venice Biennale opens in June. Noguchi shows new Akari, bronze playground models, and three large stone sculptures, including a ten-foot-high marble slide, originally conceived in 1966. Receives the Kyoto Prize from the Inomori Foundation in Japan in November. A memorial to the *Challenger* shuttle is proposed for Bayfront Park in Miami.

1987
The Isamu Noguchi Garden Museum catalog is published. Receives the National Medal of Arts, presented by President Ronald Reagan. Begins work on new constructed bronze sculptures.

1988
Begins designing three-hundred-acre park for city of Sapporo and approach and monument for airport at Takamatsu, Japan. Exhibits retrospective of bronzes at the Pace Gallery and recent bronze constructions at the Arnold Herstand Gallery in New York in May. Receives Third Order of the Sacred Treasure from the Japanese government in July and the first Award for Distinction in Sculpture from the Sculpture Center in December. Dies in New York, December 30.

Sources

INTRODUCTION

1. Gershom Scholem, *Walter Benjamin* (New York, 1988), p. 31.
2. Isamu Noguchi, *Isamu Noguchi: A Sculptor's World* (New York, 1968), p. 131.
3. Karlen Mooradian, *Arshile Gorky Adoian* (Chicago, 1978).
4. Arshile Gorky, undated note in the Archives of the Museum of Modern Art, New York.
5. Horishi Kitagura and Bruce T. Tsuchida, *The Tale of the Heike* (Tokyo, 1975), p. 695.
6. Katherine Kuh, *The Artist's Voice* (New York, 1962), p. 186.
7. Noguchi, *Sculptor's World*, p. 17.
8. Mircea Eliade, *Symbolism, the Sacred and the Arts* (New York, 1985), p. 93.
9. *Ibid.*, p. 95.
10. *Ibid.*, p. 97.
11. Yone Noguchi, *The Story of Yone Noguchi* (Tokyo, 1914).
12. J. B. Neumann, undated note in the Archives of the Museum of Modern Art, New York.
13. *Artlover* 2, ed. J. B. Neumann (1928).
14. Henry McBride, *New York Sun*, Feb. 20, 1932.
15. *Time*, Apr. 14, 1968.
16. Isamu Noguchi, interview with Matti Megged, notes, Apr. 28, 1985.
17. *Ibid.*
18. *Ibid.*
19. Isamu Noguchi, "The 'Arts' Called Primitive," *ARTnews*, no. 56 (Mar. 1957).
20. Noguchi, *Sculptor's World*, p. 7.

EARLY WANDER-YEARS

1. Isamu Noguchi, *Isamu Noguchi: A Sculptor's World* (New York, 1968), p. 7.
2. Isamu Noguchi, "Noguchi on Brancusi," *Craft Horizons*, Aug. 1976, p. 26.
3. Ezra Pound and Ernest Fenollosa, *The Classic Noh Theater of Japan* (New York,

1959), p. 155. Includes Yeats's essay for the first edition, titled "Certain Noble Plays of Japan" and published by the Cuala Press in 1916.

4. *Ibid.*, p. 161.

5. *Ibid.*, p. 161.

6. Nancy Grove, *Isamu Noguchi Portrait Sculpture* (Washington, D.C., 1989).

7. Patricia C. Willis, ed., *The Complete Prose of Marianne Moore* (New York, 1986).

8. Shotaro Oshima, *W.B. Yeats and Japan*, citing Itō's private papers (Japan, 1965), p. 47.

9. Noguchi, *Sculptor's World*, p. 19.

10. Edgar Snow, *Red Star Over China* (New York, 1938), pp. 17–18.

11. Noguchi, *Sculptor's World*.

12. Yukio Futagawa, *The Roots of Japanese Architecture* (New York, 1963), p. 8.

13. Isamu Noguchi, *The Isamu Noguchi Garden Museum* (New York, 1987), p. 24.

THE SEARCH FOR OLD JAPAN

1. Sam Hunter, *Isamu Noguchi* (New York, 1978).

2. Mary Fong, "Tang Tomb Murals Reviewed in the Light of Tang Texts on Painting," *Artibus Asiae* 45, no. 1 (1984), p. 38.

3. Isamu Noguchi, Hakone Conference transcript, 1984.

4. Isamu Noguchi, interview with author, 1984.

5. Věra Linhartová, essay in Centre Georges Pompidou catalog for *Japon des Avant-Gardes 1910–1970* (Paris, 1986), p. 142.

6. *Ibid.*

7. *Ibid.*

8. Quoted by Sukehiro Hirakawa, in an article kindly translated verbatim for me by Professor Hide Ishiguro.

9. Donald Keene, "Japanese Writers and the Greater East Asia War," *Journal of Asian Studies* 23 (Feb. 1964).

10. Sukehiro Hirakawa, "Takamura Kotaro's Love-Hate Relationship With the West," trans. Hiroaki Sato, *Comparative Literature Studies* 26, no. 3 (1989).

11. Centre Georges Pompidou catalog for *Japon des Avant-Gardes*, p. 27.

12. Rhony Alhalel, "Conversations with Isamu Noguchi," *Kyoto Journal*, spring 1989, p. 32.

13. Isamu Noguchi, interview with author, ca. 1984.

14. Isamu Noguchi, *Isamu Noguchi: A Sculptor's World* (New York, 1968), p. 21.

TOWARD A THEATER OF TWO WORLDS

1. Isamu Noguchi, *The Isamu Noguchi Garden Museum* (New York, 1987), p. 144.

2. Isamu Noguchi, *Isamu Noguchi: A Sculptor's World* (New York, 1968), p. 22.

3. Martin Friedman, *Noguchi's Imaginary Landscapes* (Minneapolis, 1978), p. 39.

4. Nancy Grove, *Isamu Noguchi Portrait Sculpture* (Washington, D.C., 1989), p. 14.

5. Henry McBride, *New York Sun*, Feb. 20, 1932.

6. Noguchi, *Sculptor's World*, p. 125.

7. Friedman, *Imaginary Landscapes*, p. 25.

8. Arata Isozaki, *MA: Space-Time in Japan* (New York, n.d.).

9. Donald Keene, *The Pleasures of Japanese Literature* (New York, 1988), p. 198.

10. Martha Graham, "From Collaboration a Strange Beauty Emerged," *New York Times*, Jan. 8, 1989.

11. Junichiro Tanizaki, *In Praise of Shadows*, trans. Thomas J. Harper and Edward G. Seidensticker (Vermont and Tokyo, 1984), p. 25.

12. Daisetz T. Suzuki, *Zen and Japanese Culture* (Tokyo, 1988), p. 220.

13. Graham, "From Collaboration," p. 47.

14. Suzuki, *Zen and Japanese Culture*, p. 48.

15. Noguchi, *Garden Museum*, p. 12.

FROM PRIVATE TO PUBLIC AND BACK

1. Isamu Noguchi, "What Is the Matter With Sculpture?" *Art Front* 3, no. 16 (Sept.–Oct. 1936), pp. 13–14.

2. Isamu Noguchi, *Isamu Noguchi: A Sculptor's World* (New York, 1968), p. 24.

3. Ethel Schwabacher, *Arshile Gorky* (New York, 1957).

4. Noguchi, *Sculptor's World*, p. 25.

5. Karlen Mooradian, *The Many Worlds of Arshile Gorky* (Chicago, 1980).

6. Yasuo Kuniyoshi, letter to George Biddle, Dec. 11, 1941, Archives of American Art, New York.

7. Noguchi, *Sculptor's World*, p. 25.

8. *Ibid.*

9. Jeanne Reynal, letter to Agnes Magruder, Archives of American Art.

10. *The New Republic*, Feb. 1, 1943, p. 142.

11. Noguchi, *Sculptor's World*, p. 25.

12. *Ibid.*

13. Isamu Noguchi, letter to George Biddle, Biddle papers, Archives of American Art.

14. Noguchi, *Sculptor's World*, p. 25.

15. *Ibid.*, p. 130.

16. Richard Kostelanetz, ed., *John Cage* (New York, 1970), p. 129.

17. John Cage, conversation with author, Dec. 5, 1989.

18. Noguchi, *Sculptor's World*, p. 130.

19. John Cage, conversation with author, Dec. 5, 1989.

20. Igor Stravinsky, quoted by Lincoln Kirstein in program notes for New York City Ballet's revival of *Orpheus*, Nov. 26, 1988.

21. Martin Friedman, *Noguchi's Imaginary Landscapes* (Minneapolis, 1978), p. 35.

22. Noguchi, *Sculptor's World*, p. 30.

23. *Ibid.*

24. Isamu Noguchi, *Interiors*, Mar. 1949.

25. "An Interview with Isamu Noguchi," *The League Quarterly* 20 (spring 1949).

26. Noguchi, *Sculptor's World*, p. 30.

A "MIGRATORY ULYSSES"

1. Isamu Noguchi, notes, n.d. (probably spring 1949), Archives of the Isamu Noguchi Foundation.

2. *Ibid.*

3. *Ibid.*

4. Isamu Noguchi, *Isamu Noguchi: A Sculptor's World* (New York, 1968), p. 30.

5. Jamake Highwater, *Dance: Rituals of Experience* (New York, 1978).

6. Noguchi, *Sculptor's World*, p. 31.

7. Paul Mus, quoted in Mircea Eliade, *Symbolism, the Sacred, and the Arts* (New York, 1985), p. 135.

8. *Ibid.*, p. 137.
9. Osvald Sirén, *A History of Early Chinese Art: Architecture*, vol. III–IV (New York, 1970; reprint of 1934 Paris edition), p. 8.
10. Eliade, *Symbolism*, p. 137.
11. Isamu Noguchi, *Arts & Architecture*, no. 67 (Nov. 1950).
12. Genichiro Inokuma, interview with author, Aug. 28, 1989.
13. Kenzaburo Oë, *A Personal Matter*, trans. John Nathan (Japan, 1969), p. viii.
14. *Ibid.*, p. viii.
15. Isamu Noguchi, "Meanings in Modern Sculpture," *ARTnews* 48 (Mar. 1949).
16. Věra Linhartová, essay in Centre Georges Pompidou catalog for *Japon des Avant-Gardes, 1910–1970* (Paris, 1986), p. 163.
17. *Ibid.*, p. 168.
18. Noguchi, *Sculptor's World*, p. 31.
19. Saburo Hasegawa, letter to Isamu Noguchi, Archives of the Isamu Noguchi Foundation.
20. *Ibid.*
21. Linhartová, *Japon des Avant-Gardes*, p. 164.
22. *Ibid.*
23. Saburo Hasegawa, "To Situate Avant-Garde Painting" (1937), quoted in Linhartová, *Japon des Avant-Gardes*, p. 165.
24. Linhartová, *Japon des Avant-Gardes*, p. 163.

A CRUCIAL JOURNEY

1. Genichiro Inokuma, interview with author, Aug. 28, 1989.
2. Saburo Hasegawa, "My Time with Isamu Noguchi" (1951), trans. Christopher Blasdel (Tokyo, 1977).
3. *Ibid.*
4. *Ibid.*
5. *Ibid.*
6. *Ibid.*
7. *Ibid.*
8. John Stevens, trans., *One Robe, One Bowl: The Zen Poetry of Ryokan* (New York and Tokyo, 1977).
9. *Ibid.*
10. Makoto Ueda, *The Master Haiku Poet Matsuo Bashō* (Tokyo, 1982), p. 23.
11. *Ibid.*, p. 168.
12. Hasegawa, "My Time."
13. Daisetz T. Suzuki, *Zen and Japanese Culture* (Tokyo, 1988), p. 318.
14. *Ibid.*, p. 284.
15. Hasegawa, "My Time."
16. Donald Keene, *The Pleasures of Japanese Literature* (New York, 1988).
17. Hasegawa, "My Time."

THE TRADITION OF THE EVER NEW AND EVER OLD

1. Kakuzo Okakura, *The Book of Tea*, trans. Everett F. Bleiler (New York, 1964), p. 31.
2. Junichiro Tanizaki, *In Praise of Shadows*, trans. Thomas J. Harper and Edward G. Seidensticker (Tokyo, 1977).
3. Yukio Futagawa, *The Roots of Japanese Architecture*, with text and commentaries by Teiji Itoh, and introduction by Isamu Noguchi (New York, 1963), p. 15.

4. Makoto Ueda, *The Master Haiku Poet Matsuo Bashō* (Tokyo, 1982).

5. Isamu Noguchi, *Isamu Noguchi: A Sculptor's World* (New York, 1968), p. 168.

6. Irmtraud Schaarschmidt Richter, and Osamu Mori, *Japanese Gardens* (New York, 1979), p. 59.

7. Saburo Hasegawa, "Katsura Palace," essay, trans. verbally for the author by Christopher Blasdel (Tokyo, 1951).

8. Akira Naito, *Katsura, A Princely Retreat* (Tokyo, 1977).

9. Lady Nijō, *The Confessions of Lady Nijō*, trans. Karen Brazell (New York, 1973).

PILGRIM AND MISSIONARY

1. Ruth B. Benedict, *The Chrysanthemum and the Sword* (New York, 1946).

2. Isamu Noguchi, *Arts & Architecture*, no. 67 (Nov. 1950), pp. 24–27.

3. *Ibid.*, introduction.

4. Yoshiro Taniguchi, note in catalog for Noguchi exhibition at the Mitsukoshi Department Store, Aug. 8, 1950.

5. Isamu Noguchi, in *Geijitsu Shincho*, trans. Saburo Hasegawa, Oct. 1951.

6. Noguchi, *Arts & Architecture*.

7. Artist identified only as Morita, translation of a newspaper clipping, Archives of the Isamu Noguchi Foundation.

8. Kenzō Tange, *Ise: Prototype of Japanese Architecture* (Boston, 1965).

9. Isamu Noguchi, *Isamu Noguchi: A Sculptor's World* (New York, 1968), p. 32.

10. *Ibid.*, p. 163.

11. Kenzō Tange, conversation with author, May 30, 1989.

12. Noguchi, *Sculptor's World*, p. 164.

13. *Ibid.*

14. *Ibid.*, p. 163.

15. Ian Buruma, "Haunted Heroine," *Interview*, Sept. 1989, pp. 124–27.

16. *Ibid.*

17. Noguchi, *Sculptor's World*, p. 32.

18. Sidney B. Cardozo, *Rosanjin: Twentieth-Century Master Potter of Japan* (New York, 1972).

19. Noguchi, *Sculptor's World*, p. 33.

20. Genichiro Inokuma, interview with author, Aug. 28, 1989.

21. Isamu Noguchi, Kamakura museum exhibition catalog, 1952.

22. Yusaku Kamekura, interview with author, May 27, 1989.

23. Yone Noguchi, *Through the Torii* (Boston, 1922).

24. Isamu Noguchi, letter to Jeanne Reynal, Nov. 2, 1952, Archives of American Art.

25. Michio Noguchi, interview with author, May 7, 1989.

26. Tadayasu Sakai, interview with author, May 6, 1989.

27. Yoshiaki Inui, Centre Georges Pompidou, *Japon des Avant-Gardes* (Paris, 1986).

28. Cardozo, *Rosanjin*.

29. Saburo Hasegawa, Kamakura museum catalog, 1952.

30. Genichiro Inokuma, interview with author, Aug. 28, 1989.

THE WAY BACK: PARIS AND NEW YORK

1. Kenzō Tange, interview with author, May 30, 1989.

2. Isamu Noguchi, *Isamu Noguchi: A Sculptor's World* (New York, 1968), p. 165.

3. *Ibid.*

4. Michio Noguchi, interview with author, May 7, 1989.

5. Isamu Noguchi, *Sculptor's World.*
6. *Ibid.*, p. 166.
7. Touemon Sanō, interview with author, Kyoto, May 20, 1989.
8. Shuji Takashina, quoted in Věra Linhartová, *Japon des Avant-Gardes* (Paris, 1986), p. 274.
9. Shuji Takashina, "Hisao Domoto," *Aujourd'hui,* no. 16 (Mar. 1958).
10. Isamu Noguchi, *Sculptor's World,* p. 35.
11. *Ibid.*
12. *Ibid.*
13. *Ibid.*, p. 36.

THE WORLD IN A SINGLE SCULPTURE

1. Museum of Modern Art, *Fourteen Americans,* ed. by Dorothy Miller (New York, 1946).
2. Martica Sawin, "An American Artist in Japan," *Art Digest,* Aug. 1955.
3. Isamu Noguchi, letter to Gordon Bunshaft, Archives of the Isamu Noguchi Foundation.
4. Robert J. Clements, ed., *Michelangelo: A Self-Portrait* (New Jersey, 1963).
5. *Ibid.*, p. 11.
6. Isamu Noguchi, *The Isamu Noguchi Garden Museum* (New York, 1987).
7. *Ibid.*, p. 98.
8. Isamu Noguchi, *Isamu Noguchi: A Sculptor's World* (New York, 1968), p. 169.
9. Isamu Noguchi, "Noguchi on Brancusi," *Craft Horizons,* Aug. 1976, p. 26.
10. Kenzō Tange, *Ise: Prototype of Japanese Architecture* (Boston, 1965).
11. Noguchi, *Garden Museum,* p. 11.
12. *Ibid.*, p. 20.
13. Martin Friedman, *Noguchi's Imaginary Landscapes* (Minneapolis, 1978), p. 14.
14. Whitney Museum of American Art, *Isamu Noguchi* (New York, 1968).

GREAT BEGINNINGS AND GRAND PROJECTS

1. Isamu Noguchi, *Isamu Noguchi* "The Sculpture of Spaces," in Whitney Museum of American Art catalog (New York, 1980), introduction.
2. Louis I. Kahn, quoted in Alexandra Tyng, *Beginnings: Louis I. Kahn's Architecture* (New York, 1984), p. 173.
3. Isamu Noguchi, *Isamu Noguchi: A Sculptor's World* (New York, 1968), p. 160.
4. Kahn, in Tyng, *Beginnings.*
5. Louis I. Kahn, letter to Isamu Noguchi, Aug., 1965, Archives of the Isamu Noguchi Foundation.
6. Martin Friedman, *Noguchi's Imaginary Landscapes* (Minneapolis, 1978), p. 60.
7. Noguchi, *Sculptor's World,* p. 169.
8. Isamu Noguchi, notes for press release, Archives of the Isamu Noguchi Foundation.
9. Isamu Noguchi, *The Isamu Noguchi Garden Museum* (New York, 1987), p. 164.
10. Noguchi, *Sculptor's World,* p. 170.
11. Rudolf Wittkower, *Sculpture: Processes and Principles* (New York, 1977), p. 150.
12. Constantin Brancusi, quoted in Ionel Jianou, *Introduction à la Sculpture de Brancusi* (Paris, 1976), p. 25.
13. Friedrich Teja Bach, *Brancusi* (Munich, 1986).
14. Isamu Noguchi, author's notes.

15. Rhony Alhalel, "Interview with Noguchi," *Kyoto Journal*, spring 1989.

16. Tatsuo Kondo, "A Conversation with Isamu Noguchi," *Geijitsu Shincho*, July 1968, pp. 15–20.

17. Isamu Noguchi, contractual letter, archives of the Isamu Noguchi Foundation.

18. Statement quoting Noguchi issued by Yale University at inauguration of Beinecke Rare Book Library.

19. Thomas B. Hess, *ARTnews* 45 (Sept. 1946), p. 33.

20. Friedman, *Imaginary Landscapes*, p. 65.

21. Noguchi, *Garden Museum*, p. 88.

22. Musō Kokushi, quoted in Irmtraud Schaarschmidt Richter and Osamu Mori, *Japanese Gardens* (New York, 1979).

23. Noguchi, *Garden Museum*, p. 52.

24. Noguchi, *Sculptor's World*, p. 131.

25. *Ibid.*, p. 171.

26. John M. Rosenfield and Shujiro Shimada, *Traditions of Japanese Art* (Cambridge, Massachusetts, 1970), p. 306.

27. Max Ernst, quoted in Carola Giedion-Welcker, *Contemporary Sculpture* (New York, 1955).

28. Friedman, *Imaginary Landscapes*, p. 61.

29. Noguchi, *Sculptor's World*, p. 171.

30. William Blake, "Jerusalem," in *Poetry and Prose of William Blake*, Geoffrey Keynes, ed. (London, 1932).

31. Isamu Noguchi, notes on travels, Archives of the Isamu Noguchi Foundation.

32. Friedman, *Imaginary Landscapes*, p. 67.

33. Isamu Noguchi, interview with Matti Megged, *Davar*, May 30, 1985.

34. Isamu Noguchi, "Sculpture Garden of the New National Museum in Jerusalem," *Arts & Architecture*, Oct. 1960.

35. Louis Kahn, letter to Isamu Noguchi, Aug. 1965, Archives of the Isamu Noguchi Foundation.

36. Isamu Noguchi, "An Art Garden in Jerusalem," 1964 typescript, Archives of the Isamu Noguchi Foundation.

37. Isamu Noguchi, letter to Gene Owens, Jan. 1964, Owens papers, Archives of American Art.

38. Isamu Noguchi, notes from interview with Matti Megged, Apr. 28, 1985.

COSMOS OUT OF CHAOS

1. Paul Klee, *The Thinking Eye*, ed. Jurg Spiller (New York, 1961).

2. Isamu Noguchi, Paul Cummings interview, Archives of American Art.

3. Tadashi Yamamoto, interview with author, May 13, 1989.

4. Genichiro Inokuma, interview with author, Tokyo, Aug. 1989.

5. Paul Valéry, *Collected Works*, vol. 8 (New York, 1947), p. 241.

6. Paul Valéry, "Eupalinos, or The Architect," in *Selected Writings of Paul Valéry* (New York, 1950).

7. Isamu Noguchi, "Noguchi on Brancusi," *Craft Horizons*, Aug. 1976.

8. Isamu Noguchi, *Isamu Noguchi: A Sculptor's World* (New York, 1968), p. 30.

9. Isamu Noguchi, "Towards a Reintegration of the Arts," *College Art Journal* 9 (1949), p. 59–60.

10. Johan Huizinga, *Homo Ludens: A Study of the Play Element in Culture* (Boston, 1955), p. 10.

11. *Ibid.*, p. 147.

12. Arthur Waley, *The Pillow Book of Sei Shonagon* (New York, 1960), p. 10.

13. Tono Yoshiaki, article in *New Art Around the World* (New York, 1966), pp. 229–37.

14. *Ibid.*

15. Noguchi, Cummings interview, Archives of American Art.

16. Isamu Noguchi, *The Isamu Noguchi Garden Museum* (New York, 1987), p. 174.

17. Gordon Onslow-Ford, interview with author, July 1990.

18. Bunji Murotani, "Noguchi's Garden for Supreme Court Building," in *Architecture and Urbanism* no. 43 (Tokyo, July 1974), p. 14.

19. Noguchi, *Garden Museum*, p. 180.

20. Isamu Noguchi, travel notes, Archives of the Isamu Noguchi Foundation.

21. Noguchi, *Garden Museum*, p. 64.

22. *Ibid.*, p. 200.

23. Edward Henning, cited in Sam Hunter, *Isamu Noguchi* (New York, 1978).

24. Octavio Paz, *The New Analogy* (New York, 1972).

25. Isamu Noguchi, typescript, Archives of the Isamu Noguchi Foundation.

26. Martin Friedman, *Noguchi's Imaginary Landscapes* (Minneapolis, 1978), p. 80.

27. Isamu Noguchi, typescript, Archives of the Isamu Noguchi Foundation.

28. John Beardsley, "The Machine Becomes a Poem," *Landscape Architecture* 80, no. 4 (Apr. 1990), p. 52.

TOWARD THE RESOLUTION OF SPACES

1. Henri Matisse, "Témoignages: Henri Matisse," *XXième Siècle*, no. 2 (Jan. 1952).

2. Guy Davenport, *A Balthus Notebook* (New York, 1989), p. 41.

3. Johann Wolfgang von Goethe, *Westöstlicher Divan* (1819). Trans. by B. Q. Morgan:

> Any west or eastern nation
> Has pure joys for delectation.
> Quit your whims and things external;
> Sit down to the feast eternal.

4. Isamu Noguchi, *Isamu Noguchi: A Sculptor's World* (New York, 1968), p. 123.

5. Donald Keene, *The Battle of Coxinga, Chikamatsu's Puppet Play* (London, 1951), p. 95.

6. Isamu Noguchi, notes in Archives of the Isamu Noguchi Foundation.

7. Keene, *Battle of Coxinga.*

8. Hugh Kenner, *Bucky: A Guided Tour of Buckminster Fuller* (New York, 1953).

9. *Ibid.*, pp. 93–94.

10. Louis Horst, "Modern Dance Forms," in *Impulse*, ed. Carroll Russell (1961).

11. Lucia Dlugoszewski, quoted in *The Dance of Erick Hawkins* (New York, n.d.). p. 34.

12. Noguchi, *Sculptor's World*, p. 60.

13. Gaston Bachelard, *La Poètique de l'Espace* (Paris, 1956).

14. Isamu Noguchi, notes, n.d., Archives of the Isamu Noguchi Foundation.

15. Isamu Noguchi, essay in *The Tragedy of King Lear*, ed. Donald Wolfit (New York, 1956).

16. Yukio Futagawa, *The Roots of Japanese Architecture*, with text and commentaries by Teiji Itoh and introduction by Noguchi (New York, 1963), pp. 7–8.

17. Isamu Noguchi, "New Stone Gardens," *Art in America* 52, no. 6 (1964).
18. Letter to Noguchi from Shigeomi Otomo, Oct. 14, 1950, Archives of the Isamu Noguchi Foundation.
19. Tōru Takemitsu, interview with author, Tokyo, May 30, 1989.
20. Tōru Takemitsu, Columbia University lecture, New York, Nov. 14, 1989.
21. Tōru Takemitsu, interview with author, Tokyo, May 30, 1989.
22. Hiroshi Teshigahara, interview with author, Kyoto, May 20, 1989.
23. Isamu Noguchi, statement in *Hiroshi Teshigahara* (Tokyo, 1985).
24. *Ibid.*
25. Hiroshi Teshigahara, interview with author, May 20, 1989.
26. *Ibid.*
27. Hiroshi Teshigahara, interview with Alan Jones, *Teshigahara* catalog for exhibition at Gallery 65, Thompson Street, New York City, April–May 1990, p. 20.
28. Arata Isozaki, *Isamu Noguchi, Space of Akari and Stone* (Tokyo, 1985), p. 92.
29. Paul Klee, *Wege der Naturstudiums* (Weimar, 1923).

"WE ARE A LANDSCAPE OF ALL WE KNOW"

1. Radu Varia, *Brancusi* (New York, 1986),
2. Isamu Noguchi, correspondence with Gene Owens, May 1968, Owens papers, Archives of American Art.
3. Benjamin Forgey, "Noguchi at Shikoku," *Landscape Architecture* 80, no. 4 (April 1990), p. 58.
4. Masatoshi Izumi, interview with author, May 1989.
5. Isamu Noguchi, *The Isamu Noguchi Garden Museum* (New York, 1987), p. 188.
6. Tōru Takemitsu, Columbia University lecture, New York, Nov. 14, 1989.
7. Tōru Takemitsu, Columbia University concert program notes, New York, Nov. 14, 1989.
8. Noguchi, *Garden Museum*, p. 19.
9. Roger Lipsey, *An Art of Our Own: The Spiritual in Twentieth-Century Art* (Boston, 1988), p. 351.
10. Bruce Bassett film.
11. Shigeo Anzai, interview with author, May 10, 1989.
12. John M. Rosenfield and Shujiro Shimada, *Traditions of Japanese Art* (Cambridge, Massachusetts, 1970).
13. Christopher Blasdel, interview with author, May 10, 1989.
14. Jamake Highwater, telephone conversation with author, Oct. 1990.
15. Sukey Hughes, *The World of Japanese Paper* (Tokyo, 1978).
16. *Ibid.*
17. Isamu Noguchi, in Paul Cummings papers, Archives of American Art.
18. Yasunari Kawabata, *Beauty and Sadness* (New York, 1975).
19. H. Paul Varley, *Japanese Culture* (Vermont and Tokyo, 1973).
20. Hisao Domoto, interview with author, Tokyo, May 7, 1989.
21. Hiroshi Teshigahara, interview with author, Kyoto, May 20, 1989.
22. Touemon Sanō, interview with author, Tokyo, May 7, 1989.
23. Ralph Waldo Emerson, quoted in Daisetz T. Suzuki, *Zen and Japanese Culture* (Tokyo, 1988).
24. Noguchi, *Garden Museum*, p. 84.
25. *Ibid.*
26. Masatoshi Izumi, interview with author, Mure, May 1989.

27. Noguchi, *Garden Museum*.
28. Masatoshi Izumi, interview with author, Mure, May 1989.
29. Isamu Noguchi, Cummings papers, Archives of American Art.
30. Isamu Noguchi, Hakone Conference transcript, Oct. 1982.
31. Isamu Noguchi, "Japanese Akari Lamps," *Craft Horizons*, Oct. 1954.
32. *Ibid.*
33. Arata Isozaki, *Isamu Noguchi, Space of Akari and Stone* (Tokyo, 1985).
34. *Ibid.*

LAST METAPHORS

1. Isamu Noguchi, to artist Ora Lerman, July 1988.
2. Isamu Noguchi, Minami Gallery catalog (Tokyo, 1973), introduction.
3. Kenzō Tange, interview with author, Tokyo, May 1989.
4. Isamu Noguchi, undated travel notes, Archives of the Isamu Noguchi Foundation.
5. Isamu Noguchi, interview in *The Houston Museum of Fine Arts Bulletin* 9, no. 3 (summer 1986), p. 20.
6. Isamu Noguchi, *The Isamu Noguchi Garden Museum* (New York, 1987).
7. Shoji Sadao, interview with author, Mar. 1988.
8. Isamu Noguchi, draft of letter to Henry Segerstrom, Archives of the Isamu Noguchi Foundation.
9. Isamu Noguchi, "The Sculptor and the Architect," *Studio*, no. 176 (1968), pp. 18–20.
10. "Noguchi, The Sculptor, Acclaimed for Stage Settings and Designs for Ballet," 1962 typescript, Archives of the Isamu Noguchi Foundation.
11. Yoshio Taniguchi, interview with author, June 1, 1989.
12. *Ibid.*
13. Isamu Noguchi, 1952 manuscript, Archives of the Isamu Noguchi Foundation.
14. Isamu Noguchi, "Projects in Japan," *Arts & Architecture*, no. 69 (Oct. 1952).
15. Saburo Hasegawa, letter to Isamu Noguchi, Jan. 18, 1951, Archives of the Isamu Noguchi Foundation.
16. *Ibid.*

CONCLUSION

1. Octavio Paz, *Alternating Current* (New York, 1973), p. 68.
2. William Blake, letter to Tommy Butts, in *Complete Writings of William Blake,* ed. Geoffrey Keynes (New York, 1957).
3. Isamu Noguchi, 1986 note, Archives of the Isamu Noguchi Foundation.
4. Stanley Kunitz, "The Quest for the Father," in *Myth and the Arts,* ed. Dore Ashton (New York, 1986).
5. Isamu Noguchi, "Gaudier-Breszka and Pound," Archives of the Isamu Noguchi Foundation.
6. *Ibid.*
7. Priscilla Morgan, interview with author, July 1990.
8. Kathleen Raine, *William Blake* (London, 1965).
9. Isamu Noguchi, interview with Diane Apostolos Cappadona, 1987, Archives of the Isamu Noguchi Foundation.
10. Isamu Noguchi, interview, Oct. 15, 1982, *Hiroba*, no. 228 (Apr. 1983).
11. Isamu Noguchi, essay in *The Tragedy of King Lear,* ed. Donald Wolfit (New York, 1956).

12. Arne Ekstrom, letter to author, July 10, 1990.

13. Shoji Sadao, interview with author, Sept. 1990.

14. Isamu Noguchi, letter to Priscilla Morgan, Sept. 24, 1964.

15. Thomas B. Hess, *ARTnews* 45 (Sept. 1946), p. 34.

16. Dorothy Norman, interview with author, Aug. 1990.

17. Erick Hawkins, interview with author, July 6, 1990.

18. Shigeo Anzai, interview with author, May 1989.

19. Bruno Taut, *Houses and People of Japan* (Tokyo, 1937).

20. Isamu Noguchi, Hakone Conference transcript, 1984.

21. William P. Malm, *Japanese Music and Musical Instruments* (Vermont and Tokyo, 1959).

22. Isamu Noguchi, letter to Anthony Lauck, Sept. 14, 1972, Archives of the Isamu Noguchi Foundation.

23. Rhony Alhalel, "Conversations with Isamu Noguchi," *Kyoto Journal*, spring 1989,

24. Tatsuo Kondo, "A Conversation with Isamu Noguchi," *Geijitsu Shincho*, July 19, 1968, p. 15.

25. Noguchi, interview, Cappadona.

26. Merce Cunningham, "Space, Time and Dance," *trans/formation* 1, no. 3 (1952), p. 150.

27. Benjamin Forgey, *Smithsonian Magazine*, Apr. 1978.

28. Roberta Smith, *New York Times*, June 10, 1988.

Bibliography

Akutagawa, Ryunosuke. *Hell Screen, Cogwheels, A Fool's Life*. Hygiene, Colorado, 1987.

Arnheim, Rudolf. *Parables of Sun Light*. Berkeley and London, 1989.

Ashihara, Yoshinobu. *The Hidden Order: Tokyo Through the 20th Century*. Trans. Lynne E. Riggs. Tokyo and New York, 1989.

Ashton, Dore, ed. *Myth and the Arts*. New York, 1986.

Atsumi, Ikuko. *Yone Noguchi: Collected English Letters*. Tokyo, 1975.

Bachelard, Gaston. *La Poétique de l'Espace*. Paris, 1957.

Benedict, Ruth B. *The Chrysanthemum and the Sword*. New York, 1946.

Blake, William. *Complete Writings of William Blake*. Ed. Geoffrey Keynes. New York, 1957.

Bowie, Henry P. *On the Laws of Japanese Painting*. New York, 1951.

Buruma, Ian. *Behind the Mask*. New York, 1984.

Caillois, Roger. *The Writing of Stones*. Trans. Barbara Bray. Virginia, 1985.

Caldwell, Helen. *Michio Ito, The Dancer and His Dances*. Berkeley, 1977.

Cardozo, Sidney B. *Rosanjin: Twentieth-Century Master Potter of Japan*. New York, 1972.

Center George Pompidou. *Japon des Avant-Gardes, 1910–1970*. Paris, 1986.

Chuang Tzu. *The Complete Works of Chuang Tzu*. Trans. Burton Watson. New York and London, 1968.

Clements, Robert J., ed. *Michelangelo: A Self-Portrait*. New Jersey, 1963.

Davenport, Guy. *A Balthus Notebook*. New York, 1989.

Dlugoszewski, Lucia. *The Dance of Erick Hawkins*. New York, n.d.

Dore, Ronald P. *Shinohata: A Portrait of a Japanese Village*. New York, 1978.

Eliade, Mircea. *Symbolism, the Sacred and the Arts*. New York, 1985.

Freer Gallery of Art. *Masterpieces of Chinese and Japanese Art*. Handbook. Washington, D.C., 1976.

Friedman, Martin. *Noguchi's Imaginary Landscapes*. Minneapolis, 1978.

Fu, Shen, Glenn P. Lowry, and Ann Yonemura, eds. *From Concept to Context: Approaches to Asian and Islamic Calligraphy*. Washington, D.C., 1986.

Futagawa, Yukio. *The Roots of Japanese Architecture*. Text and commentaries by Teiji Itoh. Japan, 1963.

Galt, Tom, trans. *The Little Treasury of One Hundred People, One Poem Each.* Princeton, 1982.

Giedion-Welcker, Carola. *Contemporary Sculpture.* New York, 1955.

Gordon, John. *Isamu Noguchi.* New York, 1968.

Grilli, Elise. *Japanese Picture Scrolls.* New York, n.d.

Grove, Nancy. *Isamu Noguchi Portrait Sculpture.* Washington, D.C., 1989.

Grove, Nancy, and Diane Botnick. *The Sculpture of Isamu Noguchi: A Catalogue.* New York and London, 1980.

Herrigel, Eugen. *Zen in the Art of Archery.* Trans. R. F. C. Hull. New York, 1953.

Highwater, Jamake. *Dance: Rituals of Experience.* New York, 1978.

Hughes, Sukey. *The World of Japanese Paper.* Tokyo, 1978.

Huizinga, Johan. *Homo Ludens: A Study of the Play Element in Culture.* Boston, 1955.

Hunter, Sam. *Isamu Noguchi.* New York, 1978.

Isozaki, Arata. *Isamu Noguchi, Space of Akari and Stone.* Tokyo, 1985.

———. *MA: Space-Time in Japan.* New York, n.d.

Jianou, Ionel. *Introduction à la Sculpture de Brancusi.* Paris, 1976.

Jung, Carl G. *Man and His Symbols.* New York, 1968.

Kawabata, Yasunari. *Beauty and Sadness.* Trans. Howard Hibbett. New York, 1975.

———. *Thousand Cranes.* Trans. Edward G. Seidensticker. New York, 1958.

Keene, Donald. *The Battle of Coxinga, Chikamatsu's Puppet Play.* London, 1951.

———. *The Pleasures of Japanese Literature.* New York, 1988.

Kenner, Hugh. *Bucky: A Guided Tour of Buckminster Fuller.* New York, 1953.

Kirby, John B., Jr. *From Castle to Teahouse.* Vermont and Tokyo, 1962.

Kitagura, Horishi, and Bruce Tsuchida. *The Tale of the Heike.* Tokyo, 1975.

Klee, Paul. *The Thinking Eye.* Ed. Jurg Spiller. New York, 1961.

Kostelanetz, Richard, ed. *John Cage.* New York, 1970.

Kuh, Katherine. *The Artist's Voice.* New York, 1962.

Linhartová, Věra. *Dada et Surréalisme au Japon.* Paris, 1987.

Lipsey, Roger. *An Art of Our Own: The Spiritual in Twentieth-Century Art.* Boston, 1988.

Mai-Mai Sze. *The Tao of Painting.* 2 vol. New York, 1956.

Malm, William P. *Japanese Music and Musical Instruments.* Vermont and Tokyo, 1959.

Martin, John. *Ruth Page.* New York, 1977.

Michaelis, David. *The Best of Friends.* New York, 1983.

Mooradian, Karlen. *Arshile Gorky Adoian.* Chicago, 1978.

———. *The Many Worlds of Arshile Gorky.* Chicago, 1980.

Morand, Paul. *Foujita.* Paris, 1928.

Mosher, Gouverneur. *Kyoto, A Contemplative Guide.* Tokyo, 1978.

Munsterberg, Hugo. *The Arts of Japan.* Vermont and Tokyo, 1957.

Naito, Akira. *Katsura, A Princely Retreat.* Tokyo, 1977.

Neumann, J. B. *Artlover.* New York, 1928.

Nijō, Lady. *The Confessions of Lady Nijō.* Trans. Karen Brazell. New York, 1973.

Noguchi, Isamu. *Isamu Noguchi: A Sculptor's World.* New York, 1968.

———. *The Isamu Noguchi Garden Museum.* New York, 1987.

Noguchi, Isamu, Kenzō Tange, and Tōru Takemitsu. *Hiroshi Teshigahara,* Tokyo, 1985.

Noguchi, Yone. *The Story of Yone Noguchi.* Tokyo, 1914.

———. *Through the Torii.* Boston, 1922.

Oë, Kenzaburo. *A Personal Matter.* Trans. John Nathan. Tokyo, 1969.

Okakura, Kakuzo. *The Book of Tea.* Trans. Everett F. Bleiler. New York, 1964.

Okudaira, Hideo. *Emaki: Japanese Picture Scrolls.* Vermont and Tokyo, 1962.

On the Dance of Erick Hawkins. Five essays, including one by Lucia Dlugoszewski. New York, n.d.

Orozco, José Clemente. *The Artist in New York.* Texas, 1974.

Oshima, Shotaro. *W.B. Yeats and Japan.* Japan, 1965.

Paternosto, César. *Piedra Abstracta.* Buenos Aires, 1989.

Paz, Octavio. *Alternating Current.* Trans. Helen R. Lane. New York, 1973.

———. *The New Analogy.* New York, 1972.

Pound, Ezra, and Ernest Fenollosa. *The Classic Noh Theater of Japan.* New York, 1959.

Raine, Kathleen. *Blake and Antiquity.* Princeton, 1974.

———. *William Blake.* London, 1965.

Richter, Irmtraud Schaarschmidt, and Osamu Mori. *Japanese Gardens.* New York, 1979.

Rosenfield, John. *Japanese Arts of the Heian Period.* New York, 1967.

Rosenfield, John M., and Shujiro Shimada. *Traditions of Japanese Art.* Cambridge, Massachusetts, 1970.

Scholem, Gershom. *Walter Benjamin.* New York, 1988.

Schwabacher, Ethel. *Arshile Gorky.* New York, 1957.

Seibu Museum. *Hisao Domoto.* Catalog, with essays by Takashi Tsujii, Tōru Takemitsu, Takahiko Okada, Yoshiba Abe, Shuji Takashina. Tokyo, 1987.

Seiden, Lloyd Steven. *Buckminster Fuller's Universe.* New York, 1989.

Shakespeare, William. *The Tragedy of King Lear.* Introduction by Donald Wolfit, essay and illustrations by Isamu Noguchi. New York, 1956.

Shimizu, Yoshiaki, ed. *Japan: The Shaping of Daimyo Culture: 1185–1868.* Washington, D.C., 1988.

Snow, Edgar. *Red Star Over China.* New York, 1962.

Soseki, Natsume. *Kokoro.* Trans. Edwin McClellan. Vermont and Tokyo, 1969.

———. *The Wayfarer.* Trans. Beongcheon Yu. Vermont and Tokyo, 1969.

Stevens, John, trans. *One Robe, One Bowl: The Zen Poetry of Ryokan.* New York and Tokyo, 1977.

Stock, Noel. *The Life of Ezra Pound.* Berkeley, 1977.

Suzuki, Daisetz T. *Zen and Japanese Culture.* Tokyo, 1988.

Takashina, S., Y. Tono, and Y. Nakahara, eds. *Art in Japan Today.* Tokyo, 1974.

Takiguchi, Shuzo, ed. *Isamu Noguchi.* Tokyo, 1953.

Tange, Kenzō. *Ise: Prototype of Japanese Architecture.* Boston, 1965.

Tanizaki, Junichiro. *In Praise of Shadows.* Trans. Thomas J. Harper and Edward G. Seidensticker. Vermont and Tokyo, 1984.

———. *Seven Japanese Tales.* Trans. Howard Hibbett. Vermont and Tokyo, 1963.

———. *Some Prefer Nettles.* Trans. Edward G. Seidensticker. New York, 1955.

Tokyo National Museum. *Screen Paintings of the Muromachi Period.* Tokyo, 1989.

Treib, Marc, and Ronald Hermon. *A Guide to Gardens in Kyoto.* Tokyo, 1980.

Tyng, Alexandra. *Beginnings: Louis I. Kahn's Architecture.* New York, 1984.

Ueda, Makoto. *The Master Haiku Poet Matsuo Bashō.* Tokyo, 1982.

Valéry, Paul. *Collected Works.* New York, 1947.

Varia, Radu. *Brancusi.* New York, 1986.

Varley, H. Paul. *Japanese Culture.* Vermont and Tokyo, 1973.

Waley, Arthur. *The Pillow Book of Sei Shonagon.* New York, 1960.

Warner, Langdon. *The Craft of the Japanese Sculptor.* Tokyo, 1936.

Willis, Patricia C., ed. *The Complete Prose of Marianne Moore.* New York, 1986.

Wittkower, Rudolf. *Sculpture: Processes and Principles.* New York, 1977.

Yashiro, Yukio. *2,000 Years of Japanese Art.* Ed. Peter C. Swann. New York, 1958.

Index

Photo Credits

The author gratefully acknowledges the assistance of the following in assembling and providing the photographs in this volume:

The Isamu Noguchi Foundation, Inc., was the source of most of the photographs.

Fuji Photo Film U.S.A., Inc., kindly furnished the film for the special photographs taken for this book by Denise Browne Hare.

Rudolph Burckhardt: pages 73, 150, 154, 161

The Cleveland Museum of Art: page 150

A NOTE ON THE TYPE

This book was set in Caledonia, a Linotype face designed by W. A. Dwiggins (1880–1956). It belongs to the family of printing types called "modern face" by printers—a term used to mark the change in style of type letters that occurred about 1800. Caledonia borders on the general design of Scotch Roman, but is more freely drawn than that letter.

Composed by The Haddon Craftsmen, Scranton, Pennsylvania

Printed and bound by Arcata-Halliday Lithographers, West Hanover, Massachusetts

Designed by Iris Weinstein